D0609507

Figures of Ill Repute

840.9352
B457

FIGURES OF ILL REPUTE,

Representing Prostitution in Nineteenth-Century France

CHARLES BERNHEIMER

WITHDRAWN

Harvard University Press
Cambridge, Massachusetts
London, England
1989

LIBRARY ST. MARY'S COLLEGE

183451

Copyright © 1989 by the President and Fellows of
Harvard College
All rights reserved
Printed in the United States of America
10 9 8 7 6 5 4 3 2 1

Publication of this book has been aided by a grant from the
Andrew W. Mellon Foundation.

This book is printed on acid-free paper, and its binding mate-
rials have been chosen for strength and durability.

Library of Congress Cataloging-in-Publication Data

Bernheimer, Charles, 1942–
Figures of ill repute: representing prostitution in nineteenth-
century France / Charles Bernheimer.
p. cm.
Bibliography: p.
Includes index.
ISBN 0–674–30115–3 (alk. paper)
1. French fiction—19th century—History and criticism.
2. Prostitutes in literature. 3. Art and literature—France—
History—19th century. 4. Art, French—19th century.
5. Prostitutes in art. 6. Sex crimes in literature. 7. Crime and
criminals in literature. 8. Prostitution—France—History—19th
century. 9. French fiction—Men authors—History and criticism.
I. Title.
PQ653.B45 1989
840'.9'3520692—dc 19 89–1993
 CIP

$27.85 hw 5-7-91 (R.S.)

Acknowledgments

It gives me great pleasure to think back over the years in which I was writing this book and to remember the various people who helped me with advice and encouragement along the way. First I must thank the Guggenheim Foundation for a grant that enabled me to spend five months in Paris, where a good deal of the writing was done. There I benefitted from the friendship and broad scholarship of Jacques Neefs, Pierre-Marc de Biasi, and Françoise Gaillard, and was given expert guidance by the foremost historian of prostitution in the nineteenth century, Alain Corbin. The Center for the Study of Zola Manuscripts, directed by Henri Mitterand, kindly put its library and its microfilms of Zola's outlines, sketches, and manuscripts at my disposal. Janet Beizer, who fortunately was in Paris during this same period, offered an insightful critique of my Balzac-Sue chapter and later was kind enough also to read my Zola chapter. The latter benefitted as well from pertinent commentaries by Sandy Petrey and Frank Bowman. Victor Brombert, supportive of my project from the start, I want especially to thank for drawing my attention to Villiers's "Les demoiselles de Bienfilâtre."

The single chapter on which I received the most feedback in the course of its difficult elaboration was "Degas's Brothels." Michael Fried first alerted me to the existence of the monotypes. Howard Bloch, who edited the issue of *Representations* in which my study first appeared, gave excellent advice, as always. Susan Suleiman's acute reading of an early version made clear the need for further interpretative work. Bill Warner wrote a careful, sophisticated, and challenging critique of the second draft, which helped me sharpen and extend my argument. Eunice Lipton and Carol Armstrong reassured me that specialists in the field did not find my readings aberrant. Susanna Barrows offered useful suggestions from the historian's point of view.

Acknowledgments

Other friends and colleagues have contributed to this book in less immediate but equally important ways. I think of Stanley Corngold, who followed me to the art library one day so that I could benefit from his response to Degas's bewildering monotype images; of Jann Matlock, with whom I have an ongoing dialogue on the subjects of our common interests; of Leo Bersani, from whom I continue to learn and whom I thank for his careful and perceptive reading of this entire book in manuscript; of David Willbern and Amy Doerr, who offered me the hospitality of their home during my last years as a commuter; and of Lionel Gossman, Natalie Davis, Gerry Prince, and Steve Nichols, all of whom helped me with advice and support at various stages of my work.

Joan DeJean has cohabited, somewhat uncomfortably, with this project from its inception. Despite having to tolerate repeated jokes about her husband's whoremastering fieldwork, she gave me encouragement at every step of the way and was constructively persistent in pushing me to complete the writing. Her example helped me combat the disturbing force of the misogynist fantasies whose analysis in this book frequently spread a vision of horror before me. The book is dedicated to Joan.

Finally, I want to thank my editors, Peg Fulton and Maria Ascher of Harvard University Press, who were helpful, cheerful, and competent at every stage of the book's preparation.

Contents

Illustrations

Abbreviations

A Jules Michelet, *L'Amour* (Paris: Calmann Lévy, 1899).

AMC Joris-Karl Huysmans, *L'art moderne / Certains* (Paris: 10/18, 1975).

AP Alexandre Dumas *fils*, "A propos de *La dame aux camélias*," in Dumas, *Théâtre complet* (Paris: Michel Lévy, 1868).

AR Joris-Karl Huysmans, *A Rebours* (Paris: Gallimard, 1977).

C Emile Zola, *La Curée*, in *Les Rougon-Macquart*, vol. I (Paris: Pléiade, 1960).

CB Walter Benjamin, *Charles Baudelaire: A Lyric Poet in the Era of High Capitalism* (London: New Left Books, 1973).

CDC Emile Zola, *La confession de Claude* (Paris: Cercle du Livre Précieux, 1966).

CR Gustave Flaubert, *Correspondance*, 2 vols. (Paris: Pléiade, 1973, 1980).

CT Gustave Flaubert, *Carnets de travail*, ed. Pierre-Marc de Biasi (Paris: Balland, 1988).

DD Jules Barbey d'Aurevilly, *Du dandysme et de George Brummell* (Paris: Balland, 1986).

DDD Paul Valéry, "Degas Danse Dessin," in *Oeuvres*, vol. II (Paris: Pléiade, 1960).

DP Alexandre Parent-Duchâtelet, *De la prostitution dans la ville de Paris*, 2 vols. (Paris: Baillière, 1836).

ER Joris-Karl Huysmans, *En Rade* (Paris: 10/18, 1976).

ES Gustave Flaubert, *L'éducation sentimentale* (Paris: Garnier, 1984).

F Sigmund Freud, "Fetishism," in *Sexuality and the Psychology of Love* (New York: Collier, 1963).

FE Jules Michelet, *La Femme* (Paris: Flammarion, 1981).

FP F.-F.-A. Béraud, *Les filles publiques de Paris et la police qui les régit* (Brussels: Meline, Cans, 1836).

HP Alexandre Parent-Duchâtelet, *Hygiène publique, ou mémoires sur les questions les plus importantes de l'hygiène appliquées aux professions et aux travaux d'utilité publique*, 2 vols. (Paris: Baillière, 1836).

IF Jean-Paul Sartre, *L'idiot de la famille: Gustave Flaubert de 1821 à 1857*, 3 vols. (Paris: Gallimard, 1971, 1972).

J Edmond and Jules de Goncourt, *Journal*, 4 vols. (Paris: Fasquelle-Flammarion, 1959).

JO Jules Michelet, *Journal*, 4 vols. (Paris: Gallimard, 1962, 1976).

LB Joris-Karl Huysmans, *Là-Bas* (Paris: Garnier-Flammarion, 1978).

LD Jules Barbey d'Aurevilly, *Les Diaboliques* (Paris: Garnier-Flammarion, 1967).

MP Eugène Sue, *Les mystères de Paris*, 10 vols. (Paris: Charles Gosselin, 1842–1843).

N Emile Zola, *Nana* (Paris: Pléiade, 1961).

OC Charles Baudelaire, *Oeuvres complètes* (Paris: Pléiade, 1961).

OE Gustave Flaubert, *Oeuvres complètes*, 2 vols. (Paris: Seuil, 1964).

PML T. J. Clark, *The Painting of Modern Life: Paris in the Art of Manet and His Followers* (New York: Knopf, 1985).

PS Maxime Du Camp, *Paris: Ses organes, ses fonctions et sa vie dans la seconde moitié du XIXe siècle*, 3rd ed. (Paris: Hachette, 1874).

RE Emile Zola, *Le roman expérimental* (Paris: Garnier-Flammarion, 1971).

SL Joris-Karl Huysmans, *Sainte Lydwine de Schiedam*, 2 vols. (Paris: Crès, 1932).

SMC Honoré de Balzac, *Splendeurs et misères des courtisanes* (Paris: Garnier, 1964).

Figures of Ill Repute

Introduction

*E*tymologically, prostitution means to set or place (Latin: *statuere*) forth, in public (*pro*). When Baudelaire wrote that art is prostitution, he may have had this etymology in mind, for indeed art is the making public of private fantasies, the public exposition of one's imaginary creations. In nineteenth-century France, as never before, male artists came forth with images of prostitutes to represent their fantasies about female sexuality. Their relation to the figure of the prostitute was complex, involving both identification and repulsion. As an emblem for their own artistic practice, it represented creative artifice, surface illusion, seductive falsity, even a kind of inspiring void. "There is, in this idea of prostitution," wrote Flaubert, "a point of intersection so complex—lust, bitterness, the void of human relations, the frenzy of muscles and the sound of gold—that looking into it makes you dizzy; and you learn so many things! And you dream so well of love!" What is dizzying is the force of contradictory impulses generated by the idea of prostitution: desire and its inevitable disappointment, the intimate contact of bodies and its demystification by monetary exchange, the ideal aspiration of love and the void enclosing each human being in his loneliness. But this entire complex of artistically productive tensions itself exists in a dizzying relation to a more threatening fantasy, whose creative role Flaubert was reluctant to acknowledge. "I love prostitution," he remarks, "for itself, independently of what is beneath." The complex fascination of the idea is posited on the denial of what is beneath, the female sexual body, which Flaubert—

in common, as we shall see, with the majority of male writers in nineteenth-century France—associated with animality, disease, castration, excrement, and decay.

My argument is that the prostitute is ubiquitous in the novels and the paintings of this period not only because of her prominence as a social phenomenon but, more important, because of her function in stimulating artistic strategies to control and dispel her fantasmatic threat to male mastery. She fascinates to the degree that that fascination can produce structures to contain, sublimate, or metaphorize the contaminating decomposition of her sexual ferment. As the century progresses, the growing fear of contamination is given medical justification by theories of degenerate heredity and syphilitic infection. In the imagination of a Huysmans, the entire organic world is diseased and decomposing, and the syphilitic prostitute is the morbid emblem of this collapse. Confronted by this pathological erosion, the writer must construct art against nature, against woman, against the organic. Such constructions of artifice and reflexivity signal the birth of modernism, which, I suggest, is inscribed on the prostitute's wounded body.

This punishing inscription has a historical parallel in the police registration and carding of prostitutes, the key administrative measures used to survey and discipline venal activity in France throughout the nineteenth century. I begin my book with a discussion of the most authoritative advocate of this system of regulation, Alexandre Parent-Duchâtelet, a public hygienist whose massive 1836 study of prostitution in Paris was, in his own view, the logical continuation of his earlier study of the city's sewers. In pursuing this and subsequent analyses of sociological, administrative, and medical reports on prostitutional behavior, I intend both to provide a historical context for the artistic figuration of the whore and to show the common fantasmatic ground shared, on the one hand, by police and medical officials dedicated to regulating prostitution for the sake of social order and, on the other, by creative artists committed to regulating the sexualized female through the formalities of literature and painting.

One of my reasons for opening this study with an analysis of Parent is to make the following point: there is no necessary break between the texts we recognize as "literary" and those we designate officially as social, historical, political, or legal. The fantasmatic

dimension that we acknowledge as inherent to literary production also constitutes a generative force in the creation of public discourses that purport to have erased the traces of unconscious desire. I believe that those traces, once uncovered, will frequently be found to display fantasies of gender and power strikingly similar to those underlying literary fictions. Such continuities demonstrate both the force of ideology in the unconscious and the force of sexual fantasies in ideological formations.

My emphasis on the fantasmatic origins of both literary and historical representations of prostitution privileges the image over the real, the word over its referent, symbol over event. Although this priority is inevitable, given my subject, I recognize that it involves me at times in what may seem like complicity with the authors whose denial of woman's physical and sexual being I denounce. No aspect of this book has been more difficult to negotiate than this one. If, for example, I claim that what is "beneath" Flaubert's love of the prostitutional idea is his dread of castration, this interpretation remains within the domain of male fantasy and neglects the realities of female exploitation, commodification, poverty, and suffering that constitute the experiential dimension "beneath" any imaginary appropriation of prostitution. I have tried as much as possible to register this neglect in describing the function of fantasy. But since that function is my primary object of analysis, the reader will find that "the real" is rapidly left behind and, with it, any attempt to describe the lived experience of the individual prostitute.

It should be noted, however, that such a description would in any event be very difficult to establish, since, with the exception of a few autobiographical writings by great courtesans of the period, we have no nineteenth-century accounts written by French prostitutes themselves. The numerous sociological studies of prostitution, Parent-Duchâtelet's included, give no voice to the women interviewed, absorbing their subjectivity into statistical tables and scientific generalizations. The female response to prostitution is articulated most strongly in this period by feminist reformers and abolitionists, first in Flora Tristan's *Promenades dans Londres* (1842) and later in books and pamphlets by Julie Daubié, Maria Deraismes, and other activist republican women of the 1870s. Empathetic and impassioned as these writings often are, they still offer only a view from outside.

In writing this book, I had to confront powerful expressions of disgust for female sexuality. These become increasingly repellent as the century progresses and as imagery of infectious disease and biological rot comes to supplement the already widespread images of animality, carnality, regression, and castration associated by men with woman's sexual function. Most critics play down this offensive material and simply refer in passing to the pervasive misogyny of the major French nineteenth-century novelists from Balzac to Huysmans. My premise, however, is that understanding these fantasies is crucial to understanding the generative impulses behind narrative and artistic structures in this period. I have consequently tried to "go with" the chains of fantasmatic associations I located in nineteenth-century texts and paintings, even when this project took me into profoundly disturbing psychic regions and at the risk of seeming to collaborate with the imagination of disgust. Thus, I found myself at times in a kind of transferential relation to these texts, discovering in them fantasies that I recognized, uncomfortably and painfully, lurking in dark regions of my own unconscious.

It would have been reassuring to imagine that what my journey into fantasy revealed could be delimited as the historically specific expression of an identifiable, and perhaps aberrant, "other." Although misogynist fantasies were particularly virulent in the second part of the nineteenth century, the fantasmatic imagery of male sexual repulsion takes strikingly similar forms in Western postindustrial capitalist societies in other eras as well. Thus, Klaus Theweleit's recent book on the fantasies of the protofascist members of the German *Freikorps* in the 1920s analyzes a repertory of images of dissolution, anality, and disease that repeats those I have found in French novels of the previous century.

If I experienced my position in writing this book as analogous in some ways to the psychoanalytic patient involved in a kind of interminable purgative cure through the recognition and working out of repressed fantasies, my critical project also put me in the position of the analyst, listening to the fantasies as they are produced, interpreting their content and structure, attentive to the plays of signification created within their verbal medium. In my analytic function, the contemporary intellectual context of my criticism played an important role: it sharpened my awareness of the sexist motivations generating formal literary strategies. Without the ana-

lyst's reading in feminism and his conversations with feminists, the patient might never have felt the need to acknowledge himself as such.

This reading of my fantasized relation to the fantasies I discuss in this book, which locates me at once inside and outside and defines me as both complicitous and critical, suggests the relevance to my topic of the psychoanalytic discourse that is one of my primary tools of interpretation. Psychoanalysis helps me to understand the genesis and imagery of fantasies through a theory of sexual difference as pertinent to the subject constructed by the nineteenth-century text as to the subject I often imagine myself to be.

This guarded formulation is meant to suggest both the privileged authority I grant psychoanalysis and my sense of the limitations of this authority. Psychoanalysis "explains" individual fantasies through a repertory of impersonal master-fantasies. Since I believe that the texts I examine submit to this mastery, I find that Freud's system of tropes provides an illuminating rhetoric to analyze the fantasmatic dynamics those texts inscribe. However, given the imaginary dimension of psychoanalysis itself—the complicity, one might say, of psychoanalysis with literature and art—I have refrained from casting the psychoanalytic net over the entire body of my criticism. Indeed, I have deliberately attempted to create a certain heterogeneity in my critical discourse, interweaving sections of close textual interpretation with biographical and anecdotal material, engaging literary history when the information seems relevant, introducing the discourse of science and history when these offer enlightening homologies to literary production. It is my hope that this pluralization of perspective serves not only to enliven my study but also to correct the occasional hermeneutic myopia of the psychoanalytic focus.

My book analyzes a limited selection of works in depth. It is not a survey. The prostitute appears overtly or in disguised form in innumerable French literary and artistic productions between 1840 and 1890. The works I have chosen to discuss are those I consider richest, most revealing, most complex. Some were notorious and controversial in their time—for example, Manet's *Olympia* and Zola's *Nana*. Others were great popular successes, their heroines celebrated as models of virtue rewarded, as was the case with Sue's *Les mystères de Paris*. Some were "in" books, influential among connoisseurs but

ignored by the general public—for instance, Flaubert's *L'éducation sentimentale* and Huysmans's *A Rebours*. And Degas's brothel images actually were not presented to the public at all, but were kept by the artist for his own private pleasure and that of a few close friends. The variousness of these works' reception reveals important differences in the ways each engages attitudes toward sex, gender, power, and pleasure. But reception also involves a response to aesthetic form, and the works I analyze most closely all show, with various degrees of self-consciousness, a complex relation between their sexualized subjects and the structures of narration or image that produce those subjects. Texts that do not involve this complexity have not retained my attention, even when, as in the case of Maupassant's well-known short stories featuring prostitutes, their thematic content may be relevant.

The absence of any discussion of prostitutional fictions or paintings by women is due not only to my focus on male representations but also to the fact that almost no such works exist. Pulchérie, sister of the heroine in George Sand's *Lélia,* is a high-society courtesan, as is Rosane d'Ermeuil, a secondary character in *Valentia,* by Daniel Stern. Both characters play primarily symbolic roles as sexually liberated women in a repressive social order. They are independent, wise, self-assertive individuals who combat the alienation and loneliness of the works' protagonists but are themselves anomalous creatures in patriarchal society. Interesting as these figures may be in the context of women's writing, their prostitutional activity is given almost no specificity in either work and seems to carry little fantasmatic investment.

Finally, a word about terminology. Parent-Duchâtelet, and most of the administrators and policemen who reported on prostitution in his wake, delighted in classifying and labeling venal women. In study after study the differences are rehearsed between a *pierreuse, femme de maison, insoumise, femme à parties, femme galante, femme entretenue, femme de spectacles et de théâtres,* and so forth. The fact that categorization persisted throughout the century as a tool of administrative science is significant, but the categories themselves are of little value for interpretation. Basically, I work with two designations, "prostitute" and "courtesan." "Prostitute" is the more general term and refers to any woman who sells the use of her body for sexual intercourse. A "courtesan" is a prostitute who associates

with men of wealth and prestige, is often kept by one or more of these men, and is a public figure, often ostentatiously so. When distinguishing the courtesan from the "common" prostitute, the latter designation refers to brothel whores, to registered prostitutes who practice in *garnis* and other such lodgings, and to independents, *insoumises* in the jargon of the time, who are not officially inscribed and who solicit on sidewalks and in cafés and bars. This distinction is not always important, in which case my use of the word "prostitute" includes the category of courtesan. In other contexts, however, the distinction is crucial, and those contexts will offer an opportunity to define the nuances of this difference in the representation of class and sex.

Parent-Duchâtelet: Engineer
of Abjection

*I*n the summer of 1818 the freighter *Arthur* took on a cargo of *poudrette,* a fertilizer composed of dried and pulverized fecal matter, for transport from Rouen to Guadeloupe. The ship's arrival at Pointe-à-Pitre was a gruesome event: it was discovered that half the crew had died on board and that the rest were seriously ill. There being no ready explanation for this disaster, the French ministry of the marine requested a report from the foremost public health specialist of the day, Jean Noël Hallé. Hallé, in turn, asked a young disciple, Alexandre Parent-Duchâtelet, to undertake a detailed investigation. Parent, as I shall call him hereafter, was a medical doctor contemplating a career in public hygiene. Thus was launched one of the paradigmatic careers of the first half of the nineteenth century. The particular fascinations, repulsions, methods, and manias of Parent's professional life reveal the social and psychological bases of contemporary attitudes linking female sexuality, excrement, and disease.

Parent's investigation of the *Arthur* case led him to visit Montfaucon, a hill on the outskirts of Paris where huge cesspits received some 240 square meters of human excreta daily. In addition, the carcasses of more than 12,000 horses and 25,000 to 30,000 smaller animals, discarded from immense butchers' yards, were strewn over twelve acres and left on the ground to rot. Although the purpose of this initial visit was only to research the production of *poudrette,* Parent would in future years become the acknowledged expert on

every aspect of what he called "this place unknown or barely known to the voluptuaries of the capital."[1] Even if they did not have first-hand acquaintance with the horrors of Montfaucon, Parisians of 1820 would nevertheless have heard of it, since in previous centuries it had been the location of the gibbet where criminals were hanged. Indeed, as if to symbolize the conjunction of crime and offal, of moral and organic degeneration, huge stone blocks that had once constituted the gibbet were used, after its destruction during the French Revolution, to build the upper reservoir for fecal matter, forming the embankment along which dung carts drew up.[2] Formerly, when the wind blew from the northeast, Parisians had smelled the odor of human corpses; now they smelled the stench of animal carrion and accumulated excrement.

In his long 1832 report on the horse butchers' yards, Parent, who since 1825 had been an esteemed member of the government's Public Health Council, drops his usual reserve to vividly evoke the horrendous stench of Montfaucon:

> If you conceive what can be produced by the putrid decay of piles of meat and guts openly exposed to the sun's glare for weeks and months on end so as to promote spontaneous putrefaction; if you then imagine the kind of gases likely to be given off by piles of carcasses with much of the offal still clinging to them, as well as the emanations generated from a soil soaked for years with blood and animal liquids, and from the blood itself left on the pavement in some yard or other with no drain, and finally from the waste streaming out of the gut-dressing works and skin-dryers' shops nearby; if you multiply at will the degrees of *stench* by comparing them with the stink that all of us have smelled when passing the decaying carcass of a dead animal we may have happened upon, you will get only a faint idea of the truly repugnant reek from this sewer, the foulest imaginable. (*HP,* II, 222)

Declaring that such a reek is intolerable to the general population and embarrassing to the city government, Parent recommends that Montfaucon be abolished. But he stresses that the effluvia pose no public health risks and were not a cause of the 1832 cholera epidemic.[3] Indeed, Parent saw as one of his primary tasks as a public hygienist the exculpation of stench, and in one report after another he attempted to persuade his colleagues in the administration of the

innocuousness of the fumes emanating from the city's decomposing waste. Investigating the manufacture of *poudrette* at Montfaucon, Parent found that the excrement industry in no way harmed the well-being of its workers (*HP*, II, 273). Examining conditions in the dissection rooms of Parisian hospitals, he determined that the health of medical students who spent weeks shut up in poorly ventilated spaces with rotting cadavers was not impaired (*HP*, II, 35–48).[4] Studying the alleged pernicious effects of putrefying hemp, he made his case by bringing the arena of experimentation into his own house and painting his personal study with a vile-smelling paste made from the substance (*HP*, I, xvii; II, 543). Analyzing the supposed dangers of work in the sewers, he argued that the six distinct odors he was able to identify after spending days in the Parisian cloacae presented no serious health hazards and that some illnesses might actually be alleviated by this special environment (*HP*, I, 219–224, 252).

In making these arguments, Parent's method was always rigorously pragmatic, statistical, and experiential. He rarely engaged in theoretical speculation. What does come through strongly from a reading of the two volumes of Parent's collected papers on public hygiene, however, is his fascination with the productivity of the biological processes of decomposition and their tendency to infiltrate, erode, and dissolve restrictive boundaries. As a public health official, Parent had the task of containing these processes within socially acceptable limits. His vocation thus involved a civilly responsible effort to channel and control his civilly subversive fascination with the rotten, corrupt, and disintegrating. It is this tension, conveyed in a style of nearly classical restraint and impersonal distance, that lifts Parent's work above that of other hygienists of his day and allies it with contemporary products of the literary imagination.

Being a man of science and enlightened rationality, Parent clearly enjoyed descending into the city's lower depths, smelling its odors, meeting its people, sharing their food, listening to their stories. Extraordinarily timid among his peers, Parent is supposed to have whispered to a friend at an official function at the Hôtel de Ville, "I would a hundred times rather go down into a sewer than come to this affair; you won't see me here anymore." And, as Parent's biographer Leuret notes, "he kept his word."[5] Although he was generally modest about his achievements, Parent comes closest to

self-praise when he describes his perseverance in studying the most repugnant conditions of working-class life. Among the many striking examples of his dedication are the years he spent researching—and the days he spent actually walking through—the sewers of Paris, which he called the city's "most useful monuments, daily trampled underfoot by its citizens solely concerned with business and pleasure" (*HP*, I, 157). His investigation resulted in two extensive reports advising how best to unclog, clean, and disinfect the sewers, build efficient new ones, and protect the workers' health and safety (see Figure 1). In the course of his scrupulous record of his experience in the tunnels of waste, he notes as a kind of personal failure his own shortness of breath and intense headaches (*HP*, I, 248).

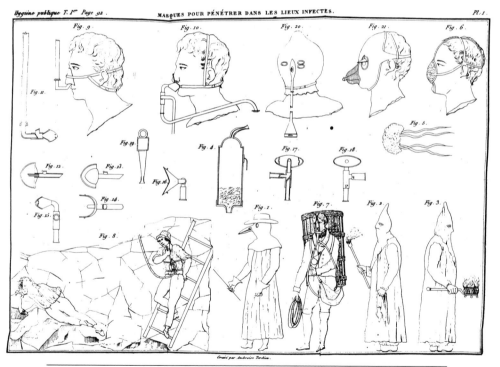

Figure 1. Masks for penetrating into infected places. Engraving. From Alexandre Parent-Duchâtelet, *Hygiène publique* (Paris: Baillière, 1836), I, 92.

He endured more successfully the distasteful task of descending into the cellar of the church of Saint Eustache to remove forty-three corpses stored there after the July Revolution and now emitting so pungent a stench that the parishioners could not complete their prayers. Despite "the frightening tumefaction of the cadavers and the greenish color of their limbs" (*HP*, II, 76), Parent, specialist of the morbid, personally found the stench quite bearable. Toiling alongside the sewermen and morgue workers, whom he had hired because of their familiarity with decomposing corpses, Parent engineered the removal of the bodies and their transport to the Montmartre cemetery in two hours and fifteen minutes and proudly reported that the whole operation had cost the city only 715 francs.

In this as in most of the other cases Parent was called in to solve, the issue, in his opinion, was not so much the threat of infectious disease as the threshold of public toleration. The stink was doing the parishioners of Saint Eustache no harm, but it interfered with their ability to worship. The situation was similar in the case of people who complained that industrial effluvia were spoiling their food. To disprove this, Parent visited the home of a certain Garet, whose commerce in dead cats and dogs filled his abode with the vilest odors, and found that this worthy man had no problem with food spoilage (*HP*, II, 98). In any case, Parent was not particularly concerned about the consequences of eating rotten food. The stomach, he maintained, can neutralize the process of organic decomposition, and he listed numerous examples of impoverished workers who had consumed spoiled horsemeat and were no worse off for it. Nor was the meat of animals that had died of disease to be mistrusted, as was demonstrated, among other instances, by the remarkable case of the voracious zoo keeper named Bijoux, who ate an entire lion infected with scabies and lived to boast of his achievement. (Unfortunately, the consumption of eight pounds of bread at one sitting later put an end to this glutton's pantophagist exploits—*HP*, II, 194.) Always ready to test his convictions on his own body, Parent did not hesitate to eat meat cooked over a fire maintained with parts of human cadavers, to ingest, in the home of a ragpicker, bouillon that had been left out for days in warm weather among piles of redolent rags (*HP*, II, 87), even to taste the brown water emanating from a cesspool of liquid excreta (*HP*, II, 386). All

this was tolerable to him. He did not fall ill. Putrefaction was proven innocent.

But Parent had to acknowledge that there were circumstances in which organic corruption could be dangerous as well as disagreeable. Indeed, the solution to the mystery of the deaths aboard the *Arthur* demonstrated the potentially lethal energy that could be released through processes of biological disintegration (*HP,* II, 257–283). Having boarded by chance a boat that had transported *poudrette* for only fifteen days, he discovered that the sailors aboard had suffered from nausea, fever, and diarrhea. The *poudrette* had reached a high temperature and was generating ammonia and hydrogen sulfate: it had begun to ferment. In the *Arthur,* this process would have been facilitated, Parent deduced, by the cargo's having gotten wet while being loaded in rainy weather and by its having been stored in the ship's unventilated hold, where tropical temperatures had brought it to a high heat, whose deadly effects the unfortunate sailors could not escape at sea. Thus, the problem for Parent was how to prevent dried excrement, a useful fertilizer, from engaging in a further organic mutation destructive to man. His solution was rigorous exclusion and containment: the *poudrette* should be enclosed in air- and watertight barrels.

Parent pursued similar strategies of enclosure and containment in many of his recommendations to the Public Health Council. In his report on water closets, he suggested collecting liquid and solid wastes in separate movable barrels instead of allowing them to accumulate in infrequently cleaned cesspits. In regard to the horse-butchering industry, he proposed locating processing plants on a single tract of land outside the city (*HP,* II, 326) and enthusiastically endorsed new methods to steam decaying horseflesh, thus separating it from the bones, and to compress the resulting carnal hash into easily transportable, odorless, nonputrefying cakes (*HP,* I, 17). To help sanitize the dissection rooms, he designed a table with holes in its top and a basin underneath from which two pipes protruded, one leading to a bucket for the storing of liquids, the other to a chimney where a fire served to draw off noxious odors (*HP,* II, 59–63; see Figure 2). For the transport of dead horses through the city streets, he recommended that each horse's hind legs be disarticulated so that the entire carcass would fit inside a cart and that this cart

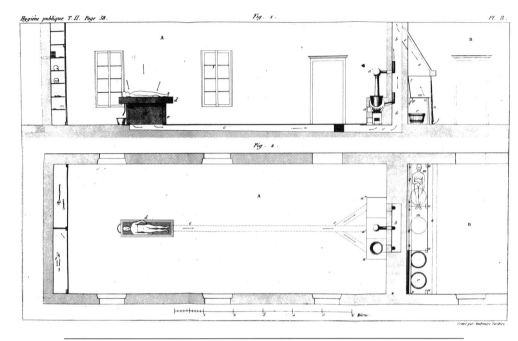

Figure 2. Project for a hospital dissection room. Engraving. From Alexandre Parent-Duchâtelet, *Hygiène publique* (Paris: Baillière, 1836), II, 58.

be enclosed to hide the repulsive contents from view (*HP*, I, 21; II, 247). Similar covered wagons should be used to transport cadavers to the anatomical amphitheaters and to move another offensive cargo, namely prostitutes, from police headquarters to prison or hospital (*DP*, II, 250).[6]

 This last recommendation is to be found in Parent's magisterial two-volume study of prostitution, *De la prostitution dans la ville de Paris*, published in 1836, the year in which he died (apparently from exhaustion) at the early age of forty-six. In his introduction, Parent explains that he began work on this project at the request of an "homme de bien" who wanted to gather information about the habits, tastes, and backgrounds of prostitutes so as to help them repent and reform. This well-meaning philanthropist died just as Parent was beginning to realize the far-reaching importance of his subject and the valuable function an extensive report would perform in acquainting foreign authorities with the admirable Parisian

administrative techniques to regulate and sanitize prostitutes. These considerations, he tells us, motivated him to pursue his investigation, despite its difficulties, in the service not only of his own country but of "all civilized governments" (*DP*, I, 6).

Parent's story of his chance involvement with prostitution and of his dedication to its study for the greater good of civilization leaves out of account the personal element of compelling fascination that links his reports on sewers, cadavers, and the like to his report on prostitution. Actually his investigations were conducted on both fronts simultaneously, since the majority of his papers on public hygiene were written during the same period (the eight years preceding his death) in which he was also engaged in research and writing on prostitution. So one has to think of him during these years as moving constantly between, on the one hand, the discourse of and on prostitution, and, on the other, his various forays into dissection rooms, sewage dumps, ragpickers' garrets, slaughterhouses, and so forth. The only connection he admits between his professional interests is his personal commitment to shed the light of scientific analysis on those dark and decaying aspects of urban life from which other officials turn away in disgust. This is how he counters the reproaches of those who object to his scabrous sphere of research:

> If, without scandalizing anyone, I was able to enter the sewers, handle putrid matter, spend part of my time in the refuse pits, and live as it were in the midst of the most abject and disgusting products of human congregations, why should I blush to tackle a sewer of another kind (more unspeakably foul, I admit, than all the others) in the well-grounded hope of effecting some good by examining all the facets it may offer? (*DP*, I, 7)

Parent's defense of his humanitarian and scientific enterprise is also, at a less explicit level, an exposure of his obsessional drive: prostitution is another kind of sewer, a place of biological decomposition and morbid decay. Alain Corbin, to whose brilliant discussions of Parent I am greatly indebted, rightly observes that the single exception the so-called "good Parent"[7] allows to his general law of the innocuousness of excrement is a highly significant one. That exception is the effect that work in the sewers is alleged to have on venereal disease, aggravating it to the point of death in only a matter

of days (*HP*, I, 256–258). Although Parent considers this "fact" inexplicable, Corbin finds that "the moral bases of such a conviction are evident: in the author's mind, the virulence of the illness transmitted by female sewers, by the vaginal filth of fallen women, is naturally linked to the mire and to excremental effluvia."[8] Just as the task of the public hygienist is to sanitize the sewers so as to promote their cleanliness and efficiency, so his task with regard to *les filles publiques* is to assure the salubrity of the sexual canals used to drain the seminal excess of male desire. Both channels for the disposal of human waste, Parent argues, are necessary for the orderly maintenance of civilized society:

> Prostitutes are as inevitable in an agglomeration of men as sewers, cesspits, and garbage dumps; civil authority should conduct itself in the same manner in regard to the one as to the other: its duty is to survey them, to attenuate by every possible means the detriments inherent to them, and for that purpose to hide them, to relegate them to the most obscure corners, in a word to render their presence as inconspicuous as possible. (*DP*, II, 513–514)

This statement summarizes the program of nineteenth-century police regulation of prostitution and reveals that program's strategy to control the visibility of purchasable women. Authority surveys, seeking out whatever attempts to escape detection, especially anything so disgusting as to repel investigation. It makes the repellent visible and submits it to scientific analysis. Parent was a staunch advocate of the *maisons de tolérance*—that is, brothels tolerated by the police and subject to their prescriptions and surveillance—and he supported the regulations requiring all prostitutes to be inscribed on the registers of the police. Indeed, it seems likely that the existence of these registers was a primary reason for Parent's attraction to prostitution as an object of study. No other working-class profession was so well documented. Besides the police registers, which furnished data concerning number, birthplace, age, father's and mother's profession, place of residence, employment, arrest record, marital status, education, number of children, "down to the smallest particularities of [the prostitute's] life" (*DP*, I, 320), there were also the extensive records of the *dispensaire de salubrité*, the medical arm of the police charged with the regular inspection of prostitutes' sexual organs. Thus, the female sewer offered itself to Parent as the

object of a regulatory machine already functioning, already producing knowledge, which he need only collect, quantify, and analyze.

Yet Parent is not satisfied with this data alone: just as he descended into the sewers, so now he goes into the brothels to make direct observations, at every hour of the day and night—always accompanied, he stresses, by a police agent. He interviews personnel at all levels in hospitals and prisons; he carefully studies the extensive police archives on individual prostitutes and on madams; he haunts the haunts of vice to pick up additional information; he asks several informants the same question so as to establish a control; he classifies prostitutes in categories according to their habitat, clientele, and behavior patterns; and whenever possible he tabulates the results of his research in statistical tables and charts. For instance, his chart of the determining causes of prostitution (see Figure 3) is admirable for its emphasis on objective social factors rather than innate depraved instincts. The purpose of all these information-gathering activities is to make prostitution the object of positive, quantifiable knowledge, the only kind worthy of consideration by the serious men to whom his study is addressed. Describing himself as a kind of free-floating intelligence—"homme libre et sans place, . . . homme exempt de préjugés" (*DP*, I, 9)—Parent adamantly distinguishes himself from earlier writers on the subject, writers who "closed themselves up in their study and let their imagination work" (*DP*, I, 10). They saw only the eloquence of their brilliant style, he objects, not the stubborn realities of social abuse.

Foremost among the blind visionaries Parent castigates is Restif de la Bretonne, whose *Le Pornographe*, published in 1769, he calls "the fruit of a delirious imagination" (*DP*, I, 321). Restif earns Parent's praise for advocating regular medical inspection of prostitutes to halt the spread of venereal disease, but otherwise the nineteenth-century public hygienist finds the project dreamed up by the eighteenth-century printer, adventurer, novelist, and pamphleteer a bookish and totally unrealizable exercise. Today's reader, however, may well be struck by certain fundamental similarities in their approaches to the problem of venal sex that make Restif seem in some respects a utopian precursor of Parent.[9] The most striking of these similarities is their common desire to render the prostitute invisible through the precise regulation of her availability.

Determining causes [of prostitution in Paris]	Born in Paris	Born in major cities	Born in subprefectures	Born in the country	Born in foreign countries	Total
Extreme poverty; absolute destitution	570	405	182	222	62	1,441
Loss of fathers and mothers; expulsion from the paternal home; complete neglect	647	201	157	211	39	1,255
To support old and invalid parents	37	0	0	0	0	37
Eldest in the family, having neither father nor mother to bring up her brothers and sisters and sometimes nephews and nieces	29	0	0	0	0	29
Widowed or abandoned women, having to bring up a large family	23	0	0	0	0	23
Come from the provinces to hide in Paris and find resources there	0	187	29	64	0	280
Brought to Paris and left there by soldiers, clerks, students, and others	0	185	75	97	47	404
Servants seduced by their masters and then dismissed by them	123	97	29	40	0	289
Ordinary concubines during a period more or less long, having lost their lovers and not knowing what to do	559	314	180	302	70	1,425
Total	1,988	1,389	652	936	218	5,183

Figure 3. The determining causes of prostitution. From Alexandre Parent-Duchâtelet, *De la prostitution dans la ville de Paris* (Paris: Baillière, 1836), I, 107.

Starting with the same premises as Parent—that prostitution is an inevitable evil, that it nevertheless serves a useful function in safeguarding the chastity of bourgeois wives and daughters, and that its major danger is contagious disease—Restif imagines what Parent judges to be a practical impossibility, sequestering all prostitutes in vast state-regulated institutions built for this purpose, which he calls *parthénions*. Each *parthénion* is conceived as a totally self-contained and self-sufficient universe, operating according to rigid codes of conduct and hierarchical categories of value. The client is important only insofar as he fathers children, who will eventually perform all the necessary tasks around the house, and pays the fees that keep the hierarchy in place. Women are classified according to age and beauty at prices ranging from six cents for those aged 40–45 to ninety-six pounds for those aged 14–16. The client may approach the bordello masked or otherwise disguised, but once inside he must remove his trappings. He then buys a ticket from the presiding *gouvernante*, and proceeds without dallying to the particular corridor where he can find the women who correspond to the price he has paid. There he makes his choice, but the desired woman may refuse the client if she finds him repugnant (this degree of freedom is calculated to promote harmony). The prostitutes are checked daily for venereal disease, and—an unheard-of innovation—the clients also must submit to an examination and pay a fine if they are found to be diseased. The inmates are permitted to leave the brothel only on holidays and then only for supervised visits to the theater, to which they must be driven in hermetically closed carriages and where they must sit in loges hung with gauze.

Although Parent calls these measures "the strangest things it is possible to imagine" (*DP*, I, 321), they actually realize in a utopian framework many of his most cherished goals. Here is a structure that submits the entire prostitutional operation to scientific knowledge and seems organized for the very purpose of orderly documentation. Cloistered in an artificial environment, defended by a well-trained police force, prostitutes in the *parthénion* serve the city without being seen by it. Their presence is acknowledged and regulated by the administrative authorities, but it is rendered perfectly inconspicuous, as well as hygienically innocuous, to the citizenry at large. This is just what Parent hopes will be accomplished if the police can pressure as many prostitutes as possible to enter the so-

called *maisons de tolérance,* where inmates are subjected to medical visits once a week. The rules in effect for such establishments, fully approved by Parent, ensure that the women will be invisible from the outside (all first-floor windows must be of ground glass, and no windows may be opened more than a few inches) and accessible to police surveillance at all times (rooms cannot be locked, and there must be a window in each door). But whereas Restif imagines placing the *parthénions* strategically in sparsely populated sections of the city, Parent argues that, since prostitution is a current that will always make its own way and establish itself in whatever quarters it finds most congenial (*DP,* I, 353), the police should concentrate their efforts on registering prostitutes rather than on the impossible task of concentrating commercial sex in designated areas.

Why can Parent not simply point out the utopian nature of Restif's proposal, its failure to deal with economic and social realities, and still give his predecessor credit for sharing his own ideological assumptions? There is first of all Parent's distaste for Restif's libertine lifestyle. Restif's knowledge of his subject came not from in-depth research and arduous fieldwork, Parent complains, but from first-hand experience. Not only did he live in a corrupt period, he was himself "an immoral man who spent his life in the society of prostitutes, and hence knew them well" (*DP,* I, 554). Restif, in other words, did not preserve the distance from his sordid object of study that Parent scrupulously imposed upon himself (remember that a police inspector always accompanied Parent into the brothels). The stalwart member of the Public Health Council may taste sewage water, he may breath nauseating air and eat putrid meat, but never will he admit having had physical contact with a prostitute, or even having found such a woman desirable. Restif, in contrast, frequented brothels in a period of French history when these haunts of debauchery were full of obscene engravings and licentious books "capable of exciting the passions" (*DP,* II, 411). All such provocative printed matter has now been outlawed, Parent reports, praising the police administrator who put through this order, which will surely inspire respect for authority in even the most shameless prostitutes. This repressive attitude toward erotic stimulation suggests the purely functional purpose Parent envisages for the brothel. He seems to imagine it as operating without exciting the passions, as a purely physiological outlet for the city's seminal excess. Thus, he transforms

his fascination with degraded sexuality into the professional interest of a humanitarian public hygienist. Just as he considers himself free of prejudice, so he judges himself purged of desire. Hence his outrage with Restif, whose knowledge has a carnal base and who, despite the systematic organization of his proposal, writes with the imagination of desire.

Take, for instance, Restif's descriptions of the insidious temptations offered in the city's brothels to innocent young men from the provinces. The writing conveys a sensual appreciation of the seductresses the speaker intends to condemn:

> She is a young object, whose beauty was her undoing: three barely completed lusters: nascent bosom, still fresh; complexion of roses and lilies . . . Nonchalantly stretched out on an easy chair, the goddess has chosen the pose best suited to bring out her charms: snow is less white than her elegant dishabille; a skirt, too short, a little disarranged, allows one to glimpse half of a perfectly shaped leg; softly resting on a pillow, a pretty foot makes one want to kiss it, while the other falls negligently on the floor; the seductive siren gives her breasts, pressed together by a corset glued to her slender waist, the lively and repeated motion that, in a naïve beauty, is the harbinger of defeat . . .[10]

A connoisseur's appreciation and a stylist's delight keep this dithyrambic sentence going until the climactic exclamation: "Stop, O unhappy young man! Stop! A serpent is hidden under those flowers"—a warning that could evidently be directed to the writer himself.

Part of what makes Restif's book interesting, and undoubtedly another reason for its disturbing impact on Parent, is that Restif fictionalizes his writer: he is named d'Alzan, and the above passage appears in a letter he is writing to his friend des Tianges. Restif encloses the long *parthénion* project, presented in forty-five articles composed in sober, legalistic language, within the frame of an epistolary novel, in which d'Alzan, a reformed rake and the supposed author of the project, writes effusively about his love for des Tianges's sister-in-law, whom he will eventually marry. The frame is not exclusively concerned with romance, however, since much of the epistolary exchange is taken up with objections to, and defenses of, various aspects of the project to regulate prostitution. So the

flowery language of proper bourgeois love and chaste desire is mixed in with the rational, cold style of bourgeois defense against commercialized sex and venereal disease. And both these discourses coexist with passages, such as the one quoted above, in which moral condemnation serves the purpose of libertine titillation. Thus, the pleasures and pressures of desire permeate Restif's book. Indeed, one suspects that his deepest commitment in devising the *parthénion* project may have been not to the maintenance of law and order but to the enhancement of social possibilities for experiencing pleasure. A long note at the back of his text nostalgically compares the depersonalized prostitutes of contemporary times, who, feeling irredeemably despised and degraded, have become "sorts of automatons animated only by money," to the self-respecting prostitutes of Greek and Roman days, for whom "the habit of pleasure had made *jouissance* a need."[11]

Parent called Restif's book *ordurier* (smutty, lewd, filthy), thereby associating it with the ordure of the city garbage dumps and sewers, because in his view *Le Pornographe* was contaminated by the corruption of desire and by the excesses of fictionalizing inventiveness that this corruption inspires. Desire shares with the biological processes of decomposition the tendency to infiltrate and erode confining limits and definitions. The hybrid quality of Restif's text, with its undigested mixture of styles and discourses, gives it some of the fascinating and dangerous qualities of a morbidly productive refuse heap. Desire ferments fiction and decomposes discourse, deflecting it from the linear path Parent proposes for himself, where "perseverance and tenacity take the place of genius" (*DP,* I, 13). Parent's intention is "to see things as they really are [*sous leur véritable aspect*], . . . to call things by their name and march straight to [my] goal" (*DP,* I, 9). Parent's exposition thus proceeds by refusing the temptations of metaphor and the flourishes and embellishments of a style that swerves promiscuously away from the literal. In the study of prostitution, the only deviance should be attributable to the objects of study, to those scandalous creatures who solicit desire and stimulate fiction. Parent understood that, to assume its authority as an instrument of disciplinary power, a discourse must always treat desire as alien to its own impersonal function.

Interestingly, it was precisely for his rigor on this score that Parent was reproached by F.-F.-A. Béraud, the first person to write a major

study of prostitution in the wake of his. Béraud was an ex-super-intendent of the Bureau of Morals whose two-volume work entitled *Les filles publiques de Paris et la police qui les régit* appeared in 1839.[12] Although he praises the thoroughness of Parent's investigation, Béraud finds that "its form is generally too scientific" (*FP*, I, 102) to be understood by the very people it should most benefit, namely "all those whose weak character, nervous organization, or straitened circumstances continually expose them to the temptations of seduction and the snares of recruitment" (*FP*, I, 105–106). To remedy this lack, Béraud proposes to offer admonitory tableaux taken from his own vast experience, and his book is full of anecdotes, the longest being a twenty-two-page story (*FP*, II, 208–230), complete with dialogue, about a deceitful actress/prostitute who cynically procures an innocent orphan girl for the lover she has herself rejected. This lover infects the girl with syphilis, of which she dies, and the evil procuress then confiscates her property, all the while successfully pretending to be heartbroken over the death of her protégée. This could easily be the plot of a Balzac story (and, who knows, was perhaps influenced by Balzac). Béraud claims to have written a more moral book than Parent to the extent that, "in order to reassure even the most timorous and modest reader" (*FP*, I, 105), he has refused, unlike Parent, to name everything he has seen (lesbianism, for instance, is too scandalous for him) and has illustrated his study with true-life stories intended to instill fear and loathing in susceptible imaginations. But the effect of Béraud's modest veiling of his gaze and of his pervasive storytelling is to diminish the impact of his administrative recommendations for the control of prostitution. It matters little that Béraud claims that his anecdotes are factual: his text is permeated by a desire for fiction, and the authority of his discourse seems to be caught up in that desire rather than, as with Parent's strategy, in its denial.

How does Parent pursue this strategy? First, his scientific and technocratic empiricism appears to leave no room for ideological bias or subjective invention. He intends not to formulate sweeping theories or interpretations but only to offer modest practical remedies in the context of the social realities his research has brought to light. Second, he identifies his proposals entirely with the administrative measures presently in force. In this way he makes current police procedures for regulating prostitution seem perfectly corre-

lated with the deviant practices they were designed to oversee and control. The individuality of his discourse, its motivating desire, is defused by its coincidence with a system of administrative rules whose impersonal basis is the maintenance of social stability and order. As Foucault has demonstrated, authority creates the individuality of its subjects by identifying their features and surveying their particular habits. Since the individual here is exclusively female, Parent pays no attention to the character or class of the client. The client's desire is simply a given. "The administration," writes Parent, "cannot make men virtuous, it cannot rectify their judgment and repress impetuous passions that speak too strongly to leave them conscious of their duty" (*DP*, II, 43). The administration's patriarchal impersonality mirrors and sustains the client's. It allows him to evacuate his excess desire in a closed and sanitary environment that, while catering to his sexual privilege, requires nothing of his individual expression.

In contrast, the prostitute's individuality is a matter of close official scrutiny. The bureaucrats who interrogate prostitutes at the time of their registration are experts at reading behavior as a text. They are able, Parent notes admiringly, to determine just by the way a prostitute sits down whether she is new at the profession or an old hand (*DP*, I, 373)—an uncanny ability worthy of a Balzacian hero (or of Freud in his case histories). The socialized female body betrays its past to the expert observer. Female sexual physiology, however, is much less revealing. For purposes of identification and discipline, it would be ideal if an examination of a woman's sexual organs could ascertain, by the degree of distention of the vagina or the enlargement of the clitoris, that the organs had been subjected to an abnormally high incidence of use. But the dispensary doctors assure Parent that "the genital parts of prostitutes do not show any special alteration particular to them" and that consequently "in this respect there is no difference between prostitutes and the most virtuous married women" (*DP*, I, 214).

From a moral perspective this lack of difference is evidently scandalous: "How can one decide now," asks Parent, "if a dead or living woman has lived, I will not say in licentiousness, but in the licentiousness of every day and every instance that characterizes the life of the prostitute?" (*DP*, I, 217). The female sexual body reveals nothing of the history of its penetration by men. Examined under

the light of science, it remains opaque, keeping its secret in death as in life. In their physiology, the female genitals are clandestine: no marks of male possession are inscribed on them; they offer no signs to be decoded as knowledge. Nor does a prostitute's overall state of health offer any clues to her profession. Prostitutes are more resistant to disease than the majority of working-class women, Parent maintains, a conclusion that Béraud finds so contrary to morality that, however true it might be, he believes Parent should not have published it (*FP,* I, 104).

So prostitutes join a host of other workers who, in Parent's judgment, remain strong and healthy despite their everyday exposure to the processes of organic decomposition in the sewers, the dissection rooms, the slaughterhouses. But there is one point of vulnerability in the prostitute's "body of iron": "The profession of prostitutes," writes Parent, "with the exception of syphilitic diseases, would not in itself be unhealthy" (*DP,* I, 279–280). The female sexual organs lose their undecidability and their clandestine status the moment their infection is ascertained by medical authority. The organ of woman's sexual function becomes knowable in the male discourse of social control only when it is syphilitic.

The fact of syphilis is the cornerstone of the entire regulatory edifice. Fear of the spread of syphilis justifies treating prostitution as a public health problem. Yet Parent, like almost all subsequent analysts of the problem of venereal disease, never envisages the possibility of subjecting the client to any kind of medical treatment. As Jill Harsin observes, "In the peculiar politics of venereal disease, women were always the guilty transmitters, men (and the wives and children of these men) their hapless victims."[13] The client remains invisible in Parent's text, as the representative of male desire whose interests the administration implicitly serves. Foremost in this campaign of service is the periodic inspection of prostitutes, which justifies the dispensary, the system of inscription, and the campaign to register clandestine prostitutes, the so-called *insoumises,* suspected of being the most highly syphilitic group of all. Parent's alarm about this group brings together his dread of venereal contagion with his dread of what is undecidable about any unregulated female sexual activity. Clandestine like the female genitals themselves, the *insoumises,* "assuming the most proper appearance, paralyze authority, defy it at every instant and spread with impunity the most awful conta-

gion and the greatest immorality" (*DP,* I, 492). The clandestine prostitute is scandalous in much the same sense that the female sexual organs are: she puts the difference between honest and venal women in doubt. Thus, she comes closest to representing the physiological truth of woman's sexual nature. Parent, of course, would not accept this conclusion, but intratextual analogies betray him. In clandestine prostitution, his text suggests, female sexuality is at one with its physiological organism. This sexuality is therefore not only immoral (the implication is that regulated prostitution is less so) but also diseased: "It is by means of clandestine prostitution," writes Parent, "that syphilis perpetuates and spreads its ravages; by its means that the wisest measures taken by the administration are rendered ineffective" (*DP,* I, 499). Parent cannot know this for sure, since *insoumises* are, by definition, absent from the police records. The positive terms of his assertion reflect his association of syphilis, the disease that erodes differential membranes, with the erosion of moral categories embodied in all women's sexual physiology.

Helping to further this breakdown by difference is the association of clandestinity with disguise and duplicity: "Clandestine prostitution operates in the shadows, avoids show and publicity, hides under the most various forms, and maintains itself by ruse, imposture, and deceit" (*DP,* I, 492). Although he usually refrains from giving illustrative anecdotes that might seem to compromise the gravity of his enterprise, Parent feels obliged in this instance to support his thesis with some examples. Unlike Restif before him and Béraud after, he is careful to offer these potential narratives in abbreviated form and sober style. There was the procuress who pretended to be a midwife; the one who set up as an extractor of teeth and whose clients always arrived with their jaws bandaged; the retired madam at whose restaurant the *table d'hôte* was a front; the alleged laundress who sent girls out to return clean linens but actually for a quite different purpose; the charity lady, respected by everyone, whose three modestly dressed charges she shepherded into *hôtels garnis* supposedly to solicit aid but actually to sell their bodies, particularly to "rich Englishmen whose tastes and addresses she knew" (*DP,* I, 496). For Parent, what is most shocking about these instances of clandestine operations is the way they transform the socialized female body into an artificial construction. Through strategies of camouflage, role playing, and fictionalizing, the clothed body of the *insoumise*

becomes a means to deceive the policing authority that attempts to translate it into knowledge. In the network of associations spun by Parent's text, the effects of clandestinity thus become linked with the effects of desire: both of them subvert scientific discourse and ferment fiction. Venereal infection is the virulent illness embodying this subversion.

The only class of prostitute Parent considers more dangerous than the *insoumises* consists of women who have made the construction of their social façades coincide so perfectly with what is publicly acceptable that the police administration cannot legally arrest them. These are the women Parent calls *femmes galantes, femmes à parties,* and *femmes de spectacles et de théâtres.* They have a home, pay taxes, enjoy all political rights, and "in public places and meetings, nothing can distinguish them from the most proper women; but, when they want to, they know how to affect a tone, a countenance, and a glance that are significant to those who look for this particular class" (*DP,* I, 174). Here it is the women themselves who have become semiotic experts, using their mastery to make their availability readable only to clients of their choice, turning their bodies into refined instruments to attract capital. They make deliberate use of female undecidability as a tactic to control and limit male authority. No wonder Parent considers them the most virulently syphilitic women of all: "More than any others, they spread serious diseases and early infirmities," he writes; "they destroy one's fortune as well as one's health, and can be considered the most dangerous people in society" (*DP,* I, 176). Once again, Parent has no statistical evidence for a claim whose hyperbolic formulation reveals its source in fantasy. That fantasy creates the following connections: these women (who might best be called courtesans) are the class of prostitute that most closely resembles honest women (they may often be "refined and clever," Parent acknowledges); they operate under the protection of the law, hence cannot be marginalized through administrative measures; their duplicitous exteriors, deliberately constructed, undermine the organic connection between appearance and personal history that renders women openly readable to the informed male gaze; this duplicity erodes the moral and sexual code of the bourgeoisie from within, installing prostitution in its midst as a *contresens* that subverts naturalized ethical and class distinctions (prostitution is "le plus grand contresens de la nature," Parent writes near the end of

his book—*DP,* II, 573); the mark of that subversion is the lesion in the male body's organic unity caused by venereal disease, a lesion that simultaneously wounds the patriarchal system of capital accumulation. A woman who "turns herself to account [*tire parti d'elle-même*], not publicly, but here and there" (*DP,* I, 176), exempts valuable capital-producing labor from male supervision and, by determining the semiotics of her availability, gains control over the public-private difference that is the basis of social formation.

This powerful fantasy suggests a motive for Parent's desire to bring prostitutional deviance under legal constraint. But it is precisely with respect to legality that the erosive force of prostitution succeeds most disturbingly in infiltrating and decomposing the authority designed to enforce its otherness. For in the matter of prostitution, authority does not coincide with law. Indeed, as Jill Harsin has demonstrated, "throughout the historical past of France, prostitutes had been treated as outcasts unworthy of the protection of the law."[14] Nineteenth-century police prefects simply continued this tradition and managed to have their authority prevail, largely because no public outcry arose against their systematic violation of the civil rights of citizens. Parent, as usual, is of one mind with the police. At the very outset of his study he writes that prostitutes are in "the state of abjection of a class that separates itself from society, renouncing it, and, by scandalous conduct, brazenly and constantly public, declares its abjuration of that society and of the common laws that govern it" (*DP,* I, 26–27). Considered as being outside the law, prostitution could be regulated only by measures whose relation to the statutory code was itself deviant. Such measures were instituted on the basis of two concepts that oscillate uncertainly between legality and illegality, *tolérance* and *l'arbitraire.*

The notion of *tolérance* developed naturally from the Augustinian dictum that prostitutes have a place in society, albeit the lowest one, because they channel potentially subversive passions away from socially disruptive violence.[15] But for authority to tolerate prostitution did not mean that it condoned or officially protected this activity, or that it tacitly agreed to look the other way so as to let this useful function prosper. On the contrary, toleration entailed strategies of enclosure and containment similar to those Parent advocated in dealing with *poudrette,* the refuse from water closets, or the remains of horse carcasses. A *maison de tolérance* was, ideally,

as carefully designed to process live flesh as was Parent's dissection table to process dead flesh. Indeed, Parent applied to hospital dissection rooms the same description he used for prostitution: they are, he says, "a necessary evil that must be tolerated" (*HP*, II, 1).

The essential ambiguity in the program of toleration derives from its shaky legal support. No law on prostitution was passed in France during the entire course of the nineteenth century.[16] Because Article 484 of the Penal Code left in force all ordinances of the Old Regime not specifically abrogated, subsequent police prefects, searching to establish a legal basis for their arbitrary powers, cited a motley variety of precedents in legislation that seemed indirectly or inferentially to relate to prostitution. Among these were laws penalizing the sale of obscene publications, justifying administrative steps to control "calamitous scourges,"[17] authorizing municipal surveillance of public health, and other such measures that only through violent acts of interpretation could be seen to justify the right of a civil authority to imprison prostitutes without trial. It was essentially in this right that *l'arbitraire* consisted. The prefect of police, acting through his agents on the morals brigade, had the right to arrest any woman who, in his judgment, was soliciting on the street. It sufficed for him to have detected "a provocative look" or an "indecent gesture." The arrested woman had no recourse to a court of law. Indeed, she was for all intents and purposes already placed outside the law by the very fact of her accusation. As soon as the *commissaire* in her *quartier* had written up a *procès-verbal* of the offense, the woman was arbitrarily subject, as a report of 1819 puts it, "to incarceration by administrative decision."[18] Her hearing before the Bureau of Morals was a purely procedural matter.

Parent supported these policies fully, arguing that civil liberties are a privilege that prostitutes renounce when "they abandon themselves to the disorder of the passions and to all the excesses of a dissolute life" (*DP*, II, 482). The population as a whole, he claims, approves of exceptional repressive measures to control prostitution, "whatever their severity and illegality," and the prostitutes themselves, "feeling their abjection, . . . realize that they cannot possibly lay claim to rights they cherish but of which they have rendered themselves unworthy" (*DP*, II, 384). So, in Parent's mind, authority does no more than discipline and punish those whose disorderly excess it is the universally acknowledged task of government to

control. Why, then, was no law passed empowering the police to administer society's repressive will?[19] Parent's attempt to answer this question is one of the few occasions when he deliberately turns away from verifiable evidence and allows himself to hypothesize: the lawmakers, he surmises, "not having the documents necessary to enable them to act with full knowledge of the facts, intentionally left everything vague, thereby abandoning the repression of prostitution to the administrative authority" (*DP,* II, 491). This is evidently an invitation to adopt Parent's own book as the heretofore lacking basis for legislation. And indeed Parent goes so far as to draw up the text of a law whose passage would remove the administration from the "false position" (*DP,* II, 449) he considers it to be in.

This position, however, is also his own. His identification with the administration has put him at odds with a legal system that refuses to legitimate his authority. If the prostitute is an outlaw, so in a sense is the police administration that maintains her legal alienation. In fact, there is evidence that the government was aware of the anomalous situation of the police prefecture and actually worked to maintain that anomaly in the face of certain pressures to bring prostitutes under common law jurisdiction. Jill Harsin found the following revealing letter of 1833 from a high official in the Ministry of the Interior to the prefect of police:

> In effect, prostitutes in Paris are considered (if not legally) as individuals outside common law, and I believe that such a regime, so long as its legality has not been contested, is useful to maintain, in that the efficacy of police measures depends on the promptness with which they can be carried out. We must, then, avoid compromising this salutary jurisprudence by urging the mayor of other cities of the kingdom to adopt it; because court cases could arise on the legality of administrative detention, and it is feared that the tribunals could rule in a manner contrary to the system established in Paris.[20]

Parent was less cynical about law than this functionary, although the public hygienist was no more eager than his ministerial counterpart to grant prostitutes legal protection. Parent's urgent concern was that the police itself be granted this protection, that its regulatory authority be legitimized. Without a fixed point of legal reference, he observes, "everything is put in question each time a new prefect

of police comes into office . . . Lacking the certainty that he is not exceeding the boundaries of a power whose limits are not traced, . . . each new prefect is afraid of compromising himself and, . . . depending on the political opinion that dominates at the moment or that put him into office, he gives the [regulatory] machine a particular impetus, often contrary to the common good" (*DP*, II, 499). Operating in a legal vacuum, the police prefect acts as if he were afraid of being arrested. He has been placed in a position where his individuality should count for little or nothing, given his function as representative of the law, but instead his appointment puts everything in question. Without a basis in law, the regulatory machine loses its impersonal dedication to the common good and becomes a tool of anxious personal interpretation. Parent believed that the construction of authority's disciplinary power depends on the maintenance of individuality and desire as attributes of the Other. In the context of a lawless authority, these very qualities invade, contaminate, and undermine that construction, disintegrating it and, along with it, the basis of Parent's own authoritative discourse, the fusion of his desire with administrative practice.

The contamination of Parent's discourse by the deviant tendencies it intends to deny is nowhere more evident than in his elaborate invention of a police prefect's potential defense against the charge of acting arbitrarily. Going back to a law of 1791 authorizing municipalities to punish offenses against the public peace, Parent maintains that prostitution is considered such an offense by all civilized nations and that consequently the police have the right to seize anyone guilty of its perpetration and to detain that person while waiting for a judge to pronounce sentence. To the objection that such detention is an arbitrary act, Parent recommends that the prefect counter with the following almost Kafkaesque piece of reasoning:

> What, just because the Constitutional Assembly [of 1789] and subsequent assemblies kept silent about the repression of prostitution, just because no judicial authority was charged to rule on this particular kind of offense, must we then give free rein to prostitutes and, without saying anything, allow them to ferment the most awful disturbances? Let us give them a judge, for the administration is only detaining these whores preventively; but no judge presents himself, none exists; the administration could

therefore detain these whores until one did exist; but this would be barbarous, it would be a burden to the city; hence the administration, despite itself, must limit the length of the state of prevention; in the absence of a judge, it must take on his functions; if it does not pronounce sentences, it makes decisions; if it does not administer penalties, it inflicts punishments; if it does not command imprisonment, it orders confinement. Is this arbitrary? [*Est-ce là de l'arbitraire?*] If it is, one has to blame the legislation; the administration is only executing what is required of it by its responsibility to look after the conservation of morals and the maintenance of security, decency, and *public health* (*DP*, II, 497–498).

According to this description, the administration exists in a state of desire, desire for the absent judge, the absent law. Just as the prostitute knows her abjection and suffers from it, so the administration knows its illegality and suffers from this awareness. Indeed, the relation of the administration to the law strikingly parallels the relation of the prostitute to the administration. Parent's writing becomes slippery and devious as he tries to prevent the reader from perceiving this analogy. But his hedging phrase—"if it is"—does not suffice to cover up the reversal in his argument whereby his proof that the administration does not act arbitrarily becomes a defense of the necessity of its acting arbitrarily.

What has happened to the man who resolved "to call things by their name and march straight to [his] goal"? At the very point where his path should be straightest, the point where he explains the source of the authority underlying the regime he has extolled, he is forced to recognize the arbitrariness of that authority and its reliance on the impropriety of words. What is the difference between "administering penalties" (*appliquer des peines*) and "inflicting punishments" (*infliger des punitions*), between "commanding imprisonment" (*prononcer l'emprisonnement*) and "ordering confinement" (*ordonner la réclusion*)? By opposing these terms, is Parent not, "despite himself," drawing attention to authority's basis in a purely arbitrary act of semantic differentiation? Are words not being prostituted here to function in a discourse whose desire is to mask the illegitimacy, the fictionality of its claim to power? What is the notion of preventive detention if not a fiction born of the desire to postulate the existence of a judge?

At this crucial moment in his argument, Parent's text seems to be infected by a kind of disease of discourse, which erodes and decomposes its claim to scientific rationality and literal naming. Authority is wounded at its very core. Just where difference should be enforced between sanction and transgression, legality and arbitrariness, it breaks down and becomes a provisional product of desire, a conditional fiction of legitimacy. It is as if what is fundamentally undecidable and duplicitous about female sexuality had invaded the discourse of authority and contaminated it with debilitating *contresens*. In the absence of any legal textual basis for the male right to discipline and punish female deviance, it would seem that deviance has come to define the *arbitraire* of the text itself.

Through implicit analogies, occasional contradictions, and the crux of legality, Parent's text reveals that prostitution's function in sustaining an administrative structure dedicated to surveillance and punishment is only part of the story, the socially responsible part, with a logical and disciplined plot. The other part reveals prostitution's function in dismantling structure, challenging legitimacy and literality, fermenting fiction through desire, and, consequently, subverting expository discourse. This is the clandestine operation of prostitution in the text, prostitution as an *agent provocateur*, infiltrating the discourse that both reflects and produces male authority and contaminating it with the fantasized degeneracy of the female sexual body. Parent responds to this threat only on the level of social policy: clandestinity, he argues strenuously, should be tolerated only to the degree that total eradication is unrealistic. He no more recognizes the implications of prostitution's infiltration of his epistemological enterprise than he acknowledges his motives for irritation with Restif, for his fascinated involvement with the female sewers he subjects to statistical study, or for his refusal to concern himself with the client's sexuality. His preoccupation with the pragmatics of maintaining public order successfully marginalizes local textual turbulences. He keeps the *poudrette* of prostitution well isolated from the light of conscious treatment. But textual fumes from the decomposing matter arise nevertheless and, for today's reader, this fermentation is what gives Parent's book its inaugural role, not just in the sociological study of prostitution but in its literary thematization.

: *Chapter Two* :

Cashing in on Hearts of Gold:
Balzac and Sue

ritical opinion about the courtesan in the works of Balzac
suggests that he celebrates just those aspects of prostitution
that Parent-Duchâtelet most fears. The people Parent con-
siders "the most dangerous in society," those he calls *femmes galantes,*
femmes à parties, and *femmes de spectacles et de théâtres,* are arguably
just the ones Balzac finds most narratable (we need only think of
Florine, Coralie, Suzanne du Val Noble, Jenny Cadine, Josépha
Mirah, Madame Schontz, and many others in *La comédie humaine*).
The same traits of the venal woman's character and behavior that
threaten the public hygienist in the discharge of his duties stimulate
the novelist's creative invention. The courtesan's refined talent as
an actress, her ability to disguise her venality and control the signs
of her sexual availability, terrifies Parent, whereas Balzac finds this
metamorphic capacity eminently novelistic. Equally attractive to
Balzac, according to received critical opinion, is the courtesan's
social mobility, her potential to cross class barriers and make con-
tacts up and down the social ladder, functioning for the novelist as
a unifying common place of desire. From Parent's perspective, the
pathology of this social amalgamation is a common venereal infec-
tion that menaces the entire patriarchal hierarchy with organic
decay. Ideally, he would like to enclose all women who put a price
on their sexuality in regulated houses of prostitution. Balzac, in
contrast, finds that the working of free-market forces in the sexual
arena produces surprising exchanges that fuel his plot-making

: 34 :

machine. He welcomes the courtesan's role in promoting a desire for fiction, while Parent tries to destroy this desire by promoting the discourse of scientific authority. In sum, the mobile, transgressive, theatrical prostitute-courtesan seems to figure the creative impulse of Balzacian narrative, whereas that same figure is the object of the disciplinary regulation advocated by Parent's text.

The contrast appears clear-cut at first and corresponds to the difference between the Romantic view, attributed to Balzac, of the courtesan's exotically deviant destiny and Parent's pragmatic treatment of her as an ordinary working-class woman struggling to survive under adverse economic conditions. Matters, however, are not quite so simple. In the 1845 preface to *Splendeurs et misères des courtisanes*, Balzac explicitly endorses a Romantic interpretation of the prostitute's marginality, finding in her separation from society the energy necessary to create fictionally productive contrasts and sustain narratable distances in a time when "the flattening, the effacement of our manners is increasing progressively."[1] But this association of prostitution with contrast and difference has an almost purely rhetorical function in Balzac's novel. As we shall see, the novel opens only after its heroine's venal sexuality has been effectively disciplined and removed from the marketplace, and its narration proceeds by identifying prostitution with a process of circulation and exchange that tends progressively to efface the distinctions between normality and deviance, centrality and marginality.

Begun in 1838 but not finished until 1847, *Splendeurs et misères des courtisanes* is the Balzacian novel that most fully develops the prostitute's significance in relation to desire, degeneration, money, and representation. It is also of particular interest in our context in that it incorporates details taken from Parent's study of prostitution, which Balzac probably read shortly after its appearance in 1836.[2] Among these is the technical vocabulary describing the circumstances of Esther Gobseck's life prior to her meeting Lucien de Rubempré: until three weeks before the novel begins, she was a *fille à numéro* in a *maison de tolérance*, "a mere number in the police files, without social identity," to quote Vautrin, who calls her "a prostitute of the lowest kind" (*SMC*, 45–46, 67). But Balzac gives us no sense of what Esther's life was like as a common brothel whore. Indeed, he seems to contradict the implications of the sociological infor-

LIBRARY ST. MARY'S COLLEGE

mation he culls from Parent by having Esther introduced to the reader through the conversation of a group of journalists and dandies at the Opera ball. These men describe her as "the only *fille de joie* with the makings of a beautiful courtesan" (*SMC,* 19) and go on to extol her qualifications to reign over Paris in the manner of such great courtesans of past centuries as Dubarry, Ninon de Lenclos, and Marion de Lorme. No *fille à numéro* encountered by Parent had anything like the intelligence, sophistication, and refinement these connoisseurs attribute to Esther, nicknamed the Torpedo. So one may well wonder why Balzac insists on having his heroine start out at the very bottom of the ladder of venal love. Is it simply because his melodramatic penchant welcomes the opportunity to trace her career all the way to the opposite extreme? Or is it from a sense of decorum, as Antoine Adam supposes, that Balzac refrains from exploiting the sordid details of brothel life made abundantly available to him in Parent?[3]

Louis Chevalier observes about *La comédie humaine* in general that "the description of working-class life is often simply a recollection of a brief, rapid and more or less forgotten phase in a lifetime."[4] He also notes that these descriptions, however fleeting and incomplete, are accurate in their portrayal of the biological vulnerability of the working class, its propensity to disease, degeneration, and death. These morbid qualities, at once material and moral, make themselves felt whenever Balzac evokes the pathological condition of the working-class Parisian environment, the muddy streets, oppressive air, decaying buildings, pervasive stench. Such is the environment in which he places the apartment Esther rents after leaving the brothel, in a working-class district known for just the kind of base prostitution in which she no longer engages. He describes in detail the darkness, pollution, dampness, and congestion that prevail in this sinister neighborhood.

These pathological conditions of urban life convinced many of Balzac's bourgeois contemporaries that poverty itself was contagious and no aspect of it more so than prostitution. To take Parent as an example, his sympathy for the plight of destitute young women, often illegitimate, uneducated or barely so, unskilled or at best able to darn and sew, who turn to prostitution as a temporary employment was limited by his anxiety about the disease and corruption with which the ex-prostitute might infect the bourgeoisie. The pro-

cess of reassimilation, whereby prostitutes emerge from their status as *un peuple à part*[5] to become unremarkable members of *le peuple*, fills Parent with anxiety. "A good number of erstwhile prostitutes return to society," he writes. "They surround us, they penetrate into our homes, into our households [*nos intérieurs*]. We are constantly exposed to the possibility of confiding our most cherished interests to them."[6] Because of this fear of both moral and biological contamination, Parent, despite his real concern for the misery of prostitutes, pays little attention to their possible reform. He is more interested in achieving "passive obedience to the regulation of the police,"[7] controlling deviance through the threat of imprisonment, than he is in enabling prostitutes to regain the privileges and rights of free women. For the prostitute is ineradicably tainted in his eyes as a sexual sewer that can never be cleansed of its contagion.

The connection between that specifically sexual contagion and the diseased organism of Paris itself was established in the imagination of many bourgeois observers by the cholera epidemic of 1832. In the course of only 189 days, it killed 18,402 residents of the city, taking the greatest toll in the poorest working-class districts.[8] These had become increasingly overcrowded, filthy, and malodorous as the city's population grew at a pace so rapid that inexpensive housing and basic public health facilities, such as water supply and sewage disposal, became inadequate to the demand. Whole sections of the population, including many of the prostitutes, were forced to live in scandalously unhealthy conditions similar to those Balzac describes in Esther's neighborhood. Watching cholera spread from these festering slums to their own affluent quarters, the bourgeoisie associated poverty with morbid infection that threatened to penetrate their households, much as Parent imagines prostitution invading and contaminating proper middle-class domesticity. Thus, as Louis Chevalier has convincingly shown, the cholera epidemic dramatically revealed the biological bases of class antagonisms.

In this context, Parent's fascination with the effects of organic decomposition no longer seems so idiosyncratic. It was a shared obsession, deeply rooted in class consciousness. Prominent among the targets of sanitary measures taken by the authorities to prevent the spread of the disease were objects of Parent's devoted study: public cesspools were cleaned, the dissection theaters were closed, money was voted to construct more sewers, the sale of spoiled meat

and produce was strictly prohibited. A certain Virey, member of the Chamber of Deputies, even recommended that men chastely conserve their sperm so as to enhance resistance to the eviscerating plague.[9] "Moderation in one's pleasures" was advised as a deterrent in the official report on the epidemic. The implication of these antiseptic precautions was clear: nothing could be more dangerous, in spreading decay and putrefaction, than the corrupt, purchasable sexuality of working-class women, fully a third of whom, according to an article in *Le Globe* of January 8, 1832, were "dévoué au déshonneur."[10]

It is now becoming clear that there is something other than a matter of tact involved in Balzac's simultaneous solicitation of the figure of the working-class prostitute and denial of her native proletarian depravity. He associates the desire she generates with biological degeneration and the collapse of social differences. Thus, in the panoptic opening section of *La fille aux yeux d'or,* the universal pursuit of the two debilitating passions epitomized by prostitution, "gold and pleasure," is described as spreading the pathological morbidity characteristic of the working class over the entire social order. The life of the Parisian, whatever his or her social position, is a process of organic depletion and physical deterioration: "One of the most horrifying sights," writes Balzac in his first sentence, "is certainly the general aspect of the Parisian population, a people of ghastly mien, gaunt, sallow, weather-beaten . . . The Parisian's face, used by abrasion, becomes gray like the plaster of houses covered over with all kinds of dirt and smoke."[11] This is the typical Parisian "effacement," of which Balzac speaks in his preface to *Splendeurs,* while asserting the prostitute's self-determined exclusion from the erosive process. But here the biological degeneration of the working class seems to be undermining the entire population. Balzac personifies this subversion by referring in one passage to "the great house of prostitution called Paris," in another to the city as "a queen who, always pregnant, has irresistibly raging desires."[12] This prostitute queen, moreover, has precisely the same physical characteristics as those that infect Esther's neighborhood: the air is polluted with "cruel miasmas," and "fetid sludge" filters up from the damp ground, producing "putrid exhalations." This is not only Balzac's but also Parent's pestilential and excremental Paris, whose emblematic figure is the putrid woman, the *putain.*[13]

Just as Parent defines his project in terms of the regulation and policing of this decadent figure, so Balzac evokes her only the better to bring disciplinary energies to bear against her disintegrative threat. Indeed, one could argue that the novel's premise, the very possibility of its generation, is the disarming of the Torpedo, which antedates the opening scene.[14] That scene recapitulates this erotic deactivation, viewing it through the eyes of the assembled roués at the Opera ball. Their description of Esther's qualifications to assume the role of royal courtesan appears at first to lift her above the menacing working-class sexuality of the *fille à numéro*. It seems, moreover, to justify a Romantic interpretation of the Balzacian courtesan such as that eloquently articulated by Albert Béguin. She is, he writes, "the author of her fortune and misfortune, the poet of her own adventures, a creature who uses her creative faculties to their fullest. Nothing is closer to the heart of the novelist than these existences made of will and imagination."[15]

This suggests that Esther as courtesan fulfills Balzac's conception of the narratability of prostitutional deviance. But a close reading of the roués' description of Esther's powers implicates the courtesan as a cause of the very collapse of difference against which her existence is supposedly a protest. The journalist Lousteau remarks that, like "great authors and great actors, . . . she [Esther] has penetrated all the social depths." He continues:

> At age eighteen, this girl has already known the highest opulence, the lowest misery, men at all levels. She holds a kind of magic wand with which she unleashes the brutal appetites so violently curbed in men who, while involved in politics or science, literature or art, are still passionate at heart. There is no woman in Paris who can so effectively say to the Animal: "Out . . ." And the Animal leaves its cage and wallows in excesses. (*SMC,* 21)

Observing that the subjacent image here is Circe, who turns men into pigs, Peter Brooks comments about this passage: "In her transformational role, in her capacity to provoke metamorphoses, the prostitute is not only herself narratable, she provokes the stuff of story in others."[16] This remark, in an essay otherwise full of stimulating insights on the topic of prostitution and narrative, ignores the important diegetic fact that Esther's story in *Splendeurs* is that of the transformation of her transformational role. What is narratable

is not her Circe-like erotic potency but the process of its control and eventual closure. Moreover, the effects this potency has had in the past link the Torpedo's energy not to the narratively productive creation of differences but to their degeneration and effacement. Her body has circulated through all levels of society, reducing men, whatever their status, to their brute animal libido and thus under-mining the patriarchal hierarchy of class and cultural distinctions. To have possessed Esther is to have been dispossessed, to have lost individuality, to have become a substitutable object of her desire. "You have all been more or less her lovers," declares another member of the group of cynical men-about-town, the caricaturist Bixiou; "none of you can say she was your mistress; she can always have you, you can never have her" (*SMC,* 22).

Now, Balzac most certainly does not identify his own creative power with this image of female sexual domination, as Béguin suggests, nor does he elaborate his plot as a function of Esther's publicly available erotic talents. Balzac evokes the Torpedo's capti-vating notoriety only the better to annihilate it. The first step in this repressive project is to rob Esther of her theatrical ability to advan-tageously stage her seductive venality. The setting at the Opera ball is suitably ironic in this regard, for this carnival event, where classes and sexes mixed in a mad transgressive medley, was notorious as a stage for the alluring exhibition of bodies actually or potentially for sale (the uncertainty was part of the intrigue—see Figure 4).[17] But Esther has lost all interest in staging her body as fantasy material for the Other. Even in disguise her body is transparent to view, and the spectacle it offers is its own de-eroticization.

The viewers of this spectacle are the same group of cynical jour-nalists and dandies who have just constructed the image of Esther's erotic potency. "These judges grown old in the knowledge of Pari-sian depravity" have made a bet as to Esther's identity (some think she might be the high-society aristocrat Madame de Sérisy), and now they "have their eyes ardently fixed on [the delicious object of their wager], a woman who could be deciphered only by them" (*SMC,* 24). These corrupt connoisseurs of female embodiment and behavior resemble the Bureau of Morals officials described by Parent, who scrutinize wayward women to determine their sexual history. In both cases the identifying look exercises male power and control over female sexual deviance. Moreover, the journalists'

inquisitorial look is a repressive agency of the narration itself. Through their eyes a new identity is created for Esther that effectively neutralizes the threat embodied in her prostitution. What they see is "the most moving of spectacles, a woman animated by true love, the metamorphosis of a woman into a goddess" (*SMC*, 24). Fundamental to this metamorphosis is the loss of the prostitute's erotic body: despite their expertise in seeing through superficial appearances, all that Esther's judges are able to recognize under her domino is "the ingenuousness of a virgin, the graces of childhood" (*SMC*, 25). The marks of her working-class origins have been entirely erased along with the traces of her venal history: "Whether she be the Torpedo, the duchess of Maufrigneuse, or Madame de Sérisy, the lowest or the highest rung in the social ladder," is entirely irrelevant since she has been transformed into "the light of happy dreams" (*SMC*, 24). She has renounced the strong independence

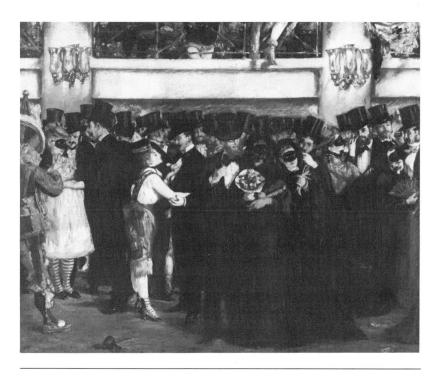

Figure 4. Edouard Manet. *A Masked Ball at the Opera* (1873). Oil on canvas. National Gallery of Art, Washington, D.C.

that enabled her to lend her body to many men while belonging definitely to none.[18] Now "the tremor of her body seemed to find its principle in the movement of her lover" (*SMC*, 24). It is only because Esther responds instinctively to her name being called that the journalists succeed in identifying her as the fabulous *fille* they have known. Her body gives away nothing of its past.

: : :

Esther is a prostitute with a heart of gold, a whore purified through love. The archetype would have been familiar to readers of Balzac's day, for it already had quite a tradition in the Romantic period. The theme goes back notably to the story entitled "The Loves of Milord Edouard Bromston," published by Rousseau in 1780 as an appendix to *La nouvelle Héloïse*. In this tale, a dissolute marquise offers the prostitute Lauretta Pisana to her lover Lord Edouard to supply him with the sexual pleasure he refuses to enjoy adulterously with her. But Lauretta falls in love with Edouard and cannot tolerate the thought of his possessing her as a degraded, venal creature. Edouard is touched by this elevated passion and continues to visit Lauretta as friend and moral counselor. Overwhelmed by this attention, Lauretta's disgust with her profession deepens to the point that she retreats into a convent. There she educates herself in all the fields of interest to Edouard, who increasingly admires her at the expense of his feelings for the depraved marquise. He is even thinking about marriage when his friend Saint-Preux intervenes to remind him that "it is not enough that she be virtuous—she must be without taint"[19] and announces Lauretta's agreement to sacrifice her happiness to her duty and never see Edouard again. Edouard gratefully accepts this virtuous renunciation.

Rousseau's insistence on the impossibility of the loving courtesan's integration into respectable society, despite her inherent purity, was repeated, though with more sympathy for the woman's victimization by patriarchal conventions, even in works by female writers he influenced, such as Madame de Charrière's *Lettres écrites de Lausanne* (1788). Restif de la Bretonne portrays a number of virtuous courtesans in his voluminous writings. One chapter of his *Contemporaines du commun* is entitled "La courtisane vertueuse, ou la vertu dans le vice," and one of his memorable characters is the reformed Céleste, who, admirably, considers herself unworthy of being taken

to wife. Such works are full of the pathos of unrewarded virtue. When prostitutes were granted the rights of citizens at the outset of the revolutionary period, this pathos was briefly replaced by a wave of egalitarian feeling. Various minor novelists, both male and female, portrayed love surmounting every class barrier and showed venal women of spirit, talent, and compassion being accepted into an enlightened secular society (see, for instance, J. H. Meister, *Betzi, ou l'amour comme il est,* 1801). But this moment was short-lived. Napoleon decreed medical examinations for prostitutes in 1802, and two years later the entire system of police regulation and *maisons de tolérance* was in place. The courtesan, reformed or not, was outlawed from the stage, as she was throughout the Restoration, and she seems to have experienced a partial literary eclipse in this period of repressive censorship.

The staging of Victor Hugo's play *Marion de Lorme* in 1831 revived the figure of the enamored, self-sacrificial courtesan in the context of revolutionary upheaval and Romantic defiance of the Classical literary norms. Hugo had chosen *Marion* in 1829 as the bravura piece with which to trumpet forth the Romantic challenge to conventional dramatic proprieties, and he read it aloud in July of that year to a group of literati that included Balzac. But Charles X's minister of the interior refused to allow the play to be performed. So *Hernani* sounded the battle cry instead, and *Marion de Lorme* was presented a year later to a public whose taste, Hugo noted in his preface, had matured with the achievement of revolutionary freedoms. Indeed, in the months just prior to the July Revolution, prostitution had become a vehicle for social and political protest, as generalized outrage with the government's repressive measures was focused on a short-lived police order to keep prostitutes off the streets. Hugo's play managed both to capitalize on this popular association of prostitution and protest and to confirm the limits of justifiable reaction.

Prior to her regeneration through love for Didier, Marion was a successful courtesan much like the Torpedo, whom Balzac's roués at the Opera ball ranked in Marion's royal lineage. The play opens, as does *Splendeurs,* at a time when the heroine has abandoned her venal past, to the great chagrin of her numerous aristocratic lovers, and is entirely given over to her one true passion. Didier, a found child whose fervent idealism seems to be a function of his freedom

from class allegiance, learns halfway through the plot that the angelic woman he wants to marry, whom he has called Marie, is the famous courtesan Marion de Lorme. His first response is as melodramatic as anything in Balzac: "O God, the angel was a devil."[20] But her selfless devotion (at one point she offers herself as "something to trample under your feet"[21]) finally convinces him of her innate goodness and, just before he is executed for having fought a duel, he pardons her. This pardon covers even the re-prostitution to which she has submitted in exchange for a lecherous judge's letting Didier escape from jail (he heroically refuses the offer). Not that Marion has ever hoped to marry her adored lover: she has the good courtesan's typical sense of her own ineradicable abjection and unworthiness, despite the "renewed virginity" she feels Didier's love has bestowed on her.[22]

This fundamental respect for a conservative, patriarchal social structure is essential to the ideological message of Hugo's play. His social compassion, like that of Rousseau and Parent, sets a strict limit to the aspirations of the sexually deviant woman whose capacity for purification it celebrates. Hugo may use Marion's almost mystical inner illumination to attack the cowardly and corrupt representatives of organized religion, but the Law of the Father is never fundamentally undermined since its dictates have been internalized in the illumination itself. Marion's regeneration can have the largely aesthetic benefit of a highly charged religious vocabulary of repentance, absolution, and redemption because this sanctification of the courtesan simultaneously confirms her permanent social marginality. Hugo manages to have it both ways: he caters to the popular desire to believe in the power of natural goodness to expose corruption and reform social inequities, and he reinforces the fundamental inequity of a social system that excludes aggressively sexual women as irremediably evil and polluted.

A similar dual perspective can be found in *Les vierges folles,* a study of the problem of prostitution published in 1840 by Hugo's friend and disciple, Alphonse Esquiros, and, as some references in *Splendeurs* prove, certainly read by Balzac. A Romantic novelist and journalist with socialist sympathies, Esquiros makes the individualist myth of the prostitute redeemed through love the basis of his proposals for social reform. He eloquently espouses the cause of destitute working-class women brutally exploited by brothel madams

and he outdoes Parent in evoking the horror of the *maisons de tolérance,* where women are treated more cruelly, he says, than slaves in the colonies. For this abuse he places the blame squarely on men: "Let there be no more men who buy; then there will be no more women who sell themselves."[23] But since men will inevitably continue to buy, Esquiros, evoking the revolutionary principles of liberty and equality, calls for a new respect for the prostitute, the return of her legal rights, and an acceptance of her useful role in society. The current attitude of contempt for the prostitute's degradation, he argues, breeds disdain for women among all the young men whose sexual initiation frequently occurs in brothels; it also breeds anger against men among the women who submit to their lust. Moreover, as long as prostitutes continue to be ostracized, they will overtly declare themselves at war with society, constituting an element of subversion and disorder.[24]

These attitudes, many deriving from contemporary socialist thinking in the line of Saint-Simon and Fourier, imply an enlightened liberal concern for women's rights and an unusual sensitivity to the psychological damage incurred by both prostitute and client in the venal exchange. But the conception of woman's true calling that Esquiros opposes to her sexual commodification completely neutralizes his social critique and suggests that its hidden motive may be more repressive than liberating. Prostitutes should be brought back into society, he maintains, so that they can recover their natural power over men, which derives from their meek submission as loving wives and mothers: "The true domination of woman consists in her beauty, in her all-powerful weakness, in her love. The influence she exercises is entirely moral and is all the stronger the more carefully she hides it: she dominates us by humiliating herself."[25] Here we have returned to Balzac's evocation of "the most moving of spectacles, a woman animated by true love," and the political function of this uplifting spectacle, embellished in Esquiros, as in Balzac, by a religious vocabulary, is now made even clearer: discipline of female deviance by patriarchal law, de-eroticization of the prostitute's threatening sexuality, control over her supposed mobility of character and propensity to foment social unrest.[26]

In her day, the most famous of reformed prostitutes was Fleur-de-Marie, the heroine of Eugène Sue's immensely popular *Les mys-*

tères de Paris, which appeared in installments in the *Journal des débats* from June 1842 to October 1843, coinciding in May and July of 1843 with Balzac's publication in *Le Parisien* of most of the first two parts of *Splendeurs.* So Balzac and Sue, who felt themselves to be in competition for the allegiance of newspapers, editors, and the reading public, were elaborating simultaneously their stories of prostitutes with hearts of gold. The lines of influence must have been reciprocal: Sue had no doubt read *La Torpille* in 1838, and Balzac, even if he may have been too busy to read all of *Les mystères de Paris,* certainly knew about the universally adored Fleur-de-Marie. More important, Balzac was envious of Sue's success in a genre he had pioneered: in 1836 *La vieille fille* had been the first novel to be serialized in a commercial newspaper, *La Presse.* By 1842, however, when the *roman-feuilleton* was flourishing in practically every Parisian newspaper, Sue, Dumas, Soulié, and others had adapted their plot structures to create the periodic effects of suspense essential to sustain reader interest, whereas Balzac was losing popularity because he had resisted the *feuilletoniste* strategy of multiplying incidents, characters and intrigues.[27] Hurting in his pride and in his pocketbook, Balzac at this point allowed himself to stoop to imitation. "Je fais du Sue tout pur,"[28] he wrote in a moment of discouragement to Madame Hanska on May 31, 1843, a judgment that critics of the day disagreed with only to the extent that they found Balzac's *Esther* (the first two parts of *Splendeurs* published in book form in 1844) less "pure" than its model. (The critic of *Commerce* complained that "the action barely circulates through the laboriously constructed labyrinths; it breaks off a thousand times on the way.")[29]

To whatever degree Balzac prostituted his better literary instincts in writing parts of *Splendeurs,* his narrative use of the figure of the reformed prostitute, although it has elements in common with Sue's, differs from his rival's in certain crucial respects that only a sustained analysis of *Les mystères de Paris* can bring to light.

At the outset of this ten-volume work, Fleur-de-Marie, age sixteen, is a registered prostitute living and practicing her trade in the heart of the Cité, the dirtiest, darkest, foulest, most sordid quarter of Paris. Parent-Duchâtelet, whom Sue had read, estimated that one out of every twenty-five to thirty inhabitants of this district was a prostitute "of the worst sort"[30] and that on the very street where Sue's protagonists meet, the rue aux Fèves, half of all the tenants

were whores. It was in this miserable slum district, where a nomadic population of prostitutes, vagabonds, and criminals lived in rundown, damp, overcrowded lodging-houses, that the cholera epidemic of 1832 took its highest percentage of victims (11 percent in four months[31]), among whom, Fleur-de-Marie has been falsely told, were her parents. Thus, her commercial sexuality is associated, as is Esther's, with the organic rot of working-class life, an association that includes contact with the great center of Parisian decomposition, the Montfaucon dump, where Fleur-de-Marie went as a seven-year-old to collect worms to sell as bait, and also includes dread of the final disarticulation awaiting the corpses of prostitutes in hospital dissection rooms.[32] (The Slasher, another denizen of the Cité whom we meet in the opening scene, was, already at age ten or twelve, an apprentice horse-butcher at Montfaucon and, like some of the workers interviewed by Parent, grew up eating meat from diseased horses.)

Although Fleur-de-Marie, unlike Esther, is actively engaged in prostitution when we meet her, Sue does not require the miracle of true love to perform her de-eroticization. All that is necessary is that Rodolphe, grand duke of Gérolstein, the superman figure of this melodramatic universe, recognize her inherent virtue. Under his benevolent auspices she is then whisked away from the criminal corruption of the city and brought to live amid the redemptive, purifying atmosphere of a bucolic country farm.

The ideological import of this transfer is brilliantly analyzed by Marx and Engels in *The Holy Family*. They note rightly that Fleur-de-Marie, as she is initially viewed by the narrator and as she presents herself in telling her story, is a plucky adolescent, cheerful and resilient. She realizes that she made a crucial mistake, when destitute and unable to find work, in letting herself be inebriated and lured into selling her body; yet she is proud to be able to say that she has never injured anyone. She feels that she has not deserved her fate, and she does not identify her inner being with her present degradation. At the Bouquenval farm, whose beauty and peace at first make her ecstatically happy, all this changes. Under the influence of Rodolphe's protégée, the pious Madame Georges, and of the local priest, Marie is made to internalize her previous abjection and to interpret it as ineffaceable sin, a lesson that comes home to her when she is compelled to lie about her past to a truly

innocent girl her own age. "From this moment," observe Marx and Engels, "Marie is *enslaved by the consciousness of sin.* In her former most unhappy situation in life she was able to develop a lovable, human individuality; in her outward debasement she was conscious that *her human* essence was *her true essence.* Now the filth of modern society, which has touched her externally, becomes her innermost being, and continual hypochondriacal self-torture because of that filth becomes her duty, the task of her life appointed by God himself, the self-purpose of her existence."[33]

Sue's reformed prostitute, like Rousseau's and Hugo's, is the guilty woman conscious of the filth inherent in her sexuality. "Hélas! Marie, it is fatal," declares the curate in response to her all-too-human complaint that she would have been better off living "in ignorance of a purity I will always regret." "An innate disposition [*une nature*]," he continues, "even when generously endowed by the Creator, if it has been plunged only a day in the slime [*fange*] out of which you were pulled, retains an ineffaceable stigma" (*MP*, III, 61–62). The word *fange* covers the transition from the physical meaning of "mud, slime, mire, filth" to the figurative/spiritual one of "vice, degradation." It is the same word used by the journalist Finot to describe Esther's origins: she has "roulé dans la fange" (*SMC*, 21). But Esther is perceived to have gained power through her experience of the basest levels of working-class sexuality, enabling her to dominate and control man's animal urges. Her own body, moreover, is complicit with these desirous impulses to the extent that, when she later enters a convent, "she could not vanquish the instincts developed by debauchery. Were the muddy streets of Paris that she had forsworn calling her back?" (*SMC*, 55). The erotic memory of her triumphant sexual body can be appeased only in the experience of a love that unites body and soul. In contrast, Fleur-de-Marie's body has been no more than the passive, unresponsive object of "the horde of savage or ferocious beasts that infested the Cité," and the narrator is careful to stress that "not only had she never loved, but her senses had always remained dormant and frigid" so that she had "emerged morally pure from this cesspool" (*MP,*, III, 241).

Marie is aware of the double bind she is in: the "elevation of her soul" would make only an equally noble soul a suitable mate, but "the more worthy this person would be of her, the more she should

think herself unworthy of him" (*MP*, III, 242). Marie's body is an ideological sign representing the denial of the soiled body in the presence of the beautiful soul. She can be manipulated at will, according to what Sue calls "the demands of this multiple narrative" (*MP*, III, 255), because whenever she appears she is read both by others and by herself in the same terms. As Umberto Eco has observed, this reiteration of what one expects reassures the reader that, however violent the coups-de-théâtre that threaten the established order of things as Sue's plot spins out its staggering climaxes, nothing will be fundamentally changed in the end.[34] Thus, when we find Marie in the St. Lazare prison in volume V, the warden remarks that her proud sadness suggests "a soul conscious of its elevation" (*MP*, V, 108), and she gains the respect of the angry and violent prostitute La Louve (the She-Wolf) by offering her body as a sacrifice to La Louve's rage. The only narrative suspense associated with Marie involves our curiosity as to how long Rodolphe will take to discover what we have known since volume II, namely that she is his daughter. It is, however, not surprising that this discovery, once it is made in volume IX, after innumerable detours, peripeties, revelations, and coincidences, should entail the ex-prostitute's death. For the fiercely misogynist Law of the Father that Marie has internalized means the unalterable degradation of her (sexual) body.

In a move that is in some ways similar to Hugo's in *Marion de Lorme*, Sue offers a narrative ending that articulates at once belief in the redemption of the prostitute's fully revirginized body and conviction of her irredeemable sexual guilt. He dissociates Rodolphe from the harshness of the paternal Law by having him work fervently to persuade Marie, now called Princess Amélie, that she was the innocent victim of harsh and unjust circumstances and that her innate purity and goodness are deserving of the happy marriage with her princely cousin that he proposes for her. But this humane voice of benign understanding and pardon cannot compete against the ideology that structures Marie's narrative function in terms of the absolute condemnation of her sexuality. Rodolphe as "real" father is no match for Rodolphe as "symbolic" father, whose authority is both psychological and ideological.

The oedipal dimension of Fleur-de-Marie's relation to Rodolphe is quite explicit. Madame d'Harville, who loves Rodolphe and eventually marries him, is temporarily jealous of Fleur-de-Marie's devo-

tion to the man she calls her benefactor and for whom, she says, she would like to die beautiful with his name on her lips (*MP*, V, 235). When Rodolphe does finally reveal his identity, Fleur-de-Marie's response, before fainting, is to thank God that "it was permissible for me to love my benefactor as much as I did" (*MP*, IX, 210), a statement that suggests how transgressive she had felt her adoration to be. And it is to that sense of guilty transgression that Marie remains faithful, refusing the husband her father has chosen, refusing the wonderful prospect of motherhood, insisting that she cannot, indeed that she *must* not, forget her tainted past when she "lived in the slime of the Cité, addressed familiarly by thieves and assassins" (*MP*, X, 120). In this one crucial instance, Rodolphe must bow to the authority of the paternal Law he embodies. In Esquiros's terms, Fleur-de-Marie dominates him by humiliating herself. In terms of class, she dominates herself by asserting the impermeability of the ruling class to contamination from below. This is the important message the narration conveys by making Rodolphe, the superman, powerless to erase Marie's sexual guilt. This failure, moreover, has its own logic within the structure of the Law: Marie becomes a nun on the very date on which, many years ago, Rodolphe had threatened to stab his father. His oedipal sin comes back to haunt him, confirming the ultimate power of a purely patriarchal ideology, in terms of which his various reforming enterprises are but minor corrections indeed.

Sue frequently masks his adherence to a repressive ideological code by attacking particular institutional abuses in the name of humanitarian liberalism. Thus, he denounces the *Bureau des moeurs* and the entire system of police toleration of prostitution for its cooperation in a system of vicious exploitation. It is outrageous, he declares, that society should have "an organizational vice so deep, so incurable in regard to the laws governing the circumstances of men and women that authority [*le pouvoir*] . . . AUTHORITY . . . that grave and moral abstraction, should feel obliged not just to tolerate, but to regulate, to legalize, to protect so as to make less dangerous this sale of body and soul that, multiplied by the unbridled appetites of an immense population, daily attains an almost immeasurable number!" (*MP*, V, 181). Although Sue had praised Parent-Duchâtelet's book on prostitution as "the work of a philosopher and man of great good will" (*MP*, I, 158), here he turns against the very basis

of Parent's project, its passion for organizing and policing. He illus-
trates the moral duplicity of the system of official toleration by
showing how the prestige of state authorization actually encourages
a destitute woman like La Louve to welcome the security of inscrip-
tion as a *fille à numéro*.[35]

Sue's humanitarian zeal is rooted in his accurate perception of
the poverty, ignorance, and overcrowded living conditions that pro-
mote incest and prostitution among the working classes. But he
criticizes governmental surveillance of prostitution only the better
to install his own policing force in its place. Take for example the
case of the prostitute La Louve, the She-Wolf, whose bestial and
voracious sexuality is signified by her name. Fleur-de-Marie de-
eroticizes La Louve by evoking the same "cheerful pictures of life in
the open fields" (*MP,* V, 190) that Rodolphe had successfully dis-
played to assure his daughter's conversion to guilt. Marie's "con-
tagious poetry" (*MP,* V, 193) is so inspiring that she manages to cast
La Louve, who now imagines the happy future of marriage, children,
and pastoral peace that she will never realize, into her own slough
of despond. Then Marie engages in a heroic effort to rescue her
fellow sinner by promising, in Rodolphe's name, the fulfillment of
La Louve's domestic dream. And, sure enough, the She-Wolf is
ultimately married to her lover Martial, a poacher become game-
keeper (hence "a good example," as Peter Brooks remarks, "of
power inverted, turned from deviance and reinvested in policing"),[36]
and set up by Rodolphe on a farm in Algeria. The prostitute's
aggressive sexuality, the poacher's threat to bourgeois property—
both these subversive energies are decathected by Rodolphe, chan-
neled into proper vehicles of working-class productivity and, for
good measure, exiled at a safe distance from the maternal homeland.

Rodolphe's private police, the model of enlightened behavior Sue
proposes for the rich, thrives on plotting the elimination of char-
acters whose erotically charged deviance provides the plot of *Les
mystères de Paris* with its most narratable story lines. But these two
apparently opposed plots are really one, deviance being tolerable
only so long as it provokes the appropriate counter-discipline. The
reader can be confident that Rodolphe's poetic justice will eventually
triumph, punishing the sinners where they have transgressed. Thus,
Rodolphe blinds the rapacious and perverse Maître d'Ecole (a sym-
bolic castration, as Brooks points out), and he employs the flaming,

vibrantly sensual Creole woman Cécily to drive the evil and lascivious notary Ferrand mad with frustrated lust. Cécily is an erotic torpedo charged with much the same deadly powder of exotic origin as is Esther before she is deactivated by love. Sue piles on the seductive attributes of Cécily's tropical ferocity—she is "a serpent that silently fascinates its prey, sucks it in little by little, enlaces it in inextricable coils, deliberately crushes it, feels it palpitate under its slow bites, and seems to feed as much on its suffering as on its blood" (*MP*, VII, 249–250). This is, of course, rhetorical overkill but, given the number of opportunities for extravagance in Sue's melodrama, that it should be exercised with such evident relish to animate the most intensely and destructively erotic of his female characters is certainly revealing. Here, under the cover of sensationalism, Sue's fascinated fear of female sexuality finds its full expression. Cécily's corruption, "worthy of the royal courtesans of ancient Rome" (*MP*, VII, 250), embodies the wanton depravity from which he is so careful to dissociate Fleur-de-Marie. Cécily is the female animal artfully exercising its power to dominate and subdue the helpless male. It is only because this exercise is a function of Rodolphe's prior domination of Cécily that it can be tolerated. Annexed to Rodolphe's moral battery, Cécily's subversive arsenal contributes to the neutalization of its own explosive energy.

: : :

In the Romantic. literary tradition from Rousseau through Sue, the figure of the reformed prostitute is plotted to support a conservative patriarchal ideology. The destabilizing force of the prostitute's erotic body can be safely evoked, if only in disguised or displaced manner, because the narration is structured to contain and discipline her unruly energy. The loving prostitute exemplifies the renunciation of a predatory female sexuality in submission to paternal Law. Thus, Lauretta Pisana is securely quarantined in her convent, Marion de Lorme is abandoned to her mourning, Fleur-de-Marie, though a princess, is consumed with morbid guilt and dies. In Rousseau's and Hugo's texts, the triumph of the male order is all the more striking in that bonds between men—Edouard and Saint-Preux, Didier and his duelling opponent and aristocratic double, Saverny—prove stronger than the love of the never sufficiently reformed prostitute.

Sue's Rodolphe, explicitly analogized to God-the-Father, needs no fraternal reinforcements.

Balzac changes this picture radically by positioning in the place of the disciplinary authority a figure defined by his legal and sexual deviance, the arch-criminal Vautrin, and by plotting the equation of this deviance with the Law: in his final incarnation Vautrin becomes chief of the Parisian secret police. Rodolphe and Vautrin, both supermen, gain their power from very different relations to bourgeois ideology. Standing within the closure of that ideology, Rodolphe reassures the reader that acknowledged social values can be enforced for the greater good of all. Standing outside that closure, Vautrin teaches that social values and discourses are purely arbitrary and that controlling their liquidity in a market economy is the name of the game. Adherence to Rodolphe's law brings you respect; adherence to Vautrin's earns you the right to continue trading in the trappings of respect.

The first such trappings to occupy Vautrin's commercial interest are those of the prostitute reformed through love. He sets out to effect Esther's rehabilitation not because, like Rodolphe, he wants to save a soul for productive moral and maternal use, but because her reformation will be strategically expedient in furthering his plot, which is also Balzac's. The terms of Esther's conversion under the direction of the false abbé Carlos Herrera closely resemble those of Fleur-de-Marie's redemption through the good graces of the pious Rodolphe. Vautrin, alias Carlos Herrera, teaches Esther the same lessons in self-condemnation that Madame Georges and the village curé inculcate in their adept pupil. "Have you thought," Vautrin asks Esther, "that you degrade [Lucien] by your past impurity?" (*SMC*, 38). Calling the ex-Torpedo "a debased and degraded creature" (*SMC*, 38), Vautrin urges her to reject the body entirely and content herself with a purely spiritual love. The narration seems to support his disgust with her biological need for sex by analogizing it to the vital need of certain carp, removed by order of Madame de Maintenon from their dark, slimy waters and returned to their native mire (*SMC*, 57). Esther nearly dies in this regenerative enterprise, undertaken in a convent to which her "spiritual father" has sent her. (Here Balzac is directly inspired by Parent-Duchâtelet's pages about the frequent deaths of prostitutes in houses of reformation.) With Vautrin's encouragement, she converts from her native

Judaism to the Catholic faith, is baptized, and emerges from the convent having "recovered her first nature" (*SMC*, 53). Her love for Lucien remains physical—that Vautrin cannot change—but the body Esther is now ready to offer her lover has been cleansed of sin and "revirginated" as a result of Vautrin's reclamation of her sexuality. Vautrin's project, indeed, coincides with Esther's own virtuous desire. The criminal wants for Esther what the love that has made her horrified of her past has prompted her to want for herself: the erasure of all signs of her sexual history. Although she fears his severity, Esther is also humbly grateful to Carlos Herrera for promoting her immaculate regeneration.

The effect of this merger of the wills of virtuous courtesan and subversive criminal is to disengage the figure of the reformed prostitute from its traditional ideological function. The reader, informed by this tradition, identifies with the patriarchal authority engaged in the edifying task of reclaiming deviant female sexuality. But this identification is with a mask, a false front, a provisional discourse. Vautrin fosters Esther's reformation and renascence in order to make her, under his command, a still more devastating Torpedo. He counsels Lucien:

> She can, she must become, under the empire of your love, a Ninon, a Marion de Lorme, a Dubarry, as that journalist at the Opera was saying. You can either acknowledge her as your mistress or you can stay behind the curtain of your creation, which would be wiser. Either arrangement will afford you both profit and pride, pleasure and advancement; but if you are as great a politician as you are a poet, Esther will still be just a whore to you. Later she may help us out of trouble: she is worth her weight in gold. (*SMC*, 70)

For Vautrin, Esther's heart of gold represents capital to be invested in the marketplace. It has no religious value, no redeeming social value, only the value it can be exchanged for: "profit and pride, pleasure and advancement." He exposes the materialist underpinnings of bourgeois ideology, its function as a curtain to screen off the trafficking in commodities that is its economic basis. Identification with him entails a commitment to this traffic, which includes the commerce in women.

The contrast with Sue's Rodolphe could hardly be more complete.

Rodolphe represents ideology naturalized. This is illustrated by his taking Fleur-de-Marie into the country where her indoctrination in guilt proceeds in the context of flowering fields and "innocent" pastoral diversions, as if her condemnation were pronounced by Nature herself. Rodolphe is the Good Father. Even when enraged, as when he blinds the Maître d'Ecole, he is protecting society from subversive forces, especially erotic ones. Vautrin is the City personified. His methods and goals are those of capitalism, even to the extent that the capitalist's dream is finally to transcend the commerce in properties and settle down in the style of established wealth: we remember from *Le Père Goriot* Vautrin's desire to be a slave owner on a plantation in the American South. He sees through the rationalizing deceit of ideology, reading the strategies of that deceit as semiotic codes available for self-interested manipulation. While Rodolphe appeals romantically to nature as the ultimate authority, Vautrin has complete disdain for the natural, especially as he finds it embodied in woman.

Vautrin's conception of woman's sexuality takes to a logical conclusion the fears of degeneration and death pervasively associated with her erotic body by the writers we have been studying. Although Balzac never gives an analysis in depth of Vautrin's feelings about women, the convict's epigrammatic pronouncements on the subject are all in the same vein: "Woman is an inferior being," he maintains, "she is too much governed by her organs"; "Woman, with her executioner's skill, her torturer's gifts, is and always will be man's ruin"; "They rob us of our intelligence"; "How much strength a man acquires when, like me, he eludes that childish tyranny" (*SMC,* 618, 656, 568, 655). (It would not be surprising to hear Vautrin pronounce Baudelaire's famous line "Woman is *natural,* that is to say, abominable.")[37] These statements all contribute to what critics have generally agreed to call Vautrin's homosexuality, too often ignoring the implications of this sexual choice for the conduct of the narrative of which he is the guiding genius. One important implication is already clear from his advice on how to treat Esther: the plot of male ambition must denaturalize woman's erotic energy so that it becomes the tool of one's own self-invention. Essential to Vautrin's program is the cooptation of whatever might be called "natural" about the threatening erotic power the roués at the Opera ball attribute to the Torpedo. The task of the "empire" of Lucien's

love is to reshape her sexuality into his creation, a reshaping performed for others according to the script of Vautrin's capitalist scenario. Esther's desire will then have been divorced from its physiological origins; she will, however provisionally, have been freed from slavery to her organs and redesigned as a sign of desire to be pro-stituted (etymologically, put forward into a public position) by the deviant master of semiotic coding.

Esther's re-prostitution, however, is held in reserve throughout what one might call Act One of Vautrin's scenario. After she leaves the convent, having been more thoroughly sanitized and regulated than any of Parent-Duchâtelet's brothel inmates, Esther is imprisoned in her apartment, and Lucien makes his seductive appearance on the stage of venality she has just left. With Esther dedicated to his exclusive use as an outlet for potentially disruptive libidinal energies, Lucien is able to sell himself more productively in society. "A habit of that kind," observes Vautrin, "preserves the ambitious from many foolish acts; caring little for any woman, they are not taken in by physical attractions" (*SMC*, 84). As regally indifferent as was the Torpedo, Lucien seems to appropriate Esther's power to bring out the animal in her lovers. He is as much of a libidinal stimulus for the aristocratic ladies of the Faubourg St. Honoré as the Torpedo was for the high-living dandies of Paris. For example, the "purely physical passion" he generates in Madame de Sérisy prompts him to write her letters praising "what was least duchesslike in her," or, in Balzac's earlier version, "what is most female in the female" (*SMC*, 586, 588, 734). Madame de Sérisy even takes pride in the fact that her relationship with Lucien, which "costs her dearly," has been more unrestrainedly passionate than that of her friend Madame de Maufrigneuse, who wrote him "scorching letters" (*SMC*, 152, 107). And all this goes on in the same period when Lucien is "bien vu" by Mademoiselle des Touches and is the accepted suitor of Clotilde de Grandlieu. Thus, in Act One of his drama, Vautrin ensures the closure of Esther's sexuality to all but Lucien in order to open the poet's erotic body to promiscuous circulation in its own prostitutional economy.

What makes Lucien so adept at operating in this economy, what makes him such "a marvelous instrument of power" for Vautrin, is the malleability of his body to act out the text of Vautrin's desire: "I will be the author, you the drama," Vautrin tells his protégé

(*SMC,* 102, 103). Lucien as prostitute is a perfectly liquid currency, and it is through the exchanges of this currency that Vautrin is "represented in social life" (*SMC,* 99). Crucial to this representational function is what one might call Lucien's liquidity of gender. "Effeminate in your whims, you have a virile mind," Vautrin tells his protégé, adding "I have thought of everything in terms of you [*j'ai tout conçu de toi*]" (*SMC,* 68). Calling Lucien "mon beau *moi*" (*SMC,* 98), Vautrin implicitly associates the poet's beauty with his bisexual potential: he is "cet homme à moitié femme," "une femme manquée" (*SMC,* 103, 613). Thus Lucien can represent both genders on the stage of Vautrin's private drama. (Balzac suggests Lucien's success in this enterprise by describing his social bearing as "impassive like a *princess* on a royal occasion"—*SMC,* 83, emphasis added.) Femininity will be an attribute of the male whose body is a polymorphic fiction subject to the control of an omnipotent author. By representing himself through this fiction, the author—and here Balzac himself is clearly implicated—pluralizes his own sexuality: Vautrin calls himself alternately Lucien's father and his mother, and the narration illustrates the phenomenon of Vautrin's "moral *paternity*" by referring to "*women* who have truly loved in their lives" (*SMC,* 506, emphasis added).[38] It is notable that a similar ambiguity exists in Vautrin's relation to Théodore Calvi, the ex-protégé he saves from execution after Lucien's death: although he has a history of romantic involvement with women, Calvi is imprisoned with "the third sex" in the "quartier des tantes" (*SMC,* 541) and he goes by a female nickname, that of Esther's Biblical model, Madeleine.

At stake here is something more than the question of Vautrin's homosexuality. Through no oversight or prudery does Balzac leave the reader in doubt as to whether or not Lucien's father-mother actually engages in homosexual acts with him. The issue is not so much carnal knowledge as representational function. Vautrin as dramatic author articulates within the text the exigencies of its creation. These are determined by the preeminently social and capitalistic processes of circulation and exchange. Value in these processes is generated artificially as a function of representation. For a commodity to maintain its liquidity in exchange, it must be able to signify desirable value according to a variety of cultural codes.[39] Such mobile signification is the driving force of prostitution, which, in *Splendeurs,* is essentially male and homosexual. Women may learn

to market themselves and even achieve, like the Torpedo, considerable success, but they will always be subject, as she is, to biological impulses. Homosexual desire, in contrast, is imagined by Balzac as desire for the exchangeability of signs, including those of gender. It coincides with the creation and circulation of values in a capitalist economy, one of whose effects, as Balzac demonstrates in *Le Père Goriot,* is the destruction of the family and of paternal authority.

Vautrin did not manage to fully displace the biological father for Rastignac. He does succeed in the case of Lucien and transforms the cornerstone of bourgeois ideology, the family, into a play of metaphorical substitutions. In this regard, it is significant that the admission that clinches Lucien's guilt in his interrogation by Camusot is that Vautrin (whose real name is Jacques Collin) is not his father. At this crucial moment, Lucien retreats sentimentally to his biological origins ("A man like Jacques Collin my father!" he exclaims in outrage at this demeaning genealogy. "Oh! my poor mother!—*SMC,* 452) and repudiates the use of family ties as a strategic fiction.[40] He gives way to what is feminine in his character, which is precisely the obedience to biology or, as the text puts it, "slavery to sensation, . . . lack of reflection" (*SMC,* 453). This is the risk Vautrin takes in his attraction to Lucien's plurality of gender: under pressure, femininity may cease to be a metaphorical alternative, a style, and may collapse from surface effect to psychological ground, which is expressed socially and politically as bondage to natural impulses. Indeed, Vautrin himself is nearly defeated by what D. A. Miller calls his "abdication of semiotic competence" in his sentimental attachment to Lucien. For despite his appreciation of Lucien's semiotic malleability, Vautrin's limited focus on this single tool of ambition "in a world where he must encounter the elusively dispersed nature of modern power, diffused in techniques and norms" is, as Miller points out, "bound to disappointment."[41]

Balzac's identification of prostitution and theft with the state of nature is a melodramatic device set up only to be deconstructed. "Prostitution and theft," he writes, "are two vital protests, male and female, of the *natural state* against the social state" (*SMC,* 527). It would be more accurate to say that the essence of the prostitutional in Balzac is a semiotic deviation from nature and conversion of the body into capital.[42] Moreover, prostitution is fundamental to society insofar as the social is created through processes of circulation and

exchange, a *chassé-croisé* that Vautrin illustrates in terms of epistolary contamination: "When whores write they go in for style and fine sentiments. Well! Society women, who go in for style and fine sentiments all day long, write as whores behave" (*SMC*, 617). Madame de Sérisy's letters, wherein her body is expressed as verbal sign, become capital to be exchanged by Vautrin against political power. Prostitution serves the interests of theft precisely to the extent that it is exchangeable as a sign of value. And theft, supposedly incarnate in Vautrin, "who embodied social evil in all its savage energy" (*SMC*, 600), is the *modus operandi* of the social mechanism itself, incarnated in the banker Nucingen, "a thief on the world's stock market" (*SMC*, 190). As Vautrin observes, Nucingen "was Jacques Collin legally and in the world of money" (*SMC*, 643). (We remember that Vautrin was called "the banker of the prisons" and was entrusted with very considerable sums by the wealthiest figures of the criminal underworld—*SMC*, 103.) That Vautrin's theft is performed for ethically more defensible motives than Nucingen's is of less significance than that both men operate according to the same capitalist processes. Legality and illegality mirror each other in the production of capital as theft. As Christopher Prendergast puts it, "Archetypal criminal of the *Comédie Humaine*, Vautrin is also, in a sense, one of its greatest capitalists, or rather he incarnates the spirit of anonymously mobile capital, its origins opaque, its transactions murky, its 'life' that of continuous circulation."[43]

If prostitution and theft are central rather than marginal to society, then they cannot provide the distance and contrast that Balzac, in his preface to *Splendeurs*, claims are necessary to structure a framework for novelistic invention in a time of pervasive cultural mediocrity. Indeed, the energy of Balzac's narration derives not from the maintenance of oppositions but from their dissolution into liquid currency. This dissolution is effected through the play of social representations, a game of illusion and disguise that constitutes a triumph over the effacement of differences caused by biological degeneration. Earlier, I identified this degeneration with female prostitution. Such an identification extends into the realm of pathology Vautrin's belief that women, all fundamentally prostitutes, are slaves to their organs. The play of representations is likewise prostitutional, in the sense that it involves the placement of one's own or another's body into a public position so as to promote

its market value. But the bodies involved are male, or the tools of male authority, and their prostitution, rather than eroding the social order, enables its functional operation.

Balzac's insistence on opposition, contrast, and contrariety is due less to the melodramatic mode of his writing than to his nostalgia for a society in which social differences would be clearly marked and representations grounded in fixed properties. His prose rises to rhetorical heights whenever he expounds the antitheses whose conflict constitutes his avowed dramatic subject. Thus, at the point when Jacques Collin is called in to negotiate with the *procureur-général* de Granville and the policeman Corentin, Balzac writes:

> What a duel, between justice and power [*l'arbitraire*] united against the penitentiary and its tricks! The penitentiary, symbol of the daring that overrides calculation and reflection, to which all means are good, which eschews the hypocrisy of power, which symbolizes hideously the interests of the empty belly, the bloody, swift protest of hunger! Was it not attack and defense, theft and property? The dreadful question of the social and natural states fighting it out in the narrowest possible space? In short, this was a terrible, living image of the antisocial compromises that too-feeble representatives of authority make with savage rioters. (*SMC*, 600)

The symbolism Balzac attributes to this conflict is artificially imposed on it rather than deriving from its narrative exposition. A moment's reflection leads one to realize that Vautrin's daring is precisely a function of calculation and reflection, not, as the text claims, of his having overcome them. Vautrin can certainly be hypocritical (think of his pretended religiosity as Carlos Herrera); his belly, as far as we know, is well satisfied, and, whatever may be his allegiance to the criminal brotherhood of the Fanandels, he is much too much of an elite individualist to associate himself with the savage protests of the hungry masses. The antisocial compromises that Balzac denounces in the prostituted relations of crime and justice, theft and property, actually constitute contemporary society. This is Balzac's great insight into the operations of a bourgeois capitalist economy, an insight that drives the multiple exchanges and duplicitous interactions of his narration. But its disillusioned lucidity runs counter to his ideological commitment to rigidly hierarchical class distinctions

and behavioral codes. In *Splendeurs,* as Pierre Barbéris has noted, this commitment is so beleaguered that Balzac seems to be undermining not just royalist authority but the very possibility of any system of law and order.[44]

In Balzac, as in Parent, the thematics of prostitution are intertwined with the theme of failure of the law. "Distrust of the magistracy is the beginning of social dissolution," Balzac declares (*SMC,* 382), and then proceeds to give ample grounds for just such distrust. Although he recognizes that examining magistrates have extraordinary, even excessive, power under the contemporary administration of justice, he considers this authority fully justified, given "the stupidity and weakness of juries," and proclaims examining magistrates to be the "column that upholds all our criminal law" (*SMC,* 382). Capitalism, however, has eroded the economic base of this column, which, under the Ancien Régime, was constituted of inherited wealth complemented by high salaries and social status. Now magistrates are no better than civil servants, concerned only with money and promotion: "The salaries paid by the State make the priest and the magistrate its employees. The grades to be scaled develop ambition; ambition engenders a subservience to power; modern egalitarianism puts the judged and the justice on the same social footing. Thus, the two columns of any social order, Religion and Law, are diminished in the nineteenth century, where progress is alleged to be occurring on all fronts" (*SMC,* 492).

The conduct of the magistrate Camusot exemplifies this reduction of the judge to the level of ambitious functionary. Having adroitly trapped Lucien into revealing Vautrin's identity and thus into implicating himself, Camusot receives a back-handed compliment from his displeased superior, the count of Granville, that means he will never be promoted. In doing his professional duty, Camusot has violated the political interests of important aristocratic families, ignoring his wife's warning that "a man [Lucien] loved by the duchess of Maufrigneuse, by the countess of Sérisy, by Clotilde de Grandlieu is not guilty" (*SMC,* 394). What Madame Camusot, a great politician, recognizes is that society at all levels is fundamentally prostituted and that success requires not only recognition of this fact but self-promotion in its terms. Here again Balzac stresses that these terms involve the manipulation of "truth" as a function of representation. Camusot redeems himself to some degree when

he resists with less than full conviction Madame de Sérisy's "crime against society" (*SMC*, 465), her burning of Lucien's *procès-verbal*. He has learned his lesson perfectly by the time he dictates invented versions of both Vautrin's and Lucien's interrogations, "showing them both as white as snow" (*SMC*, 498). At this point he is as much of a *faussaire* (forger, perverter of truth) as Vautrin himself. From belief in the written word as a direct and truthful rendition of the spoken, Camusot has been converted to belief in the arbitrariness of the verbal sign, and with this politic conversion, or prostitution, which allows a perfectly cynical and opportunistic manipulation of legal documents, his advancement is assured.

The entire relation between the Police and the Law is characterized by a similar duplicity. Balzac pictures the immense police files as a nearly infallible record of all suspect conduct throughout the society. "No deviation goes unrecorded," he declares (*SMC*, 392). Here is a great depository of truth, another strong column of law and order. But it is truth "condemned to stay underground" (*SMC*, 393) because these records, although they can be consulted by judges, cannot be adduced as evidence in court. Thus, although "the first and almost always unpublished" causes of crimes are known, the courts actually engage in a deliberate cover-up and "conceal half these infamies" (*SMC*, 393), which consequently go unpunished. The situation reverses the relation between authority and the law that we found in Parent, while it maintains the essential noncoincidence of the two. Parent is dismayed by the police's lack of legal backing for its regulatory functions, by the lawlessness of its authority. Balzac is dismayed by the lack in the legal system itself, which must operate in a deviant relation to the police's perfect record of deviations. Parent's police operate in a state of desire for an absent judge; Balzac's judge operates in a state of desire for an absent repository of truth, the police dossiers. Balzac's police, however, apply their authority in just as arbitrary a manner as Parent's, for they can raid their own records at any time in support of opportunistic political goals. And, comments Balzac, "in political matters they are as cruel and as partial as the late Inquisition" (*SMC*, 393). Thus, the police prostitute their authority and mirror a legal system that can function only by selectively ignoring its knowledge of the truth.

The conflict between criminals and the policing arm of the Law

is, of course, the dramatic antagonism that Balzac most often declares to be his primary subject: "This antagonism between people who reciprocally seek and evade each other constitutes an immense duel, eminently dramatic, sketched in this study" (*SMC,* 528). The basis of this conflict, the condition of its possibility, is what Balzac calls the "indelible character" taken on by individuals in professions such as prostitution, theft, the police, and the priesthood, which form "the strong oppositions, the *contraries* in civilization" (*SMC,* 528). Having insisted on the "unmistakable *properties*" of the prostitute and the thief, which render them "so easily recognizable that they are, to their enemies the spy and the constable, what game is to the hunter," Balzac asserts, in the final sentence of a long analytic paragraph, that their ineffaceable properties are precisely what make these outlaws such experts in the mistakable and the improper: "Whence that profound science of disguise among the celebrities of the underworld" (*SMC,* 529).

This is typical of Balzac's narrative procedure: the notion of indelible properties, which provides a conservative sensibility with reassuring evidence that social differences are clearly discernible and enforceable, collapses as soon as the narrative is put into motion.[45] For what is essential to the narration's currency is precisely the liquidity of personal properties, their easily effaceable and interchangeable qualities. An essential function of Balzacian intelligence, whether it be exercised in the name of the Law or of criminality, is the ability to subject the body to the power plays of the mind so it is always ready to serve as a political instrument. The body itself should be a cover-up. It should present, as Asie's disguised corpus does to the police agents Contenson and Corentin, or as Vautrin's mutilated back does to the judge Camusot, "an indecipherable text" (*SMC,* 267), whose opacity can be the basis for fictional self-invention. Vautrin's disguises, which include his appearance both as an actual police magistrate and as "a constable in disguise" (*SMC,* 72), are no more readable to his enemies than Contenson's impersonation of a potential thief. Thus, as D. A. Miller observes, throughout *Splendeurs,* "continually analogized to one another—Carlos Herrera is the Spanish Corentin, Paccard is Vautrin's Peyrade, etc.—police and criminals are quasi-instinctively brought together 'sans le savoir' in the duel that only the name of legitimacy prevents from being a perfect play of mirrors."[46]

With Vautrin's appointment as chief of the Parisian Sûreté, however, the play of resemblance does seem to attain perfection. "I have no other ambition," he tells the count de Granville, "than to be an instrument of order and repression, instead of being the essence of corruption" (*SMC,* 646). Vautrin's "last incarnation" is a triumph over biology effected through the mode of representation. He will be as much a functionary as Camusot, and, like Camusot, he will supervise not the separation of order and corruption but their liquid currency in an economy of marketable signs, names, and representations.

: : :

If Balzac had to renounce the title of king of the *roman-feuilleton* in favor of Sue, in Vautrin he created a character who, within the represented novelistic world, is king of the processes underlying feuilletonesque narrative practice. Sue's ideology is fundamentally opposed to those processes: he writes a teleological narrative whose meaning is wrapped up in its ending. Only then does Fleur-de-Marie's heart of gold pay back its full ideological investment. In contrast, Balzac's commitment to narrative currency overrides his participation in an ideology far more conservative than Sue's. The payoff for him consists not in the coincidence of narrative and ideological closure but in the continued liquidity of narrative processes. This liquidity requires the active trading of an important financial speculation, such as a heart of gold.

It is to facilitate such trading that Vautrin advises Lucien to consider Esther nothing more than a common whore. Having, in Act One of his scenario, closed off her venal sexuality so as to promote Lucien's, Vautrin in Act Two proposes to reopen her body for purchase. This reactivation of the Torpedo's erotic charge corresponds to her reemergence into the narrative. For the previous four years she has been so effectively removed from commercial exploitation, disciplined, and incarcerated, that Balzac's plot has short-circuited, forcing him to pass over this period with the explanation "Happiness has no story" (*SMC,* 86). Now Vautrin wants to return Esther to the public stage as a negotiable erotic commodity desired by the wealthy baron de Nucingen. He imagines that the measures he has taken to gain control of her "natural" sexuality will enable him to direct the artifice of her performance. Prostitution and narrative will advance

hand in glove because the female body will have become the instrument of male intelligence.

But Esther takes Vautrin by surprise. Against his scenario that treats the prostitute's golden heart as capital goods, the narration asserts the unmarketable integrity of the loving courtesan's revirginated body. Balzac, however, gives the myth of the "exclusivity" (*SMC,* 220) of the courtesan's love a characteristic capitalist qualification. Vautrin reasons that, once female sexuality has been sold, once it has been trafficked commercially, its currency cannot be withdrawn from circulation in a male economy. Balzac sustains this premise to the extent that he has Esther make the fulfillment of her contract with Nucingen a more worthy point of honor than the absolute preservation of her body as a temple of love. It is only *after* she has given Nucingen one night of sex that she kills herself. "You have paid; I owe myself," she tells the baron. "There is nothing more sacred than debts of dishonor" (*SMC,* 233). Through this strange argument Esther acknowledges her unalterable subjection to the laws of commercial exchange. Thus, Balzac preserves the connection between prostitution and capitalism within the chauvinist Romantic paradigm of the reformed prostitute who can no longer live with the ineffaceable stigma of her dishonor.

Although Esther might seem to be taking control of her plot by removing herself from Vautrin's, her suicide is the logical fulfillment of his disciplining of her erotic deviance in Act One of his drama. According to Vautrin, the effects of this discipline should have been to denaturalize Esther's desire and make her into an instrument for living fiction, "irresistible and insatiable" (*SMC,* 246) in compliance with his will. Balzac, however, chooses to sustain against Vautrin the conservative model of the loving prostitute's natural idealism. What the text calls "la *nature-fille*" (*SMC,* 235) corresponds to the de-eroticized woman Vautrin has formed, under the proxy empire of Lucien's love, in the first act of his scenario. This woman is constructed of precisely the kind of conservatively coded "strong oppositions" that Balzac's narration works to break down. Forced to be "at once spectator and actor, judge and defendant," Esther feels "the profound contempt borne by the angel of love, enclosed in the courtesan, for the infamous and hateful role played by the body in the presence of the soul" (*SMC,* 285). This situation reverses that of Rodolphe with Fleur-de-Marie, while remaining within the

same paradigm. Rodolphe wants Fleur-de-Marie to stop imagining her body's degradation; Vautrin wants Esther to stop imagining her soul's elevation. Both are frustrated by the fidelity of the reformed prostitute to the irresolvable duality of her position, a duality that is the ideological definition of her nature and that is ultimately unlivable.

The prolonged story of Fleur-de-Marie's struggle to maintain the conviction of her sexual guilt forms an appropriate conclusion to Sue's ideologically driven narrative. In contrast, Esther's death marks only the end of an act in Balzac's, and Vautrin's, dramatic plot. Act Three, which unfolds in the absence of the prostitute's sexually provocative body, shifts the focus of romantic interest to the male couple of Vautrin and Lucien and stages prostitution in terms of the liquidity of personal properties, including gender identities. In this understanding of the prostitutional, desire is focused not on the possession of any one object but on the process whereby objects acquire value as representations. What makes the prostitute desirable is his or her capacity to deny nature and function as a medium for representational practices. Balzac's attitude toward this seductive potency is profoundly ambivalent. Esther's death marks the conclusion of a narrative structured through the active manipulation and repression of female sexuality in the most conservative of Romantic plots, the story of the courtesan reformed through love. Esther's self-destruction leaves the narrative without its traditional chauvinist basis in a paradigm of sexual difference that naturalizes male domination. Modern processes of circulation and exchange provide a more unstable model for male hegemony. Cutting away any imagined natural ground, they set sexual difference afloat on a sea of semiotic currencies. Balzac likes to imagine that he can negotiate this artificial sea, which he and Dickens are the first to explore, without losing contact with the "natural" order it has displaced. He appreciates a certain liberating potential in the fluid exchange of constructed identities, duplicitous signs, and contrived values—in the dynamic instabilities of a prostituted culture. But, as Christopher Prendergast is right to stress, he also deeply mistrusts this divorce of value, sign, and code from property, substance, and body, fearing consequent social and political chaos.

Ambivalence of this kind seems to invade Balzac's text after Esther's death, producing what the reader experiences as a kind of

narrative hysteria. "From the moment of Esther's suicide," comments Prendergast, "the plot of *Splendeurs* runs riot, largely in the form of a series of messages and letters that cross, conflict, arrive too late or cannot be transmitted; the communicative circuits get blocked, seize up, go wild."[47] It is as if Balzac's narration, no longer given shape by its exercise of control over the prostitute's sexual activity, were seized by a panicked awareness of its own arbitrariness. Plots and subplots proliferate, dramatic foci change with bewildering rapidity, oppositional categories are no sooner set up than they collapse. The increasing frequency with which narrative voices intervene to provide explanations for events conveys a sense of exhilarated desperation about the apparent independence of fictional invention from the regime of law and order.

Balzac's concluding narrative gesture, which establishes Vautrin as chief of police, is the overdetermined climax of this exhilarated desperation. It is the subversive demonstration, on the stage of history and politics, of the complete collapse of difference. Forgery and deception are granted the authority of justice and law, whose fraudulence and duplicity have been convincingly demonstrated. The robber does not change identity in becoming a cop; he simply switches masks in a game of *agents provocateurs*, whose goal is never to win but to constantly provoke—more exchange, more disguise, more semiotic invention and distortion. In an important sense, Vautrin takes over the powers ascribed to Esther's erotic body in the novel's opening scene, where they are associated with biological decay and organic pollution. Having been disembodied as the policing principle of narrative traffic, Vautrin may lend his authority conditionally to a certain protagonist or plot development, as Esther lends her body for temporary use, but he will never allow himself to become the servant of a particular strand of story, just as Esther is possessed by none of her lovers. Vautrin's cop-out (Miller's witty term) displaces the erotic lure from the represented novelistic world, where it threatens disease and degeneration, to the narrative function itself, where it offers the pleasures of mobility, travesty, multiplicity. Having eliminated the sexually active, desiring woman, the narrative, under Vautrin's auspices, offers in her place its own prostitutional availability for renewed readerly pleasure—protean in its disguises, imaginative in its plotting, always alluring from installment to installment.

Such, at least, is the exhilarated feeling Balzac's narrative conveys as it embarks on the sea of semiosis. But the excitement is qualified and curtailed by an anxious awareness that this sea is a mirage which cannot be mapped and that successful speculation in its currencies requires a complete break with any notion of a sustaining, stable natural order, an order based on clear oppositions and contrasts, including those of gender. By denying Vautrin control over Esther's plot, Balzac maintains his narrative allegiance to this conservative structural organization. Making Vautrin top cop constitutes a much more tenuous and vulnerable effort to reinstate structure by simple reversal, asserting the integrity of opposition in the face of fluid convertibility. Balzac's ending is not so much a compromise formation that resolves opposing narrative tendencies as it is an uncanny moment when these tendencies coincide in a figure whose authority is simultaneously constructed and deconstructed, conserved and prostituted.

: *Chapter Three* :

Barbey's Dandy Narratives

*I*n my readings of both Parent-Duchâtelet and Balzac, prostitution has been associated at certain points with the textual and the figural, at the expense, to different degrees, of the corporeal and historical. Each chapter has involved a moment when prostitution lost its referential specificity and became a self-reflective function associated with a certain kind of *arbitraire*. In Parent's project, referential specificity was to be guaranteed by the use of scientific method. He believed that prostitution could be quantified, its historical behaviors analyzed, its bodies examined and regulated. These pragmatic procedures would contain and control the germs of degeneracy that threatened to infect and decompose social structure. But in the very corporeality of his scientific object, woman's sexual physiology, Parent was confronted with an organ that offered no signs of its history. The sexualized female body proved to be readable to male authority only in its social conduct, and that reading involved major interpretive difficulty, given the prevalent practices of disguise, duplicity, clandestinity. More disturbing yet, the administrative authority charged with regulating prostitution had to act in the absence of any authorizing law. The law in matters of prostitution was as unavailable to knowledge as the organ employed in the venal transactions. Through these crucial gaps in referential fidelity, the arbitrary infiltrated Parent's discourse, subverting his epistemological enterprise with the fictionalizing pressures of desire and contaminating it with the *contresens* of prostitu-

: 69 :

tional deviance. The passage in *De la prostitution dans la ville de Paris* where this contamination is most clearly discernible, although only a brief moment of textual unraveling, has a special significance in the history of prostitution's literary thematizations. For the discovery of gaps, on the one hand between prostitution and the body, on the other between prostitution and the law, though it dismayed Parent, offered novelists a way of controlling their fantasies of a degenerative female sexuality by treating prostitution as a figure for the referential gaps that generate the *arbitraire* of narrative itself.

This is the strategy Balzac adopts in *Splendeurs et misères des courtisanes.* He solicits his reader's belief in the accuracy of his depiction of the corporeal and historical by claiming that they are constructed through the same principles of opposition and contrast that subtend his novelistic structure. It is the prostitute's indelible character, he tells us, the unmistakable properties of her body and behavior, that mark her difference from the effaced and decomposed social norm and qualify her for dramatic narration. However, my analysis of Balzac's text shows this claim to be more than a little duplicitous. Balzac's construction of the prostitute in terms of her fidelity to the opposition inherent in her character—she can be either an angel of love or a devil of desire—is precisely what disqualifies her as a narrative vehicle. Having removed woman's potentially disruptive erotic body from the plot, Balzac gives prostitution a variety of figural meanings based on processes of circulation and exchange among men alone.

Perhaps the most radical of these processes involves the metaphorization of gender and genealogy so that the biological can be constructed and circulated as a male invention. Balzac exploits the epistemological gap between prostitution and the body (the gap that so distressed Parent) to stimulate his own fictional production. That production operates, moreover, within the very space of non-coincidence between authority and law through which Parent's discourse had been infected with *l'arbitraire.* In this fertile space of Balzacian narrative creation, activities associated with prostitution, such as dissemblance, clandestinity, deception, and theft, ensure the liquidity of multiple semiotic currencies. Since this mobility of representations in processes of exchange is fundamental to the modern urban world of media pluralism and commodity capitalism, coding prostitution in male terms can be considered a characteristically modern literary gesture.

This, in any case, was the opinion of the man who most power-
fully defined the meaning of the "modern" at the mid-century in
France, Charles Baudelaire. Like Balzac, Baudelaire constructed the
modernity of prostitution through a denial of woman's natural cor-
poreality. After quoting two of the poet's notorious remarks in *Mon
coeur mis à nu*—"Woman is *natural*, that is to say, abominable," and
"Woman does not know how to separate the soul from the body;
she is simplistic, like an animal"—Jean Starobinski comments,
"Baudelaire is testifying here to a malaise about the corporeal con-
dition that is one of the persistent characteristics of the spirit of his
time."[1] Symptomatic of this spirit, according to Starobinski, is the
interest shown by male writers of the later nineteenth century in
female figures who stage an idealizing transcendence of their bodies,
especially dancers and circus acrobats.

Baudelaire's story "La Fanfarlo" (1847) dramatizes this male
attraction to the female body spectacularized and transfigured in
representational practice. The poet hero, Samuel Cramer, is horrified
when the woman he loves, a dancer and actress he has admired in
"an agreeable succession of metamorphoses,"[2] offers herself to him
completely naked. "Dance," observes Baudelaire's narrator, "is
poetry with arms and legs, it is matter, graceful and terrible, ani-
mated, beautified by movement" (*OC*, 505). Without this aesthetic
embellishment, woman is no more than brute, unredeemed animal
matter. Some such perception of her inert carnality is apparently
what disturbs La Fanfarlo's lover, who insists that she put on her
fanciful Columbine costume and paint her face with rouge. Thereby
she becomes a cultural invention once again, an image that pro-
claims its distance and difference from life, a figure composed of
arbitrary signs, and he can temporarily forget her abominable bio-
logical organism.[3] (We are told that "he considered reproduction as
a vice of love, pregnancy as the illness of a spider"—*OC*, 509). But
the body's fleshy naturalism reasserts its claims, and at the story's
end Cramer is bound in "vicious marriage" (*OC*, 512) to a fat and
conniving Fanfarlo, now explicitly identified as a *courtisane*, who
has just borne him twins.

The prostitute in Baudelaire thus represents, as he says of the *filles*
in drawings by Constantin Guys (see Figure 5), "savagery within
civilization. Her beauty, which derives from Evil, is always devoid
of spirituality but sometimes tinged with fatigue that feigns melan-
choly" (*OC*, 1187–88). Such a woman is the vulgar agent of man's

"postulation toward Satan" (*OC,* 1277), of his depraved pleasure in animality. But Baudelaire's texts also offer an antithetical reading of prostitution. In *Mon coeur mis à nu* he declares that "the most prostituted being is being par excellence—that is, God—since he is the supreme friend for each individual, since he is the common, inexhaustible reservoir of love" (*OC,* 1286–87). Here the notion of prostitution is entirely removed from the debased realm of the instinctual body, domain of female sexuality, and describes a movement of empathy whereby the individual, presumably male, separates from his ego to enter into the other.[4] Prostitution in this sense, which is very close to Balzac's in *Splendeurs et misères,* does not involve possession but rather a kind of eroticized capacity for multiple identifications: "Love can arise from a generous sentiment: the taste for prostitution; but it is soon corrupted by the taste for property" (*OC,* 1247). Whereas the ordinary man cannot avoid this corruption and imagines love in terms of conquest ("Love wants to move out of

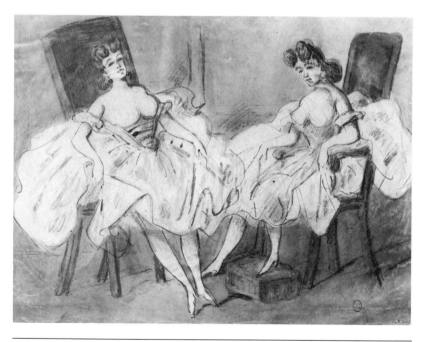

Figure 5. Constantin Guys. *Brothel Study.* Date uncertain. Pen and ink with wash. Musée Carnavalet, Paris.

itself, merge with its victim, like the victor with the vanquished, and yet keep the privileges of the conqueror"), the man of genius wants to "remain *one*, and prostitute himself in a particular manner" (*OC*, 1247, 1294). This exceptional man (Vautrin would be a good example) has no "horror of solitude," no pressing "need to forget his *ego* in external flesh" (*OC*, 1294); he cultivates his self-pluralization as an art.

When Baudelaire asks "What is art?" and answers "Prostitution," it is to this kind of biologically sterile, but erotically stimulating, multiplication of the self that he is referring.[5] The entry in *Fusées* that immediately follows this rhetorical question suggests a direct correlation in Baudelaire's thinking between prostitution and the *flâneur*-poet: "The pleasure of being in crowds," he writes, "is a mysterious expression of the enjoyment of the multiplication of number" (*OC*, 1247). The *flâneur*, who gets "an immense pleasure from choosing to be at home in number" (*OC*, 1160), has precisely the kind of unanchored empathetic capacity Baudelaire associates with prostitution. In the prose poem entitled "Crowds" in *Le spleen de Paris*, he writes: "The poet enjoys the incomparable privilege of being himself or someone else as he chooses. Like those wandering souls in search of a body, he enters whenever he wants into anyone's character. For him alone everything is vacant; and if certain places seem closed to him, it is because in his eyes they are not worth visiting" (*OC*, 244). This wandering soul, gifted from birth with a "love of disguise and masks," is the prostituted soul, for whom any one particular body is no more than a provisional identification. "What people call love is a very small, restricted, feeble thing compared to this ineffable orgy, this holy prostitution of the soul that gives itself entire, poetry and charity, to the unexpected that appears, to the unknown that passes" (*OC*, 244).

This *flâneur* in the crowd is intoxicated by the multiple opportunities for prostitution that surround him. Baudelaire calls these opportunities "poetic," suggesting a literary dimension to the *flâneur*'s activity. Each occasion for the soul's prostitution is an invitation to narrative invention: "espousing the crowd" (*OC*, 1160), the *flâneur* espouses a multiplicity of imagined stories, just as Constantin Guys, the painter of modern life, espouses a multiplicity of heightened images: "His is an *I*," writes Baudelaire of Guys, "insatiable for the *not-I*, which at every instant it renders and expresses

in images more alive than life itself, always unstable and fugitive"
(*OC*, 1161). As is also true of Balzac's narrative desire, gender is
one of these figural instabilities. The bodies into which the *flâneur*
enters as he wills (Baudelaire, significantly, does not conceive of the
possibility of a *flâneuse*) can be male or female indiscriminately,
gender being simply another of the vacancies the poet-prostitute
fills as he chooses. Gender is thus alienated from biology and rein-
vented in the mode of *contresens* or *l'arbitraire*, as cultural figure,
disguise, mask, or fetish. Fundamental to this figural creation, how-
ever, remains the ceremonial "cult of oneself [male, of course],
which," as Baudelaire writes of the dandy's meticulous vigilance,
"can survive the search for happiness to be found in others, in
woman for example, which can even survive what are commonly
called illusions" (*OC*, 1178). Such supreme "insensibilité" (*OC*,
1160) is the dream of the composite figure Baudelaire constructs of
the poet, prostitute, *flâneur*, and dandy. It is typical of what Sartre,
in *L'idiot de la famille*, terms the "practices of distinction"[6] prevalent
among writers at mid-century who "derealize" sexuality, making it
into an imaginary role, so as to escape the horror of woman's impure
and implacable flesh. "Woman is the contrary of the dandy," writes
Baudelaire in *Mon coeur mis à nu*. "Therefore she must elicit horror."
Defined as the dandy's opposite, woman is a prostitute in Baude-
laire's negative understanding of the term. She is an abominable
creature of nature. "Woman is hungry and she wants to eat, thirsty
and she wants to drink. She's in heat and she wants to be screwed"
(*OC*, 1272). From this disgust with female animality derives Bau-
delaire's masochistic attraction to the frigid, sterile, unresponsive
woman, "la froide majesté de la femme stérile" (*OC*, 28). This
sphinx's impenetrability saves the poet from engulfment and stim-
ulates his own prostitutional openness, especially to the improvis-
ation of female identities.

The theory of dandyism was set forth in 1844 in a little book
called *Du dandysme et de George Brummell* by Baudelaire's friend and
admirer, Jules Barbey d'Aurevilly. One of the points of Barbey's
essay is that a dandy should never allow himself to love, since loving
entails becoming a slave to desire. George Brummell, like Vautrin
in this respect, escaped such slavery. His triumphs, notes Barbey,
"had the insolence of disinterestedness."[7] He always stopped with
women "at the limit of gallantry" (*DD*, 55), keeping them under his

intellectual dominion by nullifying their sexual attraction. The dandy is the sovereign creation of his own "instantly mobile" intelligence; he is "intellectual even in the kind of beauty he possessed" (*DD*, 93, 64). His manner is saturated with irony, giving him "the look of a sphinx, which fascinates like a mystery and disturbs like a danger" (*DD*, 66–67). Fascination and danger of the sphinx's ambiguous sexuality: the crouching lion's body is furnished with a male head in Egyptian mythology, a female one in Greek mythology. The dandy has the ability to synthesize the signs of sexual difference in the artifice of his self-creation. Dandies, writes Barbey, are "double and multiple natures, of an undecidable intellectual sex [*d'un sexe intellectuel indécis*], in whom grace is still more graceful as strength and strength appears again as grace" (*DD*, 105).

Dandyism understood in these terms functions both as thematic focus and narrative principle in a number of the stories Barbey collected under the title *Les Diaboliques* (published in 1874, though many of the stories were written much earlier; exact dates are uncertain). Two of these stories, "La vengeance d'une femme" (probably written last, around 1870–71) and "A un dîner d'athées" (possibly 1867–68) are of particular interest to us since they dramatically cast the dandy's figuration of gender instability against the prostitute's disfiguring sexual animality. The crucial context for this drama, which the analysis of a short fictional form will allow us to trace in some detail, is the question Roland Barthes has identified as central to any narrative act: "Against what can the story be exchanged? What is the 'value' of the story?"[8]

The narrator's remarks introducing "La vengeance d'une femme" suggest that the value of the story we are about to read derives from its true reflection of a historical moment of "extreme civilization," when crime has attained "a superior level of intellectuality" (*LD*, 281).[9] Far more sophisticated in their refinement and corruption than the crudely materialistic and sensual crimes of earlier times, modern criminal acts "speak more to the mind," letting no blood flow and massacring only "in the order of feelings and manners" (*LD*, 281, 282). The reader of *Du dandysme* identifies these acts of intelligent and original cruelty as belonging to the hypercivilized domain of dandyism. Indeed, the dandy's irony is almost criminal in its cutting genius, and his autocratic power derives from his callous divorce from passion and sensuality. Thus, the narrator of

"La vengeance" is claiming that the true story he is about to tell involves a crime committed under the modern aegis of the dandy's sensibility and, by extension, he implies that what has been added to that truth, his own "manner of telling it" (*LD*, 282), is of value to the extent that it shares the same modernity.

Robert de Tressignies, the hero of "La vengeance d'une femme," is a "highly intellectualized" dandy who imagines that he has "reflected enough on his sensations so that he could never be their dupe" (*LD*, 283). He has used this confidence in his perfect self-control to take a step from which Brummell held back: he has become a libertine who is expertly acquainted with "the female animal in all the varieties of her species and race" (*LD*, 283). At the outset of the story, his curiosity is piqued by an unusually attractive prostitute he has observed promenading provocatively up and down the boulevard and he decides to follow her, more to find out what might explain such a beautiful woman's being "a whore of the lowest rank" (*LD*, 283) than to fulfill his skeptical, overindulged lust. Moreover, and psychologically this appears as the determining motive in Tressignies's curiosity, "this woman bore a resemblance for him" (*LD*, 284). He is following the trail of "another woman, seen elsewhere"—the suggestion of an unconscious maternal image will be confirmed later—but the trail takes him into so ugly and vile a neighborhood that he hesitates to enter "this black hole" (*LD*, 284, 285). Subsequently he penetrates a narrow, filthy alleyway and mounts a damp, slimy spiral staircase. Here a fantasized geography of degraded female genitalia is superimposed on an evocation of the corrupt, dirty, ruinous old Paris from which Eugène Sue had saved his heroine Fleur-de-Marie. Tressignies, however, allows himself to be seduced by the artfully presented sensual attractions of the prostitute, with whom intercourse is so terrifyingly intense that he loses his reflexive defensiveness and forgets everything. Her body is an abyss that sucks his soul into it ("Positively, she drew off the soul that was his into the body that was hers"—*LD*, 292), though his vanity is such that he interprets this castrating loss as a gain, imagining that he has inspired her with a passion greater than she has experienced with any other man.

But then Tressignies suddenly realizes that his partner, in the midst of sexual intimacy, has been absorbed in the contemplation of a man's portrait on her bracelet. Just when he is indulging the

romance of his exceptional amorous prowess, he is confronted with the humiliating realization that he is at best a stand-in. His oedipal reading of the situation casts him in a substitute role similar to the one the intriguingly resemblant whore has played in his own fantasy. He angrily imagines "that he *was posing for another*—that he was there on another's account" (*LD*, 292), which does indeed turn out to be the case but in a much more sophisticated scenario than Tressignies's banal triangular script.

The duchess of Sierra Leone now reveals her identity, which confirms the likeness Tressignies sensed from the outset. He had seen the great Spanish duchess only a few years earlier at the height of her prestige, admired her at a distance and dreamed of her thereafter, even loved her in fantasy. That such a fantasy was suffused with admiration for the pure, asexual mother becomes clear in Tressignies's response to the duchess's revelation: he divorces her entirely from the whore he has purchased and is horrified at the idea of touching her body. It is as if the incest taboo had suddenly taken effect, with a most interesting consequence. The duchess's remarkable beauty no longer attracts Tressignies. All he desires now is her story, and that desire is murderous: "He looked at her as if he wanted to witness the dissection of her cadaver. Was she going to revive it for him?" (*LD*, 297). The cadaver is no doubt that of the whore who was "annihilated" in Tressignies's fantasy when the duchess "emerged through her" (*LD*, 296). He attributes to the maternal figure the task of reviving the sexualized, passionately desiring woman as a pure figure of narration. The cadaver of the prostitute will make the mother's story available, so the dandy hopes, in terms that present her degraded sexuality as a fictional invention.

But as the duchess unveils her story, Tressignies realizes that its telling is part of a discourse addressed to a paternal figure and that his desire for narrative has been stimulated only to assist in the communication of that discourse. The duchess now acknowledges Tressignies's exceptional status among her clients, but that recognition has nothing to do with his merits as a lover. It is entirely a function of his suitability, given his having witnessed her earlier existence, to believe a story other clients had dismissed as mad fabulation and to assume a role in disseminating its subversive desire. That destructive rage is directed less against her hated hus-

band's body than against his name, the symbol of the family honor, which is all he really cares about. The duchess's masochistic strategy of revenge is to degrade herself to the level of *fille publique* so as to drag her husband's nominal heritage "in the most vile filth, . . . in refuse, in excrement" (*LD,* 305). She hopes that the story of her shameful debasement will reach the duke through one of her lovers, but, if not, she is counting on her dead body, putrefied with venereal disease, to tell the story of her prostitution. By using her body as a common place of male desire, the duchess is turning the possessive privilege inherent in the father's name against the patriarchal order that name sustains.

Her strategy shows her to be more than Tressignies's match in the intellectual mastery of sensual experience. Indeed, the blasé dandy has been entirely her dupe. Not only has she caused him to lose all self-control in the abyss of her sensuality, she has staged that sensuality as a role in her private play of representations. Tressignies's phallus has been for nothing in her purely ideal pleasure. It was valuable to her only insofar as she could imagine it as seen by the duke's eyes in the portrait on her bracelet. "His image excites my transports" (*LD,* 307), she tells the man whom those transports had, a moment earlier, carried out of himself. The duke's image serves as a sadistic phallus in a masochistic scenario that puts sexuality entirely in the service of the imaginary: "I drove that execrable image into my eyes and into my heart so as to be more pliant under you when you held me" (*LD,* 307). The prostitute, the duchess implies, was a cadaver from the outset. Performing the passionate body's revival, the duchess invents the harlot's sexuality as fiction. But the plot of her revenge drama blocks Tressignies's fantasy of appropriating that fictionality. Not only was her performance put on for another, but the divorce from the sexualized body that it entails has already been dedicated to a second Other's love.

The second Other is Don Esteban, the duke's cousin, with whom the duchess fell in love after some years of unhappy marriage. Their chaste, innocent, sublimated love was a positive version of the imaginary, visual relationship that later binds the duchess in hatred to her husband. The duke came upon the lovers, the duchess recounts, "as we always were, as we spent our life since our love began, tête-à-tête, united only through our eyes, he at my feet as if before the Virgin Mary, in such profound contemplation that we

needed no caresses" (*LD*, 303). This scene, conventional though it may be, fulfills a central fantasy in this text, repeated in Tressignies's perception that the duchess, in telling her story, has "completely effaced the whore, . . . become chaste, [with a bosom] of virginal roundness and firmness" (*LD*, 300). The fantasy is of a preoedipal union modeled on the infant's relation to the nurturant mother. It requires that any incestuous implications be sublimated ("never did Esteban's lips touch mine," declares the duchess—*LD*, 302) so that a fusion can be imagined that dissolves sexual difference ("We were melted into one another"—*LD*, 302).

Oedipal violence breaks up this "chivalric, romantic" (*LD*, 301) love, however, when the duke takes his brutal revenge by ordering Esteban murdered and his love organ cut out and fed to the dogs. That this organ is the heart rather than the penis is not only a function of literary decorum. The duke had no reason to believe that sexual relations had been consummated between his cousin and his wife. He wanted to degrade the symbolic meaning of the heart by treating the organ as meat. The duchess adopts the same strategy for her counter-revenge: she treats her body as sexual meat, repeatedly consumed by brutes, in order to attack the only symbolic value the duke cherishes, his name, the source of the patriarchal narrative of generational continuity with which he entirely identi-fies. The prostituted body thus becomes the literalized, reified body, the body that defeats symbolic recuperation by its sheer dead weight.

Tressignies's goal is to reverse this defeat and revive prostitution within a symbolic structure. "By throwing her story between the two of them, [the duchess] had cut, as if with an axe, the momentary bonds of intimacy they had just formed" (*LD*, 308). The story cas-trates the sexual relation of bodies, but is itself independent of that sexuality. Tressignies now takes advantage of this independence to hoard the story for himself, instead of repeating it as the duchess has requested. Thus, he extricates himself from the oedipal scenario of the duchess's revenge. His attitude toward the narrative, clois-tering himself in his room "tête-à-tête" with his memories of the evening, "sealing the story up in the most mysterious corner of his being" (*LD*, 312, 313), suggests that he is trying to recreate with the story a relationship not unlike Esteban's with the duchess. Instead of her eyes, which Esteban had contemplated in rapture, the duchess's story is Tressignies's object of absorbed fascination. He

feels himself narcissistically identified with the story, as if its energy alone constituted his interiority: "Thus, he spent hours, leaning against the armrests of his easychair, dreamily turning over within himself the open pages of this hideously powerful poem" (*LD*, 313). It appears that Tressignies has successfully transformed the duchess's promiscuous sexual availability into her narrative availability, as a nurturing maternal source, "strange and all-powerful" (*LD*, 312), to him alone.

One fear still troubles Tressignies, however: the duchess's story could once again function as an axe, this time to divide him from itself. Her prostituted body remains open to others and its promiscuous activity could make available to those others the story he now considers his own. Thus, when Tressignies emerges from his period of hermetic intimacy with the duchess's story, "he never encountered one of his friends without the fear of hearing him tell, as having happened to him, the adventure that was his own" (*LD*, 313). This fear of oedipal rivalry appears to be the cause of Tressignies's subsequent physical degeneration—he shows no interest in women, loses the dandy's formidable social skills, and finally appears quite sickly—as if by refusing the life of the body he could come closer to the sublimated life of narrative. His sudden disappearance from Paris, "as if through a hole" (*LD*, 314), radicalizes this movement to cancel his physical presence.

But Barbey's story does not end there. Its concluding episode puts the fantasmatic structure of the narrative entirely into the service of Tressignies's regressive desire. He returns to Paris after a year's absence and, at a swank dinner party, witnesses the first public revelation of the duchess's prostitution: a newspaper notice announcing her burial as a common whore is read to the scandalized assembly. Her story of revenge, however, is not yet known, and Tressignies does not tell it. Instead he visits the church of the Salpêtrière hospital where the duchess was buried and requests information from a priest about her final illness. He learns that she had indeed contracted the venereal disease she had wished for and that her body had rotted with decay. The text pays special attention to the gruesome fate of her eyes: one eye had popped out of its socket and fallen at her feet while the other had liquefied and melted. The imagery of castration is evident here and relates specifically to the metaphorical sense in which the duchess's soul was in her eyes. Her

love for Esteban had been a communion of souls through the spiritual path of visual contemplation. She had expressed her hatred of the duke by contemplating his portrait imagined as the voyeuristic witness to her prostitution. Now Tressignies alone hears the details that reduce the duchess's eyes to merely physical organs, ripped out of her face by self-inflicted disease. Although it is likely that the story of the duchess's prostitution will eventually reach the duke, at the end of Barbey's narrative this communication has not yet occurred and Tressignies has taken the duke's place. It is he, rather than the mutilator of Esteban, who receives the duchess's posthumous message of her self-mutilation. Thereby he takes imaginary possession of her revenge, of the reified body she had imagined to be symbolically irrecuperable. And the text sustains the fantasy that he turns that revenge against the duchess, drawing her soul into his body.

"La vengeance d'une femme," which is really that of a man, ends with Tressignies exulting in his privileged knowledge of the duchess's plot. He considers himself the only reader qualified to establish the truth of the text she has left behind. Whereas the deluded priest believes that humility prompted her to want the word "repentie" removed from the phrase "fille repentie" in her epitaph, Tressignies's command of her narrative enables him to read this gesture as a final refinement in her masochistic scenario of revenge. The duchess's masochism, which transforms her sexuality into a pleasure-denying instrument of her death drive, now appears to correspond perfectly to Tressignies's sadism. He has succeeded in appropriating her story so that it works fantasmatically to fulfill the dandy's unconscious desire, the repression of female sexuality, and to degrade that sexuality to the point where its castrating power is made to turn against itself. Tressignies gets his wish: he dissects the prostitute's cadaver and is reborn in function of its revival as fiction. This, I think, is the meaning of his departure from and return to Paris: he is revived narratively in terms of an imagined defeat of all oedipal rivals and a fantasized identification with the soul-meaning of the duchess's plot, the dissolution of sexual difference in union with the chaste and virginal mother.

A similar narrative and psychological structure is discernible in "A un dîner d'athées." The main story is introduced by its narrator, Mesnilgrand, after a lengthy description of the society of erstwhile

soldiers and officers of Napoleon's army now living in a provincial town, of which the proud, aristocratic Mesnilgrand is the acknowledged leader. The active life of these men is essentially over. The present exists for them as a vehicle to narrate the past, to tell its romantic and heroic story, and thereby to forget the banality of contemporary existence. Mesnilgrand stands out as forcefully in this narrative enterprise as he had once on the field of battle. His eloquence is so extraordinarily intense that it strikes his listeners with a physical impact. Mesnilgrand has transformed his life entirely in the service of representation. After a few initial forays into the local salons, this once passionate lover of women has retired from the social scene, although he continues to dress with the most tasteful elegance, his dandyism having "outlived this defunct, buried life" (*LD*, 231). He spends his days at an occupation as far removed from war as possible, namely landscape painting, and his somewhat dated patrician appearance actually makes him resemble "a walking portrait" (*LD*, 231).

When Mesnilgrand finally tells his story, it becomes apparent that his "transfiguration" (*LD*, 241) from soldier to artistic creator and creation was a response not so much to the loss of his military identity as to the loss of his sexual identity. As in "La vengeance d'une femme," the crucial confrontation here is with a prostitute figure. Unlike the duchess of Sierra Leone, however, Rosalba is not a whore who, subsequent to intercourse, reveals herself to be a mother, but a woman who, even in the midst of the sexual act, is simultaneously mother and whore. Mesnilgrand dwells on this paradox. Rosalba, mistress of a certain captain Ydow, provokes the entire regiment through "the diabolical construction of her being . . . that made her the most madly passionate of courtesans, with the appearance of one of the most celestial madonnas of Raphaël" (*LD*, 263). Happily she satisfies the desire she invites and sleeps with the whole officer corps, maintaining all the while the blushing virginal modesty that makes her given name, with its suggestion of combined red and white, seem allegorical and that earns her the nickname "La Pudica."

Mesnilgrand has his turn with Rosalba, thereby becoming one in a series of Others for whom she remains the same (the regimental view of her position stresses the logic of substitution: "Since she had given herself to [Ydow], she could just as well give herself to

another and, why not, everyone could be that other!"—*LD,* 258).
But he experiences his otherness to her, the principle of her sexual
openness, as a castrating refusal of his desire. Like Tressignies, who
momentarily imagines himself exceptional, Mesnilgrand wants Ros-
alba to admit to loving him, even though he has no love for her "in
the elevated and romantic sense that people give to this word, myself
first among them" (*LD,* 265). She, however, refuses to romanticize
their affair, to give him any kind of linguistic privilege over her
sexuality, to narrativize her body. Physically penetrated, she remains
"impenetrable like the sphinx" (*LD,* 266). Stories are circulated
about her among her lovers, but "she gave no hold over her openly
through her conduct" (*LD,* 264). Her body, which Mesnilgrand calls
"her only soul" (*LD,* 265), remains outside any narrative plot.

Although the duchess of Sierra Leone's soul is dramatically not
in her body and her deep sensuality is an act whereas Rosalba's is
real, the psychological function of sensuality is not dissimilar for the
two women. What the male imagines to be his act of taking pos-
session ensures the female's self-possession. The gift of her body,
offered in apparently total abandon, turns out to be a gift to herself,
of which the male is the easily replaceable vehicle. She denies love
at the very moment when sexual delight seems to be its manifest
sign. Thus the female body, as apprehended in the male fantasy
structure of these two stories, becomes most unreadable when it is
physically most open. (We remember Parent-Duchâtelet's diagnostic
distress at the impenetrable secrecy of even the most licentious
woman's genital parts.) The more fully the prostitute satisfies male
desire, the more completely she destroys the psychological dimen-
sion of that satisfaction, that is, its insertion into the male plot of
conquest and control. Intercourse with Rosalba, according to Mes-
nilgrand, denies the very temporality of male experience: "One was
always at the beginning with her, even after the conclusion . . .
Language dissolves in attempting to express this" (*LD,* 261).

The climax of Mesnilgrand's story, however, dramatizes the
dependence of narrative on precisely the erotic female body that it
cannot express. Out of what he calls "moral disgust," Mesnilgrand
dissociates himself from the castrating Rosalba, "a sphinx that
devoured pleasure silently and kept its secret" (*LD,* 266, 267). Just
as the duchess absorbed Tressignies's soul into her body, so Rosalba
threatens Mesnilgrand with the dissolution of his spiritual superi-

ority. He recaptures his virile strength by abandoning desire and becoming "very calm and very indifferent with all women" (*LD*, 266). Nonetheless, one evening he responds to the renewed call of the flesh and returns to see—that is, to make love to—Rosalba. In the unconscious structure of the story, it seems as if the violent act of sexual revenge that interrupts his erotic encounter actually fulfills his deepest wish. Surprised by the unexpected appearance of Ydow, Rosalba hides Mesnilgrand in a closet, from whose dark, protected space he overhears Ydow verbally abusing her. Ydow is in a jealous rage over a letter of assignation he has found unaddressed on her table and wants to know who the intended recipient is. She refuses to name her lover and goes on to further provoke the captain by declaring that she has never loved him.

Thus far the scene repeats Mesnilgrand's emasculating experience with Rosalba, her insistence on the substitutability of her sex partners, and her denial of romantic feeling. But now she goes a step further to mock the entire symbolic order of male authority associated with the name of the father. She denies that Ydow was the father of her son, who died a few months after birth, lists all the men who could potentially have claimed paternity, and then suddenly names as the actual father the other man in the room, Mesnilgrand, "the only man whom I have ever loved, whom I have ever idolized" (*LD*, 275). Mesnilgrand knows this romantic assertion to be a fiction and hence cannot but doubt his alleged paternity, although his name pronounced in this context "struck him like a shot through [his] closet" (*LD*, 275). Thus, Rosalba repudiates that most cherished of male stories, the history of generations, and, on the basis of the impenetrable interiority of her body, unmans both Ydow, who wants to believe himself the father, and Mesnilgrand, who does not.

Earlier in the story Mesnilgrand had already reflected that "what is most horrible about shared love affairs . . . is the terrible anxiety that prevents you from listening to the voice of nature, stifling it in a doubt that is impossible to dismiss" (*LD*, 267).[10] The voice Mesnilgrand considers natural speaks to a man of his right to possess a woman, control her sexuality, and inscribe her in his genealogical story. By placing her body outside this patriarchal scheme, Rosalba throws the scheme into confusion: paternity becomes a mere fiction, a matter of arbitrary naming. Here, as in "La vengeance," the pros-

titute figure generates narrative precisely by asserting her independence of it. The father's nomination is her prerogative, which "is impossible to dismiss."

But Barbey cannot allow the subversive power of female fictionalizing to determine the outcome of his narrative. Rosalba's open sexuality must be sealed up so that Mesnilgrand's anxiety can be calmed and he can take possession of her story. By pouring hot wax into his mistress's sexual organs, Ydow is fulfilling both his own and Mesnilgrand's vengeful impulses. Thus, it is no accident that Mesnilgrand bursts out of his closet only *after* the mutilated Rosalba has emitted a cry so wild that it seemed to come out of "the vulva of a she-wolf" (*LD*, 277). This startling phrase suggests that Rosalba's sexuality is bestial and predatory and thus warrants extermination. Mesnilgrand, however, cannot accept his implication in Ydow's act and runs him through the back with a sword.[11] Just at this point, thankfully, a call to arms sounds and the heroic violence of the battlefield displaces and veils the far more troubling arena of sexual violation.

Mesnilgrand never hears of Rosalba again—she is as good as dead, having been rejected from the narrative—but he has taken with him the heart of the child she called his. This heart, lovingly embalmed by Ydow when he thought he was the child's father, served, hideously, as a projectile in his fight with Rosalba. Its fate relates the end of the story to its beginning. After years of carrying the heart around with him like a relic, Mesnilgrand decides to give it to a priest. This accounts for his having been in the church where a scandalized fellow soldier-atheist, Rançonnet, glimpsed him in the text's opening scene. Mesnilgrand's story is a response to Rançonnet's demand to know what he was doing in this religious haunt.

One psychoanalytic interpretation of this ending, offered by Jacques Petit, is that Mesnilgrand is returning the phallus (the child's heart) to a maternal refuge (the church).[12] This analysis, however, needs to be nuanced, especially in regard to Petit's conclusion that Mesnilgrand is hereby accepting his own castration. The heart, for Mesnilgrand, is associated above all with anxiety about the potentially fictional status of paternity. He refers to it as "this child's heart about which I had doubts" (*LD*, 278). Earlier he had reflected that uncertainty about the patriarchal status of the phallus in determining the order of nature could drive a man mad: "If you were to think

long about that [the shameful partition to which you have ignobly submitted], being big-hearted [*quand on a du coeur*], you would go mad" (*LD*, 267). "Quand on a du coeur". . . . Clearly it is to this metaphorical meaning of "having the heart" that the child's actual organ must be assimilated if the madness generated by the impenetrable abyss of female sexuality is to be controlled. "Heart" in this sense corresponds to Mesnilgrand's "elevated and romantic" interpretation of love. Religion for him has this same romanticizing function of metaphorical elevation. To deposit the child's heart with the church thus is to elevate the whole question of the uncertain origin of paternal authority into the sphere of imaginary representation. Only in this sphere can the priest to whom Mesnilgrand hands over the "indistinguishable object" be called "my father" (*LD*, 223). The father's nomination becomes a male prerogative once the sexual basis of paternity has been eliminated.

In this scene of symbolic restitution, the phallus, veiled, indiscernible, is returned to the father, in name only, whose place is inside the darkened body of the maternal church, itself associated with death. ("At that hour of the day, one feels very strongly that the Christian religion is the daughter of the catacombs"—*LD*, 219). Physical presence is dissolved in a proliferation of symbolic substitutes. The maternal space, which provides the story's narrative frame, is protective precisely insofar as it sublimates the body and fictionalizes the whole issue of sexual differentiation.[13] The worshippers in the church are described as "souls" rather than as men and women. In the "ghostly twilight" of this edifice, "it was possible to see one another uncertainly and indistinctly, but it was impossible to recognize anyone" (*LD*, 220). This is not the doubt generated by sexual anxiety, but a reassuring confusion that allows sexual difference to be hidden by a veil of uncertainty.[14]

In the unfolding of the *récit*, the description of the church precedes the description of Mesnilgrand's post-Napoleonic life style. In effect, the one appears to derive from the other. Mesnilgrand, who was struck by "the almost tomb-like aspect of the church," at present "asks nothing more of life" (*LD*, 221, 232). In his roles as painter, storyteller, and dandy, he has made life over as representation, image, artifice: "One felt that the artist had passed through the soldier and transfigured him" (*LD*, 241). His having apparently renounced all sexual activity does indeed suggest an acceptance of

castration. But his dandyism is more accurately understood as a way of putting the fixity of sexual identity in doubt. We remember that Barbey thought of dandies as having "double and multiple natures, of an undecidable intellectual sex," combining strength with grace. Dandyism multiplies, intellectualizes, and transfigures nature, in particular prostituted female nature. This transfiguration constitutes the essential principle of narrative closure in both the stories we have examined. The artistic transfiguration of Mesnilgrand's soldiership is evident in the way he tells his story, as if he were directing a battle: "Stay in the ranks," he tells Rançonnet. "Let me maneuver my story as I see fit" (*LD*, 257–258). Mesnilgrand identifies with "the adventure that was his" as intimately as Tressignies does with the story he makes his. In both cases, this identification eliminates the threat that the sexualized female will control the name of the father and thus authorize the story of generations. The goal of Mesnilgrand's narrative maneuvering is a victory over the sexual determinants of the story's violence, through a return of the emblem of doubtful paternity to a symbolic space that eliminates the sexual basis of fatherhood.[15] This return corresponds, I think, to the "oneness" Baudelaire considers the glory of the man of genius, who has no need to "forget his ego in external flesh" and whose dandified cult of himself allows him to survive all illusions. Barbey's stories suggest the maternal fantasy underlying Baudelaire's insistence on oneness as the basis of a poetic "prostitution of the soul." By emptying sexuality of its physical reference, these stories sustain the fantasy that their narrators have survived their search for happiness in the sexual Other, embodied in the prostitute, and have achieved union with the generative principle of their own narrative activity. This principle is embodied in the dandy, but only in the sense that the dandy's embodiment is a transfiguring disembodiment, of undecidable sex, created in imaginary union with the mother's transformative powers.

A traditional psychoanalytic interpretation would have no trouble finding the "source" in Barbey's biography of the narrative patterns I have traced here. His need for maternal protection can be seen as a response to the coldness his actual mother displayed in his childhood, and his masochistic fascination with the dominating, masculinized female can be shown to have the same origin, via a reversal typical of the psyche ("Maternal love is the castrator of the other

love," he once wrote).[16] His hostility toward the father, represen-
tative of the sexually active male, can be traced back to an unre-
solved Oedipus complex (which, inversely, also leads him to desire
a powerful authority worthy of his rebellion).[17] But a reading along
these lines, however fruitful, would focus attention on the eccen-
tricities of individual neurotic symptomatology, whereas what is
most remarkable about Barbey's narrative strategies is the degree to
which the fantasies they encode are shared by male artists and
writers in France in the second half of the nineteenth century.

The prostitute is a key figure in these fantasies. She is imagined
as animalistic, intense, a sensual feast for the blasé upper-class male.
But almost immediately her sexuality becomes threatening. She is
somehow impenetrable even as she gives herself to be penetrated,
opaque just when she should be most readable. She asserts her
independence of the male plot at the very moment when the male
thinks he is inscribing her body into it. This assertion, which stim-
ulates narratively productive castration fears, becomes the object of
complex strategies designed to put these fears to rest and achieve
narrative closure. One of the most powerful of these strategies is the
rhetorical fictionalization of sexual difference. Domination is thus
acquired not by the assertion of power within a binary structure but
by the destabilization of that structure and its assimilation into the
sphere of male artistic invention, where the body becomes "d'un
sexe intellectuel indécis."[18] Barbey's texts reveal one of the primary
motives for this intellectualization of sexual difference: male anxiety
about woman's prerogative to designate paternity and thereby deter-
mine genealogy and patronymic lineage.[19] This anxiety inspires a
revision of the traditional plot that subverts its biological basis (asso-
ciated with devastating female sexual power) and that makes of
paternity a dandy fiction whose transfigurations inscribe fantasies
of maternal union. This revised plot is "something modern that
derives from altogether new causes," as Baudelaire wrote of dan-
dyism in 1846 (*OC,* 951). The story of modernism is beginning to
take its denatured shape.

Manet's *Olympia*:
The Figuration of Scandal

here were good reasons in the 1860s for the widespread recognition of prostitution as the most spectacular image of the bourgeoisie's somewhat uneasy will to pleasure. The radical redesign of Paris undertaken by Baron Haussmann entailed the destruction of many of the working-class neighborhoods where brothels had thrived, for instance the alleys of the Cité where Sue's Fleur-de-Marie had been led astray and the dilapidated areas near the Palais Royal where Balzac's Esther Gobseck had lived.[1] The working class was to a large extent displaced to the periphery of the city, as landlords in the central districts profited from the housing shortage to raise rents. High rents and complex official regulations made the opening of new *maisons de tolérance* in downtown Paris difficult and expensive, and the number of establishments diminished significantly (from 217 in 1852 to 152 in 1870, according to Maxime Du Camp).[2] Large luxury bordellos were most likely to survive, whereas smaller enterprises were often transformed into lodging houses, or *garnis*, in which, after a legal decision of 1866, prostitution could be practiced virtually without penalty for the owner.[3] If there were fewer *filles à numéro* in this period, the number of *insoumises* was increasing, and Haussmann's wide new boulevards, conspicuously flanked by cafés, brasseries, and restaurants, gave them a perfect theater for their flagrant self-display. Registering the ready-made bourgeois response to this public affront, Flaubert notes under "courtisane" in the *Dictionnaire des idées reçues:* "Should

be pursued without pity.—One can no longer go out with one's wife because of their presence on the boulevards."[4] So much more visible were prostitutes on the streets of Paris during the *fête impériale* than at any earlier time that observers imagined, probably incorrectly, that their number had increased dramatically and that the city was being invaded by an uncontrolled and scandalous female venality. Thus, the police prefect Charles Lecour, writing in 1870, counts 1,066 prostitutes registered in *maisons de tolérance*, 2,590 registered but living alone, and an untold number of *non-inscrites*, of whom he declares:

> They are everywhere, in the brasseries, the cafés-concerts, the theaters and the balls. One encounters them in public establishments, railway stations, even railway carriages. There are some of them on all the promenades in front of most of the cafés. Late into the night, they circulate in great numbers on the most beautiful boulevards, to the great scandal of the public, which takes them for registered prostitutes violating the regulations and hence is astonished at the inaction of the police in their regard.[5]

Not everyone would have agreed with Lecour that prostitutes could be so easily identified by an outraged public. It was a commonplace of the time to observe that a prostitute of the better class was practically indistinguishable from a proper lady of society. A lithograph published in *Le Charivari* in 1864 (Figure 6) makes the point that *grandes dames* and *petites dames* share the same dress, receive the same gentlemen, go out to the Bois at the same time in similarly equipped carriages, and have the same quantity of false hair. A journalist writing in the *Gazette de France* in 1865 observed that "dress, jargon, pursuits, pleasures, cosmetics—everything brings together the *demi-monde* and the *monde entier;* everything allows one to confuse things that should not even be aware of one another's existence."[6] The sales personnel of the huge department store Bonheur des Dames, in Zola's novel of that name, whose action takes place from 1864 to 1869, is unable to determine whether an elegant client is a *cocotte* or a lady of the best society. "With their distinguished manners, how can one tell the difference today!" exclaims the head of the silks department, no mere amateur in such matters.[7] The Goncourts report a conversation on this subject at the Princesse Mathilde's in 1868: "The guests carried on about the contagion

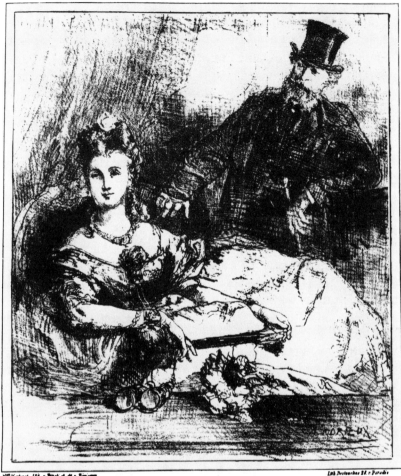

Quelle différence y a-t-il à première vue, entre une grande dame et une petite dame?
leur costume est le même, elles vont au bois à la même heure, elles reçoivent les
mêmes Messieurs, elles ont le même nombre de ressort à leurs voitures et autant de
faux cheveux l'une que l'autre. Etrange, étrange!

Figure 6. Auguste Andrieux. *"What Difference Is There . . ."* (1864). Lithograph.
Le Charivari.

spread by the corruption [of courtesans], about the imitation and counterfeiting of their fashions; people cited the names of society ladies who emulated them."[8] At the end of the decade, Maxime Du Camp found that the mode in fashion was actually being set by the hussies who had come to town (riding the new railway—the spread of prostitution parallels industrial expansion) to profit from the 1867 Universal Exhibition. "One does not know nowadays," he complains, "if it's honest women who are dressed like whores or whores who are dressed like honest women" (*PS*, 458).[9] Du Camp's inability to make this distinction may explain his extraordinarily high estimated number (120,000) of purchasable women living in Paris, from *insoumises* and *grisettes* (working girls of easy virtue) up to "the great lady who, before selling herself, demands and receives a million francs in newly minted pieces of gold" (*PS*, 464).

The conjunction of sexual and financial transactions in the context of Haussmannization is the subject of Zola's novel *La Curée*, written in 1870. The perfidious hero, Aristide Saccard, accumulates an immense fortune by profiting through shady schemes from what Zola pictures as the slashing, cross-hatching, and evisceration of Paris. His sister, a self-effacing bourgeois procuress who traffics indiscriminately in human and inanimate wares, is robbed of potential business by a high-society woman, Madame de Lauwerens, a great lady of the new school "who sells her women friends in her boudoir while drinking a cup of tea."[10] One of Aristide's co-conspirators is the *cocotte* Laure d'Aurigny, who holds open house once a week, just like a woman of the best society, and invites the same men as are received by Aristide's wife Renée, to whom, as part of a publicity trick, he offers the fabulous diamonds he had previously given Laure. Renée is seduced by her depraved son-in-law in a *cabinet particulier* of the famous Café Riche, where her incest is abetted by scenes she watches through the window—scenes of casual prostitution and voluptuous indulgence on the boulevard. Their decadent, febrile relationship is seen by Zola as emblematic of the corrupt new Paris that nourishes it. Renée has little trouble excusing herself: "She was only following the mode of the times, she dressed and undressed following the example of others" (*La Curée*, 510–511).

One of the places where Renée changes clothes most frequently is the apartment of the stylish couturier Worms, named after the famous Worth who rendered his high-priced services indiscrimi-

nately to fashionable ladies, whether courtesans or countesses. Women in vogue, whatever their rank, were also likely to rub elbows in the city's newest exhibition halls, the *grands magasins*—"*maisons de tolérance* of commerce," in Zola's phrase. These huge department stores specialized in *nouveautés* such as fabrics, ribbons, lace, and all the accessories for the elaborate fashions of the time, including, at the Bon Marché, fifty-four kinds of crinoline.[11] The building of the *grands magasins,* as Zola demonstrates in *Au Bonheur des Dames,* went hand-in-glove with Haussmann's massive demolitions. Indeed, the acquisition of the necessary land was often financed at privileged interest rates by the same Crédit Foncier that managed, disastrously in the end, the state's program of urban renewal.[12] Most of the department stores that are still famous in Paris today were founded or greatly expanded in the 1860s: the Bazar de l'Hôtel de Ville, the Bon Marché, the Printemps, the Samaritaine. And there were others that have not survived, such as the Louvre, the Grande Maison de Blanc, the Magasins de la Paix. These stores revolutionized commercial practices in some of the same ways prostitutional practices were changing in the second decade of the Empire. Internationalization of both commodity and clientele was common to the two enterprises. Whereas small Parisian boutiques had relied on local suppliers and had cultivated regular customers, the department stores purchased merchandise throughout Europe and geared its sale impersonally to any monied client. Likewise the great courtesans of the time were frequently of foreign origin (Cora Pearl and Miss Howard, who helped finance Napoleon III's rise to power, were from England; Giulia Barucci was from Italy; La Païva was from Russia), and they catered to an international clientele defined impersonally by its wealth. "Paris, a bordello for foreigners," complained the Goncourts in 1863. "There is no longer a single woman kept by a Frenchman. They all belong to Hanoverians, Brazilians, Prussians, Dutch. It's an 1815 of the phallus" (*J*, I, 1255). These international stars of venality condensed in their extravagantly staged appearance the spectacle of commodity fetishism displayed on a grandiose scale in the *grands magasins.* And *honnêtes bourgeoises* were eager to copy the signs of the suitable, coded with systematic coherence on the bodies of the brilliant professionals of desire.

The attitude of the bourgeoisie toward the spectacularly public collapse of its avowed moral code, and of the system of police

regulation set up to enforce it, was complex. Part of the response was articulated through a discourse of reprobation and denunciation, whose formulas repeated the imagery of organic contamination and disease ubiquitous in Parent-Duchâtelet. Thus, Du Camp (*PS,* 455–456) speaks of a cesspool in need of cleaning, of a gangrene so deep that it threatens to disintegrate the social organism, of a mold breaking through the cracks in a wall and spreading out on the surface. In his 1867 preface to the highly successful play he had based on his less successful novel *La dame aux camélias* (1852), Alexandre Dumas *fils* declares that French society is headed toward "universal prostitution," propelled by what he calls a "tumor in the brain, . . . a virus in the blood" (*AP,* 25, 30). He considers that sexual mores have changed so radically in the fifteen years since the play was first produced that it has become an "archeological curiosity" (*AP,* 25), his heroine with a heart of gold now being no more than a legend. Feeling has disappeared and all that is left is capital investment, declares Dumas. He looks back nostalgically to the *femme galante* of thirty years earlier, whom he portrays as an impoverished woman of some cultivation and intelligence, kept as a kind of second wife by a loyal and loving captain of industry or commerce. The ranks of venal women were subsequently increased by *grisettes,* who had the merit of being productive workers, and who, despite their susceptibility to gifts, did not surrender their bodies without also tendering their affections. Now, however, complains Dumas, the love of luxury and the frantic quest for pleasure have transformed corrupt women into mere market commodities. These women have learned how to manage and increase their value as wares: "In this hurly-burly of brand-new enterprises making profits nevertheless, beauty has become paid-in capital, virginity an asset, shamelessness an investment" (*AP,* 24). As a result, prostitutes now constitute "a class" (*AP,* 24). Their ill-gotten gains have infiltrated business affairs to such an extent that the French economy could not function without the funds put in circulation through sexual commerce. And this circulation has a biological correlative: wealthy courtesans are marrying into good bourgeois families, contaminating "le sang de la France" (*AP,* 28).

Dumas's rhetoric is obviously overblown and melodramatic, but the connection he makes between prostitutional traffic, the circulation of liquid currency, and biological, even national degeneration

was destined to resonate powerfully in the male imaginary throughout the second half of the century. This resonance, however, is barely audible in Dumas's plays of the 1850s, which attempt to exploit the sentimental myth of the loving prostitute at a time when the association of prostitution with consumer capitalism was making the myth's fictionality increasingly obvious. Rival dramatists made a point of critically updating Dumas's portrayals by offering what they claimed to be more realistic depictions of the vicious world of *galanterie*. For instance, *Les filles de marbre* by Barrière and Thiboust, which was produced a year after *La dame aux camélias*, features a venal heroine, calculating and avaricious, who drives her lover to suicide; Emile Augier's *Le mariage d'Olympe*, produced a year after Dumas's *Le Demi-monde* of 1854, desentimentalizes Dumas's portrait of the *cocotte* by showing her to be motivated by heartless, mercenary ambition.[13]

But no work of the second part of the century stands the myth of the prostitute-with-a-heart-of-gold on its head as neatly as the first of Villiers de L'Isle-Adam's *Contes cruels*, "Les Demoiselles de Bienfilâtre" (1874), a mere eight pages long. The *demoiselles* in question, Olympe and Henriette, are modest, pious young ladies, "*soeurs de joie* since their tenderest youth,"[14] who have dedicated their finely turned bodies to the support of their elderly impoverished parents. Hard-working, orderly, self-sacrificing, parsimonious, the sisters are admired and respected by all who know them. Until, that is, Olympe suddenly slips off the straight and narrow path: she makes the unconscionable mistake of falling in love. With a penniless student, to boot. All are in despair at this strange "malversation," this precipitous fall from capitalist virtue. Olympe is no longer queen of the cafés and boulevards. She has removed herself from the marketplace. And she had been such a good wage earner! So irreprochably selfless! Finally Olympe's conscience can no longer resist the justice of the arguments against her, and the good woman is overwhelmed with shame and guilt. Dying, she confesses the only crime for which she feels remorse: "I had a lover! For my own pleasure! Without earning a penny!" At the ultimate moment the lover appears, his hands full of the money his family has just donated to finance his university studies. Glimpsing this "sacred metal" in a final glorious hallucination, Olympe feels that a divine pardon has descended from above, that she has been redeemed ("rachetée," literally "bought

back") through this unmistakable sign of her worth. This ending offers an elegantly ironic reversal of the prostitute's romantic myth: Olympe feels absolved from her sin of loving through the illusion that her beloved is paying her off. The capitalist logic that made Balzac's Esther settle her "debt of dishonor" before killing herself is taken here to its parodic extreme: money is honor, no matter its origins; money is the only sign of transcendence; money alone redeems.

Mocking and flippant as this story is, it is far from conveying the kind of histrionic denunciation of prostitution that characterizes Du Camp's and Dumas's pronouncements. The target of Villiers's irony is the hypocrisy of bourgeois values rather than the degeneracy of women who sell their sexual favors. Indeed, one detects in Villiers a certain admiration for the ability of the Bienfilâtre sisters to use their bodies dispassionately as efficient money-making instruments. The playful, detached tone of his story has something in common with the cheerful independence of these resourceful ladies from any sexually mediated affective bonds. Villiers, moreover, was by no means alone among French writers and artists of the nineteenth century in sensing an analogy between his artistic practices and the spectacular artifice of the great courtesans.

The myriad names designating these women reflected their largely imaginary status. Parading ostentatiously on the stage of venality created by Baron Haussmann—the boulevards, theaters, and race-tracks—were *lionnes, grandes horizontales, amazones, filles de marbre, mangeuses d'hommes, mangeardes, biches, grandes cocottes,* and many more. These women represented the deluxe modern commodity, the image of Desire packaged and displayed for greatest impact not just on the potential customer but also on everyone who would envy him. The appeal of their show for the petty bourgeois writers and artists of the period derived largely from its deliberate artificiality, its pretentious falsity. The courtesan's performance was a matter of surface exhibition. She did not signify the sexual body so much as its production as elaborate spectacle. She was artfully constructed according to the codes defining modern desirability. Her appeal was thus largely a function of her ability to dissolve the beastly immediacy of the female animal in a play of intriguing signs and changing masks, all of them lavish and expensive.

Indeed, the courtesan's life seemed to be made up entirely of

exchange, for she was as ostentatious a consumer as she was an object of consumption. The article under the entry "courtisane" in Larousse's *Grand dictionnaire universel* (1867) explains the logic of her seemingly excessive consumerism: "The *courtisane* knows that she needs a *mise-en-scène* that will bring her close to the man who pays her. In other words, she is a gambler who constantly doubles her stake. She receives one thousand francs per month from an *entreteneur;* by spending those thousand francs on entertainment and clothing expenses, she rarely fails to catch the eye of a spend-thrift, who hastens to offer her three or four thousand, assuming that such a woman could not cost any less." Stories of the wealth of famous courtesans were an essential part of their myth and contributed to the displacement of interest away from their dis-turbing sexuality. The Goncourts, for example, were fascinated to find out from their maid (who saw the clothing displayed *chez la portière*) the precise cost of one of the boudoir ensembles that the notorious Anna Deslions regularly had made to suit the taste of each of her lovers and sent to his house the day before a rendezvous: "There's a dressing-gown of white satin, quilted and piqué, with slippers of the same color embroidered with gold—a dressing gown worth 1,200 to 1,500 francs; a batiste nightdress trimmed with lace, with insets of embroidery worth 300 francs; a petticoat trimmed with three flounces of lace worth 300 or 400 francs. A total of 2,200 francs carried to the home of anyone who can afford her" (*J,* I, 332–333).

The extravagance of this financial outlay produces what Jean Baudrillard, in an article on ideology and fetishism, calls "un travail de faire-valoir en extériorité" (a production of value through exter-nality).[15] The degenerate female body is covered over with cultural signs, whose artificiality and abstraction are the focus of fetishistic fascination. What fascinates is the *myth* of the prostitute, artfully constructed as a montage of accessories that obscures the sexual body. We are not far here from Baudelaire's idea of female beauty, which involves "a sublime deformation of nature, or rather a per-manent and successive attempt to reform nature."[16] By making herself up to resemble a work of art, enveloping her body "in muslin, gauze, vast and shimmering clouds of fabric" (*OC,* 1182), and by decorating her neck, arms, and ears with sparkling jewels and shining metals, woman produces herself as a ritualized image, a

consumable

commodified cultural idol. This idol has all the marks of the femi-
nine—dress, jewels, perfume, and so forth—but these signs are
superficial and artificial. They can be manipulated in the male ima-
ginary to defend against the threat the female sexual body symbol-
izes in the unconscious, the threat of disease, contamination, and
death, precisely the threat to which Vautrin proudly declares himself
immune.[17] *out as consumable*

Woman as commodified image is prostitutional in Baudelaire's
positive sense: she is ready to give herself sympathetically to any
admirer. (This is what Vautrin had expected of Esther, a willingness
to market herself as capital goods.) The soul of the commodity,
Walter Benjamin observes in his analysis of the Baudelairean *flâneur*,
is purely empathetic, since "it would have to see in everyone the
buyer in whose hand and house it wants to nestle."[18] Offering itself
promiscuously "to the unexpected that appears, to the unknown
that passes" (*OC*, 244), the commodity sees innumerable places
where it wants to be, where its value as fetish will be confirmed. It
imagines the entire city as the field of its wandering prostitutional
desire, wishing to be, like God in Baudelaire's aphorism, "the
supreme friend for each individual" (*OC*, 1287). In personal terms,
such friendship involves a relation of self to Other that eliminates
the threat of physical intimacy, for, as Marx says, "commodities
have absolutely no connection with their physical properties and
with the material relations arising therefrom."[19]

Benjamin considers Baudelaire's attitude toward commodities
typical of the class of the petty bourgeoisie at a time in its history
before it had become chillingly aware of the commodification of its
own labor capacity. Deprived of any real economic or political
power, this class could at best enjoy the modernity of its society
from a semidetached perspective. "If it wanted to achieve virtuosity
in this kind of enjoyment," comments Benjamin, "it could not spurn
empathizing with commodities"—even with "damaged and
decaying goods," he adds, such as aging prostitutes. "It had to enjoy
this identification with all the pleasure and uneasiness which derived
from a presentiment of its own destiny as a class" (*CB*, 59). Sartre
interprets that destiny as the reification of man, his transformation
into a human thing. In the 1860s, Sartre argues, this radical alien-
ation was justified to the bourgeoisie by artists of its own class as
signifying progress toward an ideal nonmateriality, an *antiphysis*.

The exteriority of the commodity was presented as potentially delivering man from his shameful organic functions, while retaining certain imprints of his personal desire.[20] Those imprints of subjectivity, the signs for Benjamin of empathetic identification, are judged more harshly by Sartre as deliberate lures whereby bourgeois artists disguised their intention to deny human agency altogether. In what follows, I propose to show that in the case of Manet's *Olympia*, the most famous picture of a prostitute produced in the nineteenth century, Sartre's analysis applies perfectly to the initial response to the painting whereas Benjamin's best describes the painting itself.

: : :

Exemplary of the kind of nihilistic malice Sartre finds typical of French artists and intellectuals under the Second Empire are the responses the Goncourt brothers recorded in their *Journal* to two famous courtesans of the day. The first, Suzanne Lagier, a popular actress and singer, they met at Flaubert's apartment in 1863 (she and Flaubert were probably lovers off and on); the second, La Païva, invited them in 1867, through the good graces of Théophile Gautier, to her recently completed mansion on the Champs-Elysées. What the brothers find most striking about Lagier is the salaciousness of her conversation. So vulgar and scatological is she, telling stories about "actrices dérangées de ventre, merdeuses, foireuses, diarrhéeuses" ("actresses with stomach disorders, shitters, loose-boweled ladies, diarrhetics"—*J*, I, 1237–38), that she thoroughly debases woman in the eyes of the Goncourts. According to Sartre's analysis in *L'idiot de la famille*, the courtesan's "exhibitionistic autodestruction" (*IF*, 524) is just what Lagier's intellectual friends find attractive about her. It is as if her filthy conversation confirmed the link forged by Parent-Duchâtelet between female sexuality and excrement and allowed the Goncourts to enjoy this confirmation of their sadistic misogyny without risking physical contact with the contaminated female body. On another occasion, for instance, they pretend to be outraged by the "unheard of profanation" of Lagier's holding forth for two hours on the successive subjects of "her mother, who has just died, and her cunt, which still belongs to her, and to many others. Her mother or her cunt, her cunt or her mother, her mother and her cunt, these are successively her themes of pity and obscenity" (*J*, I, 1021). "This woman associates with everything

in Paris that is dirty, questionable, suspect, and sinister" the brothers declare, clearly titillated. "She glows beneath on a base of filth" (*J*, I, 1238). Her glow is what the Goncourts can take away with them as story: it constitutes, they declare, "a scatological aesthetic" (*J*, I, 1237). She is annexed to their literary program as the linguistic expression of female degeneracy. When they are invited later to her new apartment, in a house that resembles "a columbarium of prostitution, . . . the Castle of Blois in a bidet," they are once again impressed by her "strong language that sounds like a pimp's Rabelais," and they record with relish her *mot* to Nestor Roqueplan: "How soft your neck is! It's like satin at eighteen francs. My ass is worth only fourteen" (*J*, I, 1239).

Lagier tells the truth about female sexuality as it is fantasized by Flaubert and the Goncourts: it is a depraved anal function. Her nerve and cynical wit, however, transform this truth into the figural medium of the writers' expertise and allow them to enjoy her depravity as a pleasingly original intervention in the realm of signs. When Flaubert tells George Sand in 1871 that the Second Empire, along with its "false realism, false army, false credit," was full of "false whores,"[21] he specifically mentions Lagier as the kind of whore, in the great tradition of Sophie Arnould, whom this age of falsity could only find repulsive. (As to Lagier's view of Flaubert, the Goncourts report her saying of him in public: "You are the garbage pail of my heart; I confide everything to you"—*J*, I, 1052).

In contrast, La Païva exemplified for both Flaubert and the Goncourts an extreme of artificiality and falsity. Her neo-Renaissance palace, built over a period of ten years as a tribute to her success as a *grande cocotte*, is full of *nouveau riche* ostentation. (It still stands at 25 Avenue des Champs-Elysées, with sculpted onyx staircase, immense marble baths whose bronze fixtures were once encrusted with precious stones, ornamental statues, and great ceiling paintings mostly intact. La Païva's furniture, including her extravagant bed— see Figure 7—has unfortunately been dispersed).[22] Conversation at dinner, the Goncourts report, is awkward and strained. The famous courtesan is as much a false front as are her sumptuous surroundings: she is "made up and painted, in the manner of a provincial actress, with a false smile and false hair" (*J*, I, 343). Studying her closely at another dinner six days later (note that the Goncourts return to this place they claim to detest), the brothers find that

"underneath the appearance of a courtesan still young enough for her profession is [a figure] one hundred years old, [which] takes on at times the undefinable terror of a painted corpse." The Goncourts' sadistically charged look performs a radicalization of the "faire-valoir en extériorité" which is Baudrillard's definition of the fetishizing glance: the prostitute is an elaborately decorated object, vulgar and expensive like the objects in her house, whose cost she proudly announces. The Goncourts enjoy seeing her in these terms, for, as Sartre points out (*IF*, 526), this reduction of venal woman to bourgeois corpse allows them at once to participate in the glamour of the prostitutional myth and to unmask it.

As they coldly inspect the artificial construction that passes for one of the most desirable women in Paris, the Goncourts can imagine themselves disillusioned masters of the code whereby the female is erected as idol:

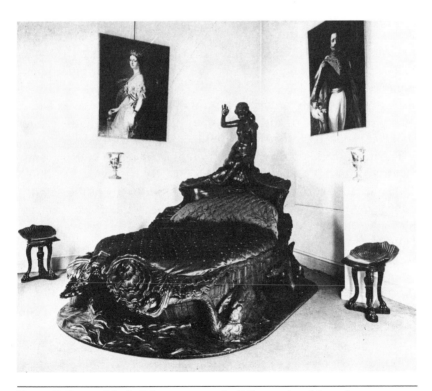

Figure 7. Reputed bed of the courtesan La Païva, sculpted in mahogany.

The woman, I look at her, I examine her. A white flesh, arms, shoulders that show down to the small of the back; shoulder straps that barely hold and partially hide the armpit; big beautiful eyes, a little round; a pear-shaped nose with a flattened end; heavy wings to the nose; the mouth, without inflection, forming a straight line the color of rouge in the face completely white from rice powder. Wrinkles in all this, which the light, playing on this white, makes appear black; and on each side of the mouth a deep furrow in the shape of a horseshoe, that comes together under the chin, which it severs with a big wrinkle of old age. A figure that, underneath the appearance of a courtesan still young enough for her profession, is one hundred years old and takes on at times the undefinable terror of a painted corpse. (*J,* I, 348)

The Goncourts' inspection derealizes La Païva's body and recreates it as an arbitrary montage of partial objects. Even individual features are divided within themselves (the red mouth crosses the white face, the nose is foreshortened, a furrow severs the chin). Split in this manner into pieces, like so many coins exchangeable on the marketplace, the courtesan's body, an artificial construction, becomes a semiotic puzzle to be assembled and disassembled at the will of its male designers. This fantasy of control over the dismembered female body enables the Goncourts to suppress their terrifying association of the sexualized woman with mutilation and death.[23]

The most scandalous representation of a prostitute in nineteenth-century painting, Manet's *Olympia* (Figure 8), met with a strikingly similar deadly gaze from the most articulate critics of the salon of 1865, at which it was first exhibited. For example, Victor de Jankovitz wrote that "the expression of [Olympia's] face is that of a being prematurely aged and vicious; the body's putrefying color recalls the horror of the morgue." The critic Geronte called Olympia "that Hottentot Venus, with a black cat, exposed completely naked on her bed, like a corpse on the counters of the morgue, this Olympia from the Rue Mouffetard [a notorious haunt of prostitution at the time], dead of yellow fever and already arrived at an advanced state of decomposition." Flaubert's friend Paul de Saint-Victor described "the crowd thronging in front of the putrefied *Olympia* as if it were at the morgue." Another journalist, Félix Deriège, found that "her face is stupid, her skin cadaverous," and that "she does not have a

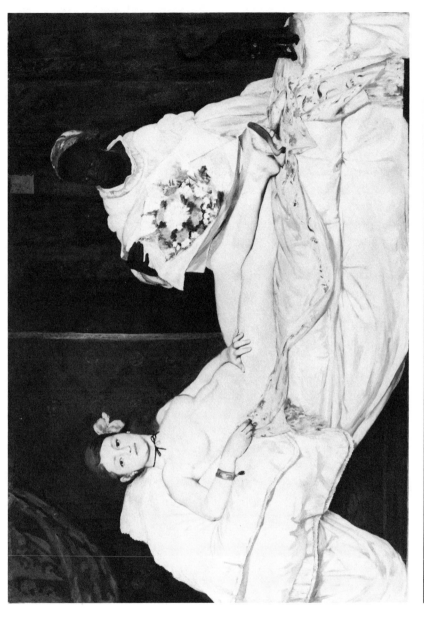

Figure 8. Edouard Manet. *Olympia* (1865). Oil on canvas. Musée d'Orsay, Paris.

human form." And a critic calling himself Ego remarked that Olympia, "a courtesan with dirty hands and wrinkled feet, . . . has the livid tint of a cadaver displayed at the morgue."[24] T. J. Clark, whose extensive research turned up these journalistic disparagements of Manet's work, notes quite rightly that they are displaced descriptions of Olympia's sexuality, but he deemphasizes the psychoanalytic implications of this displacement, choosing instead to stress issues of class. My reading of the painting, which will proceed in dialogue with Clark's strong and challenging interpretation in *The Painting of Modern Life*, will try to show that the process of fetishism at work in the displacements he observes are critical to the disconcerting effects caused by the painting. *Olympia*'s scandal, I will argue, is due to its simultaneous activation and exposure of the dynamics of the production of woman as fetish in patriarchal consumer society.

The word "scandal" originates suggestively in the Greek *skandalon*, which means "trap, snare, stumbling block." The viewers of *Olympia* at the 1865 salon acted as if they were trapped by this provocative image, able to respond only with derisive hostility and contemptuous ridicule. Indeed, the bourgeois public took such offense at this apparent affront to its morality that the painting had to be rehung higher up, out of its retaliatory reach. Not even professional critics, as Clark has demonstrated, were able to articulate any kind of coherent, intelligent response—not in terms of form, content, technique, sources, or purpose.[25] They did little more than confirm the public's indignation and incomprehension. One finds no evidence in their views of the empathy Benjamin supposed the petty bourgeoisie would feel with the bruised, commodified prostitute. Like the Goncourts viewing La Païva, the journalists seem to have relished their reduction of the prostitute to a dead and decomposing body, a painted corpse. Their rhetoric may be sensationalistic and hyperbolic, but its emphasis on absence, negativity, lack, and decay reveals a deep-seated anxiety that is at once expressed and controlled through this morbid imagery.

Traditional representations of the nude put woman on display for the pleasure of a spectator presumed to be male. Her naked body becomes nude insofar as it is seen as an erotic object offered to the man's gaze, to his imaginary knowledge. The terms of that offering in the European artistic tradition are subject to conventions calcu-

lated to flatter the male viewer and to stimulate his fantasy of sexual domination. Thus, as John Berger has observed, "almost all post-Renaissance European sexual imagery is frontal—either literally or metaphorically—because the sexual protagonist is the spectator-owner looking at it."[26] The convention of omitting female body hair from the painted image, Berger further notes, contributes to the representation of female submission by eliminating the hint of animal passion and physical desire suggested by hairy growth. The nude, like the prostitute, is an erotic commodity. Her nakedness is valuable not for its particular individuality, the marks of one woman's fleshly embodiment, but for its transcendence of these marks in a formalized language intended to feed male fantasies while it erases any potentially threatening signs of woman's desiring subjectivity.

Clark's analysis of academic paintings of the nude done in the mid-1860s by painters such as Alexandre Cabanel, William Bouguereau, Félix-Henry Giacomotti, and Paul Baudry shows that the genre, as defined in the above terms, was in disarray. Although presented in allegorical form as mythological figures flaunting their unnatural lack of pubic hair, the women in these paintings seem to collaborate a little too eagerly with the male gaze, as if they were actively soliciting it and desiring its sexual consequence. The female body is only partially abstracted from the signs of its sexuality, signs that critics of the time read as referring quite specifically to the all-too-modern world of the *courtisane*'s erotic expertise. In some cases, the identity of the idealized model was an open secret: La Païva herself was supposed to have posed for the figure of Night which Baudry painted on the ceiling of her own salon (see Figure 9). In other cases, the prurient pose was enough to suggest a venal scenario. Thus, the critic J. A. Castagnary wondered sarcastically about the lady whom he found lolling on some rocks in Baudry's *The Pearl and the Wave* (1863; Figure 10) if she might not be "a Parisian *modiste* . . . lying in wait for a millionaire gone astray in this wild spot" (*PML,* 295). The important point to note is that the critics, whether they were taken in by the seduction of these voluptuous images, as some were, or denounced their hypocrisy, as did the majority, articulated a reasoned response to these problematically sexualized nudes. When faced with *Olympia,* however, they could only cry scandal and see death. Why?

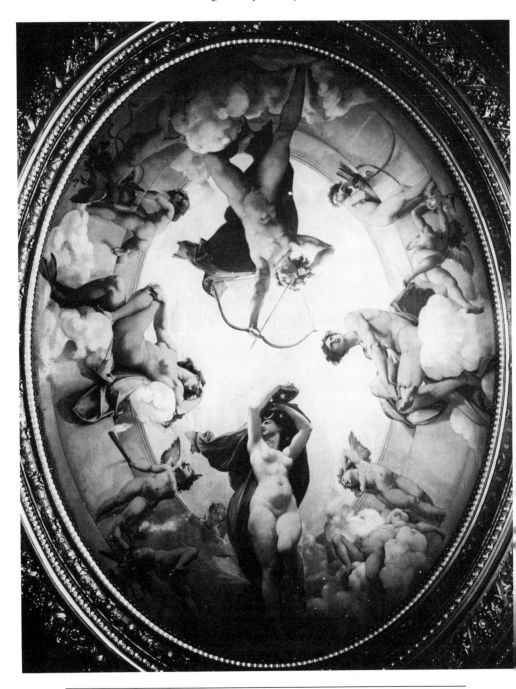

Figure 9. Paul Baudry. *Day Hunting Night* (ca. 1864). Ceiling painting in La Païva's mansion, 25 Avenue des Champs-Elysées, Paris.

Clark's answer is detailed, nuanced, and complex. Essential to it is the perception that *Olympia* took the embarrassing uncertainty about female desire expressed by Baudry and his ilk and resolved it by making desire "the property now—the deliberate production— of the female subject herself" (*PML*, 131). That property, however, is by no means unambiguous. There is, first of all, what Huysmans, in a marginal note, called "the irritating enigma"[27] of Olympia's gaze (see Figure 11). Olympia's strangely ambivalent address to the viewer could well be described in the terms Walter Benjamin associates with the self-protective wariness of the prostitute: "The deeper the remoteness which a glance has to overcome," writes Benjamin, "the stronger will be the spell that is apt to emanate from the gaze. In eyes that look at us with a mirrorlike blankness the remoteness remains complete. It is precisely for this reason that such eyes know nothing of distance."[28] Remote yet blatant, "poised between address and resistance" (*PML*, 133), Olympia's look is unmistakably hers; it is particular and individualized in a way the nude's dreamily abstracted gaze is not. But individualization does not entail readability. It may not even give access to a clear perception of class or gender. Clark suggests that the prostitute's look is not "evidently

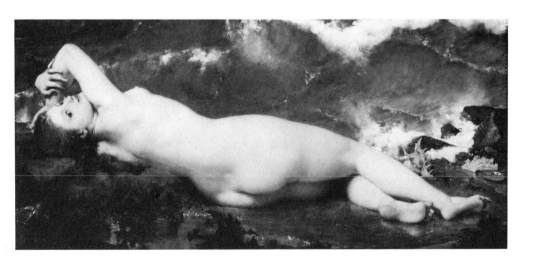

Figure 10. Paul Baudry. *The Pearl and the Wave* (1873). Oil on canvas. Museo del Prado, Madrid.

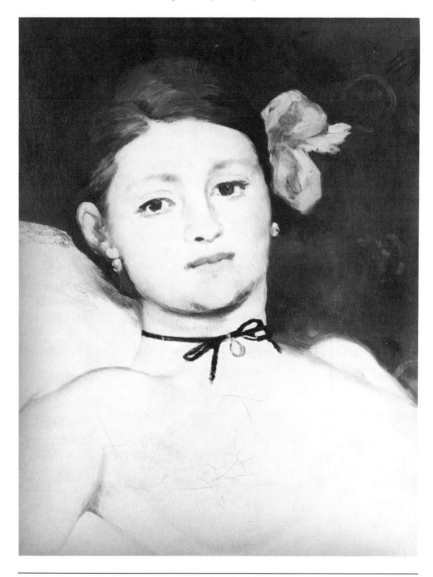

Figure 11. Edouard Manet. *Olympia* (detail of Figure 8).

feminine," and elsewhere he notes that diverse critics, in 1865 and
since, have found Olympia somehow masculinized, or androgynous.
As far as he is concerned this response is a "wrongheaded" reaction
to the figure's nonconformity to the traditional notions of Woman.
"Surely Olympia's sexual identity is not in doubt," Clark remarks;
"it is how it belongs to her that is the problem" (*PML*, 132). But I
think that in an important sense Olympia's sexuality *is* in doubt.
Her depiction, as I read it, deliberately activates in the male viewer
doubts as to whether Olympia's sexuality can indeed belong to her,
whether it is not always displaced, always re-presented elsewhere.
I will return to this point.

For the moment, I want to focus on aspects of Olympia's portrayal
other than her gaze that produce effects of ambiguity and shifting
semiosis. Clark notes the incompatible graphic modes of Manet's
drawing. On the one hand are the emphatically linear outline of
Olympia's form and the hardened breaks and intersections that
appear to sever her body into distinct pieces—the black ribbon, of
course, being the most striking instrument of this disarticulation. On
the other hand, coexisting with this representation of a *corps morcelé,*
is a kind of soft, fluid bodily territory where transitions are not
clearly defined, as in the elusive contour of the right breast and the
whole area spreading in an almost uniform tonality from that breast
down to the thigh. Thus, Olympia is at once mutilated and whole,
her bodily parts at once dislocated and fused. Her stature is similarly
uncertain: the monumentality of the image leads the viewer to think
of her as imposing, but her scale in relation to the bed, the black
servant, and the flowers produces a sense of almost childlike pro-
portions. The unusual positioning of Olympia's body within the
frame reinforces these disconcerting effects of instability and equi-
vocation. Perching on two mattresses and two immense puffed-up
pillows, she is placed just too high to offer the viewer easy access;
yet she does not look down at him either. Moreover, the pillows
are tilted at a sharp downward angle that is strangely out of relation
with the head-on perspective from which the mattress is viewed.
Even the manner of Manet's painting is ambiguous, juxtaposing
passages of sophisticated realistic illusionism with overtly simplified,
rudely abbreviated areas where paint seems to be drawing attention
to its mimetic inadequacies.

Clark argues that this proliferation of signs inscribed in different

orders of representation is a positive achievement insofar as it dismantles the decaying language of the nude and gives its female subject a particularized identity. With this interpretation I entirely agree. I part company with Clark, however, when he implicitly reproaches Manet for identifying class with this circuit of shifting signs. Manet incorporates the signs of class in Olympia's nakedness; this is, for Clark, both the painter's great originality and his failure of revolutionary nerve. Olympia's nakedness, he argues, is an arbitrary construction of codes so inconsistent among themselves that the prostitute's class can only be glimpsed elusively, not read and understood. The glimpse that Clark believes the painting affords reveals Olympia, in her blatant but ambiguous nakedness, to be a common whore, the *fille publique* of the sidewalks and brothels. This working-class subject was systematically excluded from representational practice because she signified for the bourgeoisie its own subjection to animal lust, to dark instinctual drives and shameful perversions, and because she exposed the fragility of its class dominance over the proletariat. *Olympia* afforded a glimpse onto the arena of class conflict, Clark argues, by subversively challenging the flamboyant figure through which the bourgeoisie masked its fears of the *fille*—that is, the *courtisane*. The *courtisane* was the brilliant emblem of the bourgeoisie's indulgent play with the duplicities of Desire on the stage of the *fête impériale*. The problem with *Olympia*'s challenge to this emblematic figure, as far as Clark is concerned, is that it is enacted through a construction of female nakedness whose interminably shifting semiosis is finally unreadable and indescribable. Although he recognizes that this unstable construction characterizes *Olympia*'s modernity, Clark sees it as an unfortunate failure to picture class adequately. The *fille publique* does not emerge from the complexity of her representation. Underlying this criticism is Clark's assumption that the category of class furnished more powerful causes for repression in the fantasy life of the French bourgeoisie at mid-century than did the category of sex. I would like to argue the reverse and to show that the shifting play of Manet's depiction of woman's nakedness may be his way of exposing the collapse of class difference under the pressure of a male gaze preoccupied with sexual difference.

Objections could well be raised to Clark's argument that the diversity of critical guesses about Olympia's social origins reflects bour-

geois resistance to the potential revelation of her lower-class identity. It could be maintained, for instance, that the critics' uncertainty reflects the way the picture breaks down and disqualifies the social and class distinctions through which Olympia's viewer was accustomed to classify a woman as something apart from her sexual body. After all, some viewers in 1865 had no difficulty identifying Olympia as a denizen of the threatening lower depths: we have seen that one critic associated her with the working-class environment of the Rue Mouffetard, and another called her a *petite faubourienne* of the kind likely to frequent Paul Niquet's notorious haunt for ragpickers and drunks.[29] But would such an impoverished *fille publique* have had a black servant to wait on her? Is it not possible that another critic's identification of Olympia as a courtesan from the Bréda district north of the Boulevard des Italiens (*PML*, 87) is more accurate? Moreover, could not Olympia be a dancer or an actress (such professionals were known at the time to sell their sexual favors) or simply a kept woman?

The various categories of the sexualized and/or venal woman cannot be so neatly subsumed as Clark would have us believe under the master classifications of the unrepresentable *fille* and the ultra-representable *courtisane*. Indeed, Abigail Solomon-Godeau has convincingly demonstrated that in 1865 there was a rich iconographic tradition of pornographic photographs portraying lower-class prostitutes in a great variety of lewd poses.[30] Although these images evidently had no place in the official salons, they did circulate widely among male spectators of salon pictures. Hence, their conventional modes of representing female sexual availability—among them the direct, uninflected stare characteristic of Olympia's gaze—would have constituted a covert frame of reference for many of the painting's viewers. All things considered, one cannot but agree with Solomon-Godeau that the topography of the sexualized feminine under the Second Empire was so slippery, its categories in such flux, and its gray areas so extensive that all attempts at classifying women were hopelessly subject to qualification and doubt. Recognition of this social mobility has damaging consequences for Clark's argument, since it suggests that Olympia's subversion of the *courtisane* category need not entail the revelation of any particular class identity hitherto occulted. Olympia's class origins remain unreadable because her nakedness is not, as Clark would have it, a dangerous

instance of class but a dangerous instance of sex suggesting the possible irrelevance of class.

These considerations bring us back to the images of death and putrefaction so often evoked by the critics to describe Olympia's physical appearance. They arose no doubt partly in response to the unusual tonalities of Manet's rendition of flesh and to the irregularities of his modeling. But they are also responses to the dramatic immediacy of his depiction of woman defined pointedly by her sexuality. Their association of that sexuality with decomposition and putrefaction reflects the same fantasmatic scenario we saw elaborately worked out in Parent-Duchâtelet, with the morgue here playing the central metaphorical role Parent ascribes to the sewer. It would seem that it is precisely to the degree that Manet gives Olympia strong signs of individualized subjectivity that the critics were eager to reduce her to an object, even to deprive her of human form (Amédée Cantaloube called her "a sort of female gorilla, a grotesque in India rubber outlined in black"—*PML*, 287). Thus is Olympia's scandal figured: she is a negation of the feminine, a stumbling block to the male viewer's desire, a disobedient, morbid, inhuman body that offers no flattering consolation in fantasy. The subject of scandal is some kind of lack in the representation.

Significantly, the young Emile Zola, in the first major defense of Manet's painting, promoted the notions of lack and absence as the founding principles of Manet's art. Like the salon critics, Zola violently erases Olympia's sexual challenge, but he does so by attributing the erasure to Manet's own artistic intention. In a long article published in January 1867, Zola, who had met frequently with Manet in the eight months since his first polemical article on the painter had appeared, defended his friend against critical hostility by explaining that Manet's subject matter was merely a pretext for his painting. *Olympia,* which Zola calls the painter's masterpiece, is to be read not in terms of a particular anecdotal content—Olympia in herself is of no interest, declares Zola, "this everyday girl, whom you might encounter on the sidewalk." Rather, she should be read in terms of a particular formal arrangement of chromatic tonalities and juxtaposed masses. Thus, the bouquet of flowers was included, Zola imagines, because Manet needed "some bright and luminous patches," the negress and cat because he needed "some black patches." These chromatic elements are related to each other

according to an intrinsic "loi des valeurs," equivalent to a self-referential system of aesthetic signs. Meaning is of no import. "What does all that mean?" Zola asks. "You [that is, Manet] do not know, and neither do I."[31]

Zola's formalist approach appropriates the scandalous principle of lack—the subject itself is lacking, is suppressed—in order to stress the way Manet's painting reflects not the viewer's desire but that of painting itself in its effort, begun anew by each truly original artist, to represent natural beauty truthfully. Eschewing any reading of Manet's painting that would relate it to the social context of its production, Zola erases whatever might be threatening to the viewer in the content of *Olympia* and identifies this erasure as the defining gesture of Manet's modernity.[32]

This aesthetic liquidation of the courtesan's sexual presence proved to be enormously attractive to subsequent critics of Manet's achievement, who repeated it with a kind of contagious enthusiasm.[33] The most sophisticated murder was performed by Georges Bataille in his 1955 book on Manet. Bataille quotes Paul Valéry's eloquent 1932 description of *Olympia* only to contest its accuracy. "The naked and cold Olympia, monster of banal love," wrote Valéry, "inspires a scared horror. . . . [She is] the Impure par excellence, whose function requires the untroubled and candid ignorance of all modesty. Bestial Vestal devoted to absolute nudity, she makes one dream of all that hides itself and is preserved of primitive barbarism and ritual animality in the ways and workings of big-city prostitution."[34] Bataille admits that this conception may possibly constitute what he calls the *text* of the painting, but he insists that "the text is *effaced* by the painting. *And what the painting signifies is not the text but the effacement.* It is to the extent that Manet did not want to say what Valéry says—to the extent that, on the contrary, he suppressed (pulverized) meaning—that this woman is there; in her provocative exactitude, she is nothing; her nudity (corresponding, it is true, to that of the body) is the silence that emerges from her as from a stranded ship, a vacant ship: what she is is the 'sacred horror' of her presence—of a presence whose simplicity is that of absence."[35]

One recognizes in this passage a strategy and vocabulary that has had widespread critical success in recent years: the text as effacement, the suppression of meaning, the articulation of silence and absence. The present context linking Zola to Bataille allows us to

recognize one possible originating motive for this strategy. Bataille uses it quite specifically against "all that hides itself and is preserved" in what Valéry perceives as a primitive, animalistic, degraded, yet ir)sing female sexuality. That shockingly impure sexuality is reuuced by Bataille to *rien*. Olympia as subject is pulverized; the power of her nudity is emptied of physical reference; her body is incongruously compared to a stranded boat; and her disturbing erotic presence is considered significant only insofar as it is effaced. Bataille himself acknowledges the violence involved in these operations. However, he attributes them not to the murderous desire operating in his own fascinated gaze but to the reductive operation performed by the painting itself in what Sartre might term an "exhibitionistic autodestruction." "*Olympia* as a whole cannot easily be distinguished from a crime or from the spectacle of death," writes Bataille in *Manet* (p. 69), after evoking, as did Zola, the picture's admirable still-life qualities.

Olympia is once again laid out at the morgue, this time, however, by a thinker willing to recognize his erotic attraction to this morbid spectacle. Bataille clearly enjoys his participation in the crime of Olympia's death for, as he maintains in a later book, *L'Erotisme,* the final sense of eroticism for him is death, is silence, is the violent transgression of the Other's individuality, and that Other is quintessentially Woman, Woman as object of aggressive male desire, as prostitute—prostitution being, he says, "the logical consequence of the feminine attitude."[36] According to this reasoning, it is only logical that Olympia should be represented as a prostitute, and that her class be undefined, because she is the generalized figure of man's erotic drive to still woman's animal life. It is on the basis of this suppression, according to Bataille, that Manet founds modernity in painting, *Olympia* being for Bataille, as it was for Zola, the essential masterpiece that "unveils Manet's secret" (*Manet,* 78).

Bataille's interpretive strategy is not unlike that of the bourgeois artists of the 1860s who saw in the prostitute's commodification an appealing image of her inorganic materiality. Indeed, in its violent denial of woman's physical nature, the strategy goes back to Baudelaire, for whom the aesthetic experience depends on the "vacancy" of the bodies the *flâneur* chooses to enter. Bataille echoes Baudelaire, and all those writers of the later nineteenth century who admired female dancers and acrobats, when he declares that "the

erotic value of feminine forms is linked to the effacement of that natural heaviness that recalls the material use of the members and the necessity of a skeleton: the more unreal the forms are, the less clearly they are subject to animal truth, to the physiological truth of the human body, the better they answer to the generally accepted image of the desirable woman" (*L'Erotisme*, 158). Then Bataille goes a step further to suggest that man's most intense erotic delight comes from desecrating his derealized idol by insisting on the filth of woman's animality, a filth whose ultimate form is the corpse. This is the secret that Bataille imagines he has unveiled in his reading of *Olympia:* the fixity of the female cadaver as source of (male) aesthetic pleasure. Bataille thus supposes himself in full control of the scandalous lack in Olympia's representation, having defined to his satisfaction the source of that "feeling of a suppression [that] prevails," he says, "when we look at *Olympia*" (*Manet*, 63).

But Bataille's mortifying definition itself conveys the feeling of a prevailing suppression, as if his sense of mastery were the deluded reflection of Olympia's controlling gaze. What he suppresses is the entire set of inconsistencies, disparities and ambiguities that constitute Olympia's puzzling corporeality. As we have seen, her body is represented in terms that suggest both yielding compliance and defiant resistance: it is both violently severed and smoothly unified, decapitated by the ribbon around her neck yet composed of a single mass of yellowish color. She appears small and easily dominated, but also imperious and coldly disdainful. If her blatantly advertised readiness to be consumed as an erotic commodity seems to invite objectification, her taut, self-assured, commandingly resolute pose appears to defy any appropriative gesture.

The ambiguity of her name accentuates this troubling indeterminacy. There is, of course, a classical echo, probably meant to be heard parodically here (Mount Olympus, abode of the gods; Olympia, consort of Zeus) but also a purely modern one: "Olympe" is listed by Parent-Duchâtelet as one of the *noms-de-guerre* frequently assumed by upper-class prostitutes. Dumas *fils* gave the name "Olympe" to the heartless, mercenary courtesan, modern rival of the sentimental Marguerite in *La dame aux camélias*, and the name was used frequently in the popular literature and drama of the 1860s (such as Augier's *Le mariage d'Olympe*, mentioned earlier) to designate a calculating *cocotte*. This currency accounts no doubt for Vil-

liers's choice of the name for his ironic portrait of the whore redeemed through money. The Italianate form of the name, with the *-ia* ending, was used less frequently. To Théophile Gautier (quoted in *PML*, 285) it brought to mind the infamous Roman courtesan of the Renaissance, Donna Olimpia Maldachini, beautiful sister-in-law, sordid paramour, and intriguing manipulator of Pope Innocent X. The name was associated with power wielded more independently, but again in a sexually controlling way, when used to designate a beautiful pagan queen in the grand opera *Herculanum*, first performed in 1859 and still playing to full houses in 1863, the year in which Manet created his painting.[37] Although Queen Olympia in this musical extravaganza is defeated in her appointed mission to halt the spread of Christianity by seducing, when necessary, the adepts of the new religion, she is a strong-willed, defiant, regal figure, not an egotistic, scheming demi-mondaine. But the most suggestive hypothetical reference of the name Manet chose, precisely because it thematizes the play of indeterminacy, is to the mechanical doll named Olympia in E. T. A. Hoffmann's story "The Sandman," the text on which Freud based his analysis of the uncanny. The captivating doll is at once human and nonhuman, alive and dead, whole yet dismemberable, female yet not female. It is associated, in obvious ways, with childhood, whence originate, according to Freud, the primitive beliefs whose recurrence after repression creates the unsettling effect of uncanniness.

What repressed primitive belief might Manet's painting be felt to evoke? In his mocking commentary on *Olympia*, one of the early hack critics of the 1865 salon made a connection that may provide us with a clue to this question. The journalist denounces Olympia as "some form or other blown up like a grotesque in India rubber," and goes on to call her "a sort of monkey mocking the pose and the movement of the arm of Titian's Venus, with a hand shamelessly flexed" (*PML*, 288). Viewing Olympia as a kind of doll, this writer is led to evoke the placement and articulation of the hand covering her sex. He does so via an allusion to Titian's *Venus of Urbino* (Figure 12), a reference that is now a commonplace of art history but that he was the only critic to notice in 1865.[38] Not that this commonplace, I hasten to add, unambiguously clarifies Manet's intentions, since it is impossible to decide if Olympia is to be understood as the goddess of love in a new guise, an ironic subversion of that classical

myth, or, as Theodore Reff maintains, as a modern counterpart of the wealthy courtesan commonly thought to have been Titian's model.[39]

But let us return to that hand, very differently construed in the two paintings, though occupying in both the central focus of the composition. The hand of Titian's Venus folds inward, fading from view as it elides with her sex. The gesture carries a certain autoerotic suggestion, but that suggestion, as I read it, in no way excludes a male viewer, serving rather as an invitation, a sign of willing receptivity. Venus's look goes out toward the spectator, includes him, and brings his gaze back to the central point of her pliant sexuality, precisely marked by the vertical line of the screen behind her.

In contrast, Olympia's hand, in Reff's phrase, "conveys at once greater inhibition and a more deliberate provocativeness" (*Manet,* p. 58). Her hand (Figure 13) covers the entire pubic area in a gesture that, compared to Venus's relaxed, sensuous pose, seems self-conscious and tense. This deliberate gesture of concealment, in con-

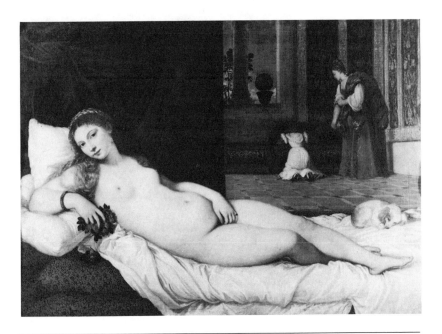

Figure 12. Titian. *Venus of Urbino* (ca. 1538). Oil on canvas. Galleria degli Uffizi, Florence.

junction with Olympia's ambiguous gaze, "poised . . . between address and resistance," appears provocative—even, to pursue my earlier line of argument, uncanny. It is as if Olympia were drawing attention to the non-coincidence of her hand with her genitals, as if they were not simply an inviting vacancy offered to male penetration but a presence in themselves. The viewer seems to be challenged to ask: What is being concealed? What is being suppressed? As if he didn't know, you may object. But perhaps at the level of primitive belief that the uncanny evokes, he is not so sure. Perhaps the subject that Zola and Bataille were so anxious to suppress is what threatens to emerge were this repressive hand removed. But let us look more closely: perhaps this repression has not been entirely successful and something is even now in the process of emerging. Are not those fingers penis-like, and did not Freud maintain that "a multiplication of penis symbols signifies castration"?[40]

Laura Mulvey has argued in an influential article that "woman

Figure 13. Edouard Manet. *Olympia* (detail of Figure 8).

as icon displayed for the gaze and enjoyment of men, the active controllers of the look, always threatens to evoke the anxiety [which that icon] originally signified, [that is, woman's] lack of a penis, implying a threat of castration and hence unpleasure."[41] Such language may seem reductive, and I do not want to suggest that, once the castration threat staged by Manet's *Olympia* is recognized, the anxious responses of its male viewers require no further explanation. Nor do I want to insist that recognition of the fingers as potentially phallic is the key to the unconscious operation performed by Manet's discomforting image. My point is that the hand focuses specifically on the genital region the extensive play of visual uncertainties and inconsistencies disseminated throughout the representational field. The dramatic ambiguity of Olympia's manual gesture not only violates the canons of the nude; it puts her in possession of her sexuality precisely to the extent that the identity of that sexuality is thrown into doubt. This is why, as Clark puts it, "[Olympia's] hand enraged and exalted the critics as nothing else did" (*PML*, 135). The hand's perplexing representation stimulates an unconscious anxiety about sexual difference that the male viewer thought he had mastered but that now returns. Further, the painting traps that viewer in his anxiety by confronting him with a display of the very processes of fetishizing displacement that had been his preferred unconscious strategy for controlling that anxiety. I argued earlier that *Olympia* does not conform to the modes of cultural construction whereby the mythic figure of the *courtisane* is produced as "un travail de faire-valoir en extériorité." Now I want to argue that in the place of this finished production, of the female idol as cultural fetish, Manet's picture offers its viewer an illustration of the very processes of displacement and substitution that generate woman as fetish.

Substitutes for Olympia's hidden pubic hair abound in the painting. The least ambiguous is the fleecy shock of fringe hanging over the side of the bed. Then there is the rose-colored flower in Olympia's hair. Reff (*Manet*, 108) identifies the flower as an orchid and associates its tropical exoticism both with the wealthy courtesan's characteristic taste for luxury and with a tradition of sexual symbolism, the orchid being widely held to have aphrodisiac powers and, depending on the species, to resemble either the male or the female genitals (a figural ambiguity that, as we shall see, Huysmans

makes much of in *A Rebours*). But could not this "flower" just as well be a silk bow, as some of the painting's first viewers thought? (See, for instance, Victor de Jankovitz in *PML*, 288.) Should that be the case, all exotic connotations fall away, leaving us with a very ordinary ornament. A still more interesting visual irresolution involves the portrayal of Olympia's hair itself. As Clark points out (*PML*, 136–137), the shock of reddish-brown hair that falls on her left shoulder is extremely difficult to distinguish from the screen behind her (see Figure 11). This luxuriant mass of hair softens Olympia's sharply outlined face, giving it a more traditional feminine look, but this comforting sign of female sensuous relaxation is nearly impossible to keep in focus. The hair tends to be absorbed by the screen, confronting the spectator once again with Olympia's hard-edged (masculinized?) silhouette. Most scandalous of the substitutes is, of course, the black cat, slang equivalent then as now, in French as in English, of the female sexual organ. The caricaturists of 1865 who gave the curved tail of Manet's feline a tumescent erection (see Figures 14 and 15) seem to have sensed the central ambiguity in the painting's sexual imagery: this *catin*'s pussy is potentially phallic.[42]

Finally, there are the flowers carried by the black servant. If the colorful bouquet functions as a desexualized displacement of Olympia's genitals (a point not lost on the caricaturists: note the way the cat's tail is raised into the flowers in Bertall's drawing), the connotations of the black female counteract this function. When Victor Fournel, using the pseudonym Geronte, referred to Olympia as "that Hottentot Venus with a black cat," he was assimilating Olympia to her maid and underlining the meaning of the maid through the debased feline association. In an article bearing specifically on Manet's painting, Sander Gilman has shown that the Hottentot women exhibited in France in the early part of the century, whose hypertrophied genitalia and protruding buttocks were considered anatomical marks of their atavistic physiology and primitive lasciviousness, were thought to typify the pathological sexuality of black women in general.[43] If a black woman was paired with a white female in a nineteenth-century representation, Gilman argues, the black figure's emblematic role was to suggest her white counterpart's primitive concupiscence and sexual degeneracy, a suggestion to which Geronte evidently responded. The link was all the easier to

MANET.

La Naissance du petit ébéniste.

M. Manet a pris la chose trop à la lettre :
Que c'était comme un bouquet de fleurs !
Les lettres de faire-part sont au nom de la mère Michel
et de son chat.

Figure 14. Cham. *Manet: The Birth of the Little Cabinetmaker* (1865). Wood engraving. *Le Charivari.*

make given Olympia's identity as a prostitute, the prostitute's deviant sexuality being associated popularly with an atavistic return to an unbridled eroticism. (The Italian criminologist Cesare Lombroso, writing in 1893, offers plates to illustrate the analogy between the prostitute's genitalia and those of the Hottentot.)[44] Moreover, a tradition existed, dating back to the eighteenth century, of paintings in which black servants displayed their mistress's intimate charms to the spectator—a voyeuristic tradition whose connotations of prostitution became increasingly overt in the nineteenth century, as Reff has shown (*Manet*, 93–95). So the black maid is not, as Zola and

La queue du chat, ou la charbonnière des Batignolles.

Chacun admire cette belle charbonnière, dont l'eau, liquide banal, n'a jamais offensé les pudiques contours. Disons-le hardiment, la charbonnière, le bouquet dans du papier, M. Manet, et son chat, sont les lions de l'exposition de 1865. Un bravo senti pour M. Zacharie Astruc.

Figure 15. Bertall. *The Cat's Tail, or the Coal-Lady of the Batignolles* (1865). Wood engraving. *L'Illustration.*

the formalists would have it, simply a dark-colored counterpart to
Olympia's whiteness. In 1865 she may well have aroused in many
viewers their fantasy of a dark, threatening, anomalous sexuality
lurking just underneath Olympia's hand. This may also have been
the fantasy Picasso had in mind in 1901 when he created his parody
of *Olympia* (see Figure 16). Here two naked men, Picasso himself
(pointing) and his friend Junyer (holding a bowl of fruit), stare in
apparent awe at the voluptuous, broad-hipped nudity of a black
woman. The unmodeled whiteness of the men's bodies, represented
only in outline, suggests their timid frailty, as compared to the three-
dimensional, powerfully sexed figure of the woman.

The maid is in many ways as difficult to interpret as is Olympia
herself. Her very existence, as I noted earlier, enters into the irre-
solvable problematic of Olympia's class. We wonder just how
common this prostitute may be if she can afford to hire such an
exotic servant. The servant's look at her mistress enters into the
equally irresolvable problematic of Olympia's gaze. Blatantly

Figure 16. Pablo Picasso. *Parody of "Olympia"* (1901). Pen and colored crayons.
Private collection, Paris.

ignoring her presence, Olympia severs communication with her attendant much as her stare severs communication with her spectator ouside the frame. Thus, the spectator is, to a degree, represented in the painting by the maid, who deferentially offers flowers but whose gift is ignored. Furthermore, the maid's gesture is itself an enactment of agency: she is, we surmise, offering the bouquet in the name of a male admirer. She is a deputy or stand-in—a servant twofold, both of Olympia and of Olympia's client. This double subservience is an essential aspect of the maid's meaning, and the male viewer's sense of being represented by a glance—a glance emanating from a recessive position defined through race and sex as one of servitude and mediation—contributes to his discomfort with the image.

My point about the displaced signs of Olympia's sexual identity is that none of them resolve the castration threat associated with that uncanny identity. Olympia's scandalous hand initiates a circuit of displacements that reflect back to the male viewer the fetishizing desire in his gaze without fulfilling it. The fetish, according to Freud, should offer "a token of triumph over the threat of castration and a safeguard against it."[45] Such a token is what the anxious viewer wants to be invited to create as he scans the painting. Instead he finds repetitions of his primary sexual uncertainty: hair that is and is not present, a *chatte* that is disturbingly aggressive, a black servant whose deferential gesture of offering flowers possibly masks a regressive if not pathological sexuality. And numerous other aspects of the painting, as we have seen, feed into this circuit of self-contesting images: Olympia's body both severed and unified, her stature both monumental and shrunken, her social status at once *courtisane* and *fille publique,* and so forth.

This saturation of the painting with images that display the fetishistic mechanism of simultaneous avowal and disavowal may be what Mallarmé was getting at when he called Olympia's accessories "intellectually perverse."[46] Likewise, Manet's suffusion of his work with citations reflects a certain perverse disposition. His complex pastiche of references, as Jean Clay declares, "suspends the possibility of a genealogy of forms,"[47] thereby subverting the usual cognitive and analytic procedures of art history. Olympia's pose no doubt imitates that of Titian's sumptuous Urbino Venus. But it also imitates, especially in the flatness and angularity of the image, crude

pornographic photographs made for male titillation.[48] (It is, moreover, quite possible that Manet's model, Victorine Meurend, posed for photographs of this kind.)[49] Small-scale drawings and lithographs by Constantin Guys and Achille Deveria, the first of sordid brothel scenes, the second of coyly inviting girls lounging in boudoirs, are alluded to by Manet's image, as are the exotic oriental odalisques painted in rich sensual color by Delacroix and flowing linear contours by Ingres. The influence of Japanese prints is perceptible alongside the influence of Goya, though Baudelaire, defending Manet against charges that he was too indebted to Spanish painting, maintained in 1864 that Manet "has never seen a Goya."[50] And the eclectic list could be extended considerably, the point being that recognition of Manet's many allusions serves less to clarify meaning by establishing relations of derivation, qualification, and innovation than it does to empty these relations of readable sense. An art historian anxiously scanning *Olympia* for the defining marks of its inscription in the tradition finds him- or herself caught up in a play of often conflicting quotations and borrowings that is "intellectually perverse" in its deliberate production of referential turbulence.[51] Clay is right to suggest that "Manet treats the [artistic] heritage like the *flâneur* of Walter Benjamin treats merchandise. The Louvre is an 'arcade,' a stall, and the painter goes to market."[52] Like the *flâneur*, Manet derives pleasure from his protean capacity for empathetic identification, which enables multiple displacements and disguises. In Baudelaire's sense, his soul is that of a prostitute, for whom art is a means of creatively destabilizing and pluralizing his identity.

Manet's empathy extends to the commodity status of the prostitute. He expresses this empathy by saturating his picture of Olympia with elements constructed so that they mirror back to the male viewer his fetishistic mode of appropriating Woman. This is why the critics of 1865, faced with Olympia's challenge, repeatedly evoked cadaver fantasies: the painting offered them no avenues of escape from their fearful association of female sexuality with castration, disease, and death. *Olympia* overtly displays the failure of the mechanisms whereby this fear is mastered, a refusal of patriarchal positioning. It translates the body into representational codes whose non-coincidence prevents visual resolutions; it performs displacements that reveal internal incompatibilities requiring further dis-

placements. The viewer witnesses Woman constructed as fetish object for capitalist consumption, but that consumption loses its appeal to the degree that the constructive machinery is exposed and the principle of lack driving the machine regains its original fantasmatic content.

Zola and Bataille attempt to block this potential return of the repressed by projecting the lack in *Olympia*'s representation back onto the canvas, where they effectively neutralize its sexual meaning. This interpretive procedure, not Manet's pictorial trap, corresponds to Sartre's view of the strategies of distinction used by Second Empire intellectuals to derealize the (female) animal body and produce a human *antiphysis*. A similar strategy today might claim that the painting's multiple displacements activate a libidinal economy that generates pleasure through the very mobility of its psychic investments. Such an analysis would suppose a viewing of *Olympia* that transcends male anxiety and causes a certain euphoria through the liberating effect of the picture's semiotic irresolutions. Although this response may account for some of the "aesthetic" pleasure the picture affords, the psychosexual origins of this pleasure are fundamentally no different from those sustaining the Zola/ Bataille formalist approach. The essential motivating drive in both cases is the denial of female desire and subjectivity and the reduction of woman to inert fetish. Whereas Manet's empathetic art makes the viewer uneasily aware of the violence involved in this reduction (the black servant, emblem of woman as slave, contributes to this awareness), the formalist reading, which inherits Vautrin's disdain for women's enslavement to their organs, invites the reader/viewer to enjoy the spectacle of the prostitute's corpse.

All through this chapter I have identified this viewer as male. My argument has been that, however critically Manet's painting may comment on the tradition of the female nude as a flattering gift offered to the male gaze, it does not subvert the gender of that gaze. What then of the position of the female viewer? According to my analysis, her position is constructed so as to problematize for the male *his* insecurity about sexual difference. How may a woman respond to being placed in this position? The question is complex, and I can do no more than allude to its importance here. The problem of describing the dynamics of the female gaze when it

emanates from a position constructed as male, which, given the assumptions underlying representational practices for centuries, is nearly always the case, is one of the primary concerns of current feminist thinking about sexuality in the field of vision. Abigail Solomon-Godeau's recent contribution to this debate—her analysis of the many photographs the Countess of Castiglione had taken of herself in the 1850s and 1860s, and again at the end of her life in the 1890s—is particularly instructive in our context, since these photographs represent a rare example of a nineteenth-century woman constructing images of herself for her own gaze. Solomon-Godeau comes to the conclusion that this famous beauty, who took an active part in choreographing her poses, could see herself only as an object of the male look, her desire for self-representation being identified entirely with male desire for the sexualized female object.

As regards *Olympia*, the historical dimension of my inquiry into viewer response could not easily be extended to female spectators since, as far as I know, no woman recorded her impressions of Manet's painting in 1865. And this situation is typical. A herstory of the female gaze would be extremely difficult to document. Our present perspective does, however, allow us to theorize the dynamics of female viewing in ways that recognize both the conditions that inform woman's internalization of a male gaze and her strategies to subvert the operations of that gaze. For example, my analysis of the way *Olympia* destabilizes the male agency of the look could be associated with the notion, elaborated by certain feminist psychoanalytic and film theorists, that femininity is a deliberate masquerade, a kind of flaunting of the conventional signs of the feminine in order to prevent appropriation of the self as a stable image of masculine desire.[53] Olympia could well be perceived as performing such a masquerade, as if she were demonstrating the diverse modes of offering her body to public view while identifying herself with none of them, refusing to be present in any single version of her image. It may be this refusal that some female viewers of today appreciate most in Olympia's representation. Perhaps these viewers identify with Olympia's defiant look and, through its medium, gaze back at the discomforted male spectator whose desire it confounds. Such an identification would involve an appropriation by women of the processes of semiotic slippage and gender instability that this

study so far has shown to be favored strategies for the control of *male* sexual anxiety. But to pursue these speculations, which would entail qualification of whatever essentialist assumptions inhere in such phrases as "the male gaze," is beyond the scope of the present inquiry.

The Idea of Prostitution
in Flaubert

*J*n March 1843, when Flaubert was twenty-two and studying law in Paris, he received the following letter from his friend and mentor Alfred Le Poittevin:

Have you seen Elodie again and, in the turf of that lascivious bitch, sucked in the mists of her clitoris? What a picture of happiness you present! You make me think of Polycratus, whom fortune had so greatly favored that he threw his ring into the Ionian sea, as if to appease it. And you too, as if to pay tribute to fate, you parade your happy phallus among the cunts of Parisian whores, as if you wanted to dredge up syphilis; but in vain; the filthiest cunts return your phallus intact, just as the fish returned his ring to Polycratus! Euh! euh! euh! . . . What a comparison! What rhetorical periods! What a model of eloquence! Read that to the negro and to the soldier and proclaim me *virum dicendi peritum* [man of excellent speech].[1]

As this letter demonstrates, the attitude of Flaubert and his friends toward women's sexuality was brutally disdainful. This was true not just when they were young men-about-town but all through their lives. The fact that their disdain was often theatricalized, elaborated as a cynical rhetorical pose for dissemination among "men of excellent speech," does not make it any less offensive. As sexual beings, women were carnal organs for sale. "Women consider their sex as a livelihood," remark the Goncourts in a similar vein. "They may

decorate it with all the flowery garlands imaginable; nevertheless, for the poor, for the rich, for those of high rank and those of no rank at all, their sex is a career, interrupted by a few short adventures."[2]

Since woman's sexuality was essentially prostitutional in the view of Flaubert and his circle, there was no better place to enjoy its animal pleasures than the bordello. Flaubert frequented prostitutes throughout his life, as did most of his friends. He had all the "bonnes addresses," as Le Poittevin knew in November 1843 when he requested that Gustave send him, for the benefit of a friend leaving for Paris, "the addresses of la Guérin, la Lebrun, the *mère* Arnoult, and the *mère* Leriche . . . Also, give me the name of Chaplâtreaux's old mistress, who is at la Lebrun's place, where you like to fuck her" (*CR*, I, 832). Four years later, a year into Flaubert's stormy liaison with Louise Colet, Maxime Du Camp writes to recommend a hussy named Angèle he had just had at the *mère* Guérin's and whom he considers "a superb piece, worthy of you: she's expert enough to make the *mère* Alphonse despair. Old man, you've got to screw that one."[3] (Flaubert and Du Camp no doubt exchanged numerous letters of this type, but by mutual agreement they destroyed the majority of their correspondence.) During his trip of 1850–1851 to Egypt and the Near East with Du Camp, about which I will have more to say presently, Flaubert wrote letters to his friend Bouilhet giving precise descriptions of his sexual prowess with whores throughout the Orient. We know, for instance, that in Beirut he "fucked three women and fired four shots—three before lunch, the fourth after dessert" and he announces proudly that he "disgusted the Turkish women by my cynicism, washing my cock in front of everyone" (*CR*, I, 668). In a subsequent letter, composed, he tells Bouilhet, in "style polisson empire" (*CR*, I, 729), he tells of being repulsed by the Negresses in the Galata district of Constantinople and being offered in compensation, as a special treat, the madam's own seventeen-year-old daughter, whose proposed examination of his diseased tool forced him to beat a hasty retreat. (Flaubert had contracted syphilis somewhere along the way, probably in Damascus. The treatments he endured as a cure may have been responsible for the gradual loss of his teeth: he had only one tooth left by the 1870s.) In 1866, Flaubert is apparently still in the habit of proclaiming the number of shots he's capable of getting off,

for a letter from Bouilhet congratulates him on having accomplished nine. "Quel gaillard!" comments Bouilhet, impressed.[4]

These passages offer glimpses of Flaubert's extensive brothel experience, otherwise difficult to document, and of what the Goncourts, in a perfect case of the pot calling the kettle black, termed the "dirty cynicism" (*J*, I, 1183) of his temperament. His conduct in the brothel seems to have involved a good deal of histrionic misogyny staged for the benefit of the *copains*. The Goncourts report that, coming away from one of the Magny dinners, where the eternal subject of conversation among such regulars as Sainte-Beuve, Flaubert, Daudet, Gautier, and Houssaye was "femme, amour, cul" (*J*, I, 1232), Flaubert told them: "My vanity was such when I was young that, when I went to a brothel with friends, I chose the ugliest whore and insisted on screwing her in front of everyone, without removing my cigar. I didn't enjoy it, but it was for the gallery" (*J*, II, 162). The premise of male vanity, according to this story, is the brutal debasement of woman—her objectification as sexualized meat. Heterosexual intercourse then becomes a communication not between man and woman but between man and man. Granted, the older Flaubert is critical of his youthful vanity, and he may well have lost some of his histrionic propensity with age, but the fundamental pattern remains: female sexuality is a disposable conduit for bonds between men. Another anecdote told by the Goncourts serves to emblematize the prevalence of this attitude among Flaubert's literary confreres: "Baudelaire, on the way down from a whore's place, encounters Sainte-Beuve on the staircase. Baudelaire: 'Ah! I know where you're going!' Sainte-Beuve: 'And I know where you're coming from! But, listen, I'd rather go talk'" (*J*, I, 352). And off they go to a café and engage in a passionate discussion of atheism.[5]

Given that she had to cope with entrenched attitudes of this kind, it is not hard to sympathize with Louise Colet's complaints about Flaubert. His letters of 1846 and 1847 (few of hers have survived) indicate that she both reproached him for treating her like a whore and was jealous of what she called his "love for *les premières venues*" (*CR*, I, 422). In response, he finds this *idée fixe* boring and reminds her condescendingly of the wise precept "Keep silent about what you don't know." Thus, he cancels the cognitive value of her experience with him. In its place he puts his own intellectual ability: "If

the subject [prostitution] amuses you," he tells Colet, "some day I'll explain my theories about it for your benefit" (*CR*, I, 432), a promise that he fulfills, as we shall see, in a letter written almost six years later. Flaubert seems to have taken a kind of sadistic pleasure in expounding the premises of his misogyny to his mistress, exploiting these opportunities to justify his keeping her at a distance. For example, he deliberately refuses to associate her remarkable intelligence and creativity with her femininity. The matter is clear-cut for Flaubert: insofar as Colet is gifted and imaginative, she is male. One should not be misled by his wish to transform her into "a sublime hermaphrodite, . . . male down to the level of the stomach" (*CR*, II, 548). There is nothing "sublime" about Flaubert's idea of bisexuality, any more than there is about Baudelaire's. Both are based on a crudely stereotypical distinction between female flesh and male spirit, the proper attitude of the latter toward the former being melancholy detachment (Flaubert praised Baudelaire for having, in *Les fleurs du mal*, "sung the flesh without loving it, in a sad and detached manner that I like"—*CR*, II, 745). When Baudelaire calls Emma Bovary a "bizarre androgyne [who] has kept all the seductions of a virile spirit in a charming feminine body,"[6] this remark, however interesting, does not reflect any complex analysis of gender difference. Emma is "almost male" because Flaubert has given her, so claims Baudelaire, "all the virile qualities" (*OC*, 653), among which he lists imagination, decisiveness, a dandy's delight in domination, and the sensitivity of a hysterical poet. All that is left to Emma as a woman is her body, Flaubert having "elevated the female to such a high power, so far from the bare animal and so close to the ideal man" (*OC*, 655). Whatever bisexual proclivities today's reader may detect in the texts of Baudelaire and Flaubert, when it came to articulating sexual difference, both men were prisoners of a resolutely chauvinist ideology.

Flaubert's letters to Louise Colet often sound as if he were trying to make her into the nearly ideal man Baudelaire claims Emma Bovary is. Intercourse with Louise could then be fantasized as an art that simultaneously indulges the body's animal needs and generates an imaginary discourse between men. The process is familiar to us from previous analyses: in fantasy, gender becomes a male invention, an arbitrary figure. Flaubert outlines the idea quite explicitly in a letter to Colet of 1853: "Woman is a product of man,"

natural / factitious

The Idea of Prostitution in Flaubert

he tells his long-suffering "muse." *"God created the female and man created woman;* she is the result of civilization, a factitious work. In countries where there is no intellectual culture, she does not exist (because she's a work of art, in the humanitarian sense; is that why all the great general ideas have symbolized themselves in the feminine?). What extraordinary women the Greek courtesans were! But then, what extraordinary art Greek art was!" (*CR*, II, 284–285). The female, Flaubert argues in agreement with Baudelaire, exists independently of gender difference: hers is a merely instinctive animal function. Flaubert does not seem to recognize any parallel function in the male: insofar as he obeys his brute libidinal urges, the male is acting like a female. What is proper to man is the creation of gender as the intellectual paradigm of difference. In this sense, man is his own creative god. He comes into being in function of his assertion of an originating factitiousness. ("After all," Flaubert remarked to Louise, "it remains to be seen if what people call the factitious is not another nature"—*CR*, II, 173.)

Flaubert is willing to recognize Colet's otherness only on the level of her sexual body, the instrument of his physical pleasure. "All I want from you as a woman," he tells her, "is the flesh [*la chair*]. Consequently, the rest should be mine, or rather be me, made of the same clay and constituting the same clay [*de même pâte et la même pâte*]" (*CR*, II, 285). Flaubert's use here of the very physical word *pâte* (dough, paste, soft material) is striking, since the context is an argument in favor of his spirit's need to "expand and enlarge itself." The point is that the formative material is factitious. It is an amorphous paste out of which the Flaubertian artist-god, in his imagination, shapes his figural extensions, be they male, female, or hermaphroditic. The motivating fantasy is not unlike Saint Anthony's climactic wish to "fuse into all forms, penetrate each atom, descend to the bottom of matter—become matter,"[7] a regressive wish I have analyzed elsewhere as a narcissistic drive to negate time and sexual difference in a dream of creative omnipotence.[8] Here also the wish is regressive and desexualizing: Flaubert first puts aside Louise's femininity, her *chair,* as irrelevant to the expansive ambitions of his creative spirit. Then, out of an imaginary primeval *pâte,* he freely conceives sexual difference as an originating figure of his narcissistic imagination. The particular role played by the prostitute in this fantasy of creative genderification is suggested by

Flaubert's reference to the Greek courtesans who functioned in consort with the creation of Greek art. "What must a creature have been like brought up to cater to the *complete* pleasures of a Plato or a Phidias?" he muses (*CR*, II, 285). She must have possessed the bare minimum of fleshly female, all the rest being transformative *pâte*. Such a creature, he laments, is now a lost myth.

It is from this perspective of loss that, in 1853, Flaubert writes Louise Colet his long-promised theoretical disquisition on prostitution:

> It may be a perverse taste, but I love prostitution, for itself, independently of what is beneath. I've never been able to see one of those women in décolleté pass by under the gaslights, in the rain, without feeling palpitations, just as monks' robes with their knotted girdles arouse my spirit in some ascetic and deep corner. There is, in this idea of prostitution, a point of intersection so complex—lust, bitterness, the void of human relations, the frenzy of muscles and the sound of gold—that looking deeply into it makes you dizzy; and you learn so many things! And you are so sad! And you dream so well of love! Ah, writers of elegies, it is not on ruins that you should go lean your elbow but on the breasts of these gay women!
>
> Yes, something is lacking in a man who has never awoken in a nameless bed, who has not seen asleep on his pillow a head that he will not see again, and who, leaving at sunrise, has not passed bridges with the longing to throw himself in the water, since life seemed to be rising up in belches from the depths of his heart to his head. If it were only for the shameless dress, the temptation of the chimera, the unknown, the *caractère maudit*, the ancient poetry of corruption and venality! In the first years when I was in Paris, during the great evenings of summer heat, I would go sit in front of Tortoni's [a famous café on the boulevards] and, while watching the sun go down, I would watch the whores pass. I consumed myself there with Biblical poetry. I would think of Isaiah, of "fornication in high places," and I would walk up the Rue de la Harpe repeating to myself this final verse: "And her throat is softer than oil." I'll be damned if I was ever more chaste! I make only one reproach to prostitution: that it is a myth. The kept woman has invaded vice, just as the journalist has invaded

poetry; we are drowning in halftones. The courtesan does not exist any more than the saint; there are *soupeuses* and *lorettes*,[9] who are even more fetid than the *grisette*. (*CR, II, 340–341*)

In this remarkable passage, prostitution is presented from a number of points of view which have belatedness, lack, and absence as elements in common. There is first of all the historical perspective: the present, Flaubert claims, offers only watered-down, prettified, commercialized versions of the authentic whore.[10] The vulgar mediocrity of modern times has erased the strong contrasts which constitute the poetry of prostitution. Flaubert's complaint is, in this regard, perfectly Balzacian. But Balzac's notion of the prostitute's myth is antithetical to Flaubert's: the Balzacian courtesan does not stimulate dreams of love; she offers the fulfillment of these dreams. The Balzacian myth is one of a plenitude of feeling that purifies the degraded body. It is a myth of presence. The Flaubertian myth is one of a void in feeling that affirms the body's degradation. His lost myth is a myth of loss.

At the outset of this passage, Flaubert suggests that it is something about his loving the *idea* of prostitution that is perverse rather than prostitution itself. The syntax of Flaubert's sentence conveys an intensified sense of what constitutes the perversity of his taste: "j'aime la prostitution et pour elle-même, indépendamment de ce qu'il y a en dessous." What are we to understand as being "beneath" prostitution? The physical reality of degraded female sexuality would appear to be the logical answer. Flaubert seems to be giving here a definition of his sexual perversion: he loves the female body only insofar as he can produce fantasmatically its independence from itself. This is the fantasy which links, in what Flaubert terms "je ne sais quels coins ascétiques et profonds [de mon] âme," prostitutes in décolleté and robed monks: the prostitute evokes her own elimination as *chair* and the radical denial of all female sexuality. The independence of female *chair* from the factitious *pâte* in which it is revived as representation is, Flaubert suggests, a proper subject for elegies. Ironic elegies, of course, since this is a clear case of *qui perd gagne*.

"The void of human relations" in the perspective of mortality: this is the philosophical lesson to be learned by looking deeply into the prostitutional idea. Death haunts its depths. But the dizzying

effect of looking into them also has its reassuring aspects. The look blinds itself even as it sees: what is beneath prostitution is not part of its idea, yet that idea invites a look that penetrates deeply, to its very bottom ("au fond"). The death that inhabits female sexuality is somehow glimpsed in prostitution yet also not seen. It is as if the male look, interpreting the female sexual organ as castrated, immediately denied that interpretation. This is the perverse strategy of the fetishist. He is, in Flaubert's phrase, "so sad!" that the female sexual organ is not the same as his own, that indeed it signifies the death of his virility, yet he is reassured and "dreams so well of love!" The premise of this dream is what I have called "creative genderification," whose psychoanalytic origins are to be found in fetishistic perversion. The fetishist attempts to deny the castration of female flesh, which he imagines as real, by inventing sexual difference as a fictional structure with a male referent. ("The normal prototype of all fetishes is the penis of the man"—Freud.)[11]

In the passage we are considering, Flaubert suggests that it is in the very movement of abstraction that the physical reality of prostitution becomes a complex idea which functions fetishistically for him. The intercourse of bodies produces the intersection of ideas, ideas that contribute to what Flaubert calls, elsewhere in the same letter, "the supreme poetry of the *néant-vivant,* of the garment that wears out or the feeling that fades away" (*CR,* II, 339). Erosion, loss, absence, death—these are the "poetic" concepts that Flaubert fetishizes as they become independent of woman's sexual body, where they originate in the castration complex.

"Oui, il manque quelque chose": thus opens the second paragraph of Flaubert's text, as if his unconscious itself were speaking. The reference is to a man (Leconte de Lisle is the target in view) who has never entered a brothel and hence never had the opportunity to think the prostitutional idea. But *manque* is also the essence of that idea itself, the motive both for a suicidal disgust with life and for the temptation to overcome that disgust through the poetic pretense that its source is chimerical or unknown. In the contemporary world, this pretense has generally been dropped: *femmes entretenues, soupeuses, lorettes, grisettes*—the very existence of these different categories implies a sociology of knowledge that defines the modern prostitute as a product of her bourgeois times. In contrast, "the ancient poetry of corruption and venality" is timeless. It

can bring together in a single imaginary space Biblical courtesans and prostitutes strolling down the boulevards of nineteenth-century Paris.[12] This poetry is powerful because it does not turn away from the sense of loss but is written amid ruins. Flaubert's recommendation that writers of elegies compose their verse leaning on a prostitute's breast rather than on a ruin suggests that prostitution is another kind of ruin, the sad remains of a once-proud erection, a *néant-vivant*.

Although the banality of European bourgeois culture trivialized the elegiac poetry of prostitution, Flaubert did find conditions conducive to its creation in the Orient. At no time were they more propitious than during the night he spent in Egypt in 1850 with the courtesan Kuchuk-Hanem, "an imperial brute," Flaubert wrote to Bouilhet, "big-titted, meaty, with split nostrils, huge eyes, magnificent knees, and incredible folds of belly flesh when she dances" (*CR*, I, 606). Flaubert gives detailed descriptions of Kuchuk's body, clothing, jewelry, perfume, dancing, singing, and more, and he declares that the "shots" were good ("the third especially was ferocious, and the last sentimental"—*CR*, I, 607). But the crucial aspect of the experience was neither Kuchuk's striptease nor her sexual expertise. "I spent the night in infinite dreamy intensities," Flaubert tells Bouilhet ("nervous intensities full of reminiscences" is the phrase he uses in his travel notes—*OE*, II, 575). "That is what I had stayed for. Contemplating this beautiful creature asleep and snoring with her head resting on my arm, I thought of my brothel nights in Paris, of a lot of old memories . . . and of this woman, of her dance, of her voice that sang songs without a meaning or words I could distinguish" (*CR*, I, 607). Sartre's comment on this passage is entirely appropriate: Flaubert loves a woman "to the degree that she derealizes herself in the midst of an imaginary world."[13] Flaubert is here following his own later advice to Louise Colet and writing on the prostitute's body an elegy for her death. That's what he had stayed for: for the perverse pleasure of loving prostitution independently of what is beneath, of confronting castration and derealizing it through the intensity of dream. His remark in the travel diary—"I thought of Judith and Holofernes sleeping together" (*OE*, II, 575)— makes the association with castration explicit.[14] But the fear of female sexuality conveyed by this association is dissolved in the elegiac poetry of reminiscence. The meaning in the vertiginous

depths of Kuchuk's sex ("I sucked her like mad"—*CR*, I, 607) becomes, in the infinitude of dreamy intensities, as indistinguishable as the sense of her song.[15] Memory and forgetting are held together in a kind of fetishistic suspension, neither one erasing the other. "You women will never understand anything about Prostitution," Flaubert told Colet, "about its bitter poetry, or about the immense forgetting that is its result" (*CR*, II, 169).[16]

As if to make sure that he would never forget his experience of forgetting, Flaubert returned to see Kuchuk-Hanem about seven weeks after his first visit. "For an experience to be done well, it has to be reiterated" (*CR*, I, 638), he tells Bouilhet. An experience well done is an experience transformed into the idea of its loss. A more psychoanalytic way of putting this would be to say that reiteration enables Flaubert to produce the "first time" from the melancholy point of view of its introjection. Sartre is right to suggest that Flaubert *knew* that seeing Kuchuk again would overwhelm him with "an infinite sadness" (*OE*, II, 588). In his travel notes and in a letter to Bouilhet, Flaubert explains that Kuchuk had been sick and looked tired. But the point is that a sensible difference from his first visit was inevitable and that this difference could be registered only as loss. "The house, the courtyard, the dilapidated staircase—everything is there," says Flaubert, "but she is no longer there, at the top, bare-chested, lit up, in the sun! We hear her voice . . ." (*OE*, II, 588). Kuchuk's presence—for she *is* there, after all—is no more than a stimulus for introjection. "I looked at her for a long time," he tells Bouilhet, referring to the second visit, "so as to keep her image well in mind" (*CR*, I, 635). Memory of forgetting, forgetting of memory: in the travel notes, he remarks: "It's over, I'll never see her again, and little by little her figure will be effaced in my memory!" (*OE*, II, 588). Her image is one of effacement; this, precisely, is its poetry, whose "bitter savor" Flaubert declares to be "the main thing" (*OE*, II, 635) he was after in his return visit to Kuchuk, a return that five months later he is already yearning to repeat (see *CR*, I, 710).

In a later letter to Bouilhet, Flaubert expresses intense regret that he did not buy the courtesan's "great shawl with gold tassels, which she put around her waist while dancing"—a regret that suggests the fetishistic nature of all of Flaubert's fantasy transactions regarding female sexuality. No object could be more classically suitable as a fetish than this shawl: it hides Kuchuk's castrated sex even as the

tassels (*gland* in French, also the word for the glans penis) symbolize the absent object. The paragraph (*CR,* I, 778) goes on to reveal with remarkable clarity what is at stake in Flaubert's fetishism. He declares that he failed to buy the shawl "through one of those *inactions* that are a frightening mystery of man." The fetishist is condemned to inertia if the "frightening mystery" that female sexuality represents in his unconscious cannot be mastered through substitutive symbolization. Maxime Du Camp had pronounced the would-be fetish a useless and quite ordinary object—"which was true" remarks Flaubert, apparently acknowledging Freud's point that "the significance of fetishes is not known to the world at large" (*F,* 216). It is an altogether different matter, however, for the man with perverse tastes: "I feel *remorse,* a bitter regret not to have it," declares Flaubert. And what would "having it" have involved? We come back to the fundamental Flaubertian fantasy in which woman's sexuality functions as a conduit between men: "We would have cut it in two," Flaubert tells Bouilhet; "you would have taken half." Bouilhet is a logical candidate for this gift because, stimulated by Flaubert's letter about Kuchuk, he wrote a poem in her praise (reproduced in *CR,* I, 1139). Flaubert imagines a fetish shared between friends, a fetish that evokes a memory of prostitution as forgetting, effacement, loss (the very mood of Bouilhet's poem). The final episode of *L'éducation sentimentale* is already in the making.[17]

Before we turn to that novel, however, it should be noted that Flaubert already links structures of reiteration to the theme of prostitution in one of his first major literary endeavors, *Novembre,* written between 1840 and 1842.[18] The adolescent narrator of this largely autobiographical text returns at night to the prostitute Marie, with whom he has lost his virginity during the afternoon.[19] The motive for the return is unclear. There is no suggestion of unsatiated lust. Moreover, just before he rushes out to visit Marie again, he has succeeded in fusing his memories of her with his previous romantic dreams to form a narcissistic synthesis (he tells us earlier in the text of his desire "to double myself, love that other being, and fuse ourselves together"—*OE,* I, 258). Yet he is unsatisfied with this synthesis. He feels that something is lacking, "something unnoticed, unexplored the first time"; the desire to see Marie again obsesses him "like a fatality that attracted me, an incline down which I was slipping" (*OE,* I, 261). This romantic notion of a fatal incline points

to an unconscious drive, a compulsion to repeat. And the text brings out quite clearly the association of this compulsion with the death instinct.

The narrator's return visit is placed under the sign of mourning: Marie, dressed in white on the occasion of their initial encounter, is now in black. Her lovemaking, which on the first occasion had given the speaker a sense of harmonious union, he now experiences as demonic, corrupt, predatory, and castrating (a double take that parallels Tressignies's response to the lovemaking of the duchess of Sierra Leone in Barbey's "La vengeance d'une femme"). He compares her smile to that of a suicide, "which made her look like a corpse waking up in the act of love" (*OE*, I, 268). Yet it is precisely this corpse that his unconscious has driven him back to find. His return enables him to think prostitution as an idea, an idea imbued with the sense of loss and absence, his own first of all. On his second visit, the narrator deliberately stages himself as his own replacement and Marie as the mournful muse of repeated substitution. Thus he refuses Marie's passionate offer to live with him and love only him, preferring to treat her venal body as fantasmatic *pâte* out of which to fabricate a dream of love.[20] Marie fulfilled the speaker's longing on the first visit; she merely intensifies it on the second. He sees himself as a serial function, as just another of Marie's countless clients who "pass sadly, uniformly, . . . [leaving behind] the traces of vanished passions" (*OE*, I, 268). Marked and worn by these alien inscriptions, themselves banal and used-up articulations of the already-said,[21] Marie has become a living corpse, a *néant-vivant*.

Meditating while Marie sleeps, much as Flaubert will later lie awake reminiscing next to Kuchuk-Hanem, the speaker strews faded violets over her chest, as if she were dead. "With what reveries have I often stayed in a whore's bed, contemplating the threadbare spots of her sheets!" Flaubert writes Louise Colet in 1853, following this remark with a reference to the inspiring qualities of the morgue (*CR*, II, 377). A prostitute's threadbare sheets, signs of transience, substitution, degradation, loss, also of the heavy materiality of the body, of its gradual decomposition and death: the narrator of *Novembre* is already a proficient reader of these morbid signs. He makes no effort to stop Marie's ongoing suicide. Having left his marks, just as his predecessors left theirs, he departs, unsure as to just what is compelling him to do so. And immediately thereafter he is overcome

by a sense of loss and a desperate need to see Marie again. It is as if the prostitutional idea were being acted out compulsively, desire for loss fulfilling itself by producing more desire for loss.

: : :

In *Novembre,* Flaubert can find only an awkward and artificial way to control the repetition compulsion inherent in the prostitutional idea: he breaks off the first-person narration and tells the end of the speaker's story in the third person. It is as if he were trying to incorporate loss through grammatical distancing from the expressive subject: the *il* is created on the premise of the speaker's having died. This gesture, through which written textuality displaces the illusion of speech, is often seen as the inaugural move in Flaubert's discovery of *écriture.* It responds to his failure to find a literary form and structure adequate to the prostitutional idea. The ending of *L'éducation sentimentale,* at once a *locus classicus* of Flaubertian textuality and the *summum* of his idea of prostitution, is a measure of his success in transforming a compulsion to lose into a structure of loss.

The phrase "structure of loss" may seem oddly abstract—my reader may wonder how an argument that began by evoking clitoral mists can, a few pages later, be talking about negative structurality. The violence of the contrast reflects what I see as the violence of Flaubert's detachment from the organic, the living, the natural, and, in his associative framework, from the female. A similar detachment serves Balzac as a principle of narrative mobility and semiotic currency. But he remains uneasy about the implications of the divorce from a natural order. Baudelaire is much closer to Flaubert in the spirit of negation, uncannily close indeed, but the poet's drive toward the autonomy of the literary work is less intense than the novelist's and less abstractly conceived. The double ending of *L'éducation*—Frédéric's final interview with Madame Arnoux, his concluding conversation with Deslauriers—stages the process of this abstraction as an elegiac hymn to the idea of prostitution.

The story that Frédéric Moreau and his friend Deslauriers tell each other "prolixement"[22] contains the essence of Flaubert's prostitutional idea: prostitution is a vehicle to deny what is beneath it. Frédéric and Deslauriers enter a brothel firmly intending to lose their virginity and come out having lost nothing. Instead they have

gained the idea of prostitution as loss—not loss of innocence, but rather the failure to lose it, prostitution as a veiling of sexual knowledge. One glance suffices for Frédéric: he sees more than he bargained for ("so many women at his disposal") and is momentarily paralyzed, as if by the castrating look of Medusa ("il restait sans avancer"). The two adolescents are seen fleeing from Nogent's notorious "lieu de perdition" (literally "place of loss"), and they are immediately transformed into story: "Cela fit une histoire . . ."

This phrase is particularly significant, given what Flaubert's grammar does with it. The "histoire" the locals disseminate might best be translated as "scandal." The scandal is due, no doubt, to a false interpretation of the event: its purveyors assume that any man leaving the notorious "maison de la Turque" is a satisfied customer. This assumption, which is unjustified in this case, makes the story scandalous and hence worth retelling. However, when Frédéric and Deslauriers retell "it" in their turn ("ils se la contèrent"), the word *histoire* takes on a significantly different meaning. The two aging friends are not participating in the spread of scandal; rather, they are enjoying their knowledge of the false premises on which the scandal was fabricated. The secret knowledge at the heart of their story is that no sex took place, that there was no contact with the degraded, corrupt female body, whereas the secret knowledge generating scandal asserts the opposite. The word *histoire* thus comes to play a curiously fetishistic role: in Freud's terms, it "has become the vehicle both of denying and of asseverating the fact of castration" (*F,* 218). Although the original German of this sentence does not qualify castration as a "fact," the translator's insertion of this word is justified by Freud's designation elsewhere in the same essay of castration as "eine unliebsame Tatsache," an unwelcome fact.

Yet castration is not, of course, a fact. It is an interpretation of sexual difference that originates in childhood and becomes crucial to the ideology of male chauvinism—an ideology that, as my discussions have shown, is profoundly fetishistic in nineteenth-century France. The peculiarity of Flaubert's text is that it ends its own *histoire,* its own narrative, with an anecdote that demonstrates the fetishistic use of narrative itself. Frédéric and Deslauriers tell each other the story of the origins of story, which lie in the simultaneous solicitation and avoidance of the scandal of female sexuality. It is this mode of narrative generation that, they agree, is "ce que nous

avons eu de meilleur." What was best in their lives, they repeat to each other, was the creation of the idea of prostitution as a fetish object to be exchanged between themselves. It is as if Frédéric and Deslauriers, reconstructing the story of their visit to the Turque, "each completing the other's memories," were weaving together the two pieces of Kuchuk-Hanem's shawl.

Psychological factors such as a lasting nostalgia for innocence, guilt in relation to a mother image, fear of judgment, and flight from reality are no doubt operative in Flaubert's concluding anecdote. As Victor Brombert has demonstrated, they not only provide a minia-ture sketch of Frédéric's ineffectual, wavering, inconclusive char-acter, they also form "a retrospective prolepsis of the very essence of the novel."[23] My point is that this essence is defined as the motivating drive of narrative itself. Brombert's telling phrase "ret-rospective prolepsis," which signifies a future whose potential is canceled from the point of view of the past, suggests that the very structure of Flaubert's novel is, from a psychological perspective, perverse. The future at issue in the retrospection of the two friends is the experience of female sexuality. Although Frédéric and Deslau-riers have long since acquired this experience, the spinning out of their *histoire* allows for its imaginary deferral. Parts of story are exchanged instead of prostituted female parts. Verbal intercourse among men elicits the scandalous subject of prostitution only the better to deny its sexual referent. It is as if narrative were functioning as does the fetish in Freud's theory, "to hold up interest at a certain point—what is possibly the last impression received before the uncanny traumatic one" (*F,* 217). Narrative is generated by pro-jecting onto a temporal axis the perverse "double attitude" of the fetishist: retrospection assumes sexual knowledge; prolepsis denies it.

Implicit in this denial is the self-sufficiency of the male couple and a fantasy of creative genderification: we remember that "Fréd-éric's physical appearance had always exercised an almost feminine charm on [Deslauriers]" (*ES,* 245). The word *fatalité,* heavy with ironic overtones when Charles Bovary utters it as a belated expla-nation of his wife's adultery, seems to overcome its ironizing poten-tial when applied to the enduring friendship of the two schoolfel-lows, "reconciled once again by the fatal element [*la fatalité*] in their nature that always reunited them in friendship [*qui les faisait toujours*

se rejoindre et s'aimer]" (*ES,* 245). Flaubert pointedly gives this fantasmatic male "fatalité" pride of place in that it displaces the last episode in Frédéric's love story with Madame Arnoux. Indeed, that "grande passion" becomes, in the final reckoning of the two friends, simply one in a series of mock epitaphic inscriptions chronicling the existential failures of the novel's principle characters, including themselves. The closing story is thus born amid ruins, a fetishized narrative composed, like the "dreamy intensities" Flaubert experienced next to the sleeping body of Kuchuk-Hanem, as a structure of loss.

The uncanny doubleness of the word *histoire* has yet further implications. So far my analysis has focused on the role of storytelling in the psychological economy of Flaubert's protagonists. But one of the most disturbing aspects of this epilogue is that Flaubert's style seems to repeat indirectly the fetishistic use of narrative dramatized in the dialogue of his antiheroes. This dialogue is, of course, only designated as such. We do not actually hear Frédéric and Deslauriers's words—not, that is, until the final confirmatory repetition: "C'est là ce que nous avons eu de meilleur!" Flaubert must have decided at a very early stage that he wanted to write their story in his own narrative terms, since the first extant sketch of this episode already includes the notation, kept in every subsequent scenario: "raconté à l'indirect," ("to be told indirectly").[24] Thus, he draws attention to the purely scriptural matter out of which he "fit une histoire." The anecdote that the friends tell each other "prolixement" as they "exhume their youth" (*ES,* 427) Flaubert compresses in a few short paragraphs that eliminate entirely any echo of speaking voices (this is emphatically *not* free indirect speech). And it is in terms of the specifically written that he evokes the function of memory, the reader's memory of his text as *histoire* rather than the protagonists' memory of their adolescent lives.

"Cela fit une histoire qui n'était pas oubliée trois ans après" ("This caused a scandal that was still not forgotten three years later"). The retrospection stimulated by this remark is the reader's (whom, so as not to generalize beyond the limits of my sex, I shall designate as male). He is being asked to conjure up in his textual memory an obscure allusion, made in a conversation between Frédéric and Deslauriers at the end of the novel's second chapter, to a "shared adventure" (*ES,* 18) involving a low-built house near the river and

consequent slander.[25] He is also being asked to remember (or physically, to flip back to) the date given in the very first sentence of the novel: September 15, 1840. With this date in mind, he can calculate that a time three years after the school vacation of summer 1837, when the visit to La Turque took place, corresponds precisely to the novel's incipit. Thus, Flaubert projects retrospectively the *histoire* of the prostitutional idea across his entire text (subtitled "L'histoire d'un jeune homme") to a point in time that precedes its beginning. The reader who collaborates with Flaubert in reconstructing this retro-projection is involved in an activity not unlike that of Frédéric and Deslauriers completing each other's memories. If this completion identifies for the two friends what was best in their lives, so, by implication, the reader's imaginative regression to a moment before any *Sentimental Education* began can be identified as what was best about his reading experience. The reading experience thus subverts itself: its greatest appeal, revealed only at its completion, is the way it can be found to cancel itself out. The return of the prostitutional anecdote at the end of Flaubert's narrative functions textually much as Flaubert's return to Kuchuk-Hanem functioned existentially (although "existence" here is, of course, available to us only textually): it enables experience, especially the experience of reading, to be considered elegiacally from the point of view of its loss.[26]

This analysis suggests the fundamental similarity of the two endings of *L'éducation*. Madame Arnoux's final visit to Frédéric is prostitutional in the self-contesting sense we can now appreciate as typically Flaubertian: she may be ready to give herself; he does not want to see what is beneath her much fetishized surface. Frédéric's reasons for refusing what he takes to be Madame Arnoux's offer of her sexuality have much in common with his reasons for escaping from La Turque. He feels "quelque chose d'inexprimable, une repulsion, et comme l'effroi d'un inceste" in the presence of Madame Arnoux; he feels "l'appréhension de l'inconnu, une espèce de remords" in the presence of the brothel whores (*ES*, 423, 428). That Frédéric's oedipal inhibition should apply to whore as well as to mother lends itself to both psychological and structural analysis. Frédéric in the brothel is full of adolescent confusion about the relation of maternal attachments to sexual urges, a confusion Flaubert illustrates by having him offer a prostitute, "like a lover to

his betrothed," a bouquet of flowers picked in his mother's garden (*ES*, 428). The implicit parallel between Frédéric's flight from the brothel and his gesture of turning away from the apparently willing Madame Arnoux "so as not to degrade his ideal" (*ES*, 423) demonstrates his continuing inhibition in regard to the coveted mother figure, and indeed in regard to most objects of his tepid desire. The fact that in one case his action is a youthful impulse and in the other a mature calculation only serves to show that his "sentimental" education has gone nowhere.

From a structural standpoint, the reductive parallel between mother and whore is more difficult to interpret. It might seem at first that Madame Arnoux is being deliberately degraded through this analogy, which reveals Frédéric's idealizing adoration as little different from his panicked retreat from sexual initiation by a prostitute. But this is to ignore the peculiar value Flaubert attributes to the prostitutional idea and the genesis of that idea in the denial of woman's sexualized body. It may be that this denial, common to the two endings of *L'éducation*, forges a link between Madame Arnoux and prostitution that, far from degrading her, highlights her crucial function in the novel as a figure of lack.

It is the story of this figuration that Frédéric and Madame Arnoux tell each other during their last encounter, the story of the lack sustaining their relationship and defining its history. Their tone is elegiac, like that of Frédéric and Deslauriers in the final episode, and the specific focus on the avoidance of female sexuality is the same in both narratives. The phrase "ils se racontèrent leurs anciens jours" (*ES*, 421) could well be followed by the phrase describing the friends' conversation, "chacun complétant les souvenirs de l'autre" (*ES*, 428). Here again what is at issue is the psychological function of the narrative act. Frédéric and Madame Arnoux become the poets of the *néant-vivant* of their lives, at the center of which is the ambiguous happiness of nonfulfillment and lack. The famous sentence in the future anterior tense—"N'importe, nous nous serons bien aimés" (*ES*, 422)—is Madame Arnoux's version of "C'est là ce que nous avons eu de meilleur." Whereas the latter phrase annihilates the novel's temporal unfolding by carrying us backward to a point before its beginning, the former places us at the end of time in a space that is entirely literary. This is the space of *histoire* for Frédéric and Madame Arnoux, a space nowhere real that conjures

presence out of books: "It seems to me that you are there," says Madame Arnoux, "when I read love scenes in books" (*ES,* 422). In this context, to have loved each other well means to have succeeded in converting experience entirely into literature. That this literature may be second-rate and cliché-ridden ultimately does not affect its viability as a vehicle of denial. It is the function of the lovers' discourse as a shared code that ensures its fetishistic efficacity. "In fetishism," observes Jean Baudrillard, "it is the passion of the code that expresses itself. Regulating and subordinating at once objects and subjects, this passion gives them both over to abstract manipulation."[27] Frédéric and Madame Arnoux construct "love" as an ideal *antiphysis,* blessedly independent, like the idea of prostitution, from what is beneath it.

This construction is explicitly dramatized in Frédéric's response to the devastating revelation of Madame Arnoux's white hair. Evidence of time passing suddenly impinges on the extratemporal space of literary re-production. Frédéric, stunned, sets to work to repair the breach and constructs rhetorically a figure "d'une importance extra-humaine" (*ES,* 422). This construction is not a lie: Frédéric has at many junctures in the novel thought about Madame Arnoux in similarly overblown terms (at one point, for instance, we are told that "his dreams had raised her to a position outside the human condition"—*ES,* 172). The fact that Frédéric in this last encounter is evidently fabricating a cover-up ("drunk with his own words, [he] began to believe what he was saying"—*ES,* 423) suggests that Flaubert is ironically exposing the emptiness of the conventional vocabulary Frédéric and Madame Arnoux have used to construct what they delusively call love. But the motive for this cover-up has been present from the moment Frédéric first glimpsed Madame Arnoux; so, too, has been the irony. Indeed, as Naomi Schor has recently argued, irony can be considered the characteristic trope of fetishism, the ironist's double vision being analogous to the fetishist's split consciousness.[28] Frédéric's shocking view of Madame Arnoux's white hair is simply the displacement upward and onto a temporal axis of another shocking view that Frédéric has symbolically avoided, through his characteristic fetishizing glance at the hem of her "unliftable" (*ES,* 200) dress and through his early identification of her as "look[ing] like the women in romantic novels" (*ES,* 10). Both these strategies are exaggerated almost to the point of parody

in the context of the lovers' last meeting (not only does Frédéric pour out more romantic clichés than ever before, he nearly faints at the sight of Madame Arnoux's shoe, declaring, "The sight of your foot disturbs me"), but the ironic value of the avoidance they enable is not in question.

What counts in Flaubert's narrative economy is that the principle of lack he considers inherent in female sexuality be incorporated into literary structure. Both panels of Flaubert's concluding diptych have this function. Like the telling of the prostitutional *histoire* in the last chapter, the romantic phrases the retrospecting lovers exchange in the foregoing scene serve to incorporate and structure loss. Madame Arnoux feels that Frédéric's praises are addressed to "the woman she no longer was," but the point is that she has never been this woman. From the outset Frédéric identified her as a function of preexistent *histoires* "so that, seeing her for the first time, he had immediately recognized her" (*ES*, 271). In a sense, recognition kills its object: Madame Arnoux is nothing more than a stimulus to create ideality through literary elaboration. Her body may not be venal, like Marie's in *Novembre*, but Frédéric's repeated experience of nonconsummation functions for him much as does Marie's lover's insistence on her multiple consummations. The prostitute's body, worn down and marked by her clients' use, becomes available as fantasmatic *pâte;* the virtuous woman's continual reminder of the refusal of her body makes it available as pliable material for fantasy. Both Maries collaborate in the denial of their desire, the prostitute Marie unhappily (she declares herself a virgin because her clients have always loved another through her), the mother-figure Marie happily ("It was clearly understood that they would not belong to each other"—*ES*, 271; Frédéric's friends, too blasé to be scandalized, assume that the belonging has long since occurred).

A figure of lack and denial, an agent of poetic creation, albeit derivative, Madame Arnoux paradoxically comes closer to embodying the qualities Flaubert associates with the idea of prostitution than any of the actual courtesans and prostitutes in the novel.[29] All the factors that constitute the "complex intersection" of prostitution according to Flaubert's letter to Louise Colet are involved in Frédéric's idealized relation to Madame Arnoux: there is lust (in the last scene Frédéric is "overcome with a frenzied, rabid lust, stronger than ever before"—*ES*, 423); there is bitterness (during the idyll at Auteuil, Frédéric begins to hate her); there is the void

of human relations (this void is precisely the emptiness they maintain at the dead center of their relationship); there is the frenzy of muscles (this, it is true, is sublimated into what Flaubert calls "an exasperated sensibility"—*ES*, 273); and finally there is the sound of gold (Frédéric is constantly coming to the financial aid of the Arnoux). Above all, however, what associates Madame Arnoux with Flaubert's prostitutional idea is that Frédéric loves her "for herself, independently of what is beneath," fetishistically, as a fictional construct veiling her sexuality. It is this fact that makes the two endings of Flaubert's novel mutually reinforce each other's structure of loss.

I use the term "structure" here because the two closural episodes of *L'éducation* condense and contain the effects of absence, avoidance, lack, and loss that in the body of the narrative undermine all attempts to organize experience meaningfully. They are burial structures, funeral monuments in which the characters enshrine themselves as stories that have been told and can be revived through retelling. What is involved is not the work of mourning, whose goal is an ultimate psychic detachment from the lost object, but an introjection of the self's death so that the corpse can be resurrected, or rather reread, as literature.[30] Peter Brooks is right to stress that this rereading in no way redeems the lives it memorializes. It is tempting to imagine Flaubert's novel as offering, in its recapitulative final moments, an anticipation of salvation through the literary incorporation of memory. Memory would then function within literary structure as an agent of humanistic meaning and narrative understanding. Novelistic form, reflecting back upon itself, would be constructing a perspective on life, from which existential failure is transformed into compensatory narrative triumph. But, as Brooks remarks, "Frédéric and Deslauriers appear to speak from beyond any possible pertinence of narrative to life, as if they had already lapsed into Freud's 'preorganic quiescence' [the goal, according to Freud, of the death instinct]."[31] There is no point of view of immortality in Flaubert's texts that might correspond to a notion of salvation: in this, as in many other respects, his writing practice is more radically nihilistic than his epistolary pronouncements about the potentially redemptive role of art. What the two friends exhume is the *néant* of a corpse, and it is in terms of this corpse's inhuman otherness that it becomes *vivant* as *histoire*. "Ce que nous avons eu de meilleur" is buried "là," in the text's crypt.

The ultimate function of the prostitutional idea is to lead away

from the castration complex, which associates woman with death, to death as the proper domain of masculinity. Flaubert's criticism of Leconte de Lisle in his letters to Louise Colet focuses on the poet's lack of virility, instancing his distaste for brothels, which entails, Flaubert claims, a fear of hospitals. "Where," Flaubert asks, "is the real [*le vrai*] more clearly visible than in these beautiful exhibitions of human misery? They have something so raw about them that the mind develops cannibalistic appetites. It rushes headlong to devour and assimilate them" (*CR*, II, 377). This oral imagery perfectly evokes the instinctual basis for the psychic process of incorporation and introjection. The prostitute, like the hospital patient, brings out aggressive urges in a "real man" to destroy the raw externality of the function of death—"external reality should enter into us, to the point that it makes us cry out"—so that death comes to inhabit the self as *néant-vivant*, the very principle of poetic creation: "How I built ferocious dramas at the Morgue, where I used to love to go," exclaims Flaubert, adding a little "etc." to the remark, probably to indicate to Colet his awareness of the histrionic romanticism it suggests. But he by no means intends to disavow the "romantic element," which is precisely what he finds lacking in de Lisle. For this is the element of death-in-life, or rather death-in-literature, the male element par excellence. "Women do not like death," Flaubert wrote in the 1845 version of *L'éducation sentimentale*. "That profound love for *le néant* that the poets of our age carry in the very depths of their being frightens them; a being that gives birth to life is angered by the thought that life is not eternal" (*OE*, I, 323). In the letter to Louise Colet, he evokes as a particularly "virilizing impression" his observation, at age six or seven, of his father dissecting corpses in the medical amphitheater at Rouen (*CR*, II, 376).

This image may remind us of Parent-Duchâtelet's professional interests, which bring together prostitutes and anatomical amphitheaters, the latter frequently the locus of the former's ultimate use by men. But Parent, whom Flaubert had read,[32] is, of course, interested in the well-being of the social order in a meliorist way totally alien to the novelist. Equally alien is the typical closural structure of the Balzacian novel, which suggests that the narrative engine, far from being entombed in a crypt, is only provisionally at rest, with many more stories waiting to be told. Insofar as it is possible to

compare painterly and literary structures, it would appear that among the creators we have studied so far, Flaubert has most in common with Manet. We remember the death fantasies *Olympia* provoked in many of its initial viewers, some of whom imagined Olympia as a cadaver laid out at the morgue. And certainly Bataille's reading of *Olympia* in terms of effacement, silence, absence, and "the spectacle of death" makes the painting seem to be a perfect illustration of Flaubert's aesthetics of the crypt. Bataille's view of prostitution as the logical consequence of woman's essentially animal nature, a logic that stimulates murderous male impulses, is likewise perfectly Flaubertian. But Bataille's interpretation of Manet fails to perceive the critique of the fetishizing look structured into the painting's ambiguities. Manet carefully contrives to fail to master the lack whose association with female sexuality he both illustrates and denounces. Flaubert and Bataille, in contrast, attempt to control that lack by making it into the fundamental principle of aesthetic creation.

(Flaubert, let it be said in passing, showed very little interest in any contemporary painting, whether avant-garde or academic, and seems to have visited the Salons only occasionally. When *Olympia* was shown at the 1865 Salon, Flaubert was in Croisset writing *L'éducation sentimentale*. He did come to Paris in November of that year, after the Salon was over, to see an exposition of "objets d'art, d'industrie et d'ameublement," presumably in order to gather information about the manufacture of china and earthenware for his chapter about Arnoux's factory. The whole of Flaubert's *Correspondance* contains only one remark about Manet, in a letter of June 1879 to Zola concerning his recently published *Mes Haines:* "As to Manet, since I don't understand a thing about his painting, I can't judge what you say about him.")[33]

If the idea of prostitution fulfills itself finally in the literary incorporation of death, it could be said that the primary theme of *L'éducation sentimentale* is the failure of this idea to be incorporated in life, its loss in the modern world of economic exchange, or, more precisely, its prostitution in that world. "Prostitution is a myth," complains Flaubert, "the kept woman has invaded vice, just as the journalist has invaded poetry; we are drowning in halftones." Since the way in which *L'éducation* records the slow process of this drowning has been perceptively studied by previous critics,[34] and

since the thematics of prostitution have been analyzed with admirable sensitivity by Victor Brombert in *The Novels of Flaubert*, I will limit myself here to a quick overview of the subject.

It is precisely the universality, the ubiquity of prostitution that destroys the possibility of thinking the prostitutional idea in the world of *L'éducation sentimentale*. Literal manifestations of prostitution in its time-honored sense are, of course, everywhere: *lorettes, grisettes*, common whores at the Alhambra; the "Louis XI of prostitution" on display at the racetrack; the *fille publique* posing as Liberty during the sack of the Tuileries; La Vatnaz, the procuress with feminist ideas who insinuates herself into everyone's confidence; and, the star of the show, Rosanette Bron, whose story of being sold by her mother to an old lecher, whom she awaited in the *salon particulier* of a restaurant while falling asleep on top of an album of obscene pictures, Flaubert took from Suzanne Lagier's personal reminiscences.[35] Then there are the many symbolic parallels that suggest the contamination of supposedly correct social circles by the prostitutional virus: the assembly of upper-class ladies at the Dambreuse mansion whose provocative dress and "bestial placidity" (*ES*, 160) remind Frédéric of brothel inmates (and whose various styles of beauty are analogous to those of the costumed ladies-of-the-night at Rosanette's ball); the discreet house with closed shutters where Rosanette gives birth—a house that resembles the kind of place she might frequent to make a quick *passe;* Madame Dambreuse herself, who was sold to her husband much as Rosanette was to her first lover and who is designated in Flaubert's notes as a "lorette manquée" (*ES*, 502).

Flaubert further expands the meaning of prostitution metaphorically by applying the designation to men. In his notes for the novel we read: "As women's prostitution diminishes (is altered or hidden), men's spreads"; "[Frédéric] acquired the charm of *putains* just by his life's having developed analogously to theirs" (*ES*, 501, 502).[36] Dussardier is probably the only man in the novel unwilling to sell himself if the price is right. And Dussardier is killed by Sénécal right in front of Tortoni's café, a place, as we know from the letter to Louise Colet quoted above, that was intimately associated in Flaubert's imagination with prostitution ("In the first years when I was in Paris . . . I would go to sit in front of Tortoni's and, while watching the sun go down, I would watch the whores pass"). All the other

men are anxious to commodify themselves on the Parisian market-place. Monsieur Dambreuse, we are told, loved power so much "he would have paid to sell himself" (*ES*, 380). Deslauriers is so envious of Frédéric's sluttish charm that he twice packages himself to resemble his friend, first in an unsuccessful attempt to seduce Madame Arnoux, then in the successful takeover of Louise Roque. Delmar's declamation of "a humanitarian poem on prostitution" (*ES*, 363) is but one of his opportunistic poses to further his career as an "homme entretenu." And the list could be extended to show men selling out in every field of cultural and political action: Arnoux and Pellerin desecrate art; Sénécal and Monsieur Roque brutally demonstrate the bankruptcy of politics and ideology; Hussonet shows the moral failure of journalism; Cisy, the effeminate degeneration of the aristocracy.

On Flaubert's largest stage, that of history, the prostitutional motif also manifests itself, in terms of repetition and imitation. As others have noted, Flaubert sees the 1848 revolution much as does Marx: as the farcical repetition of the "original" revolution.[37] Everyone at the grossly misnamed Club de l'Intelligence constructs his public personage on the model of one of the heroes of the 1790s, copying Saint-Just, Danton, or Marat. Sénécal is even engaged in a double imitation: "He tried to resemble Blanqui, who in turn imitated Robespierre" (*ES*, 306), wearing black gloves and a brushed-up hairdo. The revolutionaries of 1848 are involved in a kind of historical fetishism that parallels, on a grand scale, Frédéric's adoration of Madame Arnoux. Not for nothing does Flaubert stage the auction of Madame Arnoux's personal effects on the day before Napoleon III's coup d'état, planned by the nephew to coincide with the anniversary of his uncle's crowning, itself staged to commemorate the victory of Austerlitz. Like Marie Arnoux—like Pellerin's "Venetian" portrait, for that matter—Bonaparte is a substitute figure constructed out of props (Marx notes that under Louis Napoleon "the state seem[s] to have made itself completely independent,"[38] just as the fetish's authority is independent of what it purports to represent). Although Flaubert never names him (a gesture of political discretion from an author whose first novel was brought to trial), Napoleon III, whose "government of *hommes entretenus*" Marx denounces, embodies prostitution in power.[39]

The question as to whether, or to what degree, Madame Arnoux

escapes the degrading commodification of everyone and everything around her is, of course, central to the novel's interpretation and warrants more detailed analysis than I will undertake here. The auction scene is once again particularly revealing. Frédéric's fetishistic approach to Madame Arnoux, so blatant that it requires no demonstration, is caught up in the general practice of commodity fetishism that characterizes every aspect of social behavior in the novel. The process whereby Frédéric consecrates objects as sacred displacements of his beloved's intimacy is not fundamentally different from the process whereby the marketplace creates exchange value in abstraction from an object's intrinsic qualities. As Mark Conroy comments, "Madame Arnoux is indissolubly linked to the cultural codes her image comes to embody: codes, as vendable as goods, that provide the valuative basis on which goods of any kind can be traded."[40] The Renaissance casket is, of course, the object most heavily invested by Frédéric with coded value (sexual mystery, beauty, sacred immanence), yet this casket, as Conroy rightly stresses, is also a sign of commerce and circulation, whose movement reflects Madame Arnoux's dependence on her husband's speculations, amorous and financial. The auction demonstrates that Frédéric has constructed Madame Arnoux out of commodities that are potentially exchangeable on the public marketplace. In this sense, he has prostituted her. Frédéric resists this perception through the grand gesture of breaking off with the person who has tried to enforce it, Madame Dambreuse. But for the reader this scene is only the most vivid illustration of the failure of Frédéric's attempt to keep Madame Arnoux outside the exchanges, imitations, and substitutions that characterize his relations with his two mistresses. When we are told that Frédéric fantasizes indiscriminately the image of Madame Arnoux or that of Rosanette in order to stimulate the sensual ardor Madame Dambreuse fails to evoke, it is clear that the ideal woman, supposedly *hors commerce,* does have an exchange value in his prostituted psychic economy.

My point is that *L'éducation sentimentale* offers no possibility within its represented world to think the idea of prostitution from a position that would not itself be prostituted. A figure like Vautrin, who embodies Balzac's excitement about possibly gaining control over the rate of exchange on the Parisian marketplace, where values and ideas are traded like floating currencies, is inconceivable in Flaubert.

Whereas Balzac moves his plot forward in function of the fluid circulation of these currencies, Flaubert demonstrates that the ubiquity of exchange value produces only stasis and sterility. Whatever is positive and potentially creative in Benjamin's image of the *flâneur*-poet, who empathizes with the commodity-soul like a prostitute giving herself to whoever passes by, is emptied by Flaubert of any poetic suggestion of "negative capability." The productive chameleon quality Benjamin attributes to the *flâneur*'s having no convictions becomes, in the case of Frédéric Moreau, the languid passivity of the commodified individual whose impotent roles are copied from available cultural codes.

Frédéric certainly does not lack opportunities to meditate the prostitutional idea. Quite the contrary: the proliferation of such missed opportunities characterizes the insignificant melancholy of his life. "Lust, bitterness, the void of human relations, the frenzy of muscles and the sound of gold"—all these factors are present, contributing, precisely, to sadness and dreams of love, when Frédéric sleeps with Rosanette in the room he has carefully prepared to receive Madame Arnoux. But Flaubert does not grant Frédéric the philosophical distance necessary to formulate his position as *néant-vivant*. Frédéric explains his tears to Rosanette through a banal deception—"I'm just too happy; I've been wanting you too long" (*ES*, 285)—and the text breaks off with one of Flaubert's famous *blancs*. Thus, a sense of void, emptiness, lack is conveyed to the reader as a specifically textual effect. He meditates the idea of prostitution, which Frédéric is incapable of thinking, in function of his appreciation of the way literature structures loss.

This textual effect is pervasive; it need not depend on the material intrusion of a *blanc*. Most frequently Flaubert simply shifts away from Frédéric's awareness of loss so that its subjective impact is dissolved in the notation of external impressions. At the racetrack, for instance, Frédéric is overcome by a sense of nothingness when Rosanette, who has accompanied him, lifts a vulgar toast to the passing Madame Arnoux: "Exhausted, filled with contradictory desires, not even conscious any longer of what he wanted, he felt an immense sadness, a desire to die" (*ES*, 208). In the next sentence, a noise makes Frédéric lift his head, and subsequently Flaubert's description of the return from the races abandons Frédéric's potential insight into the prostitutional idea as if it were just one more

object left behind as his coach advances. Or take the moment the day after the auction and the break with Madame Dambreuse, when Frédéric feels "lost among the ruins of his dreams, sick, full of grief and discouragement" (*ES*, 417)—another opportunity for insight into the meaning of prostitution and loss. This time Flaubert shifts not to a description of the external world but to the iconographic clichés of Frédéric's internal landscape: "He longed for the freshness of the grass, the peace of the country, a sleepy life among simple-hearted folk, in the shadow of the house where he was born." Frédéric's failure to understand the romantic poetry of his life's ruins is a psychological sign of his superficiality. Flaubert shows that those ruins are also linguistic, the fetishized fragments of a descriptive language once alive, among which lost meaning is buried.

The two-paneled closure of *L'éducation sentimentale* encrypts for the reader the peculiar absence to which Flaubert's style has sensitized him all through the novel. It might appear that Frédéric's collaboration in structuring loss (his love story, his brothel story) implied some capacity on his part to intellectually master the idea of prostitution. But this is no *Bildungsroman*, even in the negative. Frédéric has learned nothing: he cannot read the structures that he helps build, he does not understand the value of the absence preserved in his romance, or of the virginity preserved in his innocently scandalous *histoire*. The idea of prostitution that overwhelms the reader as he closes *L'éducation* he shares only with the novel's implied author, implied not so much from intrusions as from shifts, dispersions, interruptions, disjunctions, incompletions, lacunae, effacements, cancellations. This is no imagined vital presence, but rather a figure for the lack of presence, a *néant* become *vivant* only by denying the figuration of life, "empty and sonorous, like a great sepulcher without a corpse" (*CR*, I, 224).

Degas's Brothels:
Voyeurism and Ideology

*I*n evoking the world of dance to which Degas devoted so many of his images, Paul Valéry offers a personal anecdote to confirm Mallarmé's paradox that "a danseuse is not a woman who dances, because she is not a woman, and she does not dance."[1] The truth of this enigmatic observation was demonstrated to him, Valéry says, by a film he once saw of giant, floating medusas, "not women at all, but beings of an incomparably translucent and sentient substance" (*DDD*, 1173), as fluid as the liquid surrounding them, ideally mobile and elastic, requiring no solid ground, boneless yet not without form. The dance of the medusas embodies Valéry's conception of dance in its absolute state as pure movement aimed at nothing outside itself. According to this view, a ballerina's sexual identity plays no role, for she makes her body into "an object whose transformations necessarily recall the function a poet gives to his mind."[2] Her body, in other words, is a metaphor for the leaps, swerves, inversions, and pirouettes of the poet's own verbal creativity—"a corporeal writing," in Mallarmé's phrase.[3]

Dance becomes a figure for the symbolist aesthetic—nothing terribly surprising about this, one may say. The surprise comes in Valéry's second paragraph about the medusas, in which what was repressed by the symbolist idealization returns with a vengeance:

> No human ballerina, inflamed woman, drunk with movement, with the poison of her own overwrought energy, with the ardent presence of gazes charged by desire, ever expressed the imperious

Figures of Ill Repute

oblation of sex, the mimic summons of the urge to prostitution, like the giant medusa, which, with an undulating shudder of flowing festooned skirts that she lifts and lowers with a strange and shameless insistence, transforms herself into a dream of Eros; and then, suddenly flinging back all her shivering flounces, her robes of severed lips, inverts and exposes herself, laid furiously open. (*DDD*, 1173)

This extension of Valéry's thought seems to invert it, exposing its sexual secret much as the medusa exposes hers. The dance, which had earlier been emptied of mimetic reference, now urgently summons the aroused spectator to fulfill the ballerina's "besoin de prostitution." The medusa has been transformed by the fervently fantasizing writer from a floating signifier, analogous to the male poet's creative freedom, into a very specific organic signified, a gaping female sexual organ that threatens the poet's artistic control.[4] It is as if the fascinated spectator-writer were now confronted with the symbolic meaning Freud associated with the mythological Medusa's petrifying gaze: the fear of castration. Under the skirts provocatively lifted and lowered, under the dress made up of severed lips, is the furious openness that poisons every dream of Eros.

Who is the subject of this erotic fantasm? Evidently Valéry himself, the captivated viewer of the film of giant medusas; but also, by extension, Mallarmé, since Valéry is documenting his dictum about ballerinas not being women and not dancing. Still another implied subject is Degas, known as "le peintre des Danseuses," whom Valéry mentions at the outset of this meditation drawn from "*Degas Danse Dessin*," a text of 1936. Furthermore, this scenario of appreciation for woman's sublimated aesthetic form as a cover for disgust with her natural, sexualized body has, as we have seen, a tradition that goes back at least as far as Baudelaire, whose La Fanfarlo is beautiful as long as she dances, a fleshy whore as soon as she removes her costume and makeup. Valéry notes that Degas's dancers are only superficially idealized images: their bodies bear the marks of their subjugation to the male artist's corporeal writing. Degas's passionate commitment in creating the danseuses, he argues, involved the display of female slavery rather than the elision of the body's travail in the glory of its aestheticization. "Degas was passionately determined," writes Valéry, "to reconstruct the specialized female animal

: 158 :

as the slave of the dance, the laundry, or the streets; and the more or less distorted bodies whose articulated structure he always arranges in very precarious attitudes (tying a ballet shoe, or pressing the iron on a cloth with both fists) make the whole mechanical system of a living being seem to *grimace* like a face" (*DDD*, 1202).[5] This grimace is the physiognomic manifestation of the sexualized inversion of the medusa. The grimace is a kind of furious openness displayed as bodily distortion and disarticulation.

In the social and historical context that Valéry does not evoke, this openness is quite specifically that of "the mimic summons of the urge to prostitution," for the dancers, like all the other female professionals Degas painted, be they laundresses, milliners, or café-concert singers, were known to be involved in clandestine prostitution. Parent-Duchâtelet already associated dancers with prostitutional activity in 1836,[6] and by the 1870s it was common knowledge that the dancers at the Opera were chosen more for their sex appeal than for their talent. In the words of one member of the corps de ballet who left it, "As soon as [a dancer] enters the Opera her destiny as a whore is sealed; there she will be a high-class whore."[7]

The primacy of erotic spectacle at the Opera was due in part to the institution's total dependence on private funds (in Denmark and Russia, in contrast, the ballet was state supported), which forced the Opera's directors to cater to the depraved tastes of its wealthy patrons. During the Second Empire, the Foyer de la Danse behind the stage functioned almost like the salon in an elaborate brothel. Only the subscribers (*abonnés*) and their friends, usually members of the notorious Jockey Club, were allowed access to this privileged playground for the leisured rich. Here they gathered before and after the performance to "check out" underpaid young working women for a potential rendezvous. (Compare Guys's rendition of the dance foyer, Figure 17, with his depiction of a brothel salon, Figure 24.) The function of the dance foyer as an arena for flirtation and sexual assignation persisted after 1873, when the old Opera burned down and the ballet moved to Garnier's extravagant new building. By this time, ballet as an art form had fallen from its golden age in 1830–1850 to become an elaborate public show catering to the erotic fantasies of an increasingly bourgeois audience. One consequence was the virtual disappearance of the *danseur noble*. His place in partnering the ballerina was frequently taken by travesty dancers,

whose tight costumes emphasized their unquestionably female figures and whose romantic pas de deux suggested to the jaded male eye the titillating image of lesbian erotic play.[8]

Certain of Degas's dance images in pastel acknowledge the sexualization of the ballerina's profession by representing men in formal attire waiting and observing in the wings (see Figure 18). But it is in making monotype illustrations in 1880 for his friend Ludovic Halévy's book *La famille Cardinal* that Degas most clearly shows his interest in the Opera *coulisses* and foyer as places of erotic commerce.[9] Halévy's story is a playful satire of the venal behavior of a backstage mother, a breed well known to contemporary chroniclers of the *demi-monde*, who serves as managerial *entremetteuse* for her delightful daughters. Degas's illustrations (see Figure 19), less lighthearted and debonair in tone than Halévy's text, suggest the danseuse's subjection to a capitalist economy of desire, which defines lower-class

Figure 17. Constantin Guys. *Dance Foyer.* Date uncertain. Pen and ink with wash. Musée du Petit Palais, Paris.

women as objects of sexual consumption for middle- and upper-class men. The grimacing body—distorted, disarticulated, unstable, even inverted—this "reconstructed" body of "the female animal" is, according to Valéry, the victim of Degas's misogyny.

Is this an accurate reading of Degas's images? What is the meaning of the identification of the sexualized female body with the distorted and "precarious" female body? In her recent study *Looking into Degas*, Eunice Lipton argues that Degas's images of dancers, while supporting certain prejudices about their sexual availability, also demystify these assumptions by vividly illustrating the women's involvement as workers in a communal artistic effort. Lipton stresses the novelty of Degas's portrayal of the way in which women artic-ulate their own space—a modern, dispersed, broken-up space of physical tension and relaxation, compressed nervousness, and easy grace. These qualities, she argues, empower Degas's dancers, making

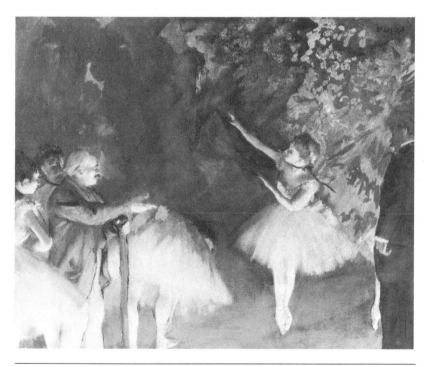

Figure 18. Edgar Degas. *The Ballet Rehearsal* (1874). Gouache and pastel. Nelson-Atkins Museum of Art, Kansas City, Missouri.

: *161* :

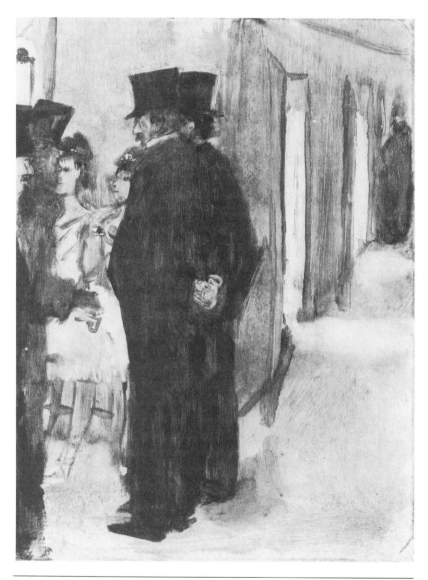

Figure 19. Edgar Degas. *Pauline and Virginie Talking with Admirers* (1880). Illustration for Ludovic Halévy, *La famille Cardinal.* Monotype. Fogg Art Museum, Cambridge, Massachusetts.

the *abonnés,* supposedly the masters of this feminine space, seem peculiarly marginal, unimpressive figures. A similar ambiguity is expressed by the paintings of laundresses and milliners that Lipton discusses: Degas deliberately solicits his viewer's associations of these activities with erotic availability, only to subvert expectations of sexual titillation (see Figures 20 and 21). His insistence on the physical effort required by specific tasks and his depiction of the absorption and isolation of the women performing them grants his female subjects a self-sufficient dignity that belies their reputation for immoral conduct.

Uncertainty about the sexual status of the women depicted provides Degas's images with one of their most powerful effects of modernity. A hint of prostitution is countered by a suggestion of autonomy; an alluring appearance of sexual accessibility is undermined by an alienating sense of the subject's absorption in work. We have seen that the mutual imitation of *femmes du monde* and *courtisanes* had so blurred the difference between them that the confusion was a commonplace of the 1860s. (In 1863 the Goncourts even remarked that, "to tell the truth," the Empress's toilette was that of "a *femme entretenue* with taste.")[10] By 1880 the possible causes for confusion had further spread, as venal practices adapted themselves to serve what Alain Corbin has called a desire for "the illusion of seduction."[11] Men from the increasingly large class of the petty bourgeoisie liked to act out a fictional scenario flattering to their *amour-propre,* in which they are found irresistibly attractive by a young working woman—a barmaid, saleswoman, seamstress, chanteuse, laundress, or ladies' maid. Such women most often collaborated in realizing this scenario, supplementing their meager wages with the regular sale of sexual favors. These casual transactions fell outside the system of state regulation of prostitution in *maisons de tolérance,* which continued officially despite attacks from abolitionists, a declining clientele, and increasingly lax police surveillance. Some madams even tried to cater to the new taste for illusionary seduction by transforming their establishments to resemble *ateliers de modes,* where the client could think that he was debauching underage apprentices.[12] But the most characteristic fate of the bordello, which no longer functioned, as Parent-Duchâtelet had hoped it would, as a seminal sewer for the working class, was to become a luxurious indulgence for the bourgeoisie (a subject to which I will return).

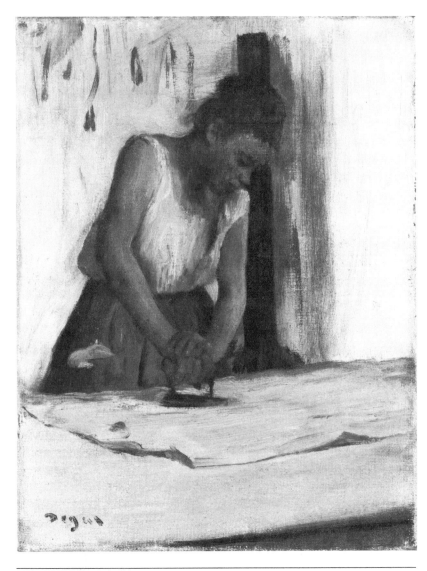

Figure 20. Edgar Degas. *The Laundress* (ca. 1873). Oil on canvas. Norton Simon Museum of Art, Pasadena, California.

Meanwhile, venal practices became so widespread in Paris that almost any woman who found herself "insuffisamment entretenue,"[13] whether by her husband, her lover, or her employer, might contemplate selling herself to maintain her lifestyle. A veritable army of procurers existed ready to help her accomplish this project. We have the records of one *maison de rendez-vous,* run by a certain widow Frétille in the 1880s. Among these documents is a list of the professions of those who recruited women for the establishment— a list that is impressive for its length and variety. It includes dressmakers, milliners, laundresses, music and dance teachers, piano tuners, directors of marriage and employment agencies, photographers, dentists, hairdressers, midwives, waiters, coachmen, and many more.[14] The carefully documented account of all this venal activity given in Corbin's *Les filles de noce* suggests that the possibility of a sexual exchange must have been latent in the majority of encounters between bourgeois men and working-class women in fin-de-siècle Paris. And this possibility contributed toward defining

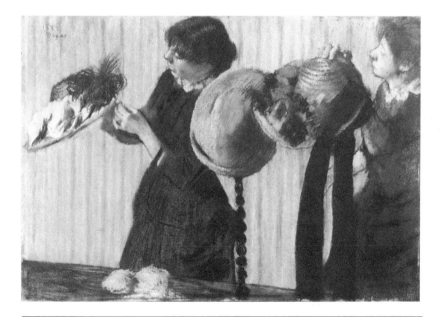

Figure 21. Edgar Degas. *The Milliner's Shop* (1882). Pastel on paper. Nelson-Atkins Museum of Art, Kansas City, Missouri.

the particular excitements, anxieties, instabilities, and ambiguities of modern urban life.

As a consequence, it might seem logical that if an artist were to portray women who were clearly sexually available—prostitutes in a brothel, for instance—a primary source of ambiguity in representation would disappear. But Degas did produce many such images, and ambiguity characterizes their pictorial language at least as much as it does that of his paintings of dancers, milliners, and laundresses. The brutal explicitness of Degas's brothel monotypes does not make the text of female sexuality any more legible than it was when disguised under the masks of more acceptable social identities. My readings of the monotypes will suggest ways in which Degas's images destabilize the male viewer's gaze and confront him with the ideological assumptions underlying his voyeuristic position. This argument, however, will itself prove to be unstable, as Degas's representational practice is seen to involve us in a reading experience that vacillates uncomfortably between psychological and social determinants, constructing its viewing subject in terms of male bourgeois hegemony while simultaneously revealing the suspect ideological artifice of that construction.

For an interpretation of Degas's portrayals of prostitutes in brothels, the medium is most certainly a good part of the message, but one whose visual language is peculiarly ambiguous and difficult. The works are all monotypes, images created through a technique that lies halfway between drawing and painting. A monotype can be made in two ways: one can either cover a metal or celluloid plate with thick, greasy printer's ink and then wipe and scrape some away to make a design (the "dark-field" manner) or one can apply printer's ink directly to a clean plate with a brush, rag, or other instrument (the "light-field" manner). Once the composition is finished, it is transferred by laying a piece of dampened paper on the plate and running both through a rolling press. Most of the ink is used up in this process, though a second, lighter impression can sometimes be pulled. The technique is imprecise and unpredictable by its very nature, since one cannot control exactly how the ink will respond in the printing operation. The primary advantage the method offers over direct drawing is the time available (up to an hour) to manipulate the ink on the plate before it loses pliability and must be fixed in the paper. This manipulation is a physically

immediate, sensuously tactile process: Degas used rags, brush handles, hard bristles, sponges, pins, and even thumb and finger applications to produce desired effects. There is no tradition of monotype making. Through the centuries, various artists discovered it but never took it seriously enough for their discovery to be significant to subsequent generations.[15] Degas used the medium not only for itself but also as a chiaroscuro base, a tonal map, for further elaboration in pastel and gouache.

Scholars have recorded approximately fifty extant monotypes by Degas of brothel scenes, most done in the light-field manner, with dimensions varying from about 4 by 6 inches to 8 by 11, the majority being 6 by 8. Degas's friend, the art dealer Vollard, declared that as many as seventy more monotypes were destroyed by the painter's brother at the time of his death, probably because they were considered obscene. It is generally thought that most were made in 1879 and 1880, a time when literary versions of the prostitute's life were arriving on the cultural scene in rapid succession (Huysmans's *Marthe* was published in 1876; Edmond de Goncourt's *La fille Elisa* appeared in 1877; Zola's *Nana* created a sensation in 1880, also the year of Maupassant's "Boule de suif," followed in 1881 by his "La maison Tellier"). Of these, we can be sure that Degas read *La fille Elisa* since he made a number of sketches illustrating scenes in that novel (as did Toulouse-Lautrec a decade later), and it is very likely that he knew the others as well.[16] We do not know to whom precisely he showed the brothel monotypes, which were never exhibited in his lifetime. Françoise Cachin believes that he showed them only to his closest friends (under what circumstances? to wives as well as husbands?) and perhaps to a few artists he liked and respected.[17] But there are no accounts of the monotypes written by any of those who may have seen them during Degas's lifetime. The public first got a chance to view them when Vollard used a selection to illustrate his 1934 edition of Maupassant's *La maison Tellier* and his 1935 edition of *Mimes de courtisanes* by Pierre Louys.

Art historians have had relatively little to say about the subject of the monotypes, choosing instead to treat them as formal and technical experiments.[18] Their usefulness, so the story goes, was that they helped liberate Degas from the excessively linear graphic mode he had inherited from Ingres and enabled him to explore the constructive potential of strong contrasts in light and shadow and to

judge the relationships between broad compositional masses.[19] The images are usually praised for their dispassionate, documentary realism, their casual immediacy, and their morally neutral perspective. This appreciation of the impersonal, objective quality of Degas's observation goes along characteristically with a claim, such as that made by Françoise Cachin in the introduction to her 1974 edition of the monotypes, that "studying the monotypes puts one in a privileged position to understand Degas's work, giving access to his most personal and private concerns, his relations with women and with femininity."[20] However, what Cachin finds most personal about Degas is an entirely traditional reading of his sexual perspective: he was, she claims, a voyeur preoccupied with woman's animal nature.[21]

This interpretation fits into a tradition of Degas criticism, founded by Huysmans, that has had an astonishingly long life. In a review of the series of pastels that Degas exhibited in 1886, featuring, among other images of women bathing and drying themselves, one entitled *The Tub* (Figure 22), Huysmans claims that Degas's point of view conveys "an attentive cruelty, a patient hatred."[22] Huysmans does not disapprove of this cruelty anymore than he accuses Degas of misogyny; on the contrary, he praises the painter for conveying a lucid and chaste "disdain for the flesh" (*AMC,* 296) such as has not been seen in art since the Middle Ages.[23] He argues that Degas shows fat, short, graceless women in the humiliating and degrading positions of intimate hygiene, because the artist is a brilliant iconoclast attacking the false idolization of Woman in conventional artistic practice.[24] Then Huysmans proceeds to construct the subjectivity of Degas's bathing women as a function of their masochistic collaboration with a sadistic male gaze. The bathers convey, he writes, "the penetrating, sure execration of a few women for the devious joys of their sex, an execration that causes them to be overwhelmed with dreadful proofs and to defile themselves, openly confessing the humid horror of a body that no lotion can purify" (*AMC,* 297).

With this evident fantasy projection, Huysmans's ideological reading of Degas's iconoclasm becomes hostage to his horrified fascination with the ineradicable dirt of female sexuality and to his need to imagine punishment for female deviance. Like Valéry, like Mallarmé, Huysmans fears his own dream of Eros, Medusa's "mimic

summons of the urge to prostitution." In reaction, he places himself in the position of a voyeur, sadistically fantasizing that his pene- trating look punishes and humiliates the woman it secretly observes. According to the psychoanalytic account, the male voyeur is trying to escape anxiety by obsessively reenacting an original trauma, his imagined perception of female castration, from a situation of mastery and control. Huysmans's hypothesis of female self-disgust and bodily loathing perfectly fulfills this fantasy of erotic domination. Woman in Huysmans's interpretation of Degas's images is not simply the object of male disdain; she has internalized that disdain to the point that she is the degraded object of her own virulent execration. The voyeur thus displaces his own guilt for his covert misogynist gaze onto the object of that controlling surveillance. What he sees is imaginary evidence of woman's enlightened awareness of her irre- deemably debased sexuality.

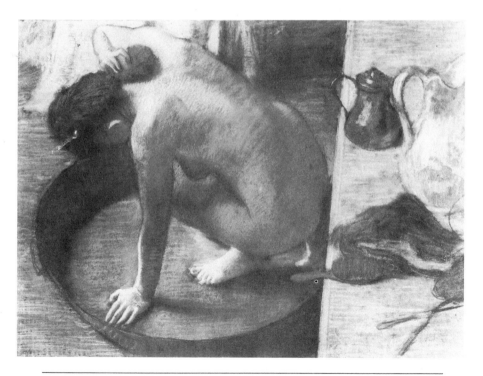

Figure 22. Edgar Degas. *The Tub* (1886). Pastel. Musée d'Orsay, Paris.

Huysmans's fantasy scenario locates woman in the position of Truth insofar as she openly confesses the horror of her sexual embodiment, the humid wound of her mutilated flesh. His vocabulary is uncannily Freudian as he praises Degas for creating in his paintings "la sensation de l'étrange exact, de l'invu si juste" ("the sensation of exact strangeness, of the precisely right unseen"—*AMC*, 297). I hardly need stress that castration for Freud is the unseeable whose provocative strangeness threatens the male subject's physical integrity and his power of accurate perception. It is this imagined threat that the misogynist voyeur overcomes, repeatedly, as he reassures himself of the visibility of the unseen. His misogyny is inherently narcissistic: the voyeur sees in female lack the evidence of his own phallic coherence. Woman's body is perceived as other only insofar as it can be marked with the signs of man's desire for himself.[25]

A number of recent readings of the bather pastels help explain how the construction of these images might provoke a defensive, self-reflective male response such as that of Huysmans. These readings, by Edward Snow, Eunice Lipton, and Carol Armstrong, all stress the extraordinary self-sufficiency, separateness, and sensuous privacy of the women depicted. Specifically countering Huysmans's argument, Snow writes that "these women are rendered as physical beings in their own right rather than as projected, complicit objects of masculine desire. [They are] delivered not only from the male gaze but from any introjected awareness of it."[26] Armstrong's analysis confirms this split between excluded male gaze and self-absorbed female embodiment. The woman's body in *The Tub*, she observes, folds over on itself in a reflexive movement signifying circularity and closure. This inverted movement, "turned in on the body's thicknesses and silences,"[27] deflects and excludes the male viewer, thereby negating the offer of erotic appropriation traditionally associated with the female nude. Indeed, both Armstrong and Lipton suggest that the paintings, far from expressing female self-disgust and sexual guilt, "invite empathy and the contemplation of narcissism" (Lipton) "in a kind of pictorial onanism" (Armstrong).[28]

These strong contemporary readings suggest that Huysmans's reaction to these pastels, like that of the critics who subsequently have agreed with him, constitutes an aggressive defense of the phallic right to annex woman's sexuality, mounted in the face of

images that emphatically assert her intrinsic, autonomous, guiltless capacity for sensual fulfillment. His reaction is, moreover, a defense of the traditional prerogatives of male spectatorship, especially of the voyeur's implied presence in a position of fantasized mastery, mounted in the face of the dislocation and problematization of that position.[29] As Armstrong points out in her essay (p. 239), the dislocation of perspective in a picture such as *The Tub* is a deliberate strategy designed to radicalize the external viewpoint of the spectator, to the extent that it loses all corporeality and becomes "a gaze without a body." Impossibly located above the right-hand ledge but not on it, in a kind of dematerialized point in space, the viewing presence loses its capacity for discursive union with its object. The voyeur's fantasy of power is subverted by the precariousness of his implied position in space. Snow interprets this subversion as "a denial of masculine will, desire, and, above all, sexual presence. Degas' privileges as an artist," he goes on to assert, "stem from and reinforce his ontologically negative sense of himself as a man."[30]

The ambiguity of the bather images has a social dimension as well. A few of the viewers of the 1886 Salon specifically identified the bathers as prostitutes. Henri Fèvre, for instance, remarked: "Degas lays bare for us the streetwalker's modern, swollen, pasty flesh. In the ambiguous bedrooms of registered houses, where certain ladies fill the social and utilitarian role of great collectors of love, fat women wash themselves, brush themselves, soak themselves, and wipe themselves off in basins as big as troughs."[31] Another reviewer, J. M. Michel, associated Degas's bathing women with Zola's notorious heroine Nana: "Nana bathing, washing herself with a sponge, taking care of herself, arming herself for battle—that is the Impressionist ideal," he writes sarcastically.[32] And Félix Fénéon located the performance of these female ablutions "in disreputable furnished rooms in the vilest retreats."[33] In her chapter on the bathers in *Looking into Degas*, Eunice Lipton argues convincingly that the women bathing could hardly be bourgeoises at their toilette because, first, depiction of middle-class women washing themselves would have constituted an ideologically unthinkable breach of decorum; and, second, bourgeois women bathed very rarely, bathing being considered dangerous to a lady's moral stamina and risky to her health. In contrast, prostitutes, especially those in regulated *maisons de tolérance*, bathed frequently, and tubs were a

feature of any brothel bedroom. Indeed, the voyeuristic excitement of observing a woman cleaning herself was no doubt part of the attraction of the bordello experience. Contributing further to the identification of the bathers as prostitutes, according to Lipton, is the fact that the postures of the women washing themselves and the decor of their surroundings, including drapes, towels, and parts of beds, are reproduced in a number of the brothel scenes, whose only difference from the bather pastels is that in the former a client is looking on.

Why then were the bathers not universally identified as registered whores by the viewers of 1886? For example, why doesn't Huysmans, attuned as he was to this subject matter and appreciating its realistic portrayal by Forain (see Figure 23)[34]—why doesn't he spell out this identification? (His evocation of "the devious joys of their sex" is hardly explicit.) Lipton's answer to this question, although lacking in complexity, is probably right in its general import. Degas's

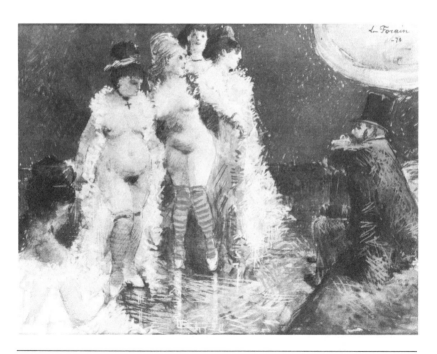

Figure 23. Jean-Louis Forain. *The Client, or the Brothel* (1878). Gouache. Private collection, London.

refusal to objectify the women he portrays, his empathetic depiction of their private self-absorbed pleasure, his omission of any explicitly sexual gestures—all this tends to generalize the images to the extent that they could refer to any woman experiencing her body in sensuous intimacy. The signs of the figures' social identity are made ambiguous and unstable, which might account for the uncertainty in the initial responses of viewers and may even have contributed, as Lipton suggests, to their outbursts of hostility against images that refused to offer any easily consumable rendition of female sexuality and class.

In contrast to the bather pastels, the subject of the brothel monotypes is not in question. The monotypes are like the pastels, however, in that they also constitute a series of repetitive images in which the variety of expressive gesture is minimized, individual physiognomic difference is reduced, and complexities of composition, such as costume and decor, are greatly simplified. But the brothel scenes go farther than any other of Degas's iconographic repertoires toward negating traditional aesthetic norms of legibility and corporeality. The pastels may subvert expectations about the correct formal display of the nude; they remain nevertheless luxuriantly colorful and sensuously rich. The monotypes, in contrast, present crude, scribbled, smudged, murky forms in what are frequently almost illegible juxtaposed masses of light and shadow. Although the images could be ordered to illustrate business in the brothel—from expectant waiting, to the arrival of a client, the retreat to a private bedroom, the cleansing ablutions, the sexual act, and the return to the salon—Degas did not arrange the pictures in any particular sequence, so far as we know. Thus, my selection of monotypes to analyze is largely a matter of personal preference and rhetorical strategy. The images are quite baffling at first sight—almost cartoonish or caricatural in their figural delineation, strangely unfinished, abbreviated, and apparently hasty in execution. One has the impression of a rapid sketch made *sur place*, although these monotypes are actually remembered images composed *après coup*.

But just what is Degas remembering? He kept his private life so secret that we do not know if his brothel imagery derives from first-hand experience or from erotic fantasies. The latter might have been fueled by viewing previous representations of brothel life (notably those of Constantin Guys), by contemplating erotic photographs, or

by reading in the extensive prostitutional literature of the time. That the source was personal experience is open to some doubt, not only because Degas was notoriously shy and sexually reticent but also because he represented prostitutes naked in the brothel salon when they usually appeared partially clothed in shifts and corsets. This is how they are dressed, as they wait for clients and gossip among themselves, in the brothel scenes painted by Guys, some of which were owned by Degas's friend Manet (see Figures 5 and 24), and this is also their attire in Toulouse-Lautrec's great painting *In the Salon of the Rue des Moulins* (see Figure 35). Hollis Clayson argues that the props of Degas's brothel scenes—upholstered furniture, large mirrors, and fancy chandeliers—are sufficient to identify the category of brothel portrayed as a deluxe *grande tolérance*, where specialized erotic services were available to wealthy connoisseurs.[35] The prostitutes' nudity may have been a feature of such luxurious

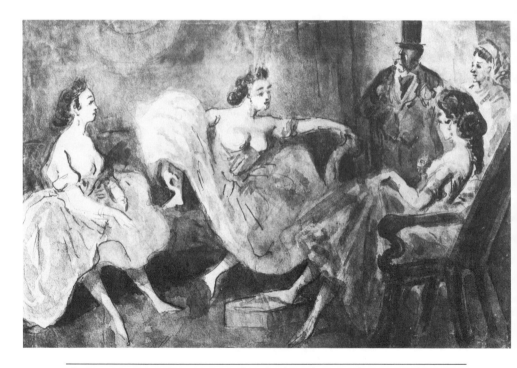

Figure 24. Constantin Guys. *"Ladies" in the Salon (Ces dames au salon)*. Date uncertain. Pen and ink with wash. Collection Dorville, Paris.

establishments. This argument, though plausible, is not totally convincing because the props of Degas's scenes are so repetitive that they seem to belong to a typically Degasian repertoire of motifs, which could well have a literary origin, rather than to any specifically realistic intention. Foremost among the literary accounts of prostitutes that Degas would surely have known and admired are those of Baudelaire in his essay "Le peintre de la vie moderne." Baudelaire's marvelous evocation of Guys's images of bordello life could almost serve as a description of Degas's monotypes:

> Sometimes, without even trying, they [the prostitutes depicted by Guys] assume poses so daring and noble that the most fastidious sculptor would be enchanted, were the sculptors of today sufficiently bold and imaginative to seize on nobility wherever it was to be found, even in the mire. At other times, they show themselves prostrated in attitudes of desperate boredom, in the apathetic poses of public-house patrons, masculine in their cynicism, smoking cigarettes to kill time, with the resignation of oriental fatalism. They sprawl on sofas, with their skirts rounded in back, spread out like a double fan in front, or they balance on the edge of stools and chairs. They are heavy, dull, stupid, extravagant, with eyes glazed by alcohol and foreheads swollen by stubbornness.[36]

The monotype entitled *The Tub* (Figure 25) provides a revealing comparison to the pastel of the same title. Here the male gaze is explicitly embodied in the image, but hardly in a way that expresses the dominating, controlling point of view of the voyeur. The man, a client in a brothel, sits hunched over in a barely articulated, murky mass. His body seems to be closed in on itself in a circular form that rhymes with the tub below and the mirror above. The sense of enclosure and separation is enhanced by the perceptible echo of the man's muddled form captured from the back in the heavily framed mirror, as if pulled thereby into the dark recesses of pictorial reflection. His space is rigidly set off from that of the woman by a sharp line that defines a black ground against which her plump, white body stands out. Although she is sitting on the floor, her upright back gives her a strong verticality, which is counterbalanced on one side by the horizontal movement of her arm and extended on the other by the upward thrust of the cheval glass. From his cringing,

regressive, closed-off position, with half his face buried in his hand, the client observes his sexual purchase. The meaning of his one-eyed look is articulated by the structure of the composition: although he has economic power over this woman's sexuality, he experiences her as a dominating presence from which he is definitively exiled. His look does not debase her; it appears rather to confirm his inadequacy, his inability to emerge out of the enclosures that inhibit his sexuality. The blurred area where her head should be suggests the generalized quality of this woman's confident embodiment. Her body may have none of the bountiful luxuriance of the pastel bathers, but its power to deny appropriation by the male gaze remains undiminished.

Two monotypes that show a client emerging from outside the

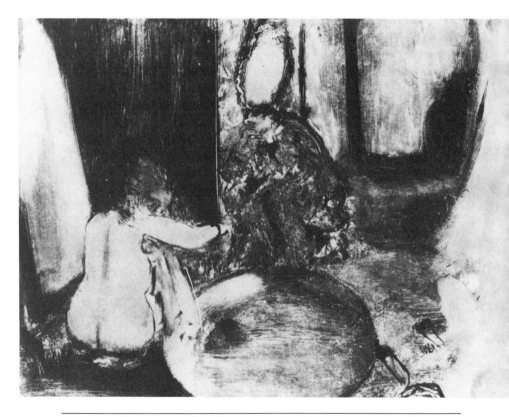

Figure 25. Edgar Degas. *The Tub* (1878–1880). Monotype. Private collection.

frame into a brothel room suggest that Degas associates hesitancy and ambivalence rather than voyeuristic power with the threshold position. In the first, entitled *The Client* (Figure 26), the forward thrust of the man's only visible leg is strongly countered by the backward tilt of his entire stiff, linear body. He seems reluctant to enter the domain of the two swollen, sitting women. The primitive graphic mode of their portrayal decomposes their bodies, randomly eliding detail, smudging outlines, erasing contours, and defacing features. The physical amorphousness and disarticulation of these figures make it seem as if they had emerged organically out of their environment, whose barely legible, splotchy, dappled, muddy forms have a certain metamorphic quality about them. In contrast, the sticklike client appears alien, his dark clothing and formal hat more defensive than authoritative. He arrives armored with the signs of his social class—top hat, dark suit—but he seems to be retreating from the exercise of his privilege. A similar defensiveness is termed "seriousness" in the title of the second monotype, *The Serious Client* (Figure 27). Here the man, again decked out in bourgeois regalia, is being actively pulled away from his position on the margin of the pictorial space. The umbrella, fulcrum of contending pressures, may suggest the sexual issue involved, as well as demark an internal threshold of male anxiety. The fact that the angle of the umbrella exactly parallels the backward lean of the client suggests that his timid seriousness is successfully resisting the fleshy solicitation of the four prostitutes.

Should this resistance be read psychoanalytically as due to a fear of woman's castrated sexuality? Do the clients resist the incitements to desire and possession because of an unconscious horror of the uncanny unseen? This was the interpretation given to these images by Pablo Picasso, who in 1971 made a series of forty superb etchings that constitute a remarkable reading of the eleven Degas monotypes he owned (including *The Client* and a picture that I will analyze shortly, *Waiting*).[37] Picasso frequently portrays Degas, an alter-ego figure, in a position much like that of the clients in the two monotypes we have just discussed. In Figure 28, Degas, fully dressed, hands behind his back, leans against a wall as he stares at exhibitionistic and wildly made-up prostitutes. A line descending from the witchlike madam's head defines a wedge-shaped space that safely separates him from the whirling sexual forms on display. Eyes,

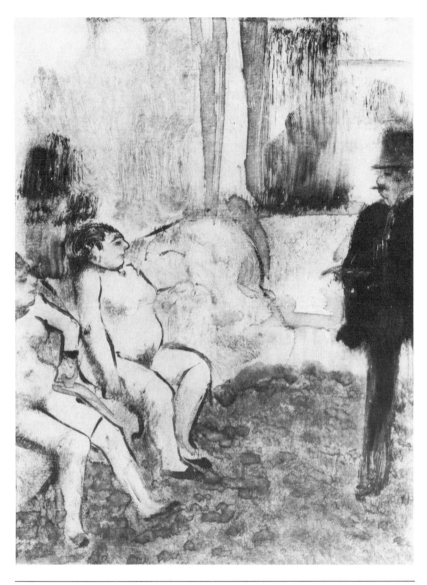

Figure 26. Edgar Degas. *The Client* (1878–1880). Monotype. Musée du Louvre, Paris.

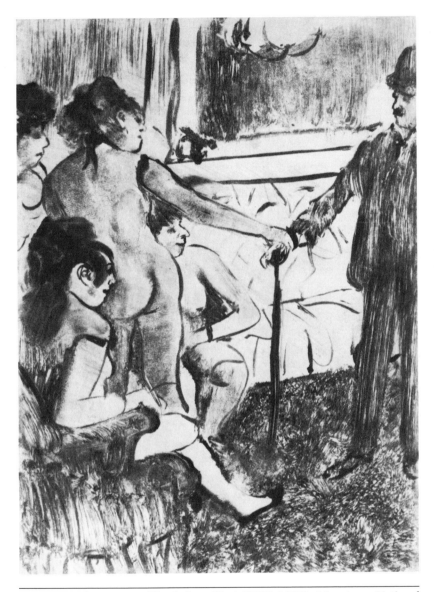

Figure 27. Edgar Degas. *The Serious Client* (1878–1880). Monotype. National Gallery of Canada, Ottawa.

nipples, and anuses resemble each other and seem to multiply ver-
tiginously. Figure 29 portrays Degas sketching an image of himself,
in diminished, shadowy, but still fully dressed form, surrounded by
naked women offering him their highly sexed bodies. Degas's cre-
ative inspiration, Picasso suggests, comes from imagining himself
inside the female erotic space he fears to penetrate. In another
etching (Figure 30), Degas's placement inside a frame removes and
distances him from an orgiastic scene of female bodies so closely
intertwined that it is hard to determine what members belong to
what bodies.

In all these scenes, the Degas figure, like the implied spectator of
the monotypes, remains impassive, hugging the margin, cherishing
the frame, refusing involvement. Yet what his fixed stare sees is
worlds apart from what Degas himself records in the monotypes.
Although the prostitutes in *The Serious Client* are spatially separate
from the customer, this division is not a function of a male drive to
fantasize woman. The client seems to be confronted with a weight

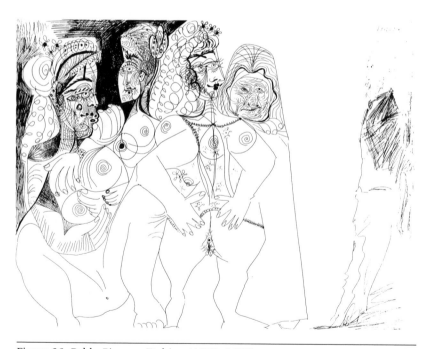

Figure 28. Pablo Picasso. Etching (1970–1972).

of female embodiment that will not yield to any appropriative fantasy. In contrast, Picasso's prostitutes are the voyeuristic projections of a (perhaps impotent?) fantasist who transforms the real into a theater of private hallucinations and erotic imaginings. This is the home territory of Valéry's dancing medusas, dreams of an inverted Eros laid furiously open to the terrified male gaze (see Figure 31). That terror, however, is controlled and overcome by the very openness and exuberance of the sexual display that is designed to provoke and stimulate the voyeur. If these lasciviously cavorting women are objectified as the castrated Other, they are still more powerfully subjectified as fetishized figures of the same. Woman's desire, seemingly in evidence throughout Picasso's bordello images, is exhibited only for the benefit of male narcissism. Her sexuality is annexed to the project of representing the male artist's ability to create the feminine as an aesthetic fiction.[38]

Versions of this fiction are embodied in Picasso's prostitutes and in Valéry's medusa. Of the latter, Valéry writes that, in the film he

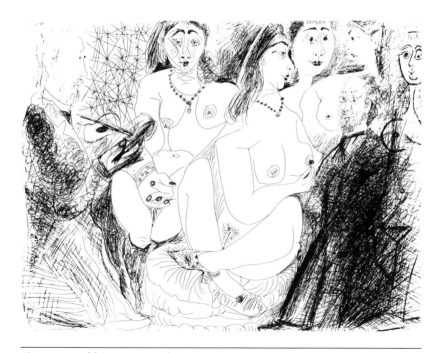

Figure 29. Pablo Picasso. Etching (1970–1972).

saw, she finally rose like a balloon "to the forbidden luminous region, the domain of the sun and the mortal air" (*DDD*, 1173). This displacement upward is the price the medusa must pay for her wanton exposure of what should have remained veiled. The darkness of the medusa's overwrought sexuality cannot survive exposure to the bright light of masculine, abstractionist control, a light that transforms woman into a metaphor for her absence. "A savoir," writes Mallarmé, "que la danseuse *n'est pas une femme qui danse*, pour ces motifs juxtaposés qu'elle *n'est pas une femme*, mais une métaphore résumant un des aspects élémentaires de notre forme, glaive, coupe, fleur, etc., et *qu'elle ne danse pas*."[39] The feminine thus becomes an elementary figure of "our" rhetorical form, that is, of the poet's favorite images for the poetic, and sexual difference (suggested by "glaive" and "coupe") becomes a function of the male writer's aesthetic choice.

As we have had occasion to observe in analyzing Balzac, Barbey,

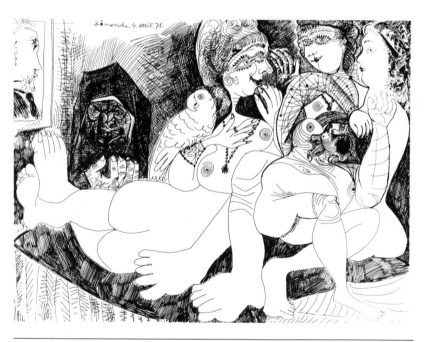

Figure 30. Pablo Picasso. Etching (1970–1972).

Baudelaire, and Flaubert, this rhetorization of female difference may be the most sophisticated of misogynistic strategies, conflating the contradictions of voyeurism and fetishism. The voyeur fictionalizes woman's otherness by constantly postponing his knowledge of it: what he sees never has the indelible stamp of truth; it must be seen again, and then again, each sight being no better than a representation of an original traumatic discovery. The fetishist avoids the knowledge of that discovery by adopting the fiction that a particular object can function, in Freud's familiar phrase, as "a token of triumph over the threat of castration and a safeguard against it."[40] Although the voyeur's compulsively ongoing investigation of female difference contrasts with the fetishist's equally compulsive fascination with displaced immediacy, both modes make woman available to the male gaze only insofar as her sexuality can be fantasized as something denatured, deflected, substitutive—"un sexe intellectuel

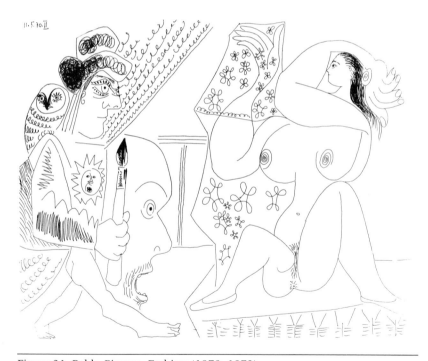

Figure 31. Pablo Picasso. Etching (1970–1972).

: *183* :

indécis," in Barbey's phrase. She is seen as what she is not, as a metaphor, at best, of what she is.[41]

Now it is evident that the conception of female sexuality as in some way lacking or negative is not the peculiar province of voyeurs and fetishists alone. Or, to put it another way, one would be right to argue that the mechanisms of voyeurism and fetishism pervade the culture of late capitalism, of which we, like Degas, are a part, to such an extent that they influence every aspect of spectatorship and of gender relations. This argument, which, in the present context, can be no more than an assertion, is helpful for our purposes insofar as it suggests that the psychodynamics put into operation by viewing Degas's monotypes in 1880 would not have been significantly different from the psychodynamics generated by viewing the pictures today. This hypothesis is plausible, I believe, despite the media explosion of the past century that has disseminated countless images of women displayed as sexualized objects for male consumption. The more troublesome issue is to know what discourses, visual and verbal, would have been available in 1880 to make sense of the viewer's response, to define his horizon of expectations—a matter further complicated by our ignorance of who the intended viewer, apart from Degas himself, may have been. Might this viewer have processed his response in terms of a semiotics of caricature, an imagistic discourse with which Degas was thoroughly familiar?[42] Would such an identification of Degas's discursive vocabulary have elicited laughter and wit in response? Or might the viewer have related the monotypes to the rich tradition of popular erotic prints of women dressing, undressing, and getting in and out of baths, and seen them as a typically "realist" debunking of this libertine imagery?[43] Finally, might the viewer not have associated the small monotype pictures with the licentious photographs, often seen enhanced through a stereoscope, which men passed around among themselves for their private titillation? Would his perception of this cultural homology have undermined his ability to distinguish between Degas's images and intentionally pornographic representations? These questions must be raised, even though I know of no satisfactory way of answering them. The specific historical context of the works' reception is nearly impossible to interpret. However, from our present point of view, the images themselves seem to critically encode the cultural context of their production. The focus

of this critique, I propose to argue, is the commodification of gender relations.

Degas's brothel images sever the metaphorical bond between the artist-viewer and the signs of his creative triumph over the prostitute's erotic threat. Degas seems to invite the viewer to adopt the position of voyeur, but then he depsychologizes that position to such an extent that no desiring subjectivity appears to inhabit it. This is part of what makes looking at Degas's images of prostitution such an uncomfortable experience. The threshold position is familiar to the male viewer as one conventionally adapted to offer him the scary but alluring secrets of female undress. The small dimensions of the monotype, allowing it to be easily held in the hand, further suggest that these are fetishistic images made for a connoisseur's private enjoyment. But it is precisely the fantasy potential of these images of available female sexuality that Degas suppresses. He simultaneously grants the spectator a wish-fulfilling viewpoint and confronts him with images that, by denying his desire, empty his position of its subjective privilege.

This deprivileging operates through a generalization of the process of substitution that replaces psychological determinants with economic ones. Degas's brothel images offer the client-viewer an economic transaction that entails *his* substitutability, given that any other monied male could just as well assume his position. Any male can take advantage of the system of exchange that allows female sexual products to be purchased on the marketplace. Whereas both voyeur and fetishist assert their phallic domination by treating any individual woman as a mere provisional substitute, an inferior proxy for the real thing, the phallus itself appears to be substitutable when it comes to serve a purely instrumental function dependent on a prior financial transaction. Unlike Picasso's prostitutes, who promiscuously offer themselves to the voyeur as a vehicle for his own signifying practice, and whose polymorphous sexuality is a metaphor for the artist's own creative desire, Degas's prostitutes exist materially, phenomenally, as alienated products of a consumer culture. Unlike the courtesans in nineteenth-century art and literature whose sexualized bodies are camouflaged to serve the ostentatious male enterprise of dominating (female) nature, Degas's prostitutes cover nothing up. There is no masochistic self-debasement here— only the flesh made available to the Other, the body waiting to fulfill

its role as capital. "Commodities, women, are a mirror of value of and for man," writes Luce Irigaray. "In order to serve as such, they give up their bodies to men as the supporting material of specularization, of speculation. They yield to him their natural and social value as a locus of imprints, marks, and mirage of his activity."[44]

This is the locus and the activity that Degas illustrates. The would-be voyeur at the brothel threshold contemplates women who have been denaturalized and marked in an economy of exchange that offers little stimulus for his narcissistic fantasy.[45] In the place of castration, the perverse goal of his private voyeurism, he sees commodification, the sign of woman's exchangeability in a system of value established to maintain the hegemony of his sex.[46] The four prostitutes in *Waiting* (Figure 32) are sprawled naked, or nearly so, on a couch in a brothel salon. Their faces have almost no particularity; their heavy, bloated bodies are crudely outlined; the strongly emphasized sexual triangle repeats itself in an insistent pattern that focuses the viewer's attention. There is no interaction among the women, or any narrative content apart from their passive waiting for a client to appear. The negative space of the carpet is echoed in small by that of the pubic areas, setting up an analogy between the common usage values of the living and the fabricated, the sexual and the material. The abstract formalism of the four pubic triangles suggests woman's generic subjugation to an ideology that transforms her body into the sign of social relations among male consumers. Despite their frontality and uninhibited exhibition, these brothel inmates are not posing seductively for the benefit of the male viewer. They do not invite the fetishizing male gaze any more than the sensuously self-absorbed bathers do. They reflect back to the viewer not so much the power of his private privilege as the discomforting impersonality of his ideological position. The dislocation and disembodiment of the observer's viewpoint that Armstrong analyzes in *The Tub* is also apparent in *Waiting*, where its function as a reflection of the depersonalizing impact of ideology makes itself forcefully felt. We look down and across at the four prostitutes from a kind of floating dematerialized spatial perspective that suggests the way ideology abstracts the individual and asserts power through invisibility and absence.

This analysis helps explain why Degas's brothel images, despite their sexual explicitness, are not pornographic.[47] Pornographic

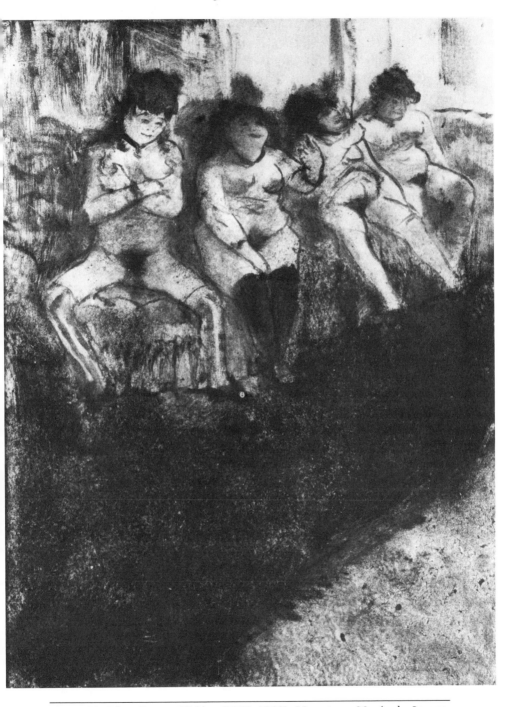

Figure 32. Edgar Degas. *Waiting* (1878–1880). Monotype. Musée du Louvre, Paris.

imagery is constructed to suggest woman's desire to submit plea-surably to phallic power. She is seen as complicitous in the display of her sexuality, which is offered to the male viewer as a fantasized extension of his own erotic body, as a narcissistic gift. Thus, if a woman is shown masturbating in a pornographic picture, she is not only an object of voyeurism but also of narcissistic identification, her orgasm becoming, in fantasy, a function of male self-enjoyment. In contrast, when Degas portrays women masturbating, as he does in a number of the monotypes (see Figure 33), he short-circuits the process of identification, cancels any illusion of female complicity, and makes the sexual gesture seem entirely banal, a casual pastime.

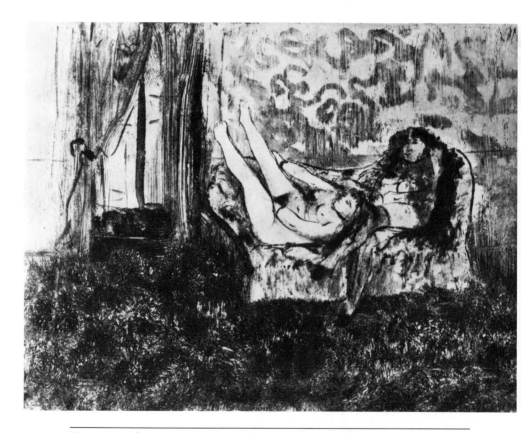

Figure 33. Edgar Degas. *Siesta in the Salon* (1878–1880). Monotype. Private collection.

Whereas pornographic representation assumes woman's depen-
dence on the phallus as access to pleasure, Degas shows women
whose sexuality is an autonomous behavioral function they perform
among themselves. There is no invitation to mastery here: these
prostitutes have found a means to survive objectification by
becoming the agents of their own *jouissance*. The material space
appears to absorb the female bodies into its splotchy, amorphous
texture rather than to articulate their privileged position as figures
of erotic fantasy.

This absorption does not denigrate or degrade the women. They
actually seem to gain in strength through their assimilation into an
unthreatening, comfortable world of things, as if their reification
involved a kind of detached enjoyment, on the artist's part, of the
ideological pressures conveyed in their representation. I hypothesize
this enjoyment much as, in the spirit of Benjamin, I postulated
earlier a certain empathy in Manet for the commodity status of the
prostitute. In my reading, Manet's monumental *Olympia* and Degas's
pocket-sized monotypes both relate critically to the chauvinist cul-
tural assumptions of their viewers, confronting those viewers with
the reifying effects of their sexual prejudice, and sympathetically
perceiving charm, as Benjamin says, "even in damaged and decaying
goods."[48]

To summarize my argument so far: Degas's brothel monotypes
appear to address the male viewer's social privilege, to construe him
as a voyeur, and to cater to his misogyny. They appear, in other
words, to construct the spectator as a bourgeois psychological subject
who desires his (phallic) self through the (castrated) other. But they
undertake this construction duplicitously, the better to dismantle the
voyeur's privileged position, depersonalize it, and reveal its primarily
social determination. The viewer's imaginary domination is short-
circuited by the confrontation of a psychologically constructed sub-
ject position with ideologically constructed objects of desire. Miso-
gyny, cruelty, disdain—attitudes often attributed to Degas as if his
art were a space of self-representation—can more accurately be
interpreted as functions of the capitalist ideology that defines and
confines woman's value in representational practice. That confining
definition is the materialist counterpart to the Mallarmé-Valéry ide-
alist conception of the ballerina who is not a woman. On one side
is a female body made useless in daily life so that it can become the

instrument of the male poet's "corporeal writing"; on the other is a female body whose value is produced and consumed in its daily exchange among men and whose being is inscribed by the marks of that commerce. Valéry participates in the repression of the female sexual threat: he kills the medusa by lifting her out of the water into the mortal air of metaphor. Degas exposes the material effects of this repression. As against the misogynist identification of woman with her inherent mutilation, the horror that must be dis-regarded, he sets a sympathetic identification of woman with her social and historical commodification. Degas suggests that the Medusa's look is no more than the reflection back to the male viewer of his own initial gaze, which paralyzes, objectifies, and commodifies woman. This gaze is the vehicle not of Degas's private obsession but of his uneasy awareness of his participation in a hegemonic ideology driven by sexual phobia. He displays the construction of his own spectatorship as historically engendered in misogynist social practices.

The continuing power of these practices accounts for the appeal of the critical tradition identifying Degas with misogyny. Unwilling to acknowledge the discomforting ways in which Degas's images of prostitutes expose the Medusa gaze of patriarchal ideology, critics have preferred to imagine Degas implicated in the very aggression he unmasks. A number of biographical anecdotes have been cited to "prove" Degas's disdain for women: in 1869 Berthe Morisot reported to her sister that Degas once sat down beside her and, instead of courting her as she expected, began a long commentary on Solomon's proverb "Woman is the desolation of the righteous";[49] Manet once commented to Morisot that Degas "lacks spontaneity; he isn't capable of loving a woman, even less of telling her that he does or of doing anything about it";[50] Degas remarked to George Moore, possibly in regard to the pastel entitled *The Tub,* that this image shows "the human animal taking care of herself, a cat licking herself."[51] But such contemporary testimony proves only that such statements were once interpreted as evidence of misogyny and that they still can be read as part of a historically identifiable misogynistic discourse. Placed in a different context of reception, these statements may take on quite different meanings. Thus, Norma Broude has convincingly demonstrated that Degas's insensitivity to the traditional manifestations of female charm may have been a deliberate

iconoclastic gesture that, far from expressing his desire to debase women, reflected his conviction that strong women never conform to conventional ideals.[52]

The biographical evidence thus cuts both ways, and Degas's supposed misogyny, as Carol Armstrong has acutely observed, becomes a part of the "myth" of Degas, deliberately constructed by the artist himself and then elaborated by his biographers.[53] The essence of the myth is enigma, opacity, isolation, withdrawal, repression. Degas's life was lived self-consciously on the margins of life and hence of the narrative forms created to make it accessible and legible.[54] Even the artist's class background is contradictory: his family was proud of an aristocratic lineage that was actually an invention;[55] his father and brothers were bourgeois bankers and wine merchants, whose adoption of a genteel *Ancien Régime* lifestyle was a major cause of the collapse of their family banking enterprise. Acquaintances often found Degas excessively dry and orderly—"a notary, a bourgeois of the time of Louis-Philippe," said Gauguin.[56] He was elitist and refined in his tastes, nationalistic and conservative in his anticapitalist politics. Yet he enjoyed the social mixtures and ambiguities of popular life in cafés and on the boulevards, was enthusiastic about new technologies (photography, for instance) and, inevitably, participated in the commercial market for art.[57] In brief, an analysis of Degas's class offers no more coherent an explanation of his subjectivity than do the biographical anecdotes adduced to construct the story of his life. We are left with fragments and glimpses, often contradictory and enigmatic, with deliberate mystifications and staged self-effacements.[58] In this context of dissolving figurations, my critical reading of Degas's alleged misogyny as his critical reading of a misogynistic ideology seems far too stable a hermeneutic construction.

What if the male viewer, whom I have been imagining uncomfortably self-conscious about his complicity in the exploitation of women, actually felt quite at ease with the marks he sees of her subjugation?[59] Could not the flattening of the prostitute's body into a common-place of male sexual privilege serve to reinforce, rather than subvert, the viewer's satisfaction with patriarchal gender arrangements? Even if Degas's images frustrate a specifically voyeuristic desire, they still might be felt to offer the misogynist the pleasure of inscribing the signs of patriarchal economic hegemony

on the female body. Perhaps the viewer's castration fears need not be overcome by the metaphorizing displacements of psychic defense, precisely because capitalist exploitation offers a still more alluring— since more objectively verifiable—means to triumph over them. Considerations such as these appear to bring us full circle: the distinction between voyeuristic modes of domination and economic ones is impossible to maintain, given that woman's commodification may be appropriated in fantasy to gratify reactionary psychic impulses. Exacerbating this hermeneutic quandary is our ignorance of the circumstances in which Degas showed the monotypes to a few select friends. Is it not possible, as I suggested earlier, that he shared with them the pleasures of viewing female objects available for purchase and of building up a rich pictorial collection of these sexual commodities? And just what might have been the role of these pictures in Degas's private sexual rituals (assuming he had any)? How can we account for those monotypes reportedly destroyed by Degas's brother—monotypes that may well have portrayed explicit scenes of sexual activity? One of these that survived after being torn in two (Figure 34) shows, in the crudest outline, a woman in bed apparently performing fellatio on a man, while a second standing woman caresses the first woman's leg. Could such an image conceivably be integrated into our analysis of Degas's empathetic portrayal of female commodification in the brothel? The picture, in the primitive coarseness of its graphic mode, seems to have more of a documentary than a pornographic quality about it. But would it not then be appropriate to argue that to undertake such documentation is itself a sexist project?

There seems to be no way to reconcile these considerations with our earlier interpretation of the monotypes. Two perspectives appear to be constructed simultaneously by Degas's images. In the first, the viewer is made to feel guilty about the ideological impact of his gaze; in the second, the viewer finds his patriarchal prejudice reinforced. In the first, the misogynist recognizes himself as a desiring psychological subject in the mirror of his capitalist activity; in the second, the misogynist recognizes only the reward of that activity, the other denied her subjectivity and desire. The first perspective is reflexive and entails moral reflection about the viewer's participation in a prostitutional economy. The second identifies the viewer unproblematically with that economy and endorses his controlling

power within its system of exchange. The first suggests a materialist critique of the psychic mechanisms sustaining patriarchal ideology; the second embraces that ideology in its purely material effects.

The discomforting oscillation between these perspectives no doubt contributes significantly to the interpretative difficulty of Degas's brothel monotypes. However, this reading in terms of a final unde-cidability leaves an important element of the representation out of account. This is the de-eroticized power these female figures gain by their assimilation into a material world whose intransigent phys-icality is reflexively constituted at the level of facture. In Figure 32, for example, the dark ink that spreads over the upper body of the right-hand figure and extends over her left shoulder onto the wall not only blends her body with the ground of the couch and asso-ciates her with the similarly textured carpet but also reflexively evokes the materiality of her production, a production whose effects even the artist himself cannot fully control. The prostitute's body seems virtually obliterated by the pressures of her facture. It is as if her presence were being absorbed into absence, and as if her body,

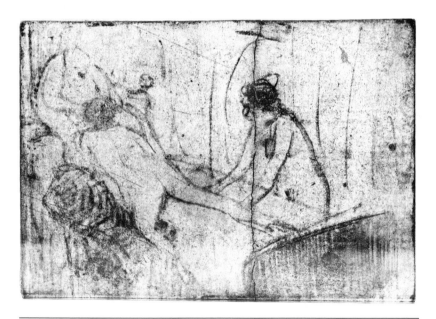

Figure 34. Edgar Degas. Zinc plate having served to print a monotype since destroyed or lost. Bibliothèque Nationale, Paris.

mutilated by the brute physical means of its depiction, were curiously privileged by its involvement in this mimetic negation. The monotype clients never participate in this reflexive process in quite the same way: their embodiment is a function of, and a response to, their gaze. We have seen that this response tends to erase the corporeality of the observing male presence as it retreats outside the frame and floats in space. The women, in contrast, barely emerge from their material surroundings. Their smudged, obscured forms reflect the crude technical means of their production. This reflexivity associates them with a nonhumanistic, modernist aesthetic practice that attempts to subvert the whole ideological structure of subjectivity within which our oscillating response to the pictures is generated. The dismembered, disheveled, "grimacing" prostitutes are the sacrificial victims of this subversion. They figure the modern precisely insofar as their subjective privilege is denied and their bodies are reified as facture. Far from expressing Degas's misogyny, the thumbprints, smudges, blots, and other traces of his gestural life that efface and disfigure the prostitutes' bodies constitute a history of his identification with these mutilated forms. The marks that we have read as signs of the prostitute's commodification are also material residues of Degas's creative desire to attack the norms of representational practice. The loss of full artistic control that he deliberately solicited by his choice to work in the monotype medium now appears as a move toward an aesthetic of randomness, whereby effects due to production technology displace the artist from the immediacy of his creative relation. The loss of immediacy thematized in the gender dynamics of the pictures might consequently be seen to reflect the artist's experimental distancing and detachment from his medium. For the viewer, no longer morally implicated, the difficulties of formal apprehension then come to displace the dilemmas of ethical judgment.

But this displacement remains problematic. The reflexive emphasis seems deviously perverse, granting Degas's brothel inmates strength by insisting on the aesthetic value of their objectification. The strategy could be viewed as a materialist version of Valéry's sublimation of the medusa into a high-flying balloon: here woman's threat is neutralized by her absorption into ink. And so the interpreter's oscillation continues, now between at least three

perspectives. Degas is reported to have said that "a picture is a thing that requires as much craftiness, malice, and vice as the perpetration of a crime."⁶⁰ My detective work has followed a few of the twisting trails of Degas's transgression. The crime, if there has been one, remains provocatively obscure.

: : :

The last great French painter of prostitutes in the nineteenth century was Toulouse-Lautrec, a fervent admirer of Degas, from whom he borrowed a number of themes and motifs, and a friend whom Degas advised, criticized, and praised in his formative years (later, as so often with Degas's friendships, the master, perhaps recognizing in Lautrec a potential competitor, subjected his pupil's work to his characteristic irony and sarcasm). Lautrec may well have been among the select few to whom Degas showed his brothel monotypes, making all the more ironic the older man's last reported comment about his follower's work: "It all stinks of syphilis."⁶¹ I will discuss Lautrec only briefly here, first to evoke the milieu of luxurious brothels he portrays and then to suggest some of his significant differences from Degas.⁶²

Whereas it is unclear just how extensive Degas's brothel experience was and of what precisely it may have consisted, Lautrec made no secret of his involvement with prostitution. In the years 1893 and 1894, among the most productive of Lautrec's career, he actually lived a good part of the time in two of the most extravagant Parisian *maisons*, the first located in a seventeenth-century *hôtel particulier* on the Rue d'Amboise, the second in a stalwart bourgeois townhouse on the Rue des Moulins, not far from the Bibliothèque Nationale. These establishments represented the upper echelon of those *grandes tolérances* that remained successful at the turn of the century, when many of the smaller, less pretentious brothels had been forced to close. They were extremely well-run businesses, operating according to a strict schedule and rigid rules of conduct. (Lautrec liked to tell the story of a madam reprimanding a licentious inmate with the exclamation, "Come now, where do you think you are anyway!") The Rue des Moulins had rooms lavishly decorated to please every taste, in numerous styles—Chinese, medieval (specially equipped for torture rituals), Louis XV (furnished with an ornate bed), Napo-

leon III, and so forth. One room may have contained La Païva's famous bed, acquired when her mansion on the Champs-Elysées was sold in 1893. There were mirrors on ceilings and walls, brocade, satin, and silk wall coverings, paintings, sculptures, and bibelots everywhere. An extensive costume collection permitted inmates to dress according to a client's fantasies. Hence it was possible to encounter in the brothel's corridors a nun, a nurse, a bride in white, a widow in mourning, an Indian dancing girl, a kimono-clad Japanese, and a tamer of wild beasts, whip in hand. So exotic and showy was all this that proper society ladies came by to see what everyone was talking about, giving rise to Lautrec's quip, "Les plus putains sont celles qui visitent."[63]

The painter was perfectly at ease in this environment. Biographers tell us of his presiding at table, offering presents on birthdays, distributing huge bouquets of flowers, playing cards in the salon, writing letters for the illiterate, consoling the depressed in their rooms, to which he had free access when no client was present, witnessing lesbian embraces, being pampered in every way by *ces dames*, for whom the diminutive "Monsieur Henri" was a priapic spirit of gaiety and mirth. He even invited the madam to accompany him to a gala soirée at the Opera! Many of the prostitutes were his friends as well as his lovers. He appreciated each of them for her individual personality, which he tried to capture in numerous sketches made on location. Mireille, the favorite whose departure for Argentina Lautrec tried to prevent, Rolande, identifiable by her reddish hair, long upward-turned nose, and thin jutting chin, Marcelle, Lucie Bellenger, Elsa the Viennese—these women become recognizable as we look through Lautrec's drawings and paintings. During their days off, they often visited him in his studio, where he had them pose for his most ambitious brothel painting, *In the Salon of the Rue des Moulins* (Figure 35).

Despite obvious differences in size (*In the Salon* measures 110 by 120 centimeters) and medium, a comparison of this painting with Degas's brothel monotypes is instructive. Common to both is a lack of prurience or moral condemnation, a willfully detached and objective treatment of the subject matter. Both artists portray the prostitutes as isolated from each other within the space they share, not communicating among themselves, waiting. But Lautrec's women

dominate their realistically delineated space, the plush neo-Moorish salon of the Rue des Moulins, in a way Degas's do not. Whereas Degas characteristically adopts an elevated point of view from which he looks down and across at the women he surveys, Lautrec chooses a perspective that puts the viewer at eye level with the two seated women gazing out of the painting, and he grants the central figure an imposing mass. The rounded and circular shapes of the divans

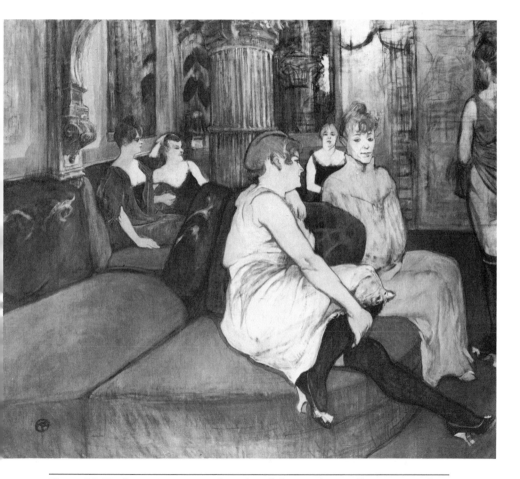

Figure 35. Toulouse-Lautrec. *In the Salon of the Rue des Moulins* (1894). Oil on canvas. Musée d'Albi, Albi.

reinforce through rhythmic repetitions the women's sloping shoulders and their curvaceous forms. Our attention is immediately drawn to the five sharply defined heads at the upper center of the picture. Each is a portrait (with a knowledge of other Lautrec works, we can identify Mireille in front, Rolande to the far left). Although there is a kind of blankness and passivity in their look, these women have retained their subjectivity and individuality. Their manner is almost demure, especially that of the blond woman, in a pink shift reaching up to her neck, who gazes out sidewise at us, hands folded in her lap. There may be a certain sadness in her facial expression, but there is also great dignity in her upright posture and undaunted gaze. Mireille's pose is more relaxed, her flesh more apparent under her gown, but her sensuous embodiment is not offered to the spectator's voyeurism as much as it is turned away from him, as if her stretched-out arm were barring the way to a more immediate apprehension.

The woman standing on the far right of the picture derives from a series of images Lautrec painted of prostitutes waiting for their periodic medical exam. In the final version of this scene (see Figure 36), he shows two women whose stooped posture, pathetic exposure of intimate flesh, and sad expressions reflect their humiliation in this demeaning ritual. The figure in *In the Salon of the Rue des Moulins* performs the same gesture as these women (she hoists her shift up in front), but the context of a medical exam is no longer implied, and the woman, severed in two by the frame, turns her back to the viewer. This figure may function as a kind of impersonal emblematic reference, which deliberately avoids any suggestion of pathos, to the humiliations and degradations to which the bordello inmates must submit. Her placement decenters the composition, shifting the balance toward the right and accentuating our awareness of the psychological isolation of each woman in her separate space.

This empathetic portrayal of individuality in isolation, of strength in vulnerability, is Lautrec's summarizing interpretation of the brothel.[64] Lautrec's prostitutes are not commodities. Their personalities have survived the objectifying force of the capitalist transactions to which Degas shows them succumbing. Lautrec celebrates this survival, but he also illustrates the psychological toll it has taken in alienation, apathy, fatigue, and humiliation.

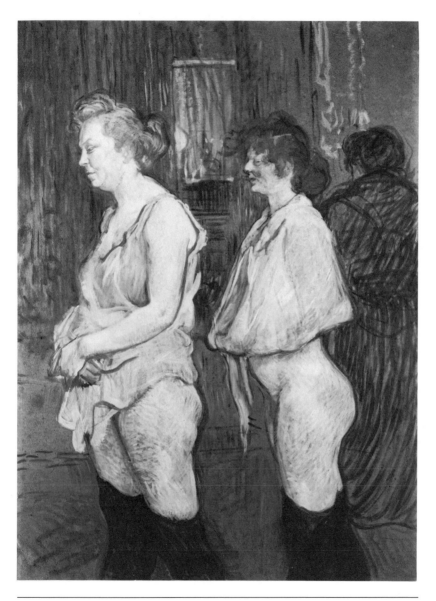

Figure 36. Toulouse-Lautrec. *Rue des Moulins, 1894* (1894). Cardboard mounted on wood. National Gallery of Art, Washington, D.C.

Decomposing Venus: The Corpse of Naturalism

"*E*st-ce que je suis méchante, moi?"[1] Nana's question is rhetorical: she expects her interlocutor, the go-between Labordette, to agree that she is innocent of the incredible devastation caused by "a little of her delicate nudity, this shameful bit of nothing [*ce rien honteux*]" (*N*, 1467). One of the peculiar effects of Zola's novel is that the reader may well have a harder time disagreeing with Nana's protestation "Moi, je n'y suis pour rien!" (*N*, 1469) than might have been expected, given the catastrophic carnage surrounding her ("the raging fire that had killed Vandeuvres, the melancholy of Foucarmont lost in the China seas, the financial disaster that had reduced Steiner to living like an honest man, the satisfied imbecility of La Faloise, the tragic collapse of the Muffats, and the white corpse of Georges, now watched over by Philippe, who had come out of prison the day before"—*N*, 1470). How can we not condemn a woman who has been responsible for such disasters?

Zola maintains our sympathy for Nana by suggesting that her *moi* and the *rien* of her sexual organ are independent of each other, the organ alone being the agent of death: "While her sex rose in a halo of glory and blazed down on its prostrate victims like a rising sun shining down on a field of carnage, [Nana] remained unconscious like a splendid animal, ignorant of the havoc she had wreaked, as good-natured as ever [bonne fille toujours]" (*N*, 1470). It is a surreal, hallucinatory image that the narrator offers here: Nana's sexual organ takes on mythic proportions, and is endowed with a destruc-

tive intention, while her self, her *moi,* is portrayed as a healthy animal, conscious only of elementary bodily needs: "She remained big and plump, wonderfully healthy and wonderfully gay, clean, wholesome, with a brand-new look as if she had never been used" (*N,* 1470). Zola seems to encourage us to like Nana, a kind of pristine creature, childlike, robust, playful, "bonne enfant" (*N,* 1118), while he solicits our horrified disgust for her carnivorous vagina.

Zola had already stressed this division in Nana's character when he wrote up a summary card describing her for his preparatory dossier. *"Bonne fille,* that's what dominates everything," he notes. "Follows her nature, but never does harm for harm's sake, and feels sorry for people . . .—With that, ends up regarding man as a material to exploit, *becoming a force of nature, a ferment of destruction, but without wanting to, by means of her sex alone and her strong female odor,* destroying everything she approaches, and turning society sour just as women having a period turn milk sour. The *cunt [cul]* in all its power; the *cunt* on an altar, with all the men offering up sacrifices to it. The book has to be the poem of the *cunt,* and the moral will lie in the *cunt* turning everything sour."[2] This sketch seems to bear out Nana's claim that her will has been for naught in the harm she has caused: her cunt is at fault; its nature is different from hers, and in a sense she is as much its victim as are her lovers.

But how can this dichotomy be maintained? How can Nana, in following her nature, be simultaneously "bonne fille" and "ferment of destruction"? The journalist Fauchery's article on "The Golden Fly," a key document for the interpretation of Nana's character that incoporates many phrases from Zola's preliminary sketch, perpetuates the confusion by suggesting that she is both a perfectly natural, healthy product of her environment and a deviation from normal growth. Fauchery writes of Nana's having been nurtured on the rich organic manure of the working-class slums and having developed into a magnificent specimen of womanhood. If she "corrupts and disorganizes Paris," it is "without wanting to," her effect being no different from the curdling that some menstruating women cause in milk.[3] Yet Nana's capacity to turn elements of society sour is not limited to monthly periods: here either the natural analogy no longer holds or we have to think of Nana as constantly menstruating or as being in some kind of equivalent physiological state. Her blood,

moreover, is "tainted by a long inheritance of poverty and drink, which in her case had taken the form of a nervous derangement of her sexual organ [*de son sexe de femme*]" (*N,* 1269). Suddenly Nana no longer seems so healthy: at her sexual core she is degenerate, deviant. The images of fertile organic decomposition that had made us think of her as a vital force of nature now seem instead to be connected to a fantasy of death, excrement, and disease. At the end of the article Nana is pictured as a fly "flown up out of the dung, a fly that absorbed death from the carrion left by the roadside" (*N,* 1270) and poisoned anyone on which it settled. The fly is a natural image, but, like that of Nana's sexual organ dominating the battle-field, it gives to her sexuality a kind of disturbing independence from the well-nurtured body of a "bonne fille."

It is as if Zola were reading Nana simultaneously within two opposed interpretive frameworks, both fantasmatic, both claiming biology and physiology as the ground for their analyses of female nature. We saw the beginnings of the link between fantasy and physiology in matters of prostitution in Parent-Duchâtelet, great advocate of the fertility of excrement, courageous investigator of the derangements of prostitutes' sexual organs. But it was not until the second half of the nineteenth century that the "naturalist" discourse on woman became dominant in such fields as biology, psychiatry, medicine, criminology, and sexology. This is, of course, a complex subject that exceeds the limits of this study. But since I want to argue that what is most original and powerful in Zola's treatment of prostitution is his manner of dramatically heightening and super-imposing the double vision of woman's sexual nature that he inherited from contemporary naturalism, it will be useful to look back briefly to the creator of that vision who influenced Zola more than any other: the historian Jules Michelet.

Michelet wrote his two books on women, *L'Amour* (1858) and *La Femme* (1859), when he was in his early sixties, interrupting his work on the massive *Histoire de France.*[4] The premise of both books is that women in France are neglecting their proper roles as house-keepers and mothers—for a variety of reasons that Michelet lists, among them the temptation to add to miserable wages through occasional prostitution, the desire of vain working-class women to be chic like their superiors, scaring prospective husbands by their spendthrift ways, and the too great independence of bourgeois

women who want to control their own property. Michelet's social goal is to educate women to acknowledge their dependence on men and the natural fulfillment of their biological destiny in marriage. He considers his project as liberating, since he imagines it to be based on recognition of, and admiration for, female difference. His authority for defining that difference is science, "mistress of the world," which will "rehabilitate woman and clear her of guilt" (*A,* 439), the nefarious legacy of Christian denunciations of her impurity.

Putting the scientist in the place of the priest, Michelet directly attacks the primary source of the stigma of female impurity: menstruation. Chemists, he declares, have found menstrual blood free of any harmful contamination. And physiologists have proven that this blood is not a sign of morbid loss but rather of beneficial productivity: it is the result of the ovary's spontaneously tearing itself open to release the egg into the uterus, where fertilization takes place. This theory of spontaneous ovulation was developed in a work of 1847 by a friend of Michelet's (and student of Flaubert's father), Félix Archimède Pouchet, who based his work on Ernest von Baèr's 1827 discovery of the ovum in women.[5] Though crucially wrong as to the timing of ovulation, Pouchet's theory served to correct earlier notions that man had the primary role in procreation (it had often been maintained that an egg was produced only in direct response to male sexual stimulation). Scientific proof that women had the independent potential to create new being was crucial to Michelet's campaign to rehabilitate the weaker sex. Science also afforded the historian new evidence of women's participation in the universal pattern of all animal life: Pouchet and others interpreted the menses as exactly equivalent to the animal condition of being in heat. "The assimilation of the menses to heat that I see in Béraud-Robin, Burdach, etc. [authors of works on physiology]," declares Michelet in a diary entry for June 5, 1857, "betrays the very important role of natural fatality in every woman's life. Before, after, nature wills that she be wiped out [*effacée*] by blood and dominated by a feeling for the species, at the disposition of the male."[6]

Thus Michelet, like Zola, portrays woman as a force of nature whose essence is menstrual blood. But whereas Zola associates this bloody flow with destruction and degeneration, Michelet celebrates

its connection to fertility, birth, and woman's absolute alterity. Michelet protests against the "impious" usage that has made the word "cunt" (*con*) a term of abuse, whereas this organ is "not only the propagator of nature but the conciliator, the real basis of social life for man. And for all of nature. Example: the cunt of flowers, which not only links flowers among themselves, but also flowers and insects, and then, through honey, flowers, insects, and superior animals" (*JO*, II, 331). Vegetable, animal, and human realms are conjoined in a flowing, continuous harmony of productive sexuality. The sign of woman's place, *effacée*, in this harmony is her bleeding wound.

Given our earlier evocation of Valéry's fantasy of medusas reversing themselves shamelessly to expose their gaping sexual organs, it is interesting to contrast Michelet's picture of the medusa in *La Mer* (1861). Like Valéry, Michelet describes this "transparent creature . . . with a singular grace"[7] as if it were a woman, but unlike Valéry, he finds nothing terrifying about her. She does not appear to provoke any castration fears. Coming across a medusa upside down on the dry sand, Michelet imagines that he is seeing her sexual organs, "those fine hairs that are her organs for breathing, absorbing, and even loving," but his fantasy is entirely engaged in picturing her as wounded, vulnerable, acutely sensitive, with "a notable susceptibility to suffering." He imagines her as an embryo sent out too soon from the mother's protection, an animal still very close to the vegetable world, barely able to survive on her own. This frail, delicate sea creature resembles Michelet's conception of the human female, who is, he claims, almost perpetually ill, an invalid fifteen to twenty days out of the cycle of twenty-eight. It is a startling change of perspective: on the level of everyday temporal experience, Michelet emphatically denies women the power he grants them on the level of myth when he associates their menstrual cycle with cosmic rhythms and the circulation of vital fluids. Only on the basis of woman's acceptance of her biological destiny, of the "grande fatalité" (*A*, 16) that determines her as a dependent, sickly creature, can her temporal being become emblematic of a redeeming connection between history and nature, between the linear time of the present and the cyclical, repetitive rhythms of the universe.

Herein lies the crisis of the mid–nineteenth century, according to Michelet: women are reacting against their natural destiny, causing

a rift to open between the historical moment and natural continuity. Contemporary women are, like Nana, nervously deranged. "The brain is not directly attacked, but it swims, it floats, as a result of the enervation of the inferior organs" (*A*, 435). This is the century of illnesses of the womb, declares Michelet (*A*, 4). And like Parent-Duchâtelet, he solicits knowledge of these matricial deformities from "someone who knows a lot about them, the sister of love: Death" (*A*, 13). Full of pity for these unfortunate women, mostly suicides who have taken their lives during their menstrual crises, for lack, Michelet supposes, of the love and protection of a good husband, he aggressively dissects their bodies. "Just dissect," he advises his readers, reminding us of Flaubert's praise for the beneficial effects of a visit to the morgue. "In a moment you will understand and feel everything" (*FE*, 77). The female corpse will teach the courageous male explorer the secrets of life. And, if he's lucky, he may find as remarkable a proof of the nineteenth century's corruption—such as the stone Michelet's friend Dr. Béraud discovered in the womb of a poor, neglected working-class woman (*FE*, 78). Visual evidence that menstrual blood is drying up, that wombs are atrophying.[8]

Although he does not often use the term "hysteria," Michelet's identification of woman with her womb ("La femme, c'est la matrice"—*JO*, II, 30), and his consequent determination that both her moral and physiological disorders originate in the abnormal function of this organ, echo ideas about hysteria that date back as far as Egyptian and Greek medical literature. Plato, for instance, describes the womb as an animal longing to generate children, which, if it remains barren too long after puberty, "is distressed and sorely disturbed, and, straying about in the body and cutting off passages of the breath, impedes respiration and brings the sufferer into the extremest anguish and provokes all manner of diseases besides" (*Timaeus*, 91c). Michelet may not have believed in the womb's capacity to displace itself within the body, but his picture of the restless, nervous modern woman, unstable and frivolous in her multiple desires if she is from the leisured classes, underpaid, anxious, and isolated if she is from the working classes, conveys a similar sense of hysteria's typical symptomatology. Dr. Prosper Lucas, whose work on heredity *Traité philosophique et physiologique de l'hérédité naturelle* (1850) profoundly influenced both Michelet

and Zola, strongly endorsed the preponderant medical opinion of his time that "it is always direct or indirect stimulation of the mediate or immediate apparatus of sexuality that engenders hysteria and gives the illness its specific type."[9]

Michelet's prescription for curing this disease of an improperly stimulated female sexual organ was the classic advice, sanctioned by centuries of patriarchal control over women's bodies: marry, get pregnant, have children. He fantasizes disastrous consequences for woman's failure to obey the laws of her biological destiny: history will become a prey to degenerative heredity. "This is the punishment," declares Michelet: "an ailing woman will only give birth, from her aching breast, to a sick child who, if he lives, will always demand, as fatal relief for his native enervation, the enervation of alcohol and narcotics. Supposing that, by ill-chance, such a man should reproduce himself, he'll have from a still more ailing wife a still more enervated child. Better that death come as remedy and radical cure" (*A,* 4–5). This devastating vision of "neurosis of the uterus" (the famous psychiatrist Esquirol's definition of hysteria, quoted by Lucas—II, 720), corrupting the blood and semen of generation after generation, illustrates Lucas's contention that hysteria is a virulently hereditary disease. (This claim is reinforced by numerous medical authorities in the second half of the century. In 1859 Dr. Pierre Briquet comes up with a precise figure: "Subjects born of hysterical patients are, by heredity, twelve times more predisposed to hysteria than subjects born of nonhysterical patients." Dr. Jules Déjerine, writing in 1886, makes the confident general assertion that "hysteria can be considered the most hereditary of the neuroses." Briquet, it might also be noted, contested Parent-Duchâtelet's opinion that hysteria was infrequent in prostitutes. He studied 197 registered prostitutes at St. Lazare prison and found that, according to his diagnostic criteria, 106 were hysterics and 28 more "impressionables.")[10]

We can see now that Michelet's scientifically grounded study of female sexual physiology leads him to mutually contradictory, if equally fantasmatic, interpretations of woman's nature. The first interpretation is holistic: woman's cunt is analogous to the generative organs of flowers and insects; the blood that circulates in and through her is a vital, fertile fluid, like the sap of trees and the mucus of the sea; her menstrual cycle determines her proper role in the

social order as passive, dependent, and maternal; her primary function in regard to her husband is to offer him revitalizing contact with the eternal rhythms of universal life. The second interpretation associates woman with a violent breach in the homogeneous continuum she simultaneously sustains. Her sexual organ is deranged, abnormal: she is a hysteric. Her blood is diseased, the carrier of an hereditary taint: "The purest, most virtuous woman," declares Michelet, "has a germ in the blood, . . . which sooner or later will betray itself . . . The dart of love she sends you in her heart-breaking smile is the shooting pain of the ferocious cancer devouring her bosom" (*A,* 334). Far from being an emblem of wholeness, this woman is fragmented, lacking, and she derives from her lack the nervous energy of desire. By refusing to accept the consequences of her biological weakness, she becomes, in Michelet's fantasy, an emasculating, violent creature seeking to revenge her own mutilation by mutilating others. Her menses do not teach her a lesson in masochistic suffering; they provide the force of animal heat necessary to fulfill her cerebrally mobile desires. This woman is not the opposite of man: her hysteria erodes the absolute difference between the sexes that Michelet sets out to define and celebrate. Instead of comforting man by offering her otherness as a mirror of his narcissism, she threatens to subvert his cherished definitions of masculine identity, foremost among which is his command of history and of its handmaiden, death.[11]

These two interpretations do not have the distinctness in Michelet's texts that my exposition has accorded them. Indeed, it is the remarkable way that these apparently opposed views of woman's nature interpenetrate and contaminate each other that gives these texts their peculiarly disturbing quality. Michelet conveys obsessional conflict through a lyrical, poetic style that works to integrate the world organically through synthesizing metaphors and verbal repetitions. The female sexual body, while it provides the origin and basis of all metaphoric unification, also threatens the male lyrical impulse with the terror of castration and the nightmare of hysterical degeneration.

Michelet does not specifically identify this threat with prostitution, although he frequently evokes the availability of venal exchange as a reason for the decline of marriage in the working class. Given the importance of the prostitute in the contemporary discourse on

Woman, it is surprising that she does not play more of a role in Michelet's fantasmatic economy. It may be that her dominance as a figure of modernity constituted so evident a denial of his myth of fertile, regenerative motherhood that he deliberately eliminated her from his social vision (she is not even mentioned in his patriotic book of 1846, *Le Peuple*). In any case, the ease with which the prostitute could be integrated into Michelet's thinking as emblematic of woman's deranged sexuality is demonstrated by her importance in the writing of his good friend and intellectual ally, Pierre-Joseph Proudhon (1809–1865). Proudhon's posthumous book, *La porno-cratie, ou les femmes dans les temps modernes* is more polemically misogynist than are any of Michelet's apparently gallant and com-passionate writings, but Proudhon is simply taking his colleague's arguments to their extreme conclusion. Thus is produced a clear-cut dichotomy between woman as pupil, housekeeper, and mother and woman as free-lover, whore, and "intellectual nympho-maniac."[12] The latter, according to Proudhon, is taking over in France: "We are tending toward universal prostitution," he declares. Bourgeois daughters slip out at night for a little excitement, working women pick up extra money on the side, professionals are omni-present. Performing love without feeling, depraving their senses, these women discover "the principle of pleasures *contre nature.*" And by emancipating themselves and associating often with men, they lose the inherent, natural characteristics of their sex and are masculinized. Thus, the prostitute becomes for Proudhon the model of any *femme émancipée.* He reproaches Parent-Duchâtelet for having neglected to stress how prostitutes "deform themselves, take on the look, the voice, and the manner of men, and retain from their sex, physically as well as morally, only the grossly material, the strictly necessary." It is a hysterical picture: female sexual organs attached to otherwise male bodies. And it is typical of the fear of a breakdown in sexual difference that underlies the naturalist insistence on har-mony, continuity, and cyclical recurrence. Such insistence, as I hope is becoming clear, is part of what motivates Zola's description of Nana as "bonne fille," while his evocation of her detached sexual organ dominating the social battlefield is related to a vision of the hystericized, unnatural, prostituted body of a masculine female.

But before returning to Zola, we should take note of a few other developments that may have contributed to his fantasmatic con-

struction of the prostitute. These are the growth of feminism, the conservative backlash against prostitutes in the wake of the Commune, and the abolitionist challenge to the police regulation of prostitution.

Proudhon is responsible *a contrario* for giving the feminist movement in France, successfully stifled by various repressive measures taken by Napoleon III, a new lease on life. His misogynist rantings stimulated some of the strongest feminist writing to be published in the early 1860s. *La pornocratie*, for example, was written to counter attacks directed against both Michelet and Proudhon by Jenny d'Héricourt (*La femme affranchie*, 1860) and Juliette Lamber (*Idées anti-Proudhoniennes*, 1861).[13] Julie Daubié, the first woman to receive a French baccalaureate degree, published an impressive study in 1866, *La femme pauvre au XIXe siècle*, in which she attacks state sponsorship of vice, denounces the depravation of contemporary male youth, advocates penalties for the patrons of bordellos, and argues for the eventual closing of these vile establishments. These opinions were echoed by the leaders of the Republican feminist movement that emerged in the last years of the Second Empire and whose organ was the newspaper founded in 1869, *Le droit des femmes*.[14] Male reaction to this rather mild-mannered reform movement had hardly had a chance to martial its forces when the reported activities of Communard women—of whom 246 out of 1,051 arrested were prostitutes, according to the report of Captain Briot—confirmed the worst fears of the conservative bourgeoisie.[15] Since Communard steering committees had closed the *maisons de tolérance* and been slack about arresting streetwalkers, preferring to employ them at filling sandbags for the barricades, the violence of the Commune was widely perceived as illustrating the consequences of abolishing the regulatory system. Stories circulated about prostitute-*pétroleuses* setting fire to the prefecture of police and partially destroying its archives, about drunken prostitutes dancing in the "saturnalia" of the Rue Royale barricade,[16] and about the bloody extremism of their vengeful acts.[17]

Such stories not only played into the eager hands of the *police des moeurs*, which used them in the period after the Commune to justify increased powers of surveillance and arrest;[18] they also contributed to the reactionary discourse of the 1870s that blamed women's sexual derangement for what was perceived as a crisis in the health

of the national organism, a lesion in the unity of the body politic.[19] Typical of the blending in this discourse of freely interpreted science, especially biology and psychology, with hyperbolic personal fantasy is Hippolyte Taine's *Les origines de la France contemporaine,* of which the volume on the Revolution was published in 1878. Although Taine, an arch-conservative, considers the Revolution as the infamous precursor of the Commune whereas Michelet, a liberal social democrat, views the Revolution as the fulfillment of the nation's destiny, the two historians have similar attitudes when it comes to diagnosing the deviance of contemporary women. Taine sees women, especially those from the lowest classes, as natural leaders of violent uprisings because of their bestial primitive mentality and instinctual disposition to violence. "When a political idea penetrates such heads," he writes, "instead of ennobling them, it becomes degraded there; its sole effect is to unleash vices which a remnant of modesty still keeps in subjection, and free reign is given to lewd and ferocious instincts under the pretense of public good."[20] Taine imagines himself as a medical diagnostician analyzing the pathological body of modern France infected by alcoholism, syphilis, and nervous depletion, all illnesses fomented by female sexuality.

Taine's therapeutic perspective was shared to a large extent by the public health officials and medical experts who supported the regulatory regime in the 1870s and 1880s.[21] The causes of prostitution are seen by these authorities less as social and external (poverty, joblessness, lack of educational opportunity—the factors stressed by Parent-Duchâtelet) than as instinctual and innate: they list most often such determining causes as a lubricious temperament, an inordinate love of pleasure, a hereditary predisposition to debauchery. According to prevailing opinion, prostitutes are not so much victims of a deranged social order as they are agents of organic derangement. Given the spread of clandestine prostitution—at an all-time high, it was thought, in this period—the very virility of France was at risk. The ubiquitous availability of venal love lures young men away from the arduous responsibilities of family life and teaches them to prefer perverse and unnatural pleasures to the more banal fulfillments of conjugal love. Such ideas gave rise to widely shared fantasies of a declining population whose young men are morally and physically debilitated by vicious practices, quite likely infected by venereal disease, unfit for the rigors of war, and scornful of marriage and children.

Feminists, mostly bourgeois and liberal after the exile of the more radical, working-class Communard leaders, were as critical of the collapse of family life as were the misogynist leaders of the male reaction. Although it is evident that feminists would fight against medicalized stereotypes (women had small brains, were instinctually depraved, etc.), the degree to which Republican feminism in the 1870s and 1880s supported the traditional structures of middle-class marriage comes as something of a surprise. Indeed, so dominant a feminist issue was the restoration of stable family life, and so widespread the fantasmatic connection of prostitution to its decay, that feminists were easily persuaded by abolitionist arguments, once again at the center of debate in the later 1870s, that domestic values would benefit from the abolition of the entire regulatory system. What the feminists seem to have overlooked is that abolitionist leaders frequently indulged in misogynist polemics to support their cause, portraying *filles de maison* as savage animals, inherently depraved and vicious.[22]

The double vision of female nature displayed by some abolitionists is, as we have seen, no exception in the second half of the nineteenth century. Much about their program, spearheaded in 1875 and 1876 by the flamboyant English reformer Josephine Butler, was progressive and positive. They fought for the freedom of prostitutes in the name of every individual's right to liberty and equality before the law. No citizen, they argued, should be subject to arbitrary arrest, demeaning medical exams, and the dehumanizing exploitation of the bordello. The most persistent and articulate of the abolitionist leaders, Yves Guyot, declared with a kind of vague liberal and positivistic optimism that the liberated prostitute would internalize a proper moral code and contribute to social stability as a responsible wife and mother. The undefined hopefulness of this general program contrasts with the vivid intensity of the imagery of repulsion associated, to some extent by Guyot but far more abusively by his ally Louis Fiaux, with life in the bordello. Fiaux's *Les maisons de tolérance: Leur fermeture* (1892) reveals prejudices less overtly displayed in his earlier book *La police des moeurs en France et dans les principaux pays de l'Europe* (1888). Fiaux makes ample use of the medical discourse of degeneration. Madams, he suggests, belong to an atavistic type "in which the spirit of procuring is hereditary."[23] About bordello inmates, he writes that "among almost all of them [one finds] the psychology of a child, the distraction of a young savage, the mobility

and emptiness of a prehistoric brain still bathed in animality . . . Delirious alcoholics and hysterics, impulsives, paranoids [*persécu-tées*], nymphomaniacs, all the varieties of the unbalanced psychic keyboard pullulate in the brothel, for which the proletarian milieus of the cities have already prepared so many hereditary degenerates." This preparation is also conducive to the perversion specific to the bordello, lesbianism, whose unnatural practices Fiaux seems to relish telling in as much sordid, repugnant detail as possible, ending with the inevitable expulsion of the prematurely worn-out whore, "rotted [like Nana] with all the putrefaction amassed since nubility."

It is tempting to argue in Fiaux's defense that he was deliberately evoking fin-de-siècle fantasies of female degeneracy in order to further his cause of abolishing the tolerated brothels where that degeneracy thrived. But his rhetoric of abuse—prostitutes are called "animated filth," "a heap of excrement encased in human skin"[24]— conveys too passionate a personal involvement to make this inter- pretation plausible. It would seem rather that Fiaux, feminist activist and liberal reformer, was simultaneously a man obsessively afraid of active female sexuality. He worked for the liberation of women from the dissolute prisonhouse of the brothel, where crimes against nature come naturally, only the better to enclose them in the con- trolled prisonhouse of marriage, where the natural sexual order is realized for the benefit of society. As was the case with Michelet, woman belongs for Fiaux simultaneously to two opposed interpre- tive frameworks, both of which have "nature" as their master met- aphor. She is worthy of respect as an autonomous being to whom nature gave certain inalienable rights; she merits only disgust as a sexual being whose nature is inherently corrupt and degenerate. The two attitudes mix and interpenetrate, as they do in Michelet, the favorite plot for both men being their redefinition of the second interpretation in terms of the first—that is, their reclaiming of "fallen" female nature for the benefit of the organic integrity of family, nation, and even cosmos. It remains for us now to see just what kind of plot Zola concocts out of the mix of "natural" ingre- dients he inherits from his culture.

: : :

The climax of Zola's naturalist discourse in *Nana,* a passage that Flaubert called "Michelangelesque" in its power,[25] is the description

of Nana's decomposing corpse in the final paragraph. The passage is unforgettable for the sheer immediacy and horrifying detail of its images of putrefaction. Readers are likely to feel that the relentlessly clinical quality of Zola's repellent picture constitutes his long-delayed revenge against his fantasy of a devastating *femme fatale*. The reduction of the plump, healthy, good-natured Nana to "a heap of pus and blood" (*N*, 1485) appears to be a physiological rendition of poetic justice. What is inside Nana, her corruption, depravation, and perversion, has finally shown itself on the surface. The authority of novelistic closure dispels the disturbing illusion that Nana's splendid animal body, clean and wholesome, might justify her claim to innocence. Her suppurating remains now tell the true story, so the reader may feel. And that story has a historical dimension: the rotten corpse of Nana is symbolically analogous to the rotten body of Imperial France about to enter the disastrous war against Bismarck's Germany.

I propose to show that this morally reassuring reading is only partly valid and is crucially wrong in its opposition of Nana "bonne fille" to Nana purulent corpse. On the one hand, I maintain that both images belong to a single cycle of natural generation, corruption, and regeneration that constitutes a profoundly conservative ideological pattern subtending Zola's novel. On the other hand, I argue that the optimism of the biological model is undermined by an opposed psychological narrative that generates Nana's decomposing cadaver as the fantasmatic emblem of female sexual morbidity. Such morbidity not only cannot be recuperated for cyclical renewal but actually infects that cycle with a deadly virus. Let us analyze first how Zola implicitly recomposes Venus by integrating her into a plot of cyclical regeneration.

Michelet, we remember, exhorted his (male) readers to dissect (female) cadavers in order to gain knowledge of, and hence power over, the bloody origins of life. The bodies most rewarding for this task, Michelet notes, are those of women who killed themselves when their desire for love was greatest, during their menstrual cycles or during pregnancy, in spring when nature's rebirth intensified their sense of isolation and abandon (*A*, 14). The eager anatomist is grateful to this "funerary alluvion" (*A*, 16), for it enables him to establish the physiology of the womb at the point of woman's most fertile insertion into the natural cycle of generation. The value of

the scalpel is thus less analytic than it is synthetic and even mythic: dissection confirms the glorious unity of all generative organisms; the sexual organs of women, flowers, insects, and animals are all alike.

Now, probably no image for the literary stance of the realist or naturalist writer was more widespread in France than that of the anatomist dissecting a cadaver. In a famous cartoon by Lemot (Figure 37), Flaubert was pictured extracting organs from Emma Bovary's corpse, and subsequently all the major figures of naturalism were held up to public opprobrium as delighting in morbid dismemberment. In his journalistic writing, Zola himself liked to flout the public's taste for sentimental idealism, declaring that a good writer should "put on the white apron of the anatomist and dissect, fiber by fiber, the human beast laid out completely naked on the marble slab of the amphitheater."[26] Following these principles, though only in the field of representation, he requested his friend Céard to send him, for the portrayal of Nana's death, "an exact description, scientific and very detailed, of the mortuary mask of a woman who died of smallpox."[27] Céard, *désolé,* was not able to find such a mask; neither was he able to observe, as he had hoped, an actual cadaver of a smallpox victim at the Lariboisière hospital ("Be especially precise about the state of the eyes, nose, and mouth," Zola had requested.)[28] He did, however, send the master a weighty scientific volume, P. Toussaint Barthélemy's *Recherches sur la variole,* from which Zola derived his clinical picture. But all this concern for physiological accuracy, this dramatizing of the artist as anatomist and surgeon, obscures the broader context of Zola's scientific inquiry, which was a holistic vision of nature that continued to reflect its Romantic origins.

This genealogy is clearly revealed in Zola's *Le roman expérimental,* which is an application to literary production of Claude Bernard's *Introduction à la médecine expérimentale,* and was published in the same numbers of the journal *Le Voltaire* as the first installments of *Nana* (October 16–20, 1879). Zola cites with approval Bernard's remark that no scientist can hope to achieve anything without having worked in the "fetid terrain" of the hospital, amphitheater, and laboratory (*RE,* 77). Then he goes on to explain Bernard's idea that there is a vital *circulus* in nature, a notion close to Michelet's fantasies about the universal circulation of blood. "The muscular

Figure 37. Lemot. *Flaubert Dissecting Emma Bovary* (1869). Lithograph. *La Parodie.*

and nervous organs," writes Bernard, "sustain the activity of the organs that prepare the blood; but the blood in its turn nourishes the organs that produce it" (*RE,* 77). The circulus thus created, "a kind of perpetual motion . . . [in the] animal machine," can be disrupted only by the malfunction of a vital element. The study of such malfunctions is the domain of the experimental novelist: "The social circulus is identical to the vital circulus," comments Zola: "in society as in the human body a solidarity exists linking the different members, the different organs, among themselves, so that if one organ decays, many others are affected, and a very complex illness breaks out" (*RE,* 78). A determination of the causes of this illness—Zola cites as an example the amorous temperament of Balzac's Baron Hulot in *La cousine Bette*—allows for a narrative cure: once Hulot's "gangrene" has been eradicated, "or at least contained and rendered inoffensive, the drama no longer has a raison d'être, and balance or, better, health is reestablished in the social body" (*RE,* 78).

Implied here is that narrative has a teleology whose model is natural wholeness and integrity, vital flow and circulation in a closed system. Desire, defined as male in Zola's model, disrupts this system, deranging the social circulus. The function of narrative is to cure itself of the illness of male passion so that it can return to a state of natural balance, in which no stories need be told. The physiology of this state is nowhere more strikingly revealed, thought Zola, following Michelet, than in an expertly dissected female corpse laid out for inspection by the intrepid "examining magistrates of nature" (*RE,* 65). There is no evidence to suggest that Zola read this morbid display any differently early in his life than he did later. And a late novel such as *Fécondité* (1899) shows him extolling fertile wombs that produce bountiful offspring destined to strengthen the nation's health and extend its boundaries—for instance, by populating colonies in Africa. Zola's ideal woman may not be physically weak like Michelet's, but her mission in life is the same. Female fecundity absorbs and neutralizes the disruptive discharges of male desire and leaves the constantly pregnant mother no time for the distractions of Eros.

Nana is an antithetical figure: she is the neglectful mother of a sickly child, pregnancy appears abnormal to her, and she gives all her time to desire's deviant pleasures. But these actions do not

necessarily qualify Nana as an unnatural aberration within the body politic. After all, the conservative patriarchal ideology that Zola, in this context, can be said to underwrite defines the working class's functions within the social organism as libidinal sexuality, primitive instinct, and excremental release. A healthy society keeps these base functions in their proper place. The bourgeoisie and the aristocracy must repress and sublimate those lower urges to which the people give full reign. Hence, Nana is right to protest that she is being blamed for the failure of the upper classes to perform their duties within the organism. The fact that she has spread her ferment in their midst—a ferment that grows naturally in the manure of working-class life—is no more than a symptom of their lack of moral discipline. She is, as Zola writes in his notes, only "following her nature."[29] The virus that Nana has picked up in the gutter does no harm to the people of her own class: witness her affairs with Fontan and with Satin. It is a poison only if it circulates outside its natural milieu, which can happen only when the organism's resistances are down and the containing membranes become porous. Then it is as if menstrual blood had contaminated the vital circulus of the upper classes, infecting them with the germs of desire. This infection first takes hold when Nana appears naked on the stage of the Variétés theater and produces the effect of an animal in heat: "All of a sudden, in the good-natured child, the woman stood revealed, a disturbing woman with the impulsive madness of her sex, opening the unknown gates of desire" (*N*, 1118).

From this point on, Nana becomes the sacrificial victim of the circulus. She attracts desire to herself, absorbs its noxious effects, like the "bonne fille" she is, and, in true scapegoat fashion, is sacrificed to restore the health and balance of the social order, thereby allowing the novel to end.[30] Even as her poison invades the upper classes, she continues to represent a patriarchal model of social biology that only the weakness and degeneracy of the superior organs have allowed her to violate. Her body is the willing vessel for all the unrepressed sexual and excremental dross of the decadent aristocracy and affluent bourgeoisie, an accumulation that finally kills her: "It seemed as if the virus she had picked up in the gutters, from the carcasses abandoned by the roadside, that ferment with which she had poisoned a whole people, had now risen to her face and rotted it" (*N*, 1485). As Michel Serres has pointed out, the

model here derives as much from Pouchet's idea of the spontaneous generation of life from dead matter ("hétérogénie") as it does from Claude Bernard's organicism.[31] The origin of the circulus is death, abandoned carcasses, more precisely, abandoned working-class carcasses—such as those for which Parent-Duchâtelet designed dissection tables, such as those on which Michelet tried out his skill with the scalpel. From working-class death, a wonderful compost heap, arises the virus of working-class sexuality, essentially female, nourished by the ferment of decomposing matter (we remember Parent's spontaneously combusting *poudrette*). If this energy can be contained—the essential problem facing all our male specialists of the sexualized female body in the nineteenth century—the social organism will be healthy, and there will be no story to tell.

Had Nana remained a *fille à numéro* in a *maison de tolérance* it is unlikely that her virus would have started an epidemic. But she had the (bad?) luck to be exhibited before all of Parisian society gathered in a theater, which, its director insists, is a brothel. Soft, decadent, degenerate, the upper-class organism welcomes Nana's contagious virus as a means to further its corruption. Even aristocratic women are affected: Count Muffat's wife has a mole with curly hairs exactly as Nana does (hairy moles are a mark of degeneration in the female subject, present among 41 percent of prostitutes but only 14 percent of "normals," according to the pioneering fin-de-siècle fantasists of criminal deviance, Cesare Lombroso and Guglielmo Ferrero),[32] and the red silk upholstered chair in the countess's drawing room appears to Fauchery to signal "le commencement d'un désir et d'une jouissance [the beginning of a desire for pleasure]" (*N,* 1153). The virus transmits desire; desire furthers the circulation of the virus, which is a disease of the blood, a curdling and decomposition of the blood; and finally the circulus returns to its origin, now the symbolic body of the cycle's end, "this grotesque and horrible mask of death [*le néant*]" (*N,* 1483). Bravo, Nana! *Bonne fille!* Purulent, suppurating, decomposing, Nana's corpse figures the end of desire's infection. Granted, there will still be the disaster of the Franco-Prussian war, foreshadowed by the call "To Berlin! To Berlin!" But Nana's death seems to include it, as if the pustules that have spread over her face, taking on the grayish aspect of mud, were the traces inscribed on her sacrificial body by the invading armies.[33] Nana deserves the halo surrounding her death mask at the end: "Her

beautiful hair still blazed like sunlight and flowed in a stream of gold" (*N*, 1485).

Zola claimed that one of his primary goals in writing *Nana* was to protest against the false picture of vice conveyed by such sentimental versions of the courtesan as *Marion De Lorme* and *La dame aux camélias*.[34] But the reading I have just given of the novel, partial though it may be, shows that Zola's naturalist scenario, if not sentimental in the mode of Hugo or Dumas, demonstrably inscribes a very similar bourgeois patriarchal ideology. In this scenario, Nana does not die for love, like her golden-hearted predecessors, but her death is sacrificial like theirs, and the order it serves is the same that triumphs over Marion's and Marguérite's passionate devotions. Indeed, it was precisely such devotion that the autobiographical hero of Zola's first novel, *La confession de Claude* (1865), vainly tried to extract from his prostitute-mistress. Evidence suggests that Zola in his youth was imbued with the myth of the whore redeemed through love—he apparently tried to "save" a certain prostitute named Berthe with whom he lived in 1860–1861.[35] More revealing, however, is the picture he gives in this early work of the prostitute's refusal to play her assigned role in the male plot of redemption. The fascinating power of this refusal influences Zola's later treatment of the prostitution theme and suggests an alternate reading of sexuality and desire in *Nana*.

La confession de Claude is the story of a man trying to come to grips with his belief in the Romantic archetype of the prostitute re-formed (indeed, "revirginated") through love. The protagonist Claude, who speaks in the first person through a series of clumsily implausible letters to his brothers back home, is a young, idealistic writer recently arrived in Paris and living in abject poverty. Claude is seduced by the prostitute Laurence, with whom he subsequently falls in love, and he tries to educate and improve her, taking Didier's relation to Marion Delorme as his inspiration. But she refuses to let herself be made over, will not declare herself in love with him, and remains provocatively unresponsive, silent, and opaque. "I could not open that soul, could not enter into it, her heart and her thought escaped me . . . I was pressing a cadaver to my chest, an unknown thing, foreign to me, whose meaning I could not penetrate" (*CDC*, 85). Faced with Laurence's obstinate depravity, Claude has an "insatiable desire for virginity" and is obsessed with the vision of a woman so

pure that she would not even have been sullied by her dreams, not have been "deflowered by the demons of [her] nights" (*CDC,* 86). Such a woman would resemble Michelet's vision of the perfect wife (as well as the sentimental *grisette* figures of popular fiction). "She would live through me," Claude imagines, "would know only me, would have only memories coming from me" (*CDC,* 86). Although Laurence is the opposite of this compliant narcissistic creation, Claude continues to be attracted to her. He realizes that he is held by masochism: "I love her for all the sharp points she forces into my flesh" (*CDC,* 95). Finally, he manages to rid himself of his demon by passing her on to his friend Jacques and retreating into the conventionally sentimental role of nurse to Jacques's erstwhile mistress Marie, a true prostitute-with-a-heart-of-gold willing to love him sweetly even as she dies.

In his 1865 introduction, Zola declares that the essence of *La confession de Claude* "consists in the struggle between dream and reality" (*CDC,* 9), but a more accurate formulation would be that the book consists in a struggle with the way the dream/reality model produces conflicting interpretations of female sexuality. Claude is a mental prisoner of this hermeneutic dualism. "Dream" de-eroticizes the prostitute's body, reconstitutes it as virginal, and links it to natural purity. Laurence fulfills this vision during a pastoral interlude when she recaptures her youthful gaiety and innocence, appearing, like Nana, "as if she had never been used." In the dream, woman is a narcissistic extension of man; he creates her nature in harmony with (his interpretation of) Nature. This patriarchal mode of fantasizing woman's difference links Zola's early commitment to the virginal whore to his later endorsement of the vital circulus. Although the dream of saving fallen female nature can only be judged hopelessly literary and sentimental from the advanced point of view of science, Zola's scientific paradigm actually performs a similar rescue operation in reverse. Nana's decomposing corpse redeems her in terms of the biological model of the natural circulus just as Laurence's pastoral ecstasy, which fills her with "sap, youth, virginity" (*CDC,* 68), redeems her in terms of the Romantic fantasy of woman's natural purity.

Laurence's coincidence with the dream of redemption is, however, only temporary; after she has returned to her corrupt urban environment, Claude sees her once again as the embodiment of reality,

of a female reality that cannot be recuperated for male narcissism. Laurence's difference reasserts itself in terms of her independent desire and alien sexuality. Unknowable, unreadable, she remains impenetrable even when physically penetrated. She resembles in this respect the imperviously promiscuous heroines of the two short stories by Barbey d'Aurevilly that we analyzed in an earlier chapter. But whereas Barbey moves to dominate this powerful assertion of the female sexual body through complex literary-textual maneuvers, Zola puts the disintegrative effects of this assertion at the center of his narrative interest. It is this focus on the psychology of male sexual obsession that makes *La confession de Claude* something more than just another version of the classic realist procedure of exposing the false literariness of fantasy in confrontation with the harsh immediacy of experience. Zola shows that reality is as much a fantasmatic projection as is dream.

The medium of this demonstration is the prostitute's corpse. Early in the novel, Claude is called in to watch over the ailing Laurence, whom he has not met before but whom he knows to be a whore. As she tosses around in bed, she exposes a bare breast to his virginal gaze. Searching for a suitable image for the impression this brutal revelation makes on him, Claude compares it to "the sacred horror that overcame me the day I saw a cadaver for the first time . . . When I saw the blue face and the black open mouth, when death thus displayed itself in its forceful [*énergique*] grandeur, I could not turn my eyes away from the cadaver, trembling with painful pleasure, attracted by I know not what effulgence of reality" (*CDC*, 19). The language here is obviously indebted to the tradition of Romantic melodrama, but it has a psychological ground that gives complexity to what otherwise might be the mere repetition of a clichéd pose. Claude's fantasy transforms the live sexualized female into the internalized dead female, thereby releasing psychic energy and producing feelings of "painful pleasure." These are the feelings that accompany Claude throughout his relation with Laurence, whom he imagines, repeatedly, to be "an inanimate body, . . . a willful corpse" (*CDC*, 85). With the energy released by her ongoing murder in fantasy, he gives himself exquisite masochistic pleasures: "I love, and I tear myself apart" (*CDC*, 86). Laurence, taciturn, inert, is the otherness within Claude, the figure for his compulsive fascination with death. At one point, he imagines that, as Laurence sleeps, her heart speaks

directly to him of her fate—she will be dissected in an anatomical amphitheater, "cut in four to determine what bitter and nauseous stuff [her body] contained." Hearing this imaginary prognosis, Claude fantasizes, "Laurence turned blue, dragged in the mud, mottled by infamous caresses, stretched out stiff on the white stone. With their knives, they were ransacking the entrails of the woman I loved to death and held desperately in my arms" (*CDC*, 87). The vision then broadens before the hallucinating Claude to include a long procession of self-destructive men and women driven to rot and ruin by desire.

It is as if Laurence's heart were beating out the plot of *Nana*. Not, however, the plot of *Nana* as we have interpreted it thus far, but *Nana* as the drama of the male death instinct, "the poem of the male's desires," as Zola called it in his notes (*N*, 1669). Nana's corpse, in this reading, embodies not the end of desire, the content of the "dream" (whether its basis be mythic virginity or scientific biology), but the "reality" of desire, desire as the female body torn in pieces, bruised, oozing nauseous fluids. Such a body cannot properly figure the return of the circulus to its origin for it cannot even be properly dissected. It is too rotten and putrid to yield to scientific knowledge. The energy causing this breakdown is first revealed in Zola's novel when Nana uncovers her nudity on the stage of the Variétés and opens the gates to the painful pleasures of "l'inconnu du désir." Just as Laurence obsesses Claude as a force of otherness within him that tears him apart, so Nana at this moment "takes possession" of her public, entering into them, as it were, through the blood (Laurence's body is *"mottled* by infamous caresses"; Muffat's face, as he ogles Nana, is *"mottled* with red"—*N*, 1119).

From this point on, Nana dominates male fantasy both from without and from within. Insofar as she appears to stand outside, she is impenetrable, autonomous, an idol of incomprehensible otherness. Thus, even as her "heat" is penetrating and decomposing every man in the audience, she remains "victorious, with her flesh of marble and her sex powerful enough to destroy the whole assembly and stay intact in the process [*et n'en être pas entamé*]" (*N*, 1120). Nana invites dreams of penetration and possession, which she is often disposed to fulfill, but her pliable body remains as unyielding as marble. The very intensity of Nana's narcissistic asser-

tion of unbreachable wholeness grants her a kind of phallic power
in male fantasy. The whore who gives herself to every man but
"stays intact [eternally virgin] in the process"—we have encoun-
tered this devastating image of female sexual duplicity many times
in the course of this study. It is an image of male exclusion and
impotence, of male desire hopelessly frustrated and ultimately
destroyed by what desires only itself.

The most striking scene of this fascination and exclusion is Muf-
fat's observation of Nana as she indulges in "solitary pleasure" (*N*,
1721) before a full-length mirror. Although Nana here is once again
staging herself, this time it is for her private benefit alone. Imper-
vious to the effect her self-loving has on Muffat, she is immersed in
the sensual appreciation of her own body, "breathing desire over
her flesh," kissing herself near the armpit while "laughing at the
other Nana who was likewise kissing herself in the mirror" (*N*,
1271). The scene is somehow the visual equivalent of Nana's name,
a name that doubles itself as if in o-nana-istic admiration of its first
syllable, a name that invites repetition yet suggests negativity (Na-
na, no-no). Muffat observes his mistress as she sensuously caresses
her body (masturbation, only suggested in Zola's text, is explicit in
the sketch by Céard that was Zola's inspiration),[36] his eyes regis-
tering all the elements of Nana's magnificent femaleness, rich golden
hair, firm breasts, solid loins, satiny skin. But her sexual organ is
veiled in shadow: the point of possible entry into this perfectly
formed creature of desire is hidden even when she's naked (a similar
ambiguity is preserved when Nana appears "naked" on the Variétés
stage, yet is covered by "a veil of gauze"—*N*, 1118). Some critics
have interpreted this veil as performing a fetishistic function for the
male viewer, offering him a fictive defense against the evidence of
sexual difference.[37] But in Muffat's case the veil over Nana's organ
has nothing reassuring about it. On the contrary, it contributes to a
terrifying fantasy of the phallic woman who both absorbs his mas-
culinity and asserts the exclusive power of her female autonomy.

Even as the phallic woman dominates male fantasy from the
outside, the castrated woman overwhelms it from the inside. This
double psychic assault signals the failure of fetishistic compromise
formations. No symbolic object succeeds in obscuring the traumatic
power of castration in the male psyche. On the contrary, imagery
of castration expresses the male's own self-perception. Contem-

plating Nana as she fondles her luxurious, intact nudity, Muffat feels "tainted to the core of his being by undreamt-of filth [*ordures*]" and realizes that "everything was going to rot in him" (*N,* 1270). Excrement, rot, poison—this is what he has picked up "between [Nana's] snow-white thighs" (*N,* 1269), this is the fantasmatic meaning of the "nervous derangement of her sexual organ." She bleeds constantly, and is capable of turning parts of Parisian society sour at any time of the month, not because she is constantly menstruating but because she is castrated. And her castration is located inside Muffat as the figure of his desire for death.[38]

When, in the novel's last paragraph, the reader is left alone with Nana's corpse, he takes Muffat's place and is confronted with what Zola called "the cunt [*cul,* which can also mean "ass"] in all its power." I designate the reader here as male because his gender is constructed through his implied complicity with fantasies of female sexual mutilation. The Freudian "displacement upward" from genitals to visage is figured in the last sentence of Zola's horrific description, when we are told that Nana's poison "had now risen to her face and rotted it" (*N,* 1485). Zola is careful to shed light only on Nana's putrefying countenance. No other parts of her body are seen, suggesting the kind of dissociation of one member from the corporeal whole that had previously been characteristic only of Nana's sexual organ. Moreover, the very disease to which Nana had succumbed, smallpox contracted from her dying child, seems like another displacement, within language, a sublimating pun. (Given Nana's promiscuity, it is not surprising that many readers remember her as dying from the pox, syphilis. The same wordplay is possible in French: "la petite vérole" means smallpox; "la grande vérole," or simply "la vérole," means syphilis.) Venus decomposing is the *cul* of desire decomposing—to follow Zola's fantasmatically charged imagery to its repellent conclusion, I think we must read "the shovelful of putrid flesh" (*N,* 1485) that Nana becomes in these terms. They are largely excremental: the "dark, decaying hole" full of "bubbling purulence" into which Nana's eyes have dissolved is a nauseating fantasmatic image that associates castration with anality.[39] The meaning of the image is in the male unconscious, the same place, Zola implies, from which issue, in "a great breath of despair," the cries "To Berlin! To Berlin! To Berlin" (*N,* 1485). The death instinct drives man forward in his historical as in his sexual

self-destructiveness. (This is also illustrated in Muffat's masochistic degradation, when Nana, commanding him to trample on his imperial decorations, reduces him "to garbage, a heap of mud in the gutter"—*N*, 1461.) Nana's death, in this reading, does the opposite of restoring the social order to health and balance. Her instinctual force cannot be contained within any kind of vital circulus: it destroys the reassuring fantasy of an organic continuity between nature and society, tearing open a gash in the female figure of natural coherence, through which flows the morbid blood of castration and of the historical process itself.

Although this gash is most vividly pictured by the suppurating hole of Nana's face, surrounded by the intact emblem of her continuing desirability, her shining golden hair, there are many other images in Zola's novel that evoke the fantasmatic landscape of "l'inconnu du désir." Perhaps the most brilliantly suggestive of these is Muffat's exploration behind the scenes at the Variétés theater. The episode is at once entirely fantasmatic and perfectly realistic (in his characteristically thorough manner, Zola visited the Variétés in 1878 and took extensive notes,[40] even though his work as drama critic and playwright had already made him thoroughly familiar with the *coulisses*). Muffat's entry behind the scenes is presented as a "trouée ardente," an exciting, passionate opening or breach, "into a world he knew nothing of" (*N*, 1206). The text is quite explicit about this being the world of female sexuality: at the furthest point of his penetration, Muffat, almost suffocating from the powerful *odore di femmina* with which the fetid atmosphere is saturated, "close[s] his eyes and inhale[s] in one breath all of woman's sex" (*N*, 1223). As Muffat climbs staircases and negotiates corridors, he is symbolically moving farther and farther up the female sexual canal. It's not a pretty picture: the air is dense, overheated, full of the stench of dirty female underwear, the pungent odor of women's hair, the acrid scents of colognes, the smell of gas and glue; dirty liquids seep out from behind doors left ajar, from leaking pails and cracked basins; dampness oozes from the walls; chamber pots and buckets of slops are left standing in filthy rooms; objects are worn, broken, twisted, and soiled. Yet Muffat emerges from this experience of the excremental filth and stench of the female sexual organs completely obsessed with their symbolic embodiment, Nana—"the central flesh," as Zola calls her in his notes (*N*, 1670). For the excitement

of desire, of the "trouée ardente," is generated by the energies of decomposition and organic decay. Nana's alluring odor, we are told, reminds Muffat of a bouquet of tuberoses that, rotting in his bedroom, once nearly caused his death.

Nana's bisexuality participates in both the currents of male fantasy that I am analyzing. As same-sex love, it has obvious analogies with Nana's auto-seduction in the mirror. Its premise is "open contempt for the male" (*N*, 1368), and Nana and Satin together emasculate an entire assembly of aristocratic men, smearing them with the ordure of their working-class origin (this origin is, in Zola's bourgeois fantasy, the social equivalent of castration). Furthermore, Nana's lesbianism constitutes a breach within her desire that erodes and decomposes the biological model of sexuality, the vital basis of the patriarchal social order. Thus, Muffat's easy acceptance of Nana's affair with Satin is a sign of how far his inner disintegration has progressed, how far he has moved from any sense of desire's being anchored in the anatomical particulars of sexual difference.

The breakdown of anatomy as the "natural" referent of desire can be read through Nana's body as its hystericization (in the 1878 version of the Rougon-Macquart genealogical tree, Nana's heredity is designated as "drunkenness turning into hysteria").[41] In a popularizing introduction to the subject of hysteria by a follower of Charcot, published in the same year as *Nana* and provocatively entitled "Les démoniaques d'aujourd'hui," Charles Richet declares that the hysteric "has only one defective side to her mind, which is the impotence of the will to hold back [the impulses of] passion."[42] Nana's passion is omnivorous and indiscriminate: she picks up sluts off the street for quick sex in her carriage, she disguises herself as a man to attend parties of debauchery, she sleeps with so many men that her bedroom is like a crossroads, and she doesn't even refuse the Marquis de Chouard, "a human rag . . . [with] the body of a skeleton" (*N*, 1463). From this perspective, Nana's bisexuality is just one function of her hystericized body. Another is her parrotlike appetite (she "gobbles radishes and burnt almonds, but merely pecks at meat"—*N*, 1433), typical, according to Richet, of the "capricious, whimsical" tastes of hysterics. Nana, of course, is capricious in all her desires, enjoying nothing more than destroying objects she coveted moments before. Her passage is marked by "a heap of nameless debris, twisted rags, and muddy tatters" (*N*, 1433), and this frag-

mentation and dispersal of the objects of her desire becomes associated metonymically with the dismemberment of her body. It is thus perfectly fitting that one of Nana's most powerful appearances in the novel should be purely fantasmatic, when she is imagined stretching her "supple limbs" above the extravagantly decadent celebration of Muffat's daughter's wedding, "decomposing the society, penetrating it with the ferment of her scent" (*N,* 1430). This theatrical appearance *in absentia* is, indeed, the apotheosis of Nana's hysterical absorption by representation. For the hysteric, declares Richet, "everything becomes a subject for drama. Existence appears like the stage of a theater." From the outset, Nana's hystericized body is like a free-floating improvisation. This is how she manages, as the Golden Fly, to enter into palaces through open windows. This is how her sexual organ manages to detach itself from the body of a "bonne fille toujours," sacrificial scapegoat of the circulus, and to rise in triumph above its death-driven victims. The poison she brings with her, which causes the varnished surface of society to crack and decompose, may derive its venom less from repressed libidinal instincts than it does from the ferment of representation itself, undermining natural reference, hystericizing its body, and infecting its vital circulus with a corrosive morbidity.

: : :

I have argued that the originality and force of *Nana* derives from the way it simultaneously generates two conflicting interpretive networks for male fantasmatic apprehension of female sexuality. The first might be called naturalist-scientific and might be associated, in the great Freudian mythic dualism, with the life instincts, which work to build and preserve ever-greater unities. This model finds its basis in the anatomized corpse, the natural body of woman spread out for dissection and translation into the discourse of male knowledge. This positivist discourse of truth, which masks its function as discourse, achieves its closural goal when it finally discards the fully anatomized female cadaver. In the second fantasmatic complex, this cadaver can be neither discarded nor successfully dissected. The decomposing female body is the very image of the work of the death instincts, which drives the male to self-destruction through an erotically charged experience of disintegration and drives the text toward self-reflexivity by the revelation of its figurative hysteria.

But *Nana* is a social-historical novel as well as a mythic construct, and I do not want to suggest that the conflicting systems of male fantasy that I have identified sufficiently account for the novel's meaning. History has a presence in the book that is not only fantasmatic, and a Marxist reading would no doubt give more critical play than I have to Zola's picture of class conflict and political decay. I will leave to others the proposal of such readings, but do not want to end my discussion of *Nana* without alluding to some of the widely shared ideas about prostitution under the Second Empire that Zola brings together in this *summum*. In *Les romanciers naturalistes* (1881), Zola tells of his having encouraged his master Flaubert to write his long-projected novel about the Second Empire, "which he [Flaubert] had seen from close up and on which he had extensive notes."[43] It is unlikely that Zola ever saw Flaubert's jottings for this novel, to be called *Sous Napoléon III;* they are full of observations that coincide perfectly with Zola's portrayal of social corruption in the period. (Flaubert, of course, was an enthusiastic reader of *Nana,* which he called "a colossus with dirty feet, but a colossus.")[44] Flaubert's thesis, announced in the first notation we have of his plan, dating probably from 1871, is "The degradation of Man by Woman."[45] Later he remarks: "At the beginning of the war with Prussia, demoralization <cowardice> caused by feminine pressures. These complete all those [practiced] <committed> under the Empire, caused by the same influences" (*CT,* 549). Flaubert goes even farther than Zola in setting up parallels between women at the upper and lower levels of society. Whereas Zola portrays at least one virtuous *mère de famille* vainly upholding the values of family and class, Madame Hugon, Flaubert intended to set up, "in parallel, abjection caused by a *lorette* and abjection caused by a good *mère de famille*" (*CT,* 554). This would demonstrate the identity of "the immorality of the Family and that of the demi-monde" (*CT,* 718). He also intended to show "a whore who works her way up. Having started in a brothel, she moves into the business world and even into politics. Procures the award of medals" (*CT,* 715). (Compare Zola's designation in his notes of the Countess Muffat as "the other side of vice, vice protected by a legal situation, hence still more destructive.")[46] Zola's invention of Mignon, who pimps for his wife, is prefigured in Flaubert's note "husband exploits his wife—it becomes a commercial enterprise" (*CT,* 574). Moreover, the mix of

themes that Flaubert projected for his novelistic recipe involves the same ingredients later used by Zola: "For the modern Parisian novel," notes the author of *L'éducation sentimentale*, "mix the most *cul*, the most money, the most devotion (St. Vincent de Paul, etc.) possible" (*CT*, 571).[47]

Although Edmond de Goncourt's novel about prostitution, *La fille Elisa* (1877), has more in common with *La confession de Claude* than it does with *Nana*, the brothers' *Journal* contains numerous passages that foreshadow scenes in Zola's book. (One remarkable fact about *La fille Elisa* should, however, be remarked in passing: its story of the life of an ordinary *fille de maison* who murders the only man she has ever idealized, because he expresses genital desire at a moment when she is dreaming of romantic innocence, is based on a medical description of misandrous hysteria.[48] The fantasy ruling this diagnosis seems to be that female sexuality, diverted from its natural purpose of marriage and motherhood and made into an instrument of male concupiscence, will revolt and destroy its tyrannical master in the name of "natural" purity. Like Zola in *La confession de Claude*, the Goncourts are working with the radical duality of the debased sexualized woman and the pure child of nature, but the brothers fail to dramatize the theme in terms of internal psychic struggle, and *La fille Elisa* remains a dryly clinical study). Their descriptions of life behind the scenes at the theater are, however, anything but dry, and sometimes even seem to outdo Zola for raciness. They tell of a theater director, lover of the actress Lagier, who, like Bordenave in *Nana*, is interested only in putting on "la pièce à cuisses, des portraits-cartes sur la scène,"[49] and remark that all he lacks is the courage—which Bordenave exhibits—to call his theater a brothel. The visit the brothers make with Flaubert behind the scenes to congratulate Lagier (whose definition of the theater is "the absinthe of the bordello") seems like a more vulgar version of Muffat's "trouée ardente." "We enter into the *coulisses*," write the Goncourts on March 23, 1862, "by the blackened, stinking corridors, smoky with burning oil. It smells of candles, dust, heat, fat, flour paste, a heap of filth that intoxicates Flaubert."[50] Sitting around in her dressing room, the three writers watch as the amply proportioned Lagier, who has just played Marguerite de Bourgogne in Dumas's *La Tour de Nesle*, undresses down to her corset, aided, as is Nana, by a sexless little maid. Lagier, however, is far more provocative

than Nana in dealing with her visitors, going from one to the other like "a hysterical cow," excited, the Goncourts surmise, by the role she's just played, hungry for sex, "wanting to treat herself to some young flesh." Flaubert and the Goncourts are hardly the kind of fresh meat she craves: sitting on Jules's lap and "tonguing" him, she declares him a cold fish; Edmond she calls "un grand *resucé*"; about Flaubert she says, "You like to fuck a lymphatic *femme du monde* in dirty corners." Finally, in disgust, she pronounces all three of them "des modernes" unworthy of her heated desire. Jules, in fascinated horror, ends his description of the scene by calling it "something frightful, repugnant, and glacial."

If Zola avoided making Nana as vulgar as Lagier—and Flaubert, we know, found few of her kind to be so—he was nevertheless taken to task by critics for having portrayed his *courtisane* as too much of a *fille*. Paul de Saint-Victor, for instance, wrote that "Nana is the *fille* in her most brutal and bestial state, a great streetwalker, catapulted by chance onto the stage and into a townhouse, who falls back into the streets by the law of gravity."[51] Zola, Saint-Victor goes on to complain, does not understand the richness, complexity, and originality of the courtesan and her world. Another critic observed that "a goose like Nana" would not be intelligent enough to succeed in the competitive milieu of luxuriously kept women.[52] This criticism could have some validity only if one imagines Zola's goal to have been the accurate recreation of the typical personality of a Second Empire *grande cocotte,* such as Anna Deslions, Cora Pearl, Valtesse de la Bigne, Delphine de Lizy, or Blanche d'Antigny. Zola is known to have gathered information about all of these famous courtesans, and he must have realized that they, and others like them, were often regarded as astute, quick-witted women, capable of holding their own in conversation with men of education and culture. But this aspect of the *courtisane* myth, dear to the likes of Saint-Victor, did not capture Zola's imagination. On the contrary, in the notes he took on conversations with two friends, Edmond Laporte and Ludovic Halévy, whom he quizzed about their extensive experience in the world of *haute cocotterie,* he tends to select details that underline the good-natured qualities of the women (they love the countryside; they are generous with the needy, not given to jealousy, indolent). Only about Caroline Letessier does he note a particular quality of intelligence, her biting wit.[53] Zola clearly had

his vision of Nana "bonne fille" in mind from the beginning of his research, which (need it be stressed?) was always in the service of his mythic portrayal of instinctual conflict.

Possibly reinforcing Zola's vision of Nana's plump animal vitality was Manet's painting, rejected from the Salon of 1877, entitled *Nana* (see Figure 38). Although the precise date when Manet began painting this picture is unknown, and it probably was before he could have begun reading about Gervaise's daughter in the final installments of *L'Assommoir,* Manet may well have heard from Zola directly about his plans for a separate novel featuring Nana's career as a courtesan. In any case, it is clear that Manet had read all of *L'Assommoir* by the time his painting was submitted to the Salon jury and that his choice of a title for his work implicitly recognized the closeness between Zola's creation and his own. In his turn, Zola may have found inspiration in Manet's image, and the scene of Count Muffat's visit to Nana's dressing room may owe something to Manet's depiction. (For whatever reasons, Zola did not record, not even in a letter, his response to Manet's painting, leaving us to speculate about his reaction.)

Manet's *Nana* offers a very different kind of pictorial complexity from his *Olympia.* The palette is bright and cheerful, the brush strokes free and broad, generating comparisons in 1877 to the newly scandalous impressionist painting. Manet's model was a well-known *cocotte* of the time, Henriette Hauser, mistress of the prince of Orange and a popular figure at Tortoni's café and on the boulevards. (The realistic portrayal of this *demi-monde* celebrity was probably one reason for the Salon jury's rejection of the picture.) Although she has none of the sinister man-eating powers Zola attributes to his *femme fatale,* she does project a kind of pert self-confidence and easy good humor. She turns her back, in apparent indifference, on the top-hatted, cane-carrying man-about-town, who is relegated, as in Degas's monotypes, to the picture's margin. Despite her being partly undressed, she seems neither vulnerable nor deliberately provocative. The emphasis on her ample hips and rounded stomach strongly sexualizes her body, and the crane in the background may even be an allusion to her amorous availability (the French word for crane, *grue,* is also slang for "prostitute"). But Nana's embodiment conveys little of a fantasmatically threatening nature:[54] she seems to be a *bonne fille,* happy in her choice of a

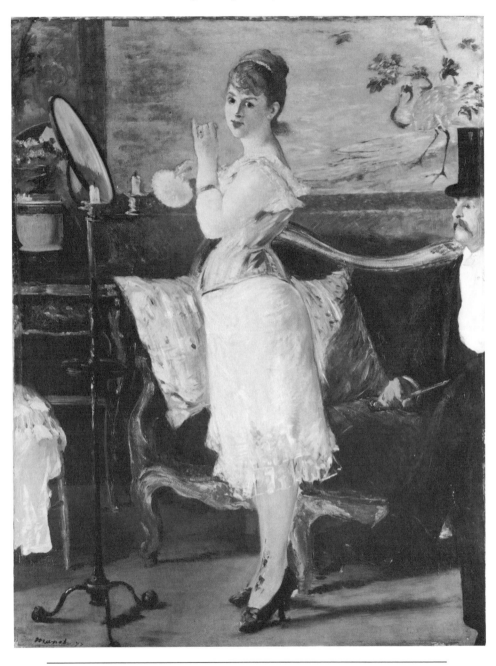

Figure 38. Edouard Manet. *Nana* (1877). Oil on canvas. Kunsthalle, Hamburg.

gallant career, secure in her animal health and cheerful indepen-
dence. Thus, Manet perfectly illustrates, *avant la lettre,* one aspect of
Zola's paradoxical creation, the woman who "remains big and
plump, wonderfully healthy and wonderfully gay, . . . clean, whole-
some, with a brand-new look as if she had never been used."

If it is difficult to know just how Manet's painting influenced
Zola's novel, it is not hard to establish where the novelist made use
of the rich anecdotal lore about the exploits of courtesans in the
1860s. In *Nana,* the prostitutional bonanza of the 1867 Exposition
Universelle is a repeated subject of enthusiastic discussion among
the women (they foresee great profits to be gained from the assembly
of dissolute princes from throughout Europe and return quickly from
their visit to Nana's country estate because the Exposition is about
to close and "the season was surpassing their expectations"—*N,*
1254). At the height of her power, Nana is celebrated in the bou-
levards, cited in the papers, and imitated by *grandes dames.* Nana's
posing in the nude for a figure of Night to be represented in silver
on her extravagant bed is no doubt indebted to Baudry's painting
of La Païva on the ceiling of her Champs-Elysées mansion (which
is in the Renaissance style like Nana's *hôtel* on the Avenue de
Villiers—see Figure 9), as well as to her famous bed. And many
other episodes in the novel have a historical basis, if not in the 1860s
then in the 1870s: the Prince of Wales visited the actress Hortense
Schneider in her dressing room; the splendid Blanche d'Antigny
had a sudden passion for an actor resembling Fontan; later, aban-
doned by her lover, she was taken ill in the Grand Hotel (she died
not there, however, but in an apartment Caroline Letessier had
found for her); La Tricon is modeled after La Guimond, one of the
most successful procuresses of the Second Empire; the Mignon
household is based on that of Anna Judic, whose husband brilliantly
managed her career and love affairs as a "bon ménage bourgeois";[55]
and so forth. All these details anchor *Nana* in history and offer the
reader a reassuring world of "realistic" reference, which counters
the vertiginous movement into the space of obsession and fantasm
that constitutes the disturbing originality of Zola's picture of Venus
decomposing.

LIBRARY ST. MARY'S COLLEGE

Huysmans: Syphilis, Hysteria, and Sublimation

Zola never explicitly identifies the virus that Nana carries. In *A Rebours,* published in 1884, four years after *Nana,* Huysmans designates that virus by name: "It all comes down to syphilis [*Tout n'est que syphilis*]," thinks Des Esseintes to himself. "And he had the sudden vision of a humanity ceaselessly mined by the virus of ages past. Ever since the beginning of the world, from fathers to sons, all living creatures had handed down the unusable legacy."[1] Huysmans inherits from naturalist literary and medical discourses the fantasm of heredity as disease, and specifies syphilis as its morbid essence. And just as Zola had brought together decomposition with gold in his picture of Nana's putrefying countenance, so Huysmans notes the ironic fact that syphilis frequently manifests itself in patches of gold that break out on the foreheads of victims, "stamping their skin with the image of money and well-being" (*AR,* 197). The Balzacian prostitute's heart of gold has surfaced, in the fin de siècle, as a symptom of universal biological morbidity.

The prevalence of syphilis as a source of libidinal anxiety in Huysmans's works is not just a function of his personal obsession with venereal disease. According to the experts of the day, this illness was at an all-time high in 1879–1880, its growth accelerated by the sexual promiscuities rampant during the 1878 Universal Exposition and by the diminished activity of the *police des moeurs* in response to abolitionist pressures.[2] Dr. Charles Mauriac estimated that 5,000 new cases of syphilis were contracted every year in Paris; Emile

Richard, in 1890, judged the number of infected people in the capital to be around 85,000.[3] Just as prostitutes had been identified as the prime source of contamination in the case of the century's earlier cause for biological panic, cholera, so they were now seen as the prime culprits in spreading syphilis. This contagion, the experts stressed, "always originates in the streets"[4] and spreads, like Nana's virus, to the upper classes from the lower. To fuel the fires of panic and to encourage further repression of clandestine prostitution, the syphilographs, led by Alfred Fournier, liked to stress the numbers of innocent bourgeois wives who, infected by their husbands, sub-sequently gave birth to diseased babies (Fournier estimated that 20 percent of syphilitic women were faithful housewives). The medical masters of the virus's subversive ways exploited the bourgeoisie's already well-established fear of depopulation by underscoring the role of syphilis in breaking up marriages, causing sterility in women, producing monsters and degenerates, and undermining the vitality of the race. The increasing risk of venereal infection served as a perfect excuse to preach marital fidelity and family devotion, to insist on the importance of the sanitary regulation of prostitution, and to repress the working class, fantasmatically the ultimate source of all disease.

Alfred Fournier specialized in the rhetoric of medical terrorism (he even trained his son Edmond to continue the family tradition). Most of his writings date from after 1884, but by the early 1880s he was already the leader of the neoregulationist movement, whose primary goal was the containment and marginalization of prostitutes through pervasive medical control. It is largely by painting the most horrendous possible picture of the biological and psychological con-sequences of venereal infection that Fournier hoped to convince legislators and public health officials to shift the ultimate authority for disciplining prostitution from the police to medical scientists. He dwells on frightening descriptions of innocent bodies covered with grotesque lesions, tells stories of fiancés who prefer to commit sui-cide rather than risk contaminating their beloveds, and generates anxiety by developing an ever-increasing list of possible sources of infection, mostly banal objects of everyday life such as pipes, coins, linen, and ordinary gestures such as kissing the crucifix at com-munion or shaking hands.[5] The special focus of Edmond Fourier's alarmist genius was the notion of "hérédosyphilis," which identified

syphilis as the essential vehicle of all morbid heredity and fueled the fires of bourgeois anxiety by stressing the uncertainty of hereditary pathology: the disease could jump a generation, Fourier claimed, and then emerge in a yet more virulent form; the paternally contaminated blood of a fetus might possibly contaminate a healthy mother, just as a diseased mother might possibly infect her fetus; the early symptoms of the illness are so various and unspecific that a discomfort seemingly as trivial as a headache might be a sign of syphilitic degeneration.[6]

Given this biological menace, it was logical, argued the neoregulationists, that the identification and treatment of diseased individuals engaged in spreading their infection be the primary goal of administrative action. Fournier wanted to replace the *police des moeurs* with the regular court and police system and to pass new laws empowering judges to punish prostitutes who engaged in provocation or refused to obey sanitary regulations. Certain of his followers even argued (in a move that foreshadows, like much of this campaign, certain contemporary proposals regarding carriers of AIDS) that anyone knowingly transmitting the disease be subject to prosecution. Although these ideas were not implemented, and prostitutes continued to be denied legal rights and subjected to arbitrary administrative measures, the medical perspective of the neoregulationists, founded on the fear of syphilitic contamination, dominated discussions of prostitution up to the outbreak of World War I.

One of the developments of the early 1880s that caused the most concern to those in charge of policing prostitution was the growing number of *brasseries à femme.*[7] These were essentially bars tended by women who sold their favors to clients but who could not officially be regarded as prostitutes or forced to submit to medical inspection. The appeal of these establishments had to do largely with the way they masked the final sexual purpose, allowing clients to imagine that they could succeed in the drama of seduction, beating out possible rivals, and that, given the absence of a *souteneur,* they might even become the one true love of a particular *verseuse.* The *brasseries* proliferated in the Latin Quarter and were, according to Maurice Barrès's reminiscences in *Les Déracinés,* an animated, congenial center of sexual and social life for bachelor students in the 1880s.[8] In contrast, Huysmans, through the medium of Des Esseintes, views the put-on camaraderie in these establishments and their dishonesty

about mutually desired exchange as a deplorable sign of "the state of mind of an entire generation, . . . a synthesis of the age" (AR, 299). He defines this synthesis as "imbecilic sentimentality combined with ruthless commercialism" (*AR,* 301). Des Esseintes mocks the tentative virility of young men who, in order to preserve "ridiculous illusions" (*AR,* 301), are willing to be fleeced by savvy bargirls who deliberately defer the sexual encounter in order to extract more money from their stupidly cooperative clients. Not only are these women inferior in looks, dress, and technique to the professionals in a luxurious tolerated brothel, remarks Des Esseintes, they are also more likely to be disease carriers. Only the persistence of "a vague, stale, old-fashioned ideal of love" (*AR,* 300) could account for this fad of willing male submission to crass exploitation by depraved women.[9]

This prolonged meditation by Des Esseintes is one of the few occasions in *A Rebours* when the text breaks out of its hermetic withdrawal from social concerns and engages an issue relevant to contemporary behavior patterns. That this opening onto society should occur precisely in the context of prostitution is no accident. Huysmans's first ambitious novel (preceded only by a collection of stories, *Le drageoir aux épices,* 1874, and a short autobiographical novel about his military service, *Sac au dos,* 1875) was the story of a common prostitute, *Marthe.* Hoping to avoid censorship and to publish before Edmond de Goncourt brought out *La fille Elisa,* Huysmans had his novel printed in Brussels in 1876. But the strategy backfired: most copies were seized at the frontier and condemned as pornographic, and the novel was not published in France until 1879. Nothing about Huysmans's portrayal of Marthe's miserable existence is sexually titillating, however. The book reads like a kind of inventory of narrative elements derived from the prostitute's realist plot, strung together in rapid-fire order with little concern for psychological motivation or character development. It begins, like *Nana* (1880), in a theatrical setting—we are behind the scenes at the Bobino theater—but Huysmans does nothing to suggest the symbolic significance of this location, and Marthe is specifically described as lacking the ability to give the kind of "coup des hanches" that will later be one of Nana's sexy talents.[10] A flashback summarizes Marthe's background: she was a worker in false pearls (Nana begins in a workshop making artificial flowers); she lost her

unwanted virginity to a disgusting old man (again, like Nana); she gave birth to a baby that died, information conveyed in one sentence; she worked for a while in a brothel (but we are not told what it was like until much later, when Marthe gives a kind of feverishly hallucinated description). Then we return to the present and move rapidly through the ins and outs of her tortured relationship with Leo, a writer and alter-ego for Huysmans, who based much of this story on an affair he had in 1867 with an actress from the Bobino. Like Nana again, Marthe at one point enjoys being beaten by her actor-lover; at another point she is set up in style by a rich patron who, foreshadowing the fatuous La Faloise in Zola's novel, is pleased to hear people speak of how she is ruining him. The book ends with the mandatory naturalist scene of dissection. This is prefaced by a quick sketch of the autopsy table, noting its hole for morbid liquids to flow into a bucket carefully placed just underneath—a detail Parent-Duchâtelet, designer of autopsy tables, would have appreciated.

Marthe seems to be an uninspired effort by a beginner eager to show that he has mastered the themes, motifs, and language of naturalism.[11] One wonders at first about the absence of the powerful fantasies of decomposition that will later dominate Huysmans's evocations of prostitution as related to venereal disease. But then one realizes that the decomposition is right there in the pastiche fabrication of the plot itself. It is as if the female sexual body were being anatomized into ready-made fragments of story, picked apart by a diagnostician of narrative who is fearful of allowing female sexuality any subjective coherence. The narrator's relation to Marthe, which vacillates between sympathy and alienation, reflects the artificiality of the entire narrative construction.[12] That it is not Marthe's body but that of the actor Ginginet, her sometime lover and protector, that is autopsied at the novel's end reflects the role that this argotic, aggressive, grotesquely ugly proletarian has played throughout Marthe's story: he is her double; his explosive violence codes as male the energy of her disruptive sexuality; his dismembered cadaver is the punishment for the attack on bourgeois rectitude that is their common pursuit and that destabilizes their gender difference in a common subversive class identity. This punishment is somewhat ironic, however, for the dissected body constitutes the model for Huysmans's own literary creation in this novel of borrowed parts.

Specifically countering the criticism that naturalism is a form of clinical analysis, Huysmans praised Zola for being less of an anatomist than Flaubert or the Goncourts ("He does not dissect fiber by fiber, he does not probe with a magnifying glass the nooks and corners of consciousness").[13] This was 1876. By 1884 Huysmans had come to agree with the critics who attacked naturalism for being too formulaic and reductive—for lending itself too easily, in other words, to the use he had made of its repertory of themes and idioms in novels like *Marthe*. *A Rebours* marks Huysmans's break with Zola's school, but it is not until *Là-Bas* (1891) that he dramatically exposes the reasons for his turn away from naturalism. And the example he gives there of an object Zola's vision cannot possibly encompass is a corpse in so extreme a state of putrefaction that its anatomy defeats scientific analysis: the body of Christ crucified as painted by Mathaeus Grünewald (see Figure 39).

Conversing with his friend Durtal, a writer, Des Hermies opens *Là-Bas* with a criticism of naturalism's purely materialist perspective: it treats man, he says, as a creature of "appetites and instincts."[14] Since naturalism conceives of human impulses as deriving exclusively from sensation and the flesh, mankind is closed off from any suprasensual experience, from the realm of dream and the spirit. Although Durtal is grateful to the naturalist masters (Flaubert, the Goncourts, and Zola) for having demolished Romantic sentimentality and idealism, he agrees with Des Hermies that naturalism has become a dead end—a point that Huysmans repeats in a 1903 preface to *A Rebours* where he describes the naturalist movement of twenty years earlier as turning in circles, its method having become predictable, repetitious, and sterile (see *AR*, 58). What is needed now, thinks Durtal, what would answer his own psychic and creative needs, is "a spiritual naturalism," the best example of which is Grünewald's terrifying depiction of the crucifixion. Huysmans's extraordinary description of this painting can retain its full force only through extended quotation, although no translation can accurately render the metaphorical ferment of the language:

> Dislocated, almost torn from their shoulders, the arms of the Christ seemed to be shackled over their entire length by the strained cords of the muscles. The broken armpits were cracking; the hands, spread open, brandished haggard fingers that still offered

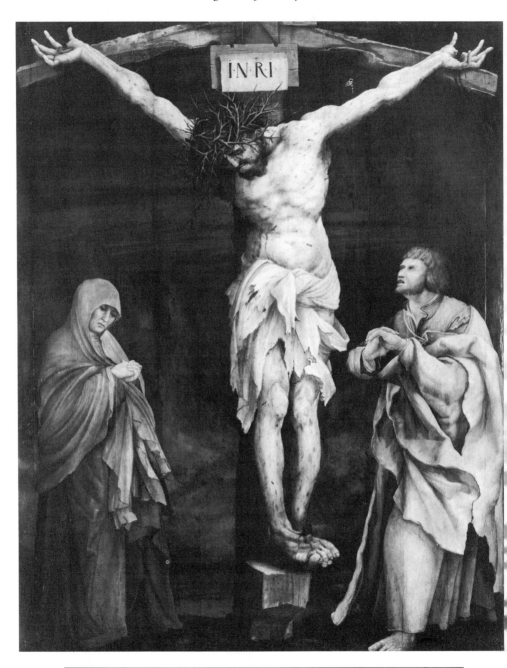

Figure 39. Mathaeus Grünewald. *Crucifixion* (ca. 1515). Staatliche Kunsthalle, Karlsruhe.

benediction, in a confused gesture of prayer and reproach; the pectoral muscles were trembling, buttered with sweat; the torso was grooved with circular trenches by the protruding rib cage; the flesh was swollen, rotten, and blue, speckled, as from pinpricks, by splinters broken off from the rods of the scourging that perforated the skin here and there with subcutaneous wounds.

The hour of sanies had come; the fluvial wound in the side, running more thickly, inundated the hip with a blood similar to the dark juice of mulberries; reddish serosities, milky liquids, water resembling gray Moselle wine oozed from the chest and soaked the stomach, under which undulated a seething loincloth; next, the knees, forced together, knocked their rotulae, and the twisted lower legs formed a hollow space down to the feet, which, placed one on top of the other, were stretched out, ready to putrefy completely, turning green amidst a flow of blood. These spongy and blistered feet were horrible [see Figure 40]; the flesh was granulating as it swelled over the head of the spike, and the grasping toes contradicted the imploring gesture of the hands, cursed, and almost seemed to claw, with their horny blue nails, the ferruginous, ochre earth, comparable to the purple soils of Thuringia.

Above this cadaver in eruption appeared the head, tumultuous and enormous; encircled by a disordered crown of thorns, it hung down, exhausted, barely opening one sunken eye in which a look of pain and terror still glimmered; the face was mountainous, the forehead demolished, the cheeks dried up; all the overturned features wept, while the mouth, unnerved, its jaw racked by atrocious tetanic convulsions, laughed. (*LB,* 38)

This is the corpse of naturalism in its most extreme state, straining the possibilities of language, cracking open accepted semantic usage, yet also offering itself as a model for a writing that would cure the text's decomposition in the very process of its literary creation. For the notion of cure is, of course, essential to the appeal of Christ's rotting corpse: "This stretched-out carcass was that of a God" (*LB,* 40). Zola's vital circulus, source of his positivist scientific notion of cure, is too closely allied to what Huysmans sees as the essentially degenerative quality of all organic life for it to serve as a model for healing the multiple wounds of existence and of the text. "If it were

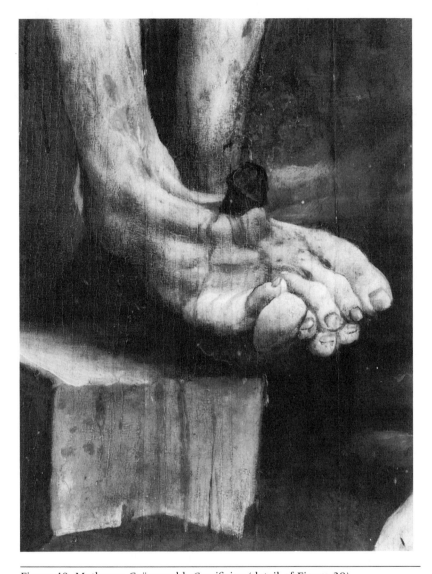

Figure 40. Mathaeus Grünewald. *Crucifixion* (detail of Figure 39).

possible," thinks Durtal, "the novel should divide of itself into two parts, that of the body and that of the soul, which should remain joined, or rather blended, as they are in life"; and he identifies Zola entirely with the bodily part, the writer's task now being "to trace in the air a parallel path, another way, so as to attain the beyonds and the hereafters" (*LB,* 36). The problem for Durtal, as for Huysmans before his conversion, is that he is not a believer. Consequently, the "parallel path," which should "sublimate the infinite distress of the soul," has a tendency to collapse back onto "the tearful refuse of the body" (*LB,* 40). What Grünewald represents as "divine abjection" (*LB,* 40) risks becoming merely human abjection. And in all-too-human terms the eruptive cadaver of Christ bears an uncanny resemblance to a syphilitic corpse.[15]

"Everything comes down to syphilis,"—even the son of God is infected. No body can escape. This is naturalism with a vengeance, naturalism fired by powerful unconscious impulses. In his 1903 preface to *A Rebours,* Huysmans claims to have submitted to this power in writing what came to be considered the canonical decadent novel. He describes *A Rebours* as "an entirely unconscious work, imagined without preconceived ideas, without any designs set aside for future use, without anything at all" (*AR,* 60). Precisely because he associates naturalism with "preconceived ideas," Huysmans does not see that his "entirely unconscious work" is, unconsciously, a revitalization of naturalism's own sources in the unconscious, in particular of its fantasmatic obsession with the female sexual body. In what follows I will attempt to trace the operation of an obsessive fantasmatic economy in Huysmans's writing and will briefly demonstrate some of the striking similarities in the ways Zola and Huysmans figure and disfigure the woman's body.

Huysmans's fictions open most transparently onto the stage of the fantasmatic in the many remarkable dream narratives interspersed throughout their representational space. These accounts are, on the one hand, carefully controlled literary structures, whose themes and images derive from and elaborate material already presented in the text, and whose artistic purpose is to give the reader the illusion of actual oneiric experience. On the other hand, these narratives are not simply representations of consciously contrived fantasmatic scenarios but are also products of what one might call a textual unconscious, an unconscious revealed in and through the process

of writing, whose compulsive obsessions may be found to influence even those elements of the narrative apparently most invulnerable to unconscious elaboration. Thus, the dream texts in Huysmans do not puncture the surface of an otherwise smooth-flowing narrative discourse; rather, they reveal the driving force of that discourse and suggest the confused interpenetration of conscious invention and unconscious fantasm in his creative process.[16]

Toward the end of a horrifying nightmare that takes up all of Chapter 10 of *En Rade* (1887), Jacques Marles sees an incredibly ugly woman sitting on the rim of one of the towers of the church of Saint-Sulpice. Jacques wonders what this foul creature might be, "a sordid trollop who was laughing in a lewd and mocking manner, . . . her nose crushed from the end, her mouth wasted, toothless in front, decayed in back, barred like that of a clown by two streaks of blood . . . She held out over the square the double bag of her old breasts, the badly closed shutters of her paunch, the wrinkled sacks of her vast thighs, between which was displayed the dry tuft of a filthy seaweed mattress!"[17] Overcoming his initial fear, Jacques manages to identify this grotesque, mutilated, degraded female through a remarkable feat of reasoning: "He succeeded in persuading himself that this tower was a well, a well that rose up in the air instead of sinking into the ground, but indeed a well." This he says, explains everything, and he concludes: "This abominable whore was [the embodiment of] Truth" (*ER*, 211).

Although in his nightmare Jacques Marles goes on to meditate on the many ways Truth acts as a prostitute (adopting every conceivable posture so as to caress each individual according to his particular lust for certitude), the bizarre reasoning that enabled him to identify this lascivious hag remains unexplained. How does a tower become an inverted well? One might begin to suggest a tentative answer by returning to the dream-event that marks the onset of this final episode of Jacques's dream. He has lost his cane, surely an unambiguous phallic symbol, and feels that "at this precise moment this event took on an enormous importance. He knew in a peremptory way that his life, his entire life, depended on that cane" (*ER*, 207). In the manner of dreams, Jacques subsequently forgets all about his lost cane, but what happens next vividly illustrates the horrifying, life-menacing significance that his unconscious attributes to being caneless. The scene seems to stage the birth of a

primal fantasy. One wall of the courtyard in which Jacques finds himself is made entirely of glass, behind which is a turbulent mass of water. Slowly a female body emerges into the water, head first, from below the pavement. She seems attractive at first, adolescent, virginal, but then Jacques notices that she is bleeding from wounds in the hips caused by the iron teeth of a huge crane that is lifting her up. She appears to accept her suffering "with a languorous and cruel smile, suggestive of an agonizing pleasure" (*ER,* 208). As Jacques rushes forward to rescue her, he hears the sound of balls falling and realizes that the woman has lost her beautiful blue eyes: "All that remained at their place were two red holes that blazed, like fire-ships, in the green water. And these eyes sprang up again, motionless, then again detached themselves and bounced back . . . Ah! how frightful were those successions of azure gazes and of sockets bathed in blood! He gasped for breath in front of this crea- ture, splendid as long as she remained intact, hideous as soon as her eyes became unstuck and fell away. This constantly interrupted beauty juxtaposed to the most terrifying ugliness . . . was a horror without name" (*ER,* 209).

The imagery of castration is unmistakable here. Woman lures man with the illusion of being intact, complete, inviolate. In this state, she invites the male to fantasize that she is no different than he. Indeed, the attributes of the adolescent body emerging from the water (tiny breasts with rigid nipples, a firm torso, a flat stomach, a slightly lifted leg that hides the sexual organs) all suggest a dis- guised phallic image. However, the attraction of sameness is destroyed with the discovery of woman's gaping wound, the hid- eously bloody sign of her lack. Moreover, this discovery is not made once and for all. Woman's beauty is constantly interrupted, the eyes repeatedly return to their orbits, then again become unglued. Cas- tration thus measures out the very rhythm of temporality. Translated into spatial terms, this is the truth of the tower that is actually a well in reverse. (In the dream, the young woman, once lifted by the crane onto the tower of Saint-Sulpice, becomes the toothless, bloody-mouthed old whore.) Female lack absorbs the male erection into her bottomless pit. Indeed the erection is nothing more than the pit turned inside out.

This turn, whereby the inside shows itself on the outside is, in Huysmans's morbid imagination, an essentially pathological phe-

nomenon. The wound of castrated woman festers and becomes syphilitic. What is inherited from father to son, "the unusable legacy" (*AR,* 197), is the virus that thrives in the female sexual organs and erodes the surface of the skin with pitted wounds and puffed-up chancres. Des Esseintes's nightmare vision of Syphilis personified is accompanied, significantly, by castration imagery. First the woman he is with—whom he is unable to recognize, despite her having been "implanted for a long time already in his inmost being and in his life" (*AR,* 199)—loses her teeth and vainly tries to replace them by thrusting bits of the white stems of clay pipes into the holes in her gums.[18] The figure of Syphilis herself is then vividly imaged as both castrating and castrated. As Des Esseintes approaches this seductive, naked figure with a mixture of horror and fascination, black Amorphophalli (exotic plants whose black stalks, scarred with gashes, he had compared earlier to "damaged Negro members"— *AR,* 194) suddenly spring up on every side and he feels "utter disgust at the sight of these warm, firm stalks twisting and turning between his fingers" (*AR,* 203).

We recall Freud's observation, mentioned earlier in connection with *Olympia,* that "a multiplication of penis symbols signifies castration" while mitigating its horror by replacing the dreaded absence by a plurality of presences.[19] Like Nana, Syphilis—who is also identified as "the Flower"—becomes phallic through the power she derives from her violent mutilation. Once the pullulating male members have disappeared from her stomach, Des Esseintes is confronted with the horrible truth that haunts his unconscious as it does Jacques Marles's: "He saw the savage Nidularium blossoming between her uplifted thighs, with its swordblades gaping open to expose the bloody depths" (*AR,* 203). Thus, the female sexual organs, flowers of evil, are armed with the very instruments of their own laceration.

It is important to see that Huysmans's fantasy here is not simply that woman is castrated, but that her sexuality operates a kind of undecidable mixture of male and female attributes. Huysmans associates this operation with a confusion of animal and vegetable realms. Woman as diseased phallic flower becomes, in the hallucinated imagination of Gilles de Rais (as recreated by Durtal in *Là-Bas*), woman as salacious self-fornicating tree:

> Here the tree appeared to him as an upright living being, with its
> head down, hidden in the hair of its roots, its legs in the air,

spreading them apart then dividing them again into new thighs that open in turn, then become smaller and smaller as they move away from the trunk; there, between these legs, another branch is thrust, in a motionless fornication that repeats itself and diminishes, from twig to twig, up to the top; there again the trunk seems to be a phallus that rises and disappears under a skirt of leaves, or, on the contrary, that emerges from a green fleece and plunges into the soft belly of the earth. (*LB,* 170)[20]

The branches of this tree, whose identification with female sexuality becomes clear when the entire forest is transformed into a nightmarish vision of "female triangles, great V's" (*LB,* 171), these proliferating branches are at once female thighs open to penetration by the phallus and the phallus itself. Increasing our sense of undecidability, Huysmans suggests furthermore that the tree can be read interchangeably as emerging upward from the earth or plunging downward into it. Thus, female sexuality, by subverting the stability of gender difference, upsets the order of high and low, active and passive, animal and vegetable. Ultimately it infects the entire biological world with the diseased blood flowing from its gaping wounds. A terrifying vision of organic decomposition and degeneration is the final stage of Gilles de Rais's hallucination:

On the treetrunks Gilles now sees disturbing polyps, horrible gnarls. He becomes aware of exostoses and ulcers, of deeply-cut wounds, chancrous tubercles, atrocious blights; it is a leprosarium of the earth, a venereal clinic of trees, among which a red hedge suddenly comes into view . . . [whose] falling leaves tinged with crimson make him feel as if he were being soaked in a rain of blood. (*LB,* 171)

It is tempting to limit the significance of these repellent images of female sexuality by ascribing them to the idiosyncrasy of Huysmans's peculiar neurotic sensibility. But they only take to the extreme point of nauseous disgust the obsessive fear of woman's sexual nature, epitomized by the prostitute, that pervades the male imagination, both novelistic and scientific, throughout the nineteenth century and that reaches a kind of hysterical paroxysm in its last two decades. Although Huysmans imagines that in *Là-Bas* he has moved away from Zola toward a "spiritual naturalism," the passage just quoted is clearly indebted to the abbé Mouret's hallucinated night-

mare of a morbidly productive nature invading and decomposing his church. The assault begins with "rust-colored lichens [that], like an inflamed leprosy, eroded the grains of plaster,"[21] and it ends with a mammoth sorb tree bursting the church apart. Zola's tree, like Huysmans's, is both vegetable and animal, obviously phallic yet also female:

> Now the giant tree touched the stars. Its forest of branches was a forest of members, of legs, of arms, of torsos, of stomachs, all exuding sap; women's hair hung down; men's heads made the bark split with the laughs of young buds; all the way on top, couples of lovers, swooning on the sides of their beds, filled the air with the music of their joy and the odor of their fecundity.[22]

This vision of organic fertility gone wild joins Huysmans's vision of rampant organic degeneration: both have their fantasmatic origin in the horror of castration, both identify female sexuality with the organic basis of nature itself and view that basis as morbidly diseased.[23]

Another passage in Zola that prefigures Huysmans's treatment of female sexuality occurs in *La Curée*.[24] An immense hothouse, teeming with the same kinds of exotic tropical plants with which Des Esseintes, thirteen years later, will fill up his country retreat, here constitutes the sexually charged environment in which Renée Sacard first imagines, then consummates, incest with her son-in-law. Zola describes the greenhouse as a kind of living organism, female, in heat, exuding sexual fluids and a "penetrating, sensual" *odore di femmina*. Stimulated by this vertiginous excess that fuses animal and vegetable—the twisted red leaves of the begonia and the white, pointed leaves of the caladium seem to the lovers "the rounded forms of hips and knees, sprawled on the ground, subject to the brutality of bloody caresses" (*C*, 486–487)—Renée becomes increasingly masculine: "It was above all in the hothouse that Renée was the man" (*C*, 486). Through her perverse and voracious sexual energy, she easily dominates the passive and effete Maxime, "cette fille manquée" (*C*, 485), the late product of a genealogical line vitiated by degenerate heredity. Thus, she becomes phallic precisely through her association with what is most intensely and characteristically female. And it is in her capacity as the phallic woman, the woman become man by the force of her sexual desire, that she

resembles, "like a sister" (*C*, 485), the black marble sphinx that crouches at the very center of the great hothouse.

The enigma of the sphinx is thus not quite as unreadable as Naomi Schor maintains in her essay on femininity in Zola. She argues that in "a mytho-pathology . . . particularly rampant in nineteenth century literature, . . . woman's literariness seems to be bound up with her being turned into marble, her enigmatization."[25] This enigmatization, I believe, is due to the sphinx's being at once decapitated (in the sense that her head is added on to an animal's body) and marmoreal, at once castrated and phallic. But this fantasmatic doubling of woman's power is a secondary formation generated by the initial perception of female lack, of the terrifying wound. Woman does not constitute in herself the undecidability of sexual difference: she produces it as a fantasized effect of the organic lesion that, in the obsessed male imagination, fissures her being. Thus, it is no accident that Zola ends his extraordinary description of hothouse incest by evoking, in images that directly foreshadow Huysmans, the voracious mouth of woman as a bleeding red flower that figures her castration: "[Renée's] mouth then opened with the avid and bleeding brilliance of the Chinese hibiscus . . . She had become the inflamed daughter of the hothouse. Her kisses bloomed and faded, like the red flowers of the great mallow, which last only a few hours and are ceaselessly revived, like the ravaged and insatiable lips of a giant Messalina" (*C*, 489).[26]

Dramatically visible on the very surface of the Huysmans text, castration causes a fissure in the surface of the real, punctures the skin of representation, erodes its containing membranes, infiltrates and contaminates its tissues. "Specialist of skin diseases," writes Alain Buisine in a suggestive article on the pathological porosity of Huysmans's world, "the describer [*descripteur*] is a dermatologist who can never stop detailing the lamentable state of innumerable membranes of all kinds."[27] Fascinated, compelled, unable to avert his eyes, Huysmans, from his first book to his last, never stops detailing the ontological consequences of the exorbitant female wound as it corrupts, infects, rots, and decomposes the real. His much-touted evolution from naturalism to decadence to satanism to Catholicism did not entail any fundamental change in his conception of the physical world, only changes in the perspective from which that world was viewed.

For instance, take this description in *En Rade* of the castle of Lourps, where Des Esseintes was born: "In short, the infirmities of a terrible old age, the catarrhal expulsion of the water, the vitriolic blotches of the plaster, the rheum of the windows, the fistulas of the stone, the leprosy of the bricks, a whole hemorrhage of refuse, all had attacked this miserable hovel that, alone and abandoned, was slowly dying in the hidden solitude of the forest" (*ER*, 70–71). The rotting body of the moribund castle bears a remarkable resemblance to that of Saint Lydwine de Schiedam, whose hagiography Huysmans wrote in 1901, after his conversion. She is the happy victim of "le feu sacré ou le mal des ardents,"[28] a dreaded disease in the Middle Ages, forerunner of syphilis, whose gangrenous infections Huysmans imagines Grünewald to have copied from hospital rooms for his rendition of the crucified Christ. Her entire organism is rotten with purulent ulcers, pustulant tumors (in which large worms swarm), degenerative nerve-destroying maladies (her arm hangs by one strand): "The forehead split apart from the roots of the hair to the middle of the nose; the chin broke away under the lower lip and the mouth swelled up; the right eye died out; . . . she lost blood through the mouth, the ears, the nose" (*SL*, 81), and, as if this were not enough, "then it was the lungs and liver that decayed" (SL, 82). The miracle is that she lives thirty-nine years in this devastated state. For her afflictions are not natural. They are the signs written in her flesh of her privileged relation to God, crowned ultimately when she receives the stigmata. By mystical substitution, she is continuing Christ's mission of suffering on earth as an expiatory victim. Thus, she invites her suffering, "cette vorace de l'immolation" (*SL*, 56), actually requesting and receiving from her beneficently sadistic master a third plague-ridden abcess "in honor of the Holy Trinity" (*SL*, 82).

There is, however, a significant difference between Jacques Marles's anxious observation of the ruinous castle of Lourps "dans un état désorbité d'âme" (*ER*, 71: literally, "in a disorbited state of mind") and Saint Lydwine's delighted perception of her body's progressive ruination: Jacques is overwhelmed by his inability to deal rationally with a world in decomposition, whereas Lydwine is able to read her physical disintegration as a text.[29] Her numerous wounds and dismemberments do more than signify the horrifying fantasy of castration: they suggest the possibility of a dialogue

between the biological world and a transcendent one. It was just
such dialogue that Durtal imagined capable of curing, through sub-
limation, the "infinite distress" of Grünewald's ulcerated, gan-
grenous Christ. Saint Lydwine's physical suffering signifies her over-
coming of the female organism; her gaping wounds are filled with
the Divine Word; her disfiguration, in the very exorbitance of its
violence, is contained in and by God's purpose. Even as the narrative
of Lydwine's life connects castration and temporality in the (to
Huysmans) satisfying mode of excess,[30] it also sublimates that nar-
rative out of temporal sequentiality into a transcendent mode of
symbolic repetition. Lydwine's reception of the stigmata is not a
further emblem of her castration, but a symbol of her being intact
as a member of the mystical body of Christ dedicated to the con-
tinued expiatory repetition of his Passion. It is, furthermore, one of
the signs of Saint Lydwine's mystical intactness, of her symbolic
equation with Christ, that her decomposing body is miraculously
sublimated: "In a constant miracle, [God] made her wounds into
cassolettes of perfumes; plasters removed pullulating with vermin
gave off delightful scents; her pus smelled good; delicate aromas
emanated from her vomit" (*SL,* 88).[31]

How to produce a cure for bodies with mysterious illnesses,
secreting unwanted fluids, suffering from paralyses, phobias, and
hallucinations—this was also the challenge facing Jean-Martin
Charcot, the acknowledged master of fin-de-siècle hysteria. In *Là-
Bas* Huysmans sees Charcot as a positivistic materialist who, despite
his brilliant diagnosis of all the phases of a hysterical attack and his
ingenious identification of the various hysterogenic zones on a wom-
an's body, still can say nothing about the "sources and motives"
(*LB,* 153) of hysteria. He considers Charcot representative of the
rampant materialism that charaterizes fins de siècles, in reaction to
which arise mysticism, magic, and the occult. But actually Charcot's
activities at the Salpêtrière hospital show that he encouraged some-
thing very like magic within the framework of his scientific natu-
ralism. Moreover, the focus of the doctor's sorcery was identical to
that of Huysmans's obsession: woman's sexualized body and its
possible sublimation.

It is not only from our present perspective that the Salpêtrière
under Charcot appears as a kind of brothel for voyeurs. The analogy
was drawn by numbers of eyewitnesses.[32] Indeed, it could be argued

that, given the increasing diffusion of prostitutional practices in this period, the hysterics on display at the Salpêtrière were the prime stimulus for many of the male fantasies about female sexuality previously projected onto prostitutes.[33] The connection was that much easier to make in that the inmates were almost all working-class women from the very professions long known to furnish recruits for prostitution: seamstresses, laundresses, domestic servants, and flower sellers.[34] At the "leçons du mardi" these women were put on exhibit—prostituted in the literal sense of "placed forth in public"—before an eager bourgeois male audience that included not only medical professionals, such as Freud, but also literary men, such as Maupassant and Huysmans, politicians, painters, sculptors, architects, and interested spectators from all walks of life. Charcot then exercized his famous clinical gaze on the hysterics' scantily clad bodies and gave a running account of his diagnostic thoughts. The sexual politics involved are clearly revealed in a well-known painting of Charcot's clinic by Pierre André Brouillet (see Figure 41) that shows an attractive young female patient, bodice exposed and shoulders bare, leaning back submissively into the solicitous arms of Charcot's disciple Babinski, while the master lectures to an audience straining forward to catch every detail of the show. The scene has a structure now familiar to us: Charcot "reading" a hysteric is like one of Parent-Duchâtelet's police officers identifying a prostitute or like a Balzacian dandy visually penetrating a Parisienne's disguise. In each of these cases, the operative scopophilic fantasy is of a female body transparently meaningful to the expert male gaze, which decodes its cultural signs and lays bare its essential nature. For Parent and Balzac, however, the imagined consequence of failing to expose woman's sexual deviance to knowledge and control was not as threatening as it had become by the fin de siècle, when the stake was felt to be the health of the human organism itself.

Charcot's model for laying bare female nature was anatomical physiology. Like Zola, he considered himself a student of Claude Bernard's experimental method. His dream was to be able to identify in an autopsy the individual brain lesions that had caused particular hysterical symptoms. The irrational behavior of the living should offer a perfectly rational map of the dead's pathology. "What I call psychology," Charcot wrote in 1887, "is the rational physiology of the cerebral cortex."[35] Although this identification of hysteria as a

neurosis rather than a disease of the womb represents a significant clinical advance, its biologism is just as fundamentally sexist as was the old theory of uterine thwarting and retardation. And this despite Charcot's famous diagnosis of hysteria in men. For the hysteric's brain remains for Charcot, as it was for his predecessor Pierre Briquet, essentially female or, more precisely, feminine.

In his work of 1859, *Traité clinique et thérapeutique de l'hystérie*, Briquet defines hysteria as "a neurosis of the encephalus, whose apparent symptoms consist primarily in the perturbation of the vital acts serving to manifest the affective sensations and the passions."[36] Then he goes on to identify woman as "predisposed," due to her biological destiny as mother and caretaker, to such perturbations.

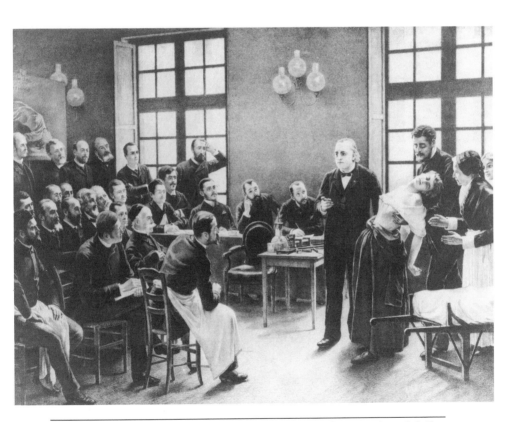

Figure 41. *Jean-Martin Charcot demonstrating a hysterical case at the Salpêtrière.* Lithograph after the painting by Pierre André Brouillet (ca. 1887).

"It is because women feel so deeply that they are fated to become the prey of hysteria," declares Briquet. His approach admits the possibility of male hysteria but only from a purely essentialist point of view: the hysterical man is cerebrally effeminate; he has too much of a woman's hyper-impressionable disposition. Briquet declares himself pleased to have liberated hysterics from the usual charges, stemming from the uterine etiology, of sexual frustration and lascivious fantasies. But this exculpation is actually a new form of repressive control: woman's true nature is defined as other than her sexual desire. What the hysteric needs to experience is senti-mental and maternal feeling, not sexual love, whose sensual excesses fuel the flames of nervous disease.

Despite his difference from Briquet on the issue of nosology (Bri-quet considered hysterical symptoms too protean to be classifiable), Charcot espoused the same patriarchal gender ideology as his fore-runner. Dissociating hysteria from sexuality and desire, he viewed the disease as an inherited taint passed on through the female line from generation to generation. His dream of identifying the precise location in the cerebral cortex of the inherited lesions that cause hysterical behavior was motivated by an imaginary equation of woman with pathology—pathology that, Charcot argued after Bri-quet, can also be found in male brains. This dream of triumphant neurology is positivist and materialist; to that extent, Huysmans was right about Charcot. But the association of woman with degenera-tive pathology is just as unscientific and fantasmatic as anything in the novelist's own texts—or in those of the majority of the medico-cultural thinkers of the fin de siècle, for whom heredity and degen-eration are practically synonymous and woman is the dangerously seductive vehicle of hereditary taints such as syphilis, hysteria, and madness. As Elisabeth Roudinesco remarks about this period in her monumental *Histoire de la psychanalyse en France,* "At the center of the question of heredity-degeneration stands the figure of a sexuality constituted of syphilis, occultism, and hysteria: by its means, mon-sters engender bastards. In spite of the introduction of the concept of neurosis, the uterine hypothesis is maintained in the green phantom of syphilis."[37] Like syphilis, hysteria so pervades the permeable, fluid, female body that Charcot's displacement of its locus from uterus to nervous system can be no more than a utopian attempt at anatomical rigor undertaken in the face of an irresolvable

porosity and pandemic sexuality. Hysteria, Charcot admits at one point, is "a sphinx that defies even the most penetrating anatomy."[38] Once again we see that the sphinx is impenetrable not so much because she is marmoreal as because her anatomy defies the goal of dissection, the clear establishment of differences, definitions, boundaries, and identities.

In Huysmans's judgment, the most perplexing of this sphinx's riddles was: "Is a woman possessed because she is hysterical, or is she hysterical because she is possessed?" (*LB,* 152). Secular and anticlerical as he was, Charcot would no doubt have chosen the first of these alternatives. Indeed, he liked to demonstrate the continuity of hysterical phenomena by showing that the hallucinated poses of demoniacs in artistic representations through the centuries corresponded to his iconography of hysterical gestures.[39] He refused to recognize that a kind of "possession" was occurring under his own auspices at the Salpêtrière and that this occult deviltry involved precisely the factor of sexuality he had split off from the hysteria diagnosis.

The relation of the hysterics at the Salpêtrière to their ruling master was not unlike Saint Lydwine's relation to God. Just as Lydwine called upon Christ to imprint her body with ever more awful signs of her election, of her possession by divine love, so Augustine, the star hysteric at the Salpêtrière, incorporated with ever greater precision and predictability the standard poses of the hysterical attack, emblems of her possession by Charcot's choreographic will and of her desire for his love. Charcot's conviction of the scientific truth of his analysis blinded him to what was truly miraculous about Augustine's conduct, its perfect conformity to his own desire. The doctor's pedagogical and therapeutic procedures constructed hysteria as a repetition, rather than an undoing, of the religious model of (female) transference onto an all-powerful (male) figure. The journalist Jules Claretie, writing in 1903, describes Charcot's clients, in imagery reminiscent of Parent-Duchâtelet, as "arriving like the detritus of Paris at the mouth of a sewer." Thereafter, he maintains, they were "miraculously transformed" by "the consoler of the century" into worthy, productive citizens.[40] But in reality the premium placed on dutifully repeating the drama of illness was more likely to lock the hysteric into disability than to release her from it. After all, Charcot's theater had one tremendous

attraction for its equivocal stars: it afforded suffering women a stage on which to express their desire, in however displaced and disguised a form.

The hysterics at the Salpêtrière acted out their sexuality in masochistic submission to their master's wish to see them perform his scenario of abjection. The famous "attitudes passionnelles," recorded for posterity in the photographs collected in the *Iconographie photographique de la Salpêtrière,* include poses labeled "amorous supplication," "erotism," "ecstasy" (see Figure 42). In these poses Augustine typically looks up in the air as if she were addressing herself to an absent Other (Lover?) to whom, according to the *Iconographie,* she put questions such as "What do you want?" followed by exclamations such as "No! No! I don't want to."[41] The question of the Other's desire is also the question of what the subject wants of the Other. One can imagine this Other to be Charcot, whose attention the hysteric welcomes as evidence of her value in his eyes, but whose gaze also painfully confirms her degradation, prompting her to stage her abnormality over and over again, like a prostitute turning tricks. One can imagine, furthermore, that the figure of Charcot may well have fused in Augustine's fantasy with that of her mother's lover, who, she claimed, raped her at age thirteen. Augustine's performance would then have incorporated a symbolic repetition of her rape, figured perhaps in her crucifixion pose (see Figure 43), which was often preceded by the appearance of "clous hystériques," as if the body were actually being nailed to the cross.[42]

Women exhibiting their wounded sexuality, performing their intimate hurt—this is what the male artists, writers, and doctors of the fin de siècle came to see at the Salpêtrière, their sadistic voyeurism excused by the prestige of Charcot's scientific enterprise. The hysterics' performances at once gratified these men's desire to see women debased and out of control, thus justifying their sexual fears (if this is essential woman, who wants her?) and afforded them a stimulus for creative sublimation. This stimulus came from the association of the hysteric's sexualized body with the spectacle of its semiosis. However much of a sphinx it might be, the hysteric's body was unquestionably seized by meaning. Its contortions, masks, and mimes called out for interpretation. The disarticulated female body urgently displayed its need to be articulated by male science. Oozing saliva, sweat, tears, urine, menstrual blood, vaginal fluids (Augus-

Planche **XXIII**

ATTITUDES PASSIONNELLES

EXTASE (1878).

Figure 42. *Passionate Attitudes: Ecstasy.* From D.-M. Bourneville and P. Régnard, *Iconographie photographique de la Salpêtrière* (Paris: Progrès Médical / Delahaye and Lecrosnier, 1878), II, plate 22.

tine is said to have had "an abundant vaginal secretion" immediately after her Passion play), this leaky vessel required expert stopgap measures. Here was "the infinite distress of the soul" somatizing its request for a sublimating cure, for a translation of obscure body language into authoritative discourse. The process of this translation offered the fin-de-siècle specialists of naturalist anatomy the attractive prospect of abandoning this degenerate body to its organic fate, the progressive erosion of syphilis or insanity, while they earnestly manipulated its significance as a semiotic corpus, whose dissection enhanced their scientific prestige.

Let us return now to Huysmans. It is clear that his persistent elaboration of fantasies of biological decay and pathological porosity

Planche XXV.

ATTITUDES PASSIONNELLES

CRUCIFIEMENT

Figure 43. *Passionate Attitudes: Crucifixion.* From D.-M. Bourneville and P. Régnard, *Iconographie photographique de la Salpêtrière* (Paris: Progrès Médical / Delahaye and Lecrosnier, 1878), II, plate 25.

reflects a fascination bordering on identification. Read in psycho-
analytic terms, Huysmans can be said to masochistically enjoy
repeating the traumatic discovery of the absence of the mother's
penis and dwelling on what he fantasizes as the consequences of
this absence, the organic world given over to syphilitic disease and
hereditary degeneration. The fearful excitement of a self unraveling,
decomposing—this is the unconscious appeal for Huysmans of the
fantasy of woman's castration. Charcot no doubt felt a similar attrac-
tion to his fantasy of a hystericized female body shattered by the
force of its flamboyantly diseased sexuality.

Indeed, for numerous male writers and artists of the fin de siècle,
the hysterical female body presented a reflection, at once seductive
and repellent, of their own anxiously deconstructed self-images. It
may be useful to remind ourselves, even if only briefly, just how
widespread the manifestations of this phenomenon were. A number
of recent studies have demonstrated that masculinity has rarely been
as vulnerable and fearfully reactive as it was in this period.[43] This
fear is evident in the numerous paintings, by both obscure and well-
known artists of the fin de siècle, analyzed by Bram Dijkstra in his
Idols of Perversity. It is also manifest in the virulently misogynist
works of the founder of criminal anthropology, Cesare Lombroso,
whose *La donna delinquente, la prostituta, e la donna normale* (1893),
published in French as *La femme criminelle et la prostituée*, describes
prostitution as "the feminine form of criminality," any prostitute
being therefore "psychologically criminal."[44] Lombroso's influential
book, written with his son-in-law Guglielmo Ferrero, is permeated
with the terror that active—that is, masculinized—female sexuality
will cause a catastrophic collapse of sexual difference (hence Lom-
broso's normative definition of woman as "naturally monogamous
and frigid"). *Any* woman, insofar as she is the subject of desire, is
branded by Lombroso as perverse, erotically deviant, and atavisti-
cally degenerate. Her truly vicious character is most clearly revealed
during her menstrual period, when the lack of proper subordination
among her organs is exacerbated, her hysteria becomes uncontrol-
lable, and she is "capable of anything." Lombroso draws authority
for his delirious vision of the menstruating woman, whose over-
flowing blood is the sign of her unbridled sexuality, from the pro-
fusely documented medical thesis (1889) of Dr. Séverin Icard, which
perpetuates the myths, dear to Michelet, that woman is ill by nature

and that her menses are the equivalent of heat in animals, hence responsible for nymphomania. Dr. Icard judges hysteria the least serious of the psychic maladies attending woman's monthly crisis, the worst being "complete loss of reason . . . and absolute irresponsibility."[45]

Another symptomatic work of the period is Max Nordau's bestselling *Entartung* (*Degeneration,* 1892), dedicated to Lombroso, which castigates fin-de-siècle art and culture for its heterogeneity, discontinuity, sensationalism, morbidity, and narcissism—all traits that Nordau, who studied with Charcot, explicitly associates with hysteria and female degeneracy. "Decadentism" is one of Nordau's favorite subjects of vituperative attack. He labels Huysmans "the classical type of the hysterical mind without originality,"[46] and likens Des Esseintes to "a parasite of the lowest grade of atavism, a sort of human sacculus" (the term is defined in a footnote: "a cirrepedia which lives in the intestinal canal of certain crustacea").[47]

Similar fantasmatic associations are the stuff of anti-Semitism (Drumont's *La France juive* was published in 1886; the Dreyfus affair was at its height from 1894 to 1900). Lombroso and Nordau, both Jewish, resisted this extension of their thinking, but whereas Nordau became an effective propagandist for Zionism, Lombroso undermined the argument of his *L'antisemitismo e le scienze moderne* (1894) by accepting the view, supported by Charcot, that Jews are disproportionately susceptible to hysteria and mental illness. The Jew who most systematically, and self-destructively, linked the doctrines of misogyny with those of anti-Semitism was Otto Weininger. His *Geschlecht und Charakter* (*Sex and Character,* 1903) expounds the connection between woman and Jew, describing them both as prostituted, characterless, materialistic, regressive, parasitic, weak-willed, mindless, mendacious, and perverse. Weininger was haunted by the specter of the erosion of the sexual polarity, which he considered fundamental to civilization, of positive male spirit and negative female flesh. He shared with many of the male thinkers and artists at the century's close an obsessive fear of becoming female and being absorbed into a morass of organic degeneracy.

Huysmans, I have suggested, was creatively stimulated by this fear, which offered the masochistic pleasure of a dissolving masculine ego. A standard Freudian explanation for the genesis of such creativity would cite the mechanism of sublimation. But insofar as

sublimation is generally thought to involve the desexualization of libido, the displacement of its original aim and the diversion of the instinct toward new, nonsexual objects, the term does not seem adequate to account for Huysmans's creative activity. Recent theories of sublimation, elaborated by Jean Laplanche and Leo Bersani, are more relevant. They demonstrate that the process of sublimation is less a repressive escape from traumatized sexuality than it is an effort to appropriate the excitement of traumatic shock for creative production.[48] In the fin-de-siècle period, this effort was focused on hysteria as a potentially original mode of representing the female body in an aesthetic medium identified as male.[49]

Huysmans portrays biological life on the model of female castration as a diseased hemorrhaging, an entropic loss of vital energy, but a loss that ostentatiously displays its biodegradable contents. The morbid brilliance of this display, Des Esseintes maintains, has been effectively represented in only a few eras in history, when the arts reflected the disintegration of tyrannically conventional social orders. in these decadent periods truth emerged from repression, and the exorbitant wound was revealed as the diseased being of the real. Significantly, Des Esseintes chooses images of biological decay to describe a language infected by decadence, the Latin language of the fifth century: "Completely rotten, she sagged, lost her members, spilling out her pus, retaining, in all the corruption of her body, hardly any firm parts" (*AR*, 125). Such a syphilitic verbal body, like the physical body of Saint Lydwine, obviously threatens the very possibility of intelligible representation. It takes an artist of the caliber of Baudelaire to express, "thanks to a muscular and firmly fleshed-out style, . . . those regions of the soul from which monstrous mental vegetations branch out" (*AR*, 261-262).

Baudelaire's style, Huysmans implies, incarnates a male triumph over female monstrosity, a sublimation of organic deformity. It has the power "to fix in curiously healthy terms the most fugitive of morbid states" (*AR*, 262). Des Esseintes's ambition is to perform a similar fixation of temporal morbidity. Sublimating artifice is, of course, the function of many of his experiments. His perfumes, for example, are all, with the single exception of jasmine, artistic *representations* of natural odors fabricated from diverse alcoholates and essences. They are simulacra, without organic content. Moreover, the perfumes, like Lydwine's body or the bodies of Charcot's hys-

terics, are readable as texts, written in a coded language with various dialects and styles. Des Esseintes learns to understand "the syntax of odors" (*AR,* 224) and to perform "the exegesis of those texts" (*AR,* 226). The great attraction of this exercise is precisely its fetishizing and sublimating functions: unity is reconstituted as a rigorously structured code, a system of signs whereby the mechanism of a work may be dismantled and reassembled. Des Esseintes, like Charcot, imagines himself in the place of God the Father, at a point of creative origin. That origin, however, is not conceived in a genealogical sense but rather, in Edward Said's terms, as an intentional beginning, a deliberate rupture with the syphilitic organic cycle.[50] This rupture initiates an artistic mode that is consciously antibiological, willfully unrealistic, and artfully superficial. Indeed, so complete is Huysmans's desired rupture with biological models of origin that the analogy with a paternal God is probably inaccurate. His fantasy seems rather to be the restoration of a purely fantasmatic model of wholeness, the phallic mother, guarantor of a world of sexual sameness purged of sexual desire.

The motivating scenario in *A Rebours* is symbolic re-memberment: the maternal phallus must be returned to its fantasized place. Thematically, this involves the creation of simulacra, artifacts that simulate nature without having nature's organic interiority. The surface without depth, made-up, factitious: this is the ideal field for fantasmatic re-membering. By means of what Des Esseintes calls "a slight subterfuge, an approximative sophistication of the object" (*AR,* 106), he hopes to obtain what the doctrine of mystical substitution obtains for Saint Lydwine in Huysmans's later book—that is, the sublimation of nature's degenerative violence into symbolic form. The danger, of course, is that this formal representation will be so emptied of living content that it will be entirely sterile, synthetic, inert, like the landscape Des Esseintes glimpses in his dream just before the terrible appearance of the figure of Syphilis: "a hideous mineral landscape . . . a wan, gullied landscape, deserted, dead" (*AR,* 202). The simulacrum, to be effective, must not destroy biological process but rather exhibit it as that which has been denied, controlled, marked, like Des Esseintes's monstrous flowers, with the artist's stamp. "Through this cunning strategy," comments Alain Buisine, "disincarnation proceeds by a spectacular exhibition of the organic; the evacuation of the real involves its display: ostentation in order

to protect oneself from what one would have preferred never to have seen."[51]

This, of course, is precisely the strategy of the fetishist, and indeed one could argue that Huysmans's entire literary project is generated according to the formula Octave Mannoni considers typical of fetishistic behavior: "je sais bien, mais quand même" ("I know perfectly well, but just the same").[52] Referentially, Huysmans is constantly evoking and vividly illustrating his traumatic fantasy of woman's castration—but still he wants to deny that trauma. This denial is the driving force motivating his choice of what we recognize today as modernist aesthetic practices. Indeed, Huysmans illustrates perhaps more strikingly than any of the other authors I have discussed the psychogenesis of modernism as a reaction to fantasy associations linking female sexuality to organic disease. His aesthetic project attacks the referential function of language and works to subvert the organic model of plot development. To accomplish this subversion is to create a text purged of mimetic dependence on female nature.

The narrative structure of *A Rebours*—like that of *Bouvard et Pécuchet*, which it resembles and from which it may derive—is discontinuous.[53] The order of the chapters could easily be changed without appreciably affecting the story. Rather than unfolding the complexities of a novelistic plot, the chapters are juxtaposed as largely self-contained units. In his preface of 1903, Huysmans writes of his "desire . . . to break the limits of the novel, to bring art, science, history into it" (*AR*, 71). Such a desire is the aesthetic correlative of traumatophilia: Huysmans welcomes fragmentation and heterogeneity. He wants to shatter the organic model of a plot's developing body. Each chapter, he declares in a suggestive formula, is "the sublimate of a different art" (*AR*, 60). These "sublimates" act as experimental vehicles to stimulate fantasies and thereby displace present reality. The fantasies, which may evoke past experiences, in life or in the library, as well as imaginary possibilities, constitute the signified of much of the narrative. They have no logical or natural place in a temporal continuum. But however heterogeneous their referential contents may be, these carefully cultivated fantasies all have the same function of denying the organic basis of sexual difference. Structural discontinuity in the Huysmanian novel is in the service of unifying sublimation. For Huysmans, denial is vital—and

denial always bears specifically upon the traumatic perception of female castration. Thus, it is no accident that in his preface Huysmans declares that his formal project to "abolish the traditional plot" requires the suppression of "passion, woman" (*AR*, 71). But we have seen that this sublimation of the trauma of woman actually serves to maintain that trauma as a continual source of masochistic sexual excitation stimulating the writing process. The decomposing, shattering energies of syphilis and hysteria are sublimated to function as sources of modernist aesthetic shocks. Trauma is freed of its specific sexual origin and becomes, paradoxically, a libidinal tool of unifying reparation.[54]

Huysmans uses modernist techniques of rupture and discontinuity to re-member the surface of the text as a fetish. He inserts great masses of dense erudite material, sometimes taken verbatim from unidentified sources. He cites literary texts at length and analyzes their merits. He makes lists of exotic proper names, of plants, of stones, of authors. He loves rare, difficult words and a deliberately tortured syntax. The effect of all this is to create a textual surface that, like the tortoise's shell that Des Esseintes encrusts with precious stones, is studded with elements alien to biological life. The text's linear development and its referential function are constantly being interrupted as the reader encounters verbal entities, large or small, that impose their presence on his attention because of their rarity as objects, their material density, their provocative strangeness. Thus, Huysmans's text can accurately be called ornamental, and the connection brilliantly established by Naomi Schor in regard to one of Des Esseintes's favorite novels, *Salammbô*, between textual ornamentation and fetishism applies perfectly here.[55] As Schor reminds us, the ornamental should not be conflated with the secondary or accessory. Art history teaches that the original function of ornament was of a magical and metaphysical order. And this is precisely its function for Huysmans. The encrusted verbal surface serves, in Des Esseintes's formula, to "supplement the vulgar reality of facts" (*AR*, 105). The supplement magically denaturalizes and sublimates. As was also the case with Charcot's hysterics, the female wound is repaired in fantasy by a textuality that finds its source not in nature but in the dictionary, the catalogue, the archive, the library. Textuality becomes intertextuality; the fetish spreads its veil; modernism

espouses the unnatural logic of the supplement. But the fantasy of the castrated, syphilitic, hysterical female sexual body remains— provocative, unsettling, destructive, fascinating. The library cannot conjure it away, the supplement cannot take its place. Unconsciously, Huysmans would not have had it any other way.

Conclusion

*T*he year is 1907: Picasso paints the *Demoiselles d'Avignon* (see Figure 44), a revolutionary work, often considered the first "Cubist" painting or the first "truly twentieth-century" painting. If one is not going to go back as far as Manet's *Olympia* to identify the beginning of modern art, then the *Demoiselles* might well be the next most suitable candidate. Can it be an accident that the subject of this huge canvas is five whores in a brothel? The argument I have pursued in this book suggests that there is something uncannily necessary about Picasso's choice of subject. From the mid–nineteenth century to the beginning of the twentieth, modernism obsessionally and anxiously displays its innovative desire by fragmenting and disfiguring the female sexual body, epitomized in male fantasy by the prostitute.[1]

The long-prevailing critical response to the *Demoiselles* echoes significantly the formalist analysis of *Olympia* initiated by Zola and carried through to its logical extreme by Bataille. The painting was repeatedly said to demonstrate the modernist emancipation of form from content, the abandon of naturalistic reference in favor of self-reflective abstraction. Such criticism espouses what is unquestionably a powerful vector of desire in modernism: to dissociate the energies of female sexuality from their biological source, imagined as castrated and diseased, and to capture their force in the hard-edged discontinuities and heterogeneous discrepancies of non-organic structures. It is characteristic of the greatest modernist works, however, that their dissociative projects fail. As we have

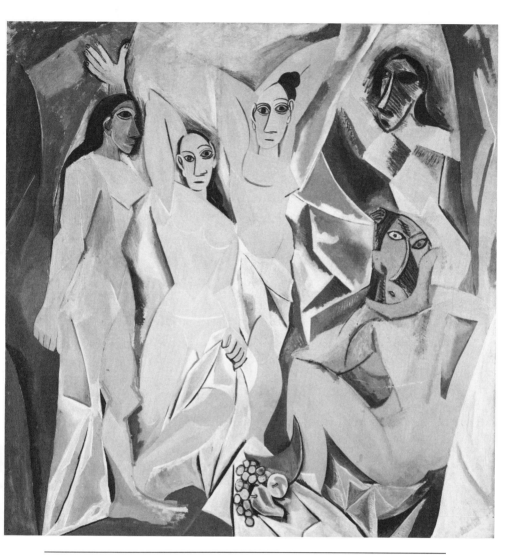

Figure 44. Pablo Picasso, *The Demoiselles of Avignon* (1907). Oil on canvas. Museum of Modern Art, New York.

seen, the fascination exercised by fantasies of female sexuality repeatedly compels expressive representation. In the case of Picasso's painting, which he liked to call simply "mon bordel," it was not until Leo Steinberg's essay of 1972, "The Philosophical Brothel," that the defensiveness of the formalist reading of the picture was exposed. Steinberg's article brilliantly demonstrates how Picasso's compressed interior space and jarringly disjunctive styles physically render the theme of savage, disfiguring sexual menace.

Stretching to find images adequate to express the corporeal impact of the *Demoiselles* on its viewer, Steinberg creates metaphors whose sexual resonance goes significantly beyond his generalizing formulation about Picasso's "making the action of painting coincident with making love."[2] Picasso's pictorial space, writes Steinberg, "insinuates total initiation"; it is "like the feel of an inhabited pocket, a contracting sheath heated by the massed human presence." The vaginal image is unmistakable, and when one associates it with Steinberg's earlier suggestion that the picture arouses and engulfs the viewer through a process of "overriding contagion," it is hard not to feel that the critic has (unconsciously?) fantasized venereal infection as an essential element of the *Demoiselles*'s sexual threat. Recent biographical information confirms that Steinberg was responding to something very much on Picasso's mind in 1907: it is now thought that the artist had contracted syphilis on one of his frequent brothel visits.[3] Noting this biographical revelation in a new postscript to his essay, and warning against the temptation to reduce the meaning of Picasso's masterpiece to a vengeful portrait of female evil, Steinberg asks rhetorically: "But if this were indeed the rock-bottom truth about a picture acclaimed 'the first modern painting,' would this tell us something we perhaps ought to know about being modern?"

Having loaded the dice with the phrase "rock-bottom truth," Steinberg clearly expects his reader to find little relation between modernity, syphilis, and male rage against women. The reader of this book will know on what grounds to disagree. One can recognize the reductiveness of any "explanation" of the *Demoiselles* through its creator's medical history while one also acknowledges the importance of the fantasmatic associations linking prostitution, disease, and modernist art. It is, furthermore, not irrelevant to note Picasso's long-standing interest in observing the corrosive effects of syphilis

on women's bodies: during his second stay in Paris, in the summer of 1901 when he was nineteen years old, he was granted his special request to visit St. Lazare, the hospital for prostitutes with venereal disease, and he apparently spent several weeks there, inspecting the morgue as well as the wards. Just what motivated this visit is not clear. One critic speculates that Picasso's social conscience was aroused by the debate between abolitionists and neo-regulationists which, fueled by the professionally groomed specter of syphilis, raged with new intensity between 1898 and 1902.[4] Many of the paintings the artist produced in the years immediately after his visit are sympathetic portrayals of lonely lower-class women threatened in their desire for love by the dual hazards of venereal infection and joyless maternity. But it is fruitless to gauge the precise impact of Picasso's presence among the diseased whores of St. Lazare. My point is that his visit is emblematic of a fascination that, far from being personal and idiosyncratic, pervades the imagination of creative artists in France from the 1840s until well into the twentieth century.

In the final version of the *Demoiselles,* Picasso eliminated the two men he had sketched in the studies for the picture: a shy sailor at the center of the composition, overwhelmed by five naked women soliciting his attention, and a youth, identified by the artist as a medical student (he carries a book and/or a skull), entering the brothel salon from the left. Steinberg is surely right to associate these figures with a dialectic of analytic detachment (the skull reminds us of the fervor for anatomical dissection shared by so many of the writers we have discussed) and fearful initiation, of scientific observation (the medical student is marginalized much as is the Degas figure in Picasso's later brothel etchings) and threatening immersion (the sailor's regressive position resembles that of Degas's alter ego in Figure 29). Picasso's decision to remove these two figures—representatives, one may feel, of the artist's own split response to his sexual subject—eliminates any mediating actors between the spectator, now cast in the position of brothel patron, and the fiercely staring, physically aggressive, anatomically disjointed, self-exhibiting whores. The viewer, constructed as male through the picture's implications of commodification and exchange, is challenged to imagine exercising his power of sexual purchase in the face of women whose portrayal expresses his worst fears of their atavistic

primitivism, animalistic destructiveness, and cold, impersonal erot-icism. Indeed, the picture seems to portray the very process of atavistic regression, from the "normal" heads of the two central figures, through the dark metamorphosis of the woman on the left, to the Africanized masks and twisted, disordered anatomies of the two right-hand figures. The different styles juxtaposed within Picas-so's painting challenge traditional notions of stylistic coherence and focused perspective; they also express a fantasy about the active presence in woman's sexual nature of her dark, primitive, degen-erate, perhaps diseased biological origins. Here, once again, the theme of prostitution simultaneously activates fears of decomposi-tion and decay and stimulates the creation of new artistic strategies, which display that very disintegration and proclaim their modernity.

Those critics of Picasso who read this proclamation as heralding the emancipation of formal energies from referential content were not misreading; they were failing to interpret dialectically, to see the techniques of self-reflection, discontinuity, and spatial compression as generated in response to powerful conscious and unconscious fantasies of prostitutes and brothels. I have tried throughout this book to foreground the complex operations of this dialectic and to demonstrate that they underlie even those discourses, like Parent-Duchâtelet's on public hygiene and Charcot's on hysteria, that pur-port to be free of fantasmatic investment. Although each of my readings has produced a different analytic plot of the relation between fantasies of prostitution and the formal properties of art, I find that the elements of many of these analyses could be integrated into a kind of dialectical masterplot. To offer a schematic outline of such a masterplot is to risk oversimplification. However, I believe the risk is worth taking, since this process helps clarify the impli-cations of my readings of nineteenth-century French texts for current critical theorizing about gender.

There is evidently a good deal of arbitrariness involved in choosing a beginning for a fantasy process that is, at all its points, overdeter-mined. I begin in this book with Parent-Duchâtelet, not just because he wrote the first extensively documented and statistically sophis-ticated study of prostitution, but also because his epistemological enterprise is driven by a fantasy that pervades literary and artistic production in his wake, the fantasy of knowing female sexuality and defining its essential difference. The prostitute's availability, her

openness, her pliancy to male desire, all this makes her sexual body the logical site for male exploration and analysis—in death as in life, for the corpses of destitute prostitutes often served for anatomical dissection, thereby fulfilling the explicit fantasy of numerous nineteenth-century writers to examine female physiology by literally cutting women up. The brothel and the hospital inspire the same kind of poetry, writes Flaubert, recalling his youthful habit of climbing up the trellis outside the anatomical amphitheater to watch his father dissect cadavers. "Just dissect," advises Michelet, enthusiastically convinced that female sexual physiology proves incontrovertibly that women are sickly, dependent, wounded creatures. Later in the century, the strategy will be to demonstrate female atavism and degeneracy on the model of prostitutional deviance.

Some such certainty about women's biological inferiority is a crucial fantasy motivating the essentialist plot. Structurally, this plot moves toward closure, revelation, the clarity of dramatic dualisms, and the purgation of desire. The prostitute in Parent is a seminal sewer, cleansing the city of excess libido. The prostitute in Zola draws the evils of desire into her body and thus reestablishes the proper balance of the vital circulus. The Balzacian prostitute-with-a-heart-of-gold kills herself to assert the finality of her sexual closure.

But in each of these cases, the conservative drive to closure encounters an opposing fantasmatic force that undermines its totalizing ambition. This subversive fantasm emerges, typically, on the very site of presumed mastery and control, the prostitute's exposed body. Parent gives testimony on the most pragmatic of levels to the enigma of woman's sexual being: her vagina retains no traces of its penetrations. Dr. Prosper Lucas's theory in *L'hérédité physique* (1847) that a woman's children will carry the genetic imprint of her first lover is an essentialist foil, adopted by Michelet, Zola, and many others, to the threatening realization of male substitutability. Male fantasy now becomes obsessed with what is unknowable about female sexuality, with what resists dissection and positive identification. The power behind this resistance is fantasized as a lack, gap, or fissure, most specifically in the place of the genitals. That lack is felt to motivate female desire, indeed to create woman as the subject of desire. The fantasy of woman as castrated does not diminish her potency in the male unconscious. Castration does not fulfill the

essentialist dream of defining woman's difference. On the contrary, the castrated body destabilizes gender by investing woman's wound with such intense negative cathexes that the castrated woman becomes phallic through her association with this powerful fantasmatic energy. In Des Esseintes's dream evocation, we remember, the figure of Syphilis displays a hideous vaginal wound surrounded by phallic swordblades. Insofar as it erodes the body, obscuring differences between organs, rupturing membranes, causing abcesses and chancres, syphilis is the appropriate pathological analogue of the collapse of gender difference. And hysteria is the appropriate psychiatric analogue, for the hysteric typically identifies with both male and female figures, fusing and confusing their attributes in a fluid slippage between gender models.

The prostitute is syphilitic and hysterical in male fantasies of the fin de siècle, and her perverse desire threatens to absorb her victims into a diseased morass. The challenge to male autonomy and power is critical; to a significant degree, modernist techniques in art and literature are generated in response to this challenge. Fundamental to these techniques is what I have called the fantasy of creative genderification. In this fantasy the threat that female castration will erode all distinctions of gender is subjected to a sublimating maneuver whereby gender is defined as a function of male creativity. We first encountered this strategic maneuver in Balzac, who codes it as homosexual: Vautrin redefines prostitution as a capitalization of the male body so that it can be circulated and exchanged as liquid currency within a semiotic system. Gender for Vautrin is a male construction, woman being too exclusively "governed by her organs" to be capable of creatively denaturing her animal sexuality. Proceeding by the constant reinvention of oppositional categories, Balzacian narrative excludes the female sexual body from the male prostitutional economy of multiple impersonations.

In contrast to the teleological movement of the essentialist plot, which tends toward the elimination of desire and the stabilization of binary structures, what one might call the figural plot is open-ended, unresolved. Its always-already displaced goal is for representation to coincide with its rhetorical tropes. Desire is dissociated from specifically genital sexuality and becomes a matter of ironic play with substitutive cultural representations. My readings of Barbey, Flaubert, and Huysmans show how strategies linking literary

self-reflexivity to gender trans-figuration are used to master sexually charged fantasies of structural collapse and organic decay. These strategies are fetishistic in that they operate by displacing into the structures of representation the principle of lack associated with female castration. In Flaubert, for instance, the structure of *L'éducation sentimentale* incorporates his idea of prostitution as the denial of female sexuality and desire. Prostitution as idea becomes the vehicle for narrative's recuperation of its origins in loss, absence, negativity. As a correlate of this recuperation, Flaubert suggests, like Balzac before him, that gender may be an entirely rhetorical signifier of differential relations.

What is insidious about this interpretation of gender difference as an arbitary, unstable construction of signs and codes, a creation of figure and metaphor, is that it seems to offer a liberating release from the reductive biologism of the essentialist plot. The critic/reader who uncovers the complex devices of the figural plot may easily neglect their strategic role in a dialectical scenario and valorize them as reflecting the text's self-consciousness about its constitutive rhetoricity. Such a reader may then promote the notion of the tropological substitutability of gender characteristics as a politically emancipating idea, which deconstructs the rigid dichotomies of patriarchal essentialist thinking and liberates each of us to play creatively, and subversively, with the cultural constructions of gender.

The appeal of such a position is evident, and it has had an influential vogue in contemporary critical thinking. As a philosophically argued position it need not, of course, be interpreted in terms of its insertion in the masterplot of nineteenth-century male fantasy that I have outlined here. But this context should nevertheless give pause to anyone pursuing too glibly the argument that gender difference is a tropological or semiotic construct. The history of this argument is intimately linked to that of modernism in the arts, where its formal and stylistic manifestations may indeed be liberating, but where its sexual and political implications are frequently just as reactionary and misogynist as those of essentialism. In the literature written by men in France in the nineteenth century, the troping of gender is most often a rhetorical strategy whose goal is the displacement, if not exclusion, of representations of the female sexualized body. The rhetoricization of gender difference in the texts I have studied is a

defensive maneuver invented by an anxious male imaginary in flight from the fantasmatic association of female sexuality with biological decay and the loss of phallic supremacy. Whatever is potentially progressive about this move away from physiological determinism is canceled by the move's fetishizing function within a repressive cultural scenario. For men to liberate themselves from the constraints of patriarchal ideologies of gender and power, this entire scenario needs to be dismantled. Given the script's efficacy in generating the sophisticated formal structures of modernist art, the critical task will not be easy.

Notes · Credits · Index

NOTES

One. *Parent-Duchâtelet*

1. Alexandre Parent-Duchâtelet, *Hygiène publique, ou mémoires sur les questions les plus importantes de l'hygiène appliquées aux professions et aux travaux d'utilité publique,* 2 vols. (Paris: Baillière, 1836), II, 259. Subsequent references to this work, abbreviated *HP,* will appear in the text.

2. Louis Chevalier, *Laboring Classes and Dangerous Classes in Paris during the First Half of the Nineteenth Century* (Princeton: Princeton University Press, 1981), pp. 81, 212.

3. Parent was one of the contributors to the extensive study of this epidemic published in 1834: Benoiston de Châteauneuf et al., *Rapport sur la marche et les effets du choléra morbus dans Paris et les communes rurales du département de la Seine* (Paris: Baillière, 1834). An abbreviated English translation of this work appeared as *Report on the Cholera in Paris* (New York: S. S. and W. Wood, 1849).

4. In a deadpan style that heightens the horror of what he describes, Parent evokes the most squalid living conditions imaginable as further proof of the ability of the human organism to thrive amid putrefaction. John Gilmore, his wife, and two sons lived for more than ten years, Parent tells us, in a single small room located directly above the dissection rooms of the Saint-Barthélemy hospital. Their cubicle was at the end of a corridor lined with open tubs full of macerating human bones; along the corridor were doorless entries to cavernous cesspools containing anatomical debris. The smell in this dwelling was, in Parent's words, "cadaverous, penetrating," and Gilmore's work in the dissection rooms, where he "handled almost continually substances in the most advanced state of putrefaction" (*Hygiène publique,* II, 52), kept him in this morbid atmosphere day and night. But Parent does not find these circumstances unhealthy and gives the entire family a clean bill of health, noting with satisfaction the pleasant *embonpoint* Gilmore had acquired by the time he died at the ripe age of sixty-nine.

5. François Leuret, "Notice historique sur A.-J.-B. Parent-Duchâtelet," in Alexandre Parent-Duchâtelet, *De la prostitution dans la ville de Paris,* 2 vols. (Paris: Baillière, 1836), I, xii. Subsequent references to *De la prostitution,* abbreviated *DP,* will be given in the text.

6. Parent's recommendations in this respect coincide precisely with those of the criminal police, who decided, after the popular celebrations that accompanied the transport of chain gangs in the summer of 1836, to put an end to such spectacles. In June 1837 they began using an immense covered wagon, windowless, with six individual cells, each furnished with a seat and chains, and a corridor from which two guardians could keep the prisoners under constant surveillance. Michel Foucault discusses this penitentiary vehicle as part of his analysis of evolving techniques of panoptic social discipline. See Foucault, *Surveiller et punir: Naissance de la prison* (Paris: Gallimard, 1975), pp. 260–269.

7. Leuret, "Notice historique," p. xix.

8. Alain Corbin, "Présentation," in Alexandre Parent-Duchâtelet, *La prostitution à Paris au XIXe siècle* (Paris: Seuil, 1981), p. 16. This work is a much-abbreviated edition of Parent's *De la prostitution dans la ville de Paris*.

9. Erica-Marie Benabou interprets Restif in just these terms. See her recent study of prostitution in eighteenth-century France, the best currently available: *La prostitution et la police des moeurs au XVIIIe siècle* (Paris: Perrin, 1987). Her discussion of Restif is on pp. 482–490.

10. Restif de la Bretonne, *Le Pornographe* (Paris: S.E.C.L.E.–Régine Deforges, 1977), p. 44.

11. Ibid., pp. 167, 168.

12. F.-F.-A. Béraud, *Les filles publiques de Paris et la police qui les régit* (Brussels: Meline, Cans, 1839). Subsequent references to this work will be abbreviated *FP.*.

13. Jill Harsin, *Policing Prostitution in Nineteenth-Century Paris* (Princeton: Princeton University Press, 1985), p. 258. This book is generally valuable as a mine of information, much from archival records, about the regulatory system, especially in the first third of the century.

14. Ibid., p. 57.

15. Parent quotes Augustine (*De Ordine*) to this effect in *De la prostitution*, II, 514.

16. Harsin, *Policing Prostitution*, p. 80.

17. From a law of 1790 cited ibid., p. 83. I am indebted in what follows to Harsin's excellent discussion of the legal foundations of police regulation (ibid., pp. 80–95).

18. Quoted ibid., p. 20.

19. It is interesting to note that the anonymous author of the "Prostitution" article in Pierre Larousse's *Grand dictionnaire universel*, published in 1867, is still asking this question. He (it is unlikely that a woman would have been invited to write this article, which was most probably written by Larousse himself) notes that "this *mise hors la loi* is incompatible with the progress of ideas in the nineteenth century. Only in the most barbarous and inhuman of times could a whole class, whatever it may be, be overlooked by the system of justice and abandoned to administrative discretion" (XIII, 296). Their subjection to *l'arbitraire*, this writer goes on to observe, makes prostitutes feel forever cast out from society and hence discourages any process of repentance and reinte-

gration. To the objection that *l'arbitraire* is necessary because judges are not armed with enough repressive laws, the author recommends, sensibly, that the lacunae in the penal code be filled through new legislation.

20. Quoted in Harsin, *Policing Prostitution*, p. 90.

Two. Cashing in on Hearts of Gold

1. Honoré de Balzac, *Splendeurs et misères des courtisanes*, ed. Antoine Adam (Paris: Garnier, 1964), p. 661. Subsequent references to this work, abbreviated *SMC,* will be given in the text.

2. Balzac's borrowings from Parent are pointed out by Antoine Adam in the notes to his edition of *Splendeurs*. See pp. 26, 29, 31, 35, 36, 37, 38, 43, 46, 48, 50, 55, 187, 245, 266.

3. See Adam's introduction to his edition of *Splendeurs*, p. xix.

4. Louis Chevalier, *Laboring Classes and Dangerous Classes in Paris during the First Half of the Nineteenth Century* (Princeton: Princeton University Press, 1981), p. 378.

5. Alexandre Parent-Duchâtelet, *De la prostitution dans la ville de Paris*, 2 vols. (Paris: Baillière, 1836), 4.

6. Ibid., II, 14.

7. Ibid., II, 261.

8. These are the figures given in the official report on the epidemic, Benoiston de Châteauneuf et al., *Rapport sur la marche et les effets du choléra morbus dans Paris et les communes rurales du département de la Seine* (Paris: Baillière, 1834).

9. This is noted by Ange-Pierre Leca in his account of the epidemic, *Et le choléra s'abattit sur Paris, 1832* (Paris: Albin Michel, 1982), p. 68. See also the more recent study by Patrice Bourdelais and Jean-Yves Raulot, *Une peur bleue: Histoire du choléra en France, 1832–1854* (Paris: Payot, 1987).

10. Cited by W. H. Van Der Gun in his valuable study, *La courtisane romantique et son rôle dans "La comédie humaine" de Balzac* (Assen, Holland: Van Gorcum, 1963), p. 21.

11. Balzac, *La fille aux yeux d'or*, in *La comédie humaine* (Paris: Pléiade, 1977), V, 1039, 1040. It is interesting to note the similarity between Balzac's description of the Parisian population as a whole in its "healthy" state and Jules Janin's evocation of the working classes of Paris as they appeared during the cholera epidemic. In his little book published just after the epidemic, *Paris depuis la révolution de 1830* (Brussels: Louis Hanman, 1832), Janin describes the population as "pale and defeated, . . . without color, without character, . . . having lost its idiom, its language, its customs," having "become uniform"; and he wonders if this appearance does not signify "an internal disease devouring our capital" (pp. 71, 73, 74, 77).

12. Ibid., p. 1546 (a variant) and p. 1051. In the opening pages of *Ferragus*, Paris is termed a "grande courtisane" (*La comédie humaine*, V, 795).

13. Parent's follower F.-F.-A. Béraud typically uses miasmatic imagery to evoke what he calls "the cloaca of prostitution": "The prostitute has voluntarily

broken with society by trampling under foot all conservative principles and all honorable conventions so as to live in a corrupt atmosphere from which miasmas escape that are morbid for the population in general." See Béraud, *Les filles publiques de Paris et la police qui les régit* (Brussels: Meline, Cans, 1839), II, 26. As Alain Corbin notes in a recent, characteristically stimulating article, the etymology that derives *putain* from the Latin *putida,* meaning rotten, decaying, putrid, is not certain but has nevertheless long been accepted. See Corbin, "Commercial Sexuality in Nineteenth-Century France: A System of Images and Regulations," *Representations* 14 (Spring 1986): 210.

14. Torpedoes did not, of course, exist as weapons in Balzac's day. The Torpedo's nickname refers to an electric ray fish, which is also the origin of the weapon's name.

15. Albert Béguin, *Balzac lu et relu* (Paris: Seuil, 1965), p. 109.

16. Peter Brooks, *Reading for the Plot: Design and Intention in Narrative* (New York: Knopf, 1984), p. 157. Brooks's illuminating chapter entitled "The Mark of the Beast: Prostitution, Serialization, and Narrative," which focuses on Sue's *Les mystères de Paris,* is one of the few published studies on the specific topic of my book.

17. Béraud is so concerned about the use of the public stages which theaters and balls provide for the display of venal goods that he recommends legislation forbidding courtesans to use theaters as a means of advertising their sexual availability (see *Les filles publiques de Paris,* II, 236). The notoriety of the Opera balls continued late into the century. In their play *Henriette Maréchale* (1865), the Goncourts identify the Bal de l'Opéra as the center of Parisian corruption. For a discussion of Manet's painting, see Linda Nochlin, "A Thoroughly Modern Masked Ball: Manet's Masked Ball at the Opera," *Art in America* 71 (November 1983): 187–201. The whole phenomenon of masked balls in nineteenth-century France has been studied in depth by Francois Gasnault, *Guinguettes et lorettes: Bals publics à Paris au XIXe siècle* (Paris: Aubier, 1986).

18. These are the qualities Simone de Beauvoir attributes to the successful courtesan: "Lending herself to several men, she belongs definitely to none; the money she piles up and the name she 'sells,' as one sells a product ['the Torpedo,' for instance], assure her economic independence . . . Paradoxically, those women who exploit their femininity to the limit create for themselves a situation almost equivalent to that of a man; beginning with that sex which gives them over to the males as objects, they come to be subjects" (*The Second Sex* [New York: Bantam, 1961], p. 535). It is precisely Esther's subjective gain that Balzac reverses into a loss, so that she thinks herself happy to be, for Lucien, "comme une chose à lui" (86).

19. Jean-Jacques Rousseau, *La nouvelle Héloïse,* in *Oeuvres complètes* (Paris: Pléiade, 1964), II, 652.

20. Victor Hugo, *Marion de Lorme,* in *Théâtre complet* (Paris: Pléiade, 1963), I, 1041.

21. Ibid., p. 1135.

22. After the first performance, when these lines were hissed, Hugo cut the reference to Marion's renewed virginity, noting in the edition of 1836 that,

despite the public's incomprehension, this "austere" passage provided the "essential explanation" of his work. The lines read: "Mon Didier! près de toi rien de moi n'est resté, / Et ton amour m'a fait une virginité!" Balzac refers to this last line, which he claims was sacrificed to "le génie essentiellement vaudevilliste du parterre," in *Les Marana* (*La comédie humaine,* X, 1067).

23. Alphonse Esquiros, *Les vierges folles,* 2nd ed. (Paris: Auguste le Gallois, 1841), p. 79.

24. "Repudiated and outlawed, the whore overtly declares herself in a state of war with society" (ibid., p. 143).

25. Ibid., p. 183.

26. Esquiros's divided attitude toward madness resembled his conflicted view of prostitution. In line with his sympathetic treatment of prostitutes as mad virgins, he argued the closeness of normality and madness on a psychological continuum, investigated for himself the medical handling of lunatics, and demanded their reintegration into society in the name of a revolutionary humanitarianism exemplified by Pinel's liberating the inmates of the Bicêtre hospital in 1792. But, as Stéphane Michaud has shown, he reinforced the conventional social limits between reason and madness even as he argued against them, imagining the miraculous intervention of a doctor-god to save from the hell of insanity the very people he pretended to find little different from the bourgeois norm and stigmatizing women as those most likely to inhabit this hell. See Michaud, "Esquirol et Esquiros," *Romantisme* 24 (1979).

27. See René Guise, "Balzac et le roman feuilleton," *Année Balzacienne* (Paris: Garnier, 1964), pp. 283–338.

28. Balzac, *Lettres à l'étrangère: 1842–1844* (Paris: Calmann-Lévy, 1906), p. 171.

29. Quoted in Guise, "Balzac et le roman feuilleton," p. 304.

30. Parent-Duchâtelet, *De la prostitution,* I, 583.

31. This figure comes from a study written by Parent's close friend and colleague on the Parisian Public Health Council, Louis René Villermé, "Notes sur les ravages du choléra morbus dans les maisons garnies de Paris, depuis le 29 mars jusqu'au 1er août 1832," *Annales d'hygiène publique et de médecine légale* 11 (1834): 385–409. This article is discussed at length in a useful book by William Coleman, *Death Is a Social Disease: Public Health and Political Economy in Early Industrial France* (Madison: University of Wisconsin Press, 1982), pp. 171–180.

32. See Eugène Sue, *Les mystères de Paris,* 10 vols. (Paris: Charles Gosselin, 1842–1843), I, 189; IX, 102–103, 162–163. Subsequent references to this work, abbreviated *MP,* will be given in the text.

33. Karl Marx and Friedrich Engels, *The Holy Family,* in *Collected Works* (London: Lawrence and Wishart, 1975), IV, 174.

34. Umberto Eco, "Rhetoric and Ideology in Sue's *Les mystères de Paris,*" in Eco, *The Role of the Reader: Explorations in the Semiotics of Texts* (Bloomington: Indiana University Press, 1979), pp. 128–143.

35. Sue's diatribe expresses the point of view not only of contemporary socialist and feminist reformers but also of the founder of the Parisian secret

police, Vidocq—an ex-convict and the model for Balzac's Vautrin. In the fourth volume of his *Mémoires,* which appeared in 1829, Vidocq tells the story of a certain Adèle d'Escars, a beautiful blue-eyed blond with a distinct physical resemblance to both Esther and Fleur-de-Marie, who is kidnapped by an *entre-metteuse* and registered, though underage, by the corrupt officials at the Bureau des Moeurs. Her dishonor, her perversion, says Vidocq, is their work. Like both Sue and Balzac, he criticizes the difficulties put in the way of the prostitute who asks to be erased from the official list of infamy. In the context of Adèle's later release after a sixteen-year jail term for robbery, he condemns the prejudice against ex-cons that makes it impossible for them to find jobs even when, like the high-spirited and appealing Adèle, they sincerely want to go straight.

36. Brooks, *Reading for the Plot,* p. 160.

37. Charles Baudelaire, *Mon coeur mis à nu,* in *Oeuvres complètes* (Paris: Pléiade, 1961), p. 1272.

38. Vautrin asserts his plural parental role from the very moment he first encounters Lucien, when the poet is about to commit suicide at the end of *Illusions perdues.* Vautrin then promises to love Lucien "as a father loves his child" and asks that, in return, Lucien obey him "as a child obeys his mother." Janet Beizer, who cites these passages, has written very perceptively of the "overdetermination which makes Herrera at once Lucien's mirror image, his mother, and his father. By identifying with Herrera as mother," observes Beizer, "Lucien can *be* the mother, love other men as he was once loved; by identifying with Herrera as father, he can *have* the mother, the woman whom the father has access to." Beizer, *Family Plots: Balzac's Narrative Generations* (New Haven: Yale University Press, 1986), p. 162.

Beizer's book, which studies with sophistication and sensitivity the thematics of sexual indeterminacy in Balzac, unfortunately appeared only after my chapter was written, as did the illuminating analysis of Balzac in Christopher Prendergast's *The Order of Mimesis: Balzac, Stendhal, Nerval, Flaubert* (Cambridge: Cambridge University Press, 1986), which parallels and supplements my discussion. In revising my chapter, I have indicated some points where I agree or disagree with these two excellent studies.

39. Prendergast writes of Lucien that "he encapsulates the theme of pure 'exchange value,' he 'is' whatever he offers for exchange in any given situation (friendship, love, treachery, Liberal politics, Royalist politics, honest writing, mendacious writing" (*The Order of Mimesis,* p. 99).

40. Janet Beizer (*Family Plots,* pp. 150–157, 162) points out that Lucien's repudiation of Vautrin's paternity repeats his parricidal gesture, in *Illusions perdues,* of repudiating his father's petty bourgeois name (Chardon) to assume his mother's aristocratic name (Rubempré). She sees both gestures as motivated by Lucien's narcissistic bond to a fantasized pure, ideal mother.

41. D. A. Miller, "Balzac's Illusions Lost and Found," *Yale French Studies* 67 (1984): 177. This is an altogether brilliant essay that has fundamentally influenced my thinking about Balzac.

42. This is the lesson Lucien is taught shortly after his arrival in Paris in *Illusions perdues.* Journalism, which sells language on the market for duplicitous

signs, operates according to the same principles as prostitution (and, prior to 1830, has the same squalid locus, the infamous *galeries de bois* of the Palais Royal): "Seeing that an eminent poet prostituted the muse for a journalist, thereby humiliating Art, just as Woman was humiliated and prostituted in these wretched *galeries,* the great man from the provinces learned a terrible lesson." Balzac, *Illusions perdues* (Paris: Garnier, 1961), p. 301.

43. Prendergast, *The Order of Mimesis,* p. 97.

44. Pierre Barbéris, "Préface," in *Splendeurs et misères des courtisanes* (Paris: Gallimard, 1973).

45. A similar point is made by Christopher Prendergast in his insightful study *Balzac: Fiction and Melodrama* (London: Edward Arnold, 1978), esp. pp. 86–89. In *The Order of Mimesis,* Prendergast notes rightly that Balzac's early contributions to the popular genre of his period, the *physiologie,* demonstrate his conservatively motivated interest in mapping legible discriminations as to social rank, occupation, and identity at a time when these were rapidly collapsing. I also agree with Prendergast's subsequent point that the dandy fascinates Balzac precisely because he undermines the ground the *physiologies* attempted to establish between appearance and biology by producing himself as an artificial, travestied construction. Prendergast's observation that "the real interest of clothes [for Balzac] revolves more around a blurring than a clarifying of the social map" (p. 95) is corroborated by my analysis, this blurring being an essential motor force of Balzacian narrative production.

46. Miller, "Balzac's Illusions Lost and Found," p. 174.

47. Prendergast, *The Order of Mimesis,* pp. 98–99. Janet Beizer identifies the death of Lucien as the moment when the collapse of oppositional differences reaches a crisis "changing the shape of the novel, . . . inaugurating a reign of chaos" (*Family Plots,* pp. 164, 165). It is true that Lucien's suicide produces a kind of paroxysm in Vautrin's metaphorization of parental roles (he even sees himself as the Virgin kissing Jesus at the tomb), but I do not see that Vautrin's loss of his alter-ego causes "sexual, narrative, and linguistic systems [to] come to a foundering halt" (ibid., 163). Though it relies greatly on Vautrin's representational energy as vehicle, the narration has resources apart from its identification with the *faussaire*'s persona. These resources are a measure of the distance between Balzac's narrative energy, which takes all of French society as its text, and Vautrin's, which can be so exclusively focused on one alluringly hermaphroditic young man that the loss of this creative material produces temporary narrative blockages (for instance, as Beizer remarks, the repetition of Lucien's death note).

Three. Barbey's Dandy Narratives

1. Jean Starobinski, *Portrait de l'artiste en saltimbanque* (Geneva: Albert Skira, 1970), p. 64.

2. Charles Baudelaire, *Oeuvres complètes* (Paris: Pléiade, 1966), p. 505. Subsequent references to this edition, abbreviated *OC,* will be given in the text.

3. In a brilliant little book that perfectly complements Starobinski's *Portrait*

LIBRARY ST. MARY'S COLLEGE

de l'artiste, Ross Chambers associates the actress with the coquette and the cocotte as figures who actualize for the male imagination the troubling and fascinating arbitrariness of signs, whose founding presupposition is a lack of being. See *L'ange et l'automate: Variations sur le mythe de l'actrice de Nerval à Proust* (Paris: Archives des Lettres Modernes, 1971). Although she is not a professional actress but rather a figure for what is artificial and histrionic about all appearance coded for social success, Foedora in Balzac's *La peau de chagrin* is a perfect example of this lack of being. Raphaël de Valentin's fascination with her is fetishistic in much the same way Samuel Cramer's love for La Fanfarlo is. Raphaël reflects at one point: "To be sure, I've found myself ridiculous a hundred times over for loving a few lengths of silk lace, velvet, or fine cambric, a coiffeur's tours de force, candles, a carriage, a title, heraldic coronets painted on glass or crafted by a goldsmith, in short, all that is artificial and least womanly in a woman" (*La comédie humaine* [Paris: Pléiade, 1977], IX, 142). The importance of role playing as a cover-up of the threatening female body is also illustrated in Dorian Gray's infatuation with the actress Sybil Vane, who transforms herself every night into a different Shakespearean heroine. When Sybil abandons her aesthetic masks (inventions of male genius) for love of Dorian, he becomes disgusted with her banality and brutally abandons her.

4. George Sand's *Lélia* (1833, revised 1839), one of the few novels by a major female writer of the nineteenth century to dramatize the figure of a courtesan, offers an interpretation of prostitution that attempts to unite female sexual pleasure with a spirit of religious charity. Criticizing her sister Lélia's frigid chastity, Pulchérie, known as the courtesan Zinzolina, justifies her promiscuity as a way of avoiding despair by sharing God's blessings with others of his children (see *Lélia* [Paris: Garnier, 1960], pp. 148–153, 207–209). In this free-form novel, Sand splits Woman into an intellectual and highly verbal being, for whom the body is an unresolvable problem, and a sensual being, for whom the body is a comfortable source of pleasure but who does not experience love or happiness. The courtesan is a figure of resigned strength: she braves the contempt of society, having a clear sense of her value in God's world. Thus the hero Trenmor can say of her, "I like a logical and complete character like yours and I respect you, courtesan in love with all men, as much as an abbess in love with all the saints" (ibid., p. 243). For an illuminating reading of *Lélia,* see Eileen Sivert, "*Lélia* and Feminism," *French Studies* 62 (1981): 45–66.

5. In his book on Baudelaire, Sartre remarks: "What he [Baudelaire] could not abide about paternity was the continuity of life between the progenitor and his descendants, which meant that the first begetter was compromised by those who came after him and went on leading an obscure and humiliating life in them. This biological eternity seemed intolerable to him: the rare being took the secret of his creation with him to the grave. Baudelaire wanted to be completely sterile because it was the only means of putting a price on himself." Jean-Paul Sartre, *Baudelaire,* tr. Martin Turnell (New York: New Directions, 1950), p. 107.

6. Jean-Paul Sartre, *L'idiot de la famille: Gustave Flaubert de 1821 à 1857* (Paris: Gallimard, 1972), III, 367. See also Sartre's remarks about Baudelaire's

self-seeking, narcissistic, "spiritualized" sexuality in *Baudelaire*, pp. 125–133; and Leo Bersani's stimulating analysis of many of the passages I have just cited in *Baudelaire and Freud* (Berkeley: University of California Press, 1977), pp. 8–15.

7. Jules Barbey d'Aurevilly, *Du dandysme et de George Brummell* (Paris: Balland, 1986), p. 54. Subsequent page references to this edition, abbreviated *DD*, will be given in the text.

8. Roland Barthes, *S/Z* (Paris: Seuil, 1970), p. 95.

9. Jules Barbey d'Aurevilly, *Les Diaboliques* (Paris: Garnier-Flammarion, 1967). Subsequent page references to this edition, abbreviated *LD*, will be given in the text.

10. In an illuminating article, Philippe Berthier notes that the problem of paternity haunts all of Barbey's works: "*Who is the Father?* In diverse more or less devastating variants, this question resounds everywhere in Barbey's works, where the search goes on for a Father whose name cannot be said." Philippe Berthier, "La question du père dans les romans de Barbey d'Aurevilly," *La revue des lettres modernes* 600–604 (1981): 13.

11. At least two critics interpret this act as symbolic sodomy: Claudine Herrmann (*Les voleuses de langue* [Paris: Editions des femmes, 1967], pp. 118–119), and Pierre Tranouez ("Un récit révocatoire: 'A un dîner d'athées,'" *Littérature* 38 [May 1980]: 31–33). They see Rosalba as a mediating figure between Mesnilgrand and the ambivalent object of his homosexual desire, Ydow. Once Rosalba's function is terminated, Mesnilgrand's powerful ambivalence expresses itself in a murder that is simultaneously a rape. Philippe Berthier discusses the evidence of repressed homosexual tendencies in Barbey in his fine book *Barbey d'Aurevilly et l'imagination* (Geneva: Droz, 1978), pp. 174–175.

12. Jacques Petit, *Essais de lectures des "Diaboliques" de Barbey Aurevilly* (Paris: Minard, 1974), p. 159.

13. Marcelle Marini observes a marked instability of sexual identity in all the principal characters of *Les Diaboliques*. "There is no true classification possible of the characters according to sex, not even according to alternation between phallic and castrated," she argues. "The indicators of castration or of phallic power, the signs the text gives to mark femininity or virility, circulate from character to character" ("Ricochets de lecture: Le fantasmatique des *Diaboliques*," *Littérature* 10 [May 1973]: 16). I have argued that the circulation of sexual signs is not as arbitrary as this comment suggests but is a function of an overriding fear of female sexuality, which motivates a regressive desire to erase all signs of sexual difference.

14. The imagery of veiling is made explicitly in a description of the night falling within the church. The narrator refers here to "un voile" ("a veil") where the metaphorical context would lead one to expect "une voile" ("a sail"): "The night, already dense in the church, spread out its great drapery of shadow, which seemed to unfurl from the arches like a veil falling from a mast" (*Les Diaboliques*, p. 220).

15. In "Un récit révocatoire," Pierre Tranouez reads Mesnilgrand's narration as the vehicle of his homoerotic seduction of his most excitedly attentive

listener, Rançonnet. Thus, for Tranouez, the scene of narration is homologous to the crucial scene of desire and horror when Mesnilgrand symbolically sodomizes Ydow by killing him. Although to my mind this ingenious argument does not give enough weight to the sublimating function of narration, it does provide a provocative alternative way of understanding Barbey's powerful impulse to deny sexual difference. Tranouez has addressed the question of narrative closure in another stimulating article, "La narration neutralisante: Etude de quatre *Diaboliques*," *Poétique* 17 (1974).

16. Barbey d'Aurevilly, *Disjecta membra* (Paris: La Connaissance, 1925), II, 177. Quoted in Berthier, *Barbey d'Aurevilly,* p. 167.

17. Berthier puts it very well: "Such is the Aurevillian aporia: to defend and illustrate the sacred cause of the Father, Barbey's work must, and indeed can, do no more than tell of the excess, transgression and revolt that menaces the Father" ("La question du père," p. 41).

18. For a very different approach to the thematics of the body in the same two stories I analyze here, see Eileen Sivert's Barthesian elaboration of an erotics of reading in her excellent article, "Text, Body, and Reader in Barbey d'Aurevilly's *Les Diaboliques*," *Symposium* (Summer 1977): 151–164.

19. Barbey's fear of woman's potential to destroy the lineage of patriarchal family structure is one of the driving forces behind his attack on women writers, *Les Bas-bleus* (Paris: V. Palmé, 1878). Female writers, Barbey argues in this misogynist treatise, are trying to steal a male privilege for whose proper exercise their minds are too small. They are infected with "la fureur d'écrire, le choléra des femmes du XIXe siècle," a revealing description of female mental activity in terms of organic disease. This disease threatens "the negation of all authority, of all hierarchy, [through] a furious desire for equality with man. They want to be the husbands of their husbands."

Four. Manet's Olympia

1. The Goncourt brothers were proud to have retrieved, possibly in 1863 through the good graces of the police prefect Boitelle, a packet of letters found in one of the Cité brothels just prior to its demolition. For an account of these letters, see Robert Ricatte, *La genèse de "La fille Elisa"* (Paris: Presses Universitaires de France, 1960), pp. 69–72, 171. For a brilliant discussion of Haussmannization, see Jeanne Gaillard, *Paris, la ville: 1852–1870* (Paris: Champion, 1977). T. J. Clark's excellent chapter "The View from Notre-Dame" extends some of Gaillard's perceptions; see Clark, *The Painting of Modern Life: Paris in the Art of Manet and His Followers* (New York: Knopf, 1985). References to this work in the text are abbreviated *PML.* See also David Pinkney, *Napoleon III and the Rebuilding of Modern Paris* (Princeton: Princeton University Press, 1958).

2. Maxime Du Camp, *Paris: Ses organes, ses fonctions et sa vie dans la seconde moitié du XIXe siècle,* 3rd ed. (Paris: Hachette, 1874), III, 433. Hereafter abbreviated *PS.*

3. See Jill Harsin, *Policing Prostitution in Nineteenth-Century Paris* (Princeton: Princeton University Press, 1985), pp. 316–317.

4. Gustave Flaubert, *Oeuvres complètes,* (Paris: Seuil, 1964), II, 306.

5. Charles Lecour, *La prostitution à Paris et à Londres, 1789–1877,* 3rd ed. (Paris: Asselin, 1882; orig. pub. 1872), p. 145. Lecour's statistics are on p. 126.

6. A. de Pontmartin, "Semaines littéraires," *La gazette de France,* 11 June 1865. Quoted by Clark, *The Painting of Modern Life,* p. 111.

7. Emile Zola, *Au Bonheur des Dames,* in *Les Rougon-Macquart,* 5 vols. (Paris: Pléiade, 1960–1967), III, 481.

8. Edmond and Jules de Goncourt, *Journal,* 4 vols. (Paris: Fasquelle-Flammarion, 1959), II, 450 (7 August 1868). Hereafter abbreviated *J.* In Maupassant's novel of 1885, *Bel-Ami,* the society lady Madame de Marelle is fascinated not so much by high-flying courtesans as by lower-class dance hall prostitutes. At the Folies-Bergère, where she has requested that her lover take her, "she turned around constantly to look at [the prostitutes], wanting to touch them, to feel their busts, their cheeks, their hair, so as to learn how such beings are made." *Bel-Ami* (Paris: Gallimard, 1973, p. 140).

9. Alexandre Dumas *fils* makes a similar observation. "*Femmes du monde,*" he writes retrospectively in 1867, "set themselves to rivaling the luxury, expenditure, and external eccentricities of creatures whose names they should never even have known . . . They had not only the same dress but the same language, the same dances, the same adventures, the same loves—to tell all, the same specialties." Dumas, "A propos de *La dame aux camélias,*" *Théâtre complet* (Paris: Michel Lévy, 1868), I, 25. Hereafter abbreviated *AP.*

10. Emile Zola, *La Curée,* in *Les Rougon-Macquart,* I, 424.

11. See Gaillard, *Paris,* p. 539; and Zola, *Au Bonheur des Dames,* p. 681.

12. See Gaillard, *Paris,* p. 533.

13. These plays are discussed in S. D. Braun, *The "Courtisane" in the French Theatre from Hugo to Becque,* Johns Hopkins Studies in Romance Literature and Language, extra vol. 22 (Baltimore: Johns Hopkins University Press, 1947). See also Theodore Reff, *Manet: Olympia* (New York: Viking, 1977), pp. 112–113. It is interesting to note that, in the introduction to his study of prostitution, Charles Lecour quotes a letter he has received from Dumas in which the famous playwright bemoans the infiltration of loose women into all social classes. In the letter, the police commissioner comments, quite appropriately, that Dumas's plays, "in which the personnel of the *demi-monde* [a term Dumas invented] and of even lower levels benefit, not without glamour, from too many attenuating circumstances," may have contributed to the very situation their author laments. Lecour, *La prostitution,* p. ix.

14. Villiers de L'Isle-Adam, *Contes cruels* (Paris: Garnier-Flammarion, 1980), p. 37. Subsequent citations in this paragraph are on pp. 39, 42, 43.

15. Jean Baudrillard, *Pour une critique de l'économie politique du signe* (Paris: Gallimard, 1972), p. 104.

16. Charles Baudelaire, *Oeuvres complètes* (Paris: Pléiade, 1961), p. 1184. Hereafter abbreviated *OC.*

17. As Jean-Paul Sartre points out, Baudelaire's desire for pleasures enjoyed at a distance can be described in more strictly psychological terms: "He was a *voyeur* and a fetishist precisely because such vices alleviated *volupté,*

because they stood for possession at a distance and, so to speak, in a symbolical form." Sartre, *Baudelaire*, tr. Martin Turnell (New York: New Directions, 1950), p. 77.

18. Walter Benjamin, *Charles Baudelaire: A Lyric Poet in the Era of High Capitalism* (London: New Left Books, 1973), p. 55. Hereafter abbreviated *CB*.

19. Karl Marx, *Capital: A Critique of Political Economy* (New York: Random House, 1906), p. 83.

20. Jean-Paul Sartre, *L'idiot de la famille: Gustave Flaubert de 1821 à 1857* (Paris: Gallimard, 1972), III, 294. Hereafter abbreviated *IF*.

21. Gustave Flaubert, *Correspondance* (Paris: Conard, 1928), IV, 230.

22. By my picture of La Païva's bed hangs a tale. I found the photograph reproduced in Chapter 4 (Figure 7) at the Roger-Viollet Center for Documentation on the Rue de Seine. No origin or date was available, but I was told that the picture had probably been taken in the early part of this century. A few weeks later I toured the courtesan's mansion on the Champs-Elysées, and the guide informed me that La Païva's bed was now in the collection of the museum of Neuilly, on the outskirts of Paris. Curious to see this extraordinary artifact, I went out to Neuilly, where the curator of the museum, M. Henry Canal, was proud to show me the bed his predecessor, M. Jacques Damiot, had discovered in a flea market and identified as having belonged to the notorious La Païva. As is clear from the photograph reproduced in Figure N.1, this bed bears next to no resemblance to the one in the Roger-Viollet picture and is far less impressive (both carving and painting are of rather mediocre quality). M. Canal could not furnish me with any specific documentation about his bed's origins and advised me to research the matter in the library of the Musée des Arts Décoratifs. I had no luck there. Since then I have written to a number of authorities on the period, who have not been able to resolve this sleeping mystery. The recent popular biography of the courtesan by Janine Alexandre-Debray, *La Païva, 1819–1884: Ses amants, ses maris* (Paris: Librairie Académique Perrin, 1986), reproduces the photograph in Figure N.1, identifying it, apparently on the authority of M. Damiot, as the famous bed. Although it is evident that La Païva must have had more than one bed in the course of her career, *both* beds I have photos of are claimed to be the one she commissioned for her mansion, possibly with carving by Dalou and painting by Baudry. I have become quite fascinated by the peripeties of this bed, which, as I note later, may have been located in the mid-1890s in a brothel of the Rue des Moulins, where it may have been slept in by Toulouse-Lautrec. Any information helping to further identify the beds and write their history will be most welcome.

23. La Païva was not the only *grande cocotte* the Goncourts submitted to their mortifying analysis. About Jeanne de Tourbey, a beautiful and brilliant courtesan, whose salon was frequented by all the most famous writers of the Second Empire, who was admired by Flaubert and was probably his lover between 1868 and 1870, the acidic brothers wrote on April 16, 1865: "The woman's conversation is driven, abrupt, nervous, mentally tortured; a green face, horrible rings under the eyes; in her whole person the appearance of a crazy, long drawn-out death agony" (*Journal*, II, 152).

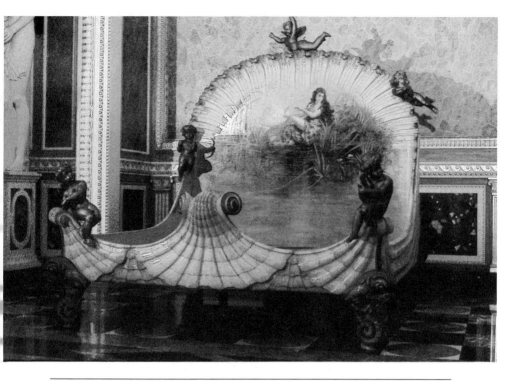

Figure N.1. Reputed bed of the courtesan La Païva. Musée de Neuilly, Neuilly.

24. These articles are quoted in French in Clark, *The Painting of Modern Life*, pp. 288–289. He identifies all sources on pp. 282–283. I have relied entirely on Clark's thorough documentation of the contemporary criticism. For later critical response to Manet's painting see Reff, *Manet: Olympia*, pp. 16–41; and G. H. Hamilton, *Manet and His Critics* (New Haven: Yale University Press, 1954).

25. Clark notes one exception, a short text by Jean Ravenel (pseudonym of Alfred Sensier), a friend of the painter Millet. Ravenel mentions Baudelaire and Goya in a suggestive but choppy listing of allusions and qualities that still fails to produce a coherent interpretation. See Clark, *The Painting of Modern Life*, pp. 139–144.

26. John Berger, *Ways of Seeing* (London: Penguin, 1972), p. 56.

27. Quoted from Huysmans's annotated copy of the catalogue of an 1884 Manet exhibition in Reff, *Manet: Olympia*, p. 28.

28. Walter Benjamin, "On Some Motifs in Baudelaire," *Illuminations* (New York: Harcourt, Brace and World, 1968), p. 192.

29. This is Ravenel's guess. But it should be noted that this same critic begins his commentary by associating Olympia with the general class of *belle*

courtisane. For the entire article in French, see Clark, *The Painting of Modern Life*, p. 296, n. 144.

30. Abigail Solomon-Godeau, "The Legs of the Countess," *October* 39 (Winter 1986): 65–108. See also Beatrice Farwell, *The Cult of Images: Baudelaire and the Nineteenth-Century Media Explosion* (Santa Barbara: University of Santa Barabara Art Museum, 1977).

31. Emile Zola, "Edouard Manet: Etude biographique et critique," in *Mon salon Manet: Ecrits sur l'art* (Paris: Garnier-Flammarion, 1970), pp. 100, 109, 110.

32. By treating Olympia's body as just one inanimate object among others, Zola attempts to dismiss her provocative sexuality. It appears, however, in displaced form in his evocation of the bourgeoisie's attitude toward the profession of painting in general: "The arts, painting, is for them the great Impure, the Courtesan always hungry for young flesh, who will drink the blood of their children and wring them dry, gasping, on her insatiable breast. It's an orgy, debauchery without forgiveness, a bloody specter that sometimes arises in the midst of families and disturbs the peace of domestic hearths" (ibid., p. 93). Zola is, of course, mocking the bourgeois association of flagrant immorality with an artistic calling, but he also makes a point of stressing that Manet's own mode of life is entirely bourgeois (after working hard all day, Manet "returns to his home where he enjoys all the calm joys of the modern bourgeoisie"—ibid., p. 95). Adapting the logic of Zola's own argument, one can imagine *Olympia* as Manet's deliberate representation of a fantasy he may have shared with his bourgeois brothers: that art is prostitution, impurity, degenerate sensuality.

33. Reff gives a brief account of this tradition in *Manet: Olympia,* pp. 26–29. See also Hamilton, *Manet and His Critics.*

34. Paul Valéry, "Triomphe de Manet," in *Oeuvres* (Paris: Pléiade, 1960), II, 1329.

35. Georges Bataille, *Manet* (Geneva: Skira, 1983), p. 62.

36. Georges Bataille, *L'Erotisme* (Paris: 10/18, 1957).

37. This context for Manet's use of the name is discussed by Sharon Flescher, "More on a Name: Manet's 'Olympia' and the Defiant Heroine in Mid-Nineteenth-Century France," *Art Journal* 45 (Spring 1985). Flescher also identifies a self-determined figure named Olympia in an unpublished play by Manet's friend Zacharie Astruc, whose poem "Olympia, la fille des îles" was printed in the salon catalogue and much derided by the critics, especially for its last line, "L'auguste jeune fille en qui la flamme veille." Astruc has often been credited with having given the painting its title, although this cannot be proven. See Reff, *Manet: Olympia,* pp. 111–113 for further discussion of the name.

38. A second salon notice that mentions the Urbino Venus was no doubt written by the same critic, who signs himself Amédée Cantaloube for one newspaper, Pierrot for another. Compare Clark, *The Painting of Modern Life,* p. 287, n. 59, and p. 288, n. 60.

39. See Reff, *Manet: Olympia,* pp. 54-59. Reff notes that one of the aspects of Olympia's modernity is her thinness. ("Thinness is more naked, more inde-

cent than fat," observed Baudelaire, *Oeuvres complètes,* p. 1251). The emperor's mistress, Marguérite Bellanger, was slight of build and slender.

40. Sigmund Freud, "Medusa's Head," in *Sexuality and the Psychology of Love,* ed. Philip Rieff (New York: Collier, 1972), p. 212. Clark moves tentatively in the direction I am suggesting here when he observes that Olympia's hand may have enraged the critics "because it failed to enact the lack of the phallus (which is not to say it quite signified the opposite)." See Clark, *The Painting of Modern Life,* p. 135. This equivocation is, from the psychoanalytic perspective, precisely what is at issue.

41. Laura Mulvey, "Visual Pleasure and Narrative Cinema," *Screen* 16, no. 3 (1975): 13.

42. The cat is also quite clearly a Baudelairean motif and may owe something as well, via Baudelaire's 1857 translation of "The Black Cat," to Poe's association of the dark feline with the uncanny effects of the return of the repressed. See Reff, *Manet: Olympia,* pp. 96–101. Werner Hofmann makes a suggestion that further links the cat with a threatening ambiguity about woman's sexual nature. He sees the cat as figuring the animal part of a portrait of Woman as Sphinx. See Hofmann, *The Earthly Paradise: Art in the Nineteenth Century* (New York: Braziller, 1961), pp. 350–351.

43. See Sander Gilman, *Difference and Pathology: Stereotypes of Sexuality, Race, and Madness* (Ithaca: Cornell University Press, 1985), pp. 76–108. Reff also notes that the Negress was commonly associated with lascivious sensuality and cites as evidence J. J. Virey's three-volume popularization *Histoire naturelle du genre humain* (Paris, 1824), II, 150: "Negresses carry voluptuousness to a degree of lascivity unknown in our climate [because] their sexual organs are much more developed than those of whites." Reff, *Manet: Olympia,* p. 92.

44. Cesare Lombroso and Guglielmo Ferrero, *La donna delinquente e la prostituta* (Turin: Roux, 1893), p. 38. Cited in Gilman, *Difference and Pathology,* p. 98.

45. Freud, "Fetishism," in *Sexuality and the Psychology of Love,* p. 216.

46. Stéphane Mallarmé, "The Impressionists and Edouard Manet," *Art Monthly Review* 1 (September 1876): 118.

47. Jean Clay, "Unguents, fards, pollens," in *Bonjour Monsieur Manet* (Paris: Centre Georges Pompidou, 1983), p. 6. This stimulating article has been translated in *October* 27 (1983). No one has researched Manet's sources with more imaginative scholarship than Michael Fried; see Fried, "Manet's Sources: Aspects of His Art," *Artforum* 7 (March 1969). The whole problem of interpreting Manet is treated in sophisticated fashion by David Carrier, "Manet and His Interpreters," *Art History* 8 (September 1985).

48. See Gerald Needham, "Manet, 'Olympia' and Pornographic Photography," *Art News Annual* 38 (1972), reprinted in Thomas Hart and Linda Nochlin, eds., *Woman as Sex Object: Studies in Erotic Art, 1730–1970* (New York: Newsweek, 1972), pp. 81–89; also Solomon-Godeau, "The Legs of the Countess," pp. 95–99.

49. Beatrice Farwell, *Manet and the Nude: A Study in Iconography of the Second Empire* (New York: Garland, 1981), reproduces a number of photographs

of nudes that bear a striking resemblance to the Victorine Meurend familiar to us from Manet's paintings. Farwell argues that if these photographs are indeed of Victorine, she may have been active as a prostitute as well as a model, since only prostitutes would have posed naked for a photographer.

50. Letter to Thoré, 20 June 1864. Quoted in Reff, *Manet: Olympia,* p. 63.

51. Reff suggests that what I am calling "referential turbulence" might in part be a response by Manet to the following passage in Baudelaire's "The Painter of Modern Life": "If a patient, scrupulous, but feebly imaginative painter faced with the task of painting a courtesan of today takes his *inspiration* (that is the hallowed word) from a courtesan by Titian or Raphael, it is entirely probable that he will produce a false, ambiguous and obscure work" (Baudelaire, *Oeuvres complètes,* p. 1165). Manet may have wanted to show that a powerful creative imagination could draw on Titian, among other sources, to intentionally create a work whose ambiguity and obscurity were its strength. This speculative hypothesis can be extended by quoting Baudelaire's ambiguous phrase in his letter from Brussels of May 1865 replying to Manet's complaint about the critical insults hurled at his salon picture: "You are only the first in the decrepitude of your art" (*Correspondance générale,* 6 vols. [Paris: Conard, 1947–1953], V, 95). Baudelaire had probably not seen *Olympia* when he wrote this letter, but it is tempting to imagine him calling artistic "decrepitude" the kind of subversive bricolage with tradition that is the sign of Manet's seminal modernity.

52. Clay, "Unguents, fards, pollens," p. 6.

53. See Michèle Montrelay, "Inquiry into Femininity," *m/f* 1 (1978): 83–101; and Mary Ann Doane, "Film and the Masquerade: Theorising the Female Spectator," *Screen* 23 (September–October 1982): 74–87.

Five. The Idea of Prostitution in Flaubert

1. Gustave Flaubert, *Correspondance,* ed. Jean Bruneau, 2 vols. (Paris: Pléiade, 1973, 1980), I, 832. Hereafter abbreviated *CR.*

2. Edmond and Jules de Goncourt, *Journal,* 4 vols. (Paris: Fasquelle-Flammarion, 1959), I, 356. Hereafter abbreviated *J.*

3. Letter of 6 August 1847, quoted in Jacques-Louis Douchin, *La vie érotique de Flaubert* (Paris: Carrere, 1984), p. 190.

4. Quoted by Douchin from an unpublished letter, ibid., p. 191.

5. The most famous account of Baudelaire in a brothel is the poet's own dream narrative in a letter to his friend Charles Asselineau dated 13 March 1856; see Baudelaire, *Correspondance* (Paris: Pléiade, 1973), I, 338–341. This remarkable and complex dream has been the object of extended analysis; see, among others, René Laforgue, *L'échec de Baudelaire* (Paris: Denoël and Steele, 1931), pp. 126–141; and Michel Butor, *Histoire Extraordinaire: Essay on a Dream of Baudelaire's,* tr. Richard Howard (London: Jonathan Cape, 1969). I will limit myself here to observing that Baudelaire in his dream does not engage in sexual intercourse in the brothel, is intimidated by the women, conjures up images of

mutilations and grotesque births, and spends his time talking to a sympathetic monster with a distinctly male rope-like appendage.

6. Charles Baudelaire, *Oeuvres complètes* (Paris: Pléiade, 1961), p. 652. Hereafter abbreviated *OC.*

7. Gustave Flaubert, *Oeuvres complètes*, 2 vols. (Paris: Seuil, 1964), I, 571. Hereafter abbreviated *OE.*

8. See Charles Bernheimer, *Flaubert and Kafka: Studies in Psychopoetic Structure* (New Haven: Yale University Press, 1982), esp. pp. 66–76.

9. *Soupeuses* were so designated because of their habit of dining with clients in the *cabinets particuliers* of restaurants; *lorettes* were so named about 1840 after the church of Notre-Dame de Lorette, around which lived many women of easy virtue. See the study by the Goncourt brothers, *La Lorette* (Paris: Dentu, 1853).

10. As is true of many of Flaubert's opinions, this one dates from way back. In a letter of 1839, Flaubert reproaches his friend Ernest Chevalier for being horrified by *ces dames* and recommends that he change his attitude to "a philosophical love." "I prefer a hundredfold a *putain* to a *grisette*," declares the eighteen-year-old Flaubert, "because, of all the genres, the one I hate the most is the genre *grisette*, which is, I think, what one calls a bit of something fidgety, proper, coquette, simpering, affected, pert, and stupid! that pesters you constantly and wants to 'do' passion as she's seen it staged in vaudeville. No, I much prefer the abject for the abject; it's a pose like any other, which I feel better than anyone" (*Correspondance*, I, 39).

Flaubert returns to this theme in the account of his 1847 trip to Brittany, *Par les champs et par les grèves*, which includes a lyrical series of one-sentence, one-paragraph, chronologically ordered evocations of prostitutes living in the romantic contexts of ancient Greece and Rome, and of Paris in medieval times, the eighteenth century, and the Napoleonic age. He reports having seen an authentic whore on the boulevards not long ago but that that was her last appearance. Now, he says, "her hemline is high, she's got manners, she's put off by vulgar language, and she places her earnings in a savings bank. Swept clean of her presence, the street has lost the only poetry that had remained its own: they have filtered the gutters, strained the ordure" (*Oeuvres complètes*, II, 528). Flaubert claims to have had these thoughts about the demise of the *fille de joie* while sitting on a sofa in a brothel salon, from which he escaped in disgust without having made a single purchase.

11. Sigmund Freud, "Fetishism," in *Sexuality and the Psychology of Love* (New York: Collier, 1963), p. 219. Hereafter abbreviated *F.*

12. Two letters to Ernest Chevalier dating from Flaubert's 1842 Parisian period confirm what he tells Louise Colet eleven years later about his chaste *flânerie* observing prostitutes on the boulevards and dreaming of antiquity. See Flaubert, *Correspondance*, I, 100, 106.

13. Jean-Paul Sartre, *L'idiot de la famille: Gustave Flaubert de 1821 à 1857*, 3 vols. (Paris: Gallimard, 1971), I, 713.

14. Richard Terdiman interprets this imagined threat of violence as a moment when the sociocultural conditions of Flaubert's domination are

momentarily demystified in "a powerful fantasy of the revenge of the oppressed." See Terdiman, *Discourse/Counter-Discourse: The Theory and Practice of Symbolic Resistance in Nineteenth-Century France* (Ithaca: Cornell University Press, 1985), p. 251. Terdiman offers a very interesting reading of the *Voyage en Orient* as a work that documents Flaubert's failure to produce out of the Orient's otherness a counter-discourse to the exhausted, degraded discourse whose prevalence at home was driving him to furious desperation.

15. What may well have been distinguishable, however, given the intimacy of Flaubert's sexual contacts with Kuchuk, is an aspect of her sexuality he mentions to Louise in 1853, no doubt to appease the jealousy her reading of his travel notes had aroused: "As to the physical *jouissance* [of the Oriental woman], it must be very slight, since its center, the notorious button, is cut off at an early age" (*Correspondance,* II, 282). Kuchuk's clitoridectomy—if indeed she had one—may have served Flaubert's "poetic" fantasies as the realization of a male revenge against woman's difference. Such an interpretation helps make sense of the extraordinary remark that follows the sentence just quoted: "And that is what renders [the Oriental woman] so poetic from a certain point of view: that she returns absolutely back into nature" (ibid., p. 282). The virulent sexism of this comment is evident: what is natural for woman is to have no organ for her own sexual pleasure, to be merely the object of male gratification. Here again female lack becomes for Flaubert the source of poetic feeling.

16. The problematic of memory and forgetting is also at work in Flaubert's fantasies concerning what Kuchuk might remember about him. When revising his travel notes, he added the romantic thought, reminiscent of Tressignies's fantasy in Barbey's "La vengeance d'une femme": "How it would flatter your pride if, as you left, you were sure that a memory would remain, and that she would think of you more than of the others, that you would stay in her heart!" (*Oeuvres complètes,* II, 575). Richard Terdiman (*Discourse/Counter-Discourse,* p. 250) notes rightly the incongruity of this romantic wish, which inverts the conditions of Flaubert's colonialist relationship with his purchased sexual object, suddenly casting him in the position of supplicant. The fact that the thought is a later addition suggests the role of distance in structuring the dialectic of memory. Writing to Louise in 1853, Flaubert imagines Kuchuk as a blank slate that holds no traces of his passage: "It is we who think of her, whereas she never thinks of us" (*Correspondance,* II, 284). Louise's own jealous memory of Kuchuk was so tenacious that, in November 1869, long after her break-up with Flaubert, she actually spent a hot afternoon in Egypt vainly searching for her rival (see her account in *Les pays lumineux: Voyage en Orient* (Paris: Dentu, 1879).

17. In the same letter to Bouilhet in which he describes his first visit to Kuchuk-Hanem, Flaubert tells of an earlier experience with prostitutes in Egypt that foreshadows the famous ending of *L'éducation,* even in regard to the element of nonfulfillment. Having suddenly come upon the "quartier des garces" in the town of Keneh, Flaubert finds himself accosted right and left by exotic-looking whores. He deliberately decides not to go with one, "so as to

retain the melancholy of this picture and make it stay more deeply inside me. Thus, I left in great wonderment, a feeling I have kept. There is nothing more beautiful than those women calling you. If I had fucked, another image would have come on top of this one and attenuated its splendor" (*Correspondance*, I, 605; see also *Oeuvres complètes*, II, 573).

18. I have analyzed *Novembre* from a somewhat different perspective in *Flaubert and Kafka*, pp. 79–83.

19. Biographers agree that Flaubert based the speaker's affair with Marie on his own brief encounter in Marseille with a certain Eulalie Foucaud (at 2:30 A.M. on 17 October 1840, according to the detective work of Jacques-Louis Douchin; see *La vie érotique de Flaubert*, p. 59). The Goncourts give an account of Flaubert's telling them of this "first love" on 20 January 1860. According to their story, Flaubert blew a kiss to the attractive woman who kept the hotel where he was staying, and, of her own accord, she came to his room that night. Although there was an exchange of letters subsequently, Flaubert did not see Eulalie again. But every time he returned to Marseille he went by the increasingly dilapidated hotel where they had met, as if compelled to commemorate *sur place* the erasure of sexual intimacy through an experience of physical deterioration, absence, and death. "Returning over my past makes me feel completely disgusted," he tells Le Poittevin in 1845, "yet my pitiless curiosity drives me to dig out and excavate everything, down to the deepest slime" (*Correspondance*, I, 224). There is clearly something masochistic about what Flaubert calls his "pitiless curiosity": excavation always uncovers graves, inevitably certifies death—and he enjoys this morbid confirmation, especially when it concerns what is "beneath" prostitution.

Flaubert's first return to Marseille occurs in 1845, three years after *Novembre* was completed. Not knowing yet that Eulalie has left the city, he writes Le Poittevin: "I will go see Madame Foucaud, it will be strangely bitter and farcical, especially if I find, as I expect to, that she's grown ugly" (ibid., p. 222). So the return is undertaken in the fervent expectation of a "poetic" disillusionment. And Flaubert is not disappointed, for the deserted hotel is a perfect symbol, he tells Le Poittevin, of his closed-up heart, "empty and sonorous, like a great sepulcher without a corpse" (ibid., p. 224; see also p. 227). Le Poittevin is perfectly in tune with Flaubert's thinking in this matter. In his response, he tells his friend of his plan to take a slut "chosen ad hoc" to Le Havre and Honfleur, places where he "had believed when [he] was young"; he intends to promenade her around, sleep with her, and dismiss her upon their return—all, it seems, in order to profane and masochistically destroy his memories of innocence and love. See Alfred Le Poittevin, *Une promenade de Bélial* (Paris: Les Presses Françaises, 1924), p. 194. Most of this letter is quoted in *Correspondance*, I, 956–957.

Thirteen years later, Flaubert again seizes the opportunity for "retrospective lust" (a phrase from *L'éducation sentimentale* that Peter Brooks uses in the title of his excellent chapter on that novel in *Reading for the Plot: Design and Intention in Narrative* [New York: Knopf, 1984]). On his way to Tunisia to gather data for Salammbô, he stops again to see the "*fameuse maison* where eighteen years

earlier I fucked Madame Foucaud," and he enjoys the special retrospective thrill of having his hair cut in the very room (now a barbershop) in which he formerly received Eulalie. "It had been a long time," he writes Bouilhet, "since I had so deeply thought or felt, I don't know which" (*Correspondance*, II, 808).

20. Marie is the speaker's mirror image: she claims still to be a virgin in that she has never known pleasure or love and dreams constantly of both. The Goncourts report that Flaubert made the same claim to them: "He says he's never really fucked a woman, that he's a virgin, that all the women he's had he made into the mattress for another woman he dreamed of" (*Journal*, II, 12).

21. On the link between prostitution and the erosion of signs, see Victor Brombert, "Usure et rupture chez Flaubert: L'exemple de *Novembre*," in *Essais sur Flaubert*, ed. Charles Carlut (Paris: Nizet, 1979), pp. 145–154; and idem, "De *Novembre* à *L'éducation*: Communication et voie publique," *Revue d'Histoire Littéraire de la France* 81 (July–October 1981): 563–572. For a complex and stimulating discussion of *Novembre*, which credits the novel, I think prematurely, with a modernist understanding of the impropriety and citationality of all language, see Shoshana Felman, *La folie et la chose littéraire* (Paris: Seuil, 1978), pp. 191–213.

22. Gustave Flaubert, *L'éducation sentimentale*, ed. P. M. Wetherill (Paris: Garnier, 1984), p. 428. This excellent edition, besides offering extensive notes and choice of variants, reproduces *in extenso* Flaubert's sketches and scenarios relating to the February revolution as Frédéric experiences it; it also gives a selection of scenarios for other important episodes. Subsequent references to this edition, abbreviated *ES*, will be given in the text.

23. Victor Brombert, *The Novels of Flaubert: A Study of Themes and Techniques* (Princeton: Princeton University Press, 1966), p. 128.

24. The scenarios and sketches for the last episode have been transcribed and analyzed by Peter Michael Wetherill, "'C'est là ce que nous avons eu de meilleur,'" in *Flaubert à l'oeuvre* (Paris: Flammarion, 1980), pp. 35–68. The scenarios are on pp. 37–44.

25. Wetherill notes that an early scenario indicates Flaubert's intention to remind the reader that this anecdote had been alluded to in the second chapter (*Flaubert à l'oeuvre*, pp. 59–60). Observing that such explicit textual guidance by the narrator is typically Balzacian, Wetherill claims that Flaubert's early versions often contain many Balzacian elements. Later, Flaubert works to eliminate these elements to produce his own characteristic style, which is often deliberately opaque in comparison to the more informative first drafts.

26. The memory of Kuchuk-Hanem may actually play a role in Flaubert's concluding anecdote. According to Antoine-Youssef Naaman, her name is Turkish in origin; see Naaman, *Les lettres d'Egypte de Gustave Flaubert* (Paris: Nizet, 1965), p. lxxiv. Hence, perhaps, the name "Turc" for the madam of this brothel situated not on the Nile but on its French counterpart, the Seine. It is interesting to note, given my earlier discussion of the name "Olympia," that Flaubert's initial choice for Zoraïde Turc's first name was "Olympe" (see Wetherill, *Flaubert à l'oeuvre*, p. 37).

The Turkish connection returns in a burlesque farce which the twenty-seven-year-old Maupassant put on in 1877 for the entertainment of an august literary gathering, but most especially for his friend and master Flaubert. The farce was entitled *A la feuille de rose, maison turque.* The ribald action, which takes place in a Parisian brothel decorated in Oriental style, has as its central plot device the pretense that the whores are actually a Turkish harem. In the performance, all the roles were played by men, dressed in extravagantly sexed costumes. Flaubert loved it; Edmond de Goncourt found it obscene (see his account in *Journal,* II, 1189). The text of the play was recently published (Paris: Encore, 1984), edited with an informative introduction by Alexandre Grenier.

27. Jean Baudrillard, *Pour une critique de l'économie politique du signe* (Paris: Gallimard, 1972), p. 100.

28. See Naomi Schor, "Fetishism and Its Ironies," *Nineteenth-Century French Studies* 17 (Fall 1988).

29. Although this is not a point I would want to make too much of, Flaubert may have indulged a kind of private fantasy of Marie Arnoux as Kuchuk-Hanem. The famous phrase that signals the appearance of Madame Arnoux, "Ce fût comme une apparition," appears verbatim in Maxime Du Camp's description of his visit to the Egyptian courtesan: "En haut des degrés, Koutchouk-Hanem m'attendait. Je la vis en levant la tête; ce fût comme une apparition" (*Le Nil,* 2nd ed. [Paris: Librairie Nouvelle, 1860], p. 116). Of course, it is perfectly possible that Flaubert wrote this sentence having completely forgotten Du Camp's identical wording. Or the echo may be a function of the logic of the unconscious.

30. I am indebted for this argument to Eugenio Donato's reading of Flaubert's relation to the corpse as a privileged genetic emblem of writing. See Donato, "The Crypt of Flaubert," in *Flaubert and Postmodernism,* ed. Henry Majewski and Naomi Schor (Lincoln: Nebraska University Press, 1984).

31. Brooks, *Reading for the Plot,* p. 213.

32. Flaubert's second notebook of reading notes contains the following entry, apparently intended for Bouvard and Pécuchet's *copie:* "See in the first volume (Parent du Châtelet) some remarkable letters by procuresses who profess their virtue and modesty in order to obtain permission to open brothels." I owe this reference to Pierre-Marc de Biasi, whose mammoth edition of the *Carnets de travail de Gustave Flaubert* has just been published (Paris: Balland, 1988). The above note is on p. 223.

33. Gustave Flaubert, *Correspondance,* 9 vols. (Paris: Conard, 1926–1933), VII, 279.

34. In addition to the studies by Brombert and Brooks referred to above, I would recommend the articles collected in *Histoire et langage dans "L'éducation sentimentale" de Flaubert* (Paris: SEDES-CDU, 1981), especially those by Philippe Berthier and Jacques Neefs; and, despite its frequent recourse to methodological jargon, the frequently suggestive little book by Jeanne Bem, *Clefs pour "L'éducation sentimentale"* (Tübingen: Günter Narr, 1981). See also Mark Conroy, *Modernism and Authority: Strategies of Legitimation in Flaubert and Conrad* (Baltimore: Johns Hopkins University Press, 1985).

35. This source is clearly designated in a note from the scenarios reproduced in Marie-Jeanne Durry, *Flaubert et ses projets inédits* (Paris: Nizet, 1950), pp. 124–125, and in Biasi, *Carnets de travail*, p. 284.

36. The parvenu hero of *Bel-Ami* (1885), by Flaubert's disciple Maupassant, is quite happy to imagine his career as analogous to that of a successful courtesan: "Maybe he felt vaguely that they had something in common, a natural bond, that they were kindred by race and spirit, and that his success would be due to audacious methods similar to those she had used." *Bel-Ami* (Paris: Gallimard, 1973), p. 174.

37. On Flaubert and Marx, see Richard Terdiman, "Counter-Humorists: Strategies of Resistance in Marx and Flaubert," in *Discourse/Counter-Discourse*, pp. 198–226 (focusing on *Bouvard et Pécuchet*); and the remarks by Claudine Gothot-Mersch in the introduction to her excellent edition of *L'éducation sentimentale* (Paris: Flammarion, 1985), pp. 17–20.

38. Karl Marx, *The Eighteenth Brumaire of Louis Bonaparte* (New York: International Publishers, n.d.), p. 108.

39. Ibid., p. 120. This, I think, is the logical conclusion of a literary analysis. Flaubert's personal attitude toward Napoleon III was very complex. See Sartre's analysis in *L'idiot de la famille*, III, 445–665.

40. Conroy, *Modernism and Authority*, p. 60.

Six. Degas's Brothels

1. Paul Valéry, "Degas danse dessin," in Valéry, *Oeuvres*, ed. J. Hytier, 2 vols. (Paris: Pléiade, 1960), II, 1173. Hereafter abbreviated *DDD*.

2. Paul Valéry, "Philosophie de la danse," in Valéry, *Oeuvres* I, 1403.

3. Stéphane Mallarmé, "Crayonné au théâtre," in Mallarmé, *Oeuvres complètes*, ed. H. Mondor and G. Jean-Aubry (Paris: Pléiade, 1945), p. 304.

4. This metamorphosis follows the story told by Ovid of the beautiful Gorgon, raped in the temple of Athena by Poseidon, god of the sea, and then punished by Athena by having her lovely hair turned into snakes.

5. Theodore Reff echoes Valéry's remark: "Like the laundress pressing down hard on her iron or yawning, overheated and exhausted, like the street-walker waiting on the café terrace in a torpor, the dancer in Degas' work is often not an embodiment of feminine charm but of the lower-class woman's struggle for survival, burdened and deformed by her labors." Reff, "Edgar Degas and Dance," *Arts Magazine*, 53 (November 1978): 147.

6. Alexandre Parent-Duchâtelet, *De la prostitution dans la ville de Paris*, 2 vols. (Paris: Baillière, 1836), I, 183–184. Subsequent studies mention "blanchisseuses," "repasseuses," and "modistes" as likely to be sexually available. See, for example, C. J. Lecour, *La prostitution à Paris et à Londres, 1789–1877*, 3rd ed. (Paris: Asselin, 1882), pp. 197–200.

7. Gustave Coquiot, *Degas* (Paris: Librairie Ollendorff, 1924), p. 73; quoted in Eunice Lipton, *Looking into Degas: Uneasy Images of Women and Modern Life* (Berkeley: University of California Press, 1986), p. 79.

8. See Lynn Garafola, "The Travesty Dancer in Nineteenth-Century Ballet,"

Dance Research Journal 17–18 (Fall 1985–Spring 1986): 35–40; and Abigail Solomon-Godeau, "The Legs of the Countess," *October* 39 (Winter 1986): 83–92. The standard history of the French ballet in this period is Ivor Guest, *The Ballet of the Second Empire* (Middletown: Wesleyan University Press, 1974). For the special role played by the Jockey Club in determining the sexual commodification of the dancer, see Joseph-Antoine Roy, *Histoire du Jockey-Club de Paris* (Paris: Rivière, 1958); and Lipton, *Looking into Degas,* pp. 44–45, 79.

9. For reproductions of these images see Jean Adhémar and Françoise Cachin, *Degas: The Complete Etchings, Lithographs and Monotypes* (London: Thames and Hudson, 1974), monotypes nos. 56–82. Halévy's reasons for refusing to accept Degas's illustrations for publication are unclear. Linda Nochlin has recently made the interesting suggestion that Halévy may have been disturbed by Degas's having taken the first-person narration of his story literally and shown the author himself engaged behind the scenes in bargaining for sexual favors. Nochlin goes on to suppose that Halévy may also have been displeased to remark the similarity between his depiction in the *Famille Cardinal* series and the representation of the client in the brothel monotypes of the same period. Furthermore, notes Nochlin, Halévy might have detected a touch of anti-Semitic feeling in the caricatured manner of his portrayal. See Nochlin, "Degas and the Dreyfus Affair: A Portrait of the Artist as Anti-Semite," in Norman Kleeblatt, ed. *The Dreyfus Affair: Art, Truth, Justice* (Berkeley: University of California Press, 1987), pp. 104–105.

10. Edmond and Jules de Goncourt, *Journal,* 4 vols. (Paris: Fasquelle-Flammarion, 1956), I, 1219.

11. See Alain Corbin, *Les filles de noce: Misère sexuelle et prostitution aux 19e et 20e siècles* (Paris: Aubier Montaigne, 1978), esp. pp. 171–314.

12. The existence of such brothels is noted in Louis Fiaux, *Les maisons de tolérance, leur fermeture* (Paris: Carré, 1892), p. 256; cited in Corbin, *Les filles de noce,* p. 179.

13. Félix Carlier, *Etude de pathologie sociale: Les deux prostitutions, 1860 à 1870* (Paris: Dentu, 1877), p. 32; cited in Corbin, *Les filles de noce,* p. 261.

14. G. Macé, *La police parisienne,* vol. 4, *Gibier de Saint-Lazare* (Paris: Charpentier, 1888), p. 236. See Corbin, *Les filles de noce,* p. 264.

15. The monotype technique was apparently invented by the Genovese artist Giovanni Benedetto Castiglione (1600–1665). William Blake made a series of twelve beautiful monotypes in 1795 on themes from the Bible, Milton, and Shakespeare. For other artists who have used the medium, see *The Painterly Print: Monotypes from the Seventeenth to the Twentieth Century* (New York: Metropolitan Museum of Art, 1980).

16. The sketches illustrating *La fille Elisa* have been published by Theodore Reff in *The Notebooks of Edgar Degas,* 2nd ed., rev., 2 vols. (New York: Hacker Art Books, 1985), notebook 28, nos. 26–27, 29, 31, 33, 35, 45, and 65 (described by Reff in I, 130).

17. Adhémar and Cachin, *Degas,* p. 75. Among Degas's friends, Cachin mentions the Halévys and the Rouarts. Artists she considers likely to have seen the monotypes (no evidence is cited) are Bartholomé and Pissaro and, perhaps,

Toulouse-Lautrec and Gauguin. A number of monotypes, done in the dark-field manner, of scenes not explicitly related to brothel life carry scratched-in dedications to friends of Degas (see Adhémar and Cachin, *Degas,* monotypes nos. 160, 161, 163, and 165).

18. Since I completed this chapter, two new works have been published that discuss the brothel monotypes. See Richard Thomson, *Degas: The Nudes* (London: Thames and Hudson, 1988), pp. 97–117; and idem, *Degas* (Paris: Editions de la Réunion des Musées Nationaux, 1988), pp. 296–309. One of the editors of the latter work, Michael Pantazzi, argues that the monotypes should be dated 1876–1877, three years earlier than the commonly accepted time frame. His basis for this argument is a statement made by Jules Claretie in a review of the 1877 impressionist exhibition in the journal *L'indépendance belge,* 15 April 1877, p. 1: "The horrors of war by the Spanish master [Goya] are not stranger than the love scenes that Degas has undertaken to paint and to engrave. His etchings would provide an eloquent translation of certain pages from *La fille Elisa.*" Pantazzi claims that the only works by Degas that could conceivably be associated with *La fille Elisa* are the brothel monotypes, which Claretie may have thought to be etchings. But this is a very problematic argument, given the association of so many of Degas's characteristic subjects with the general domain of prostitution. Still, it is possible that Degas may have publicly shown a few of the monotypes in 1877 and that some of them do indeed date to that period.

19. See Eugenia Janis, "The Role of the Monotype in the Working Method of Degas," *Burlington Magazine* 109 (January–February 1967). Janis drew up the first comprehensive catalogue of the monotypes for an exhibition at the Fogg Art Museum in 1968: *Degas Monotypes: Essay, Catalogue and Checklist* (Cambridge, Mass.: Harvard University Press, 1968).

20. Adhémar and Cachin, *Degas,* 80.

21. It is interesting to note that the most recent discussion of the mono-types, Richard Thomson, *Degas: The Nudes,* perpetuates the standard interpre-tation. Thomson describes the prostitutes as "bestial, keyed up for sex, beyond the bounds of decency . . . They also convey disgust . . . They are shown as women of a baser race" (p. 117).

22. Joris-Karl Huysmans, *L'art moderne / Certains* (Paris: 10/18, 1975), p. 294. Hereafter abbreviated *AMC.*

23. Auguste Renoir also found something peculiarly chaste about Degas's bordello images. Vollard quotes him as saying: "When one paints a bordello, it's often pornographic, but always hopelessly sad. Only Degas could give an air of rejoicing to such a subject, along with the look of an Egyptian bas-relief. This quasi-religious and chaste aspect of his work, which makes it so great, becomes still more pronounced when he treats the prostitute." Ambroise Vol-lard, *Degas* (Paris: Crès, 1924), pp. 59–60.

24. Here Huysmans, who did not publish his comments on Degas's pastels until 1889, is echoing the misogynist praise Octave Mirbeau proclaimed three years earlier for Degas's rigorously unsentimental and antiromantic depictions

of women. They do not "inspire passion or sensual desire," Mirbeau wrote. "On the contrary, there is a ferocity that speaks clearly of a disdain for women and a horror of love. It is the same bitter philosophy, the same arrogant vision, that one finds in his studies of dancers." See Mirbeau's piece in *La France* (21 May 1886); quoted in Fine Arts Museum of San Francisco, *The New Painting: Impressionism, 1874–1886* (San Francisco: Fine Arts Museum, 1986), p. 453. Huysmans, it seems, codified in its most extreme terms an interpretation of Degas's attitude toward women that had already gained a certain acceptance among professional critics. See Martha Ward's excellent review of the criticism of the 1886 exhibition as focused on the question of Degas's misogyny, "The Rhetoric of Independence and Innovation," in *The New Painting*, pp. 430–434.

25. Freud remarks of the scopophilic instinct that it begins as a narcissistic formation. Its first stage, which is never left behind, is autoerotic: "It has indeed an object, but that object is part of the subject's own body." Sigmund Freud, "Instincts and Their Vicissitudes," *The Standard Edition of the Complete Psychological Works of Sigmund Freud*, 24 vols. (London: Hogarth, 1957), XIV, 130.

26. Edward Snow, *A Study of Vermeer* (Berkeley: University of California Press, 1979), p. 28.

27. Carol Armstrong, "Edgar Degas and the Representation of the Female Body," in Susan Rubin Suleiman, ed., *The Female Body in Western Culture: Contemporary Perspectives* (Cambridge, Mass.: Harvard University Press, 1985), p. 239.

28. "Invite empathy": Eunice Lipton, "Degas' Bathers: The Case for Realism," *Arts Magazine* (May 1980): 96. "Pictorial onanism": Armstrong, "Edgar Degas," p. 238.

29. A number of the reviewers of Degas's contribution to the 1886 exhibition specifically define the observer's perspective as that of a voyeur: Degas, writes Gustave Geffroy, "wanted to paint a woman *who did not know she was being watched*, as one would see her hidden by a curtain or through a keyhole" (*La Justice*, 26 May 1886; quoted in *The New Painting*, p. 453). Geffroy notes the obliqueness of Degas's points of view but apparently considers them to be realistically determined by the voyeur's adoption of concealed places for clandestine observation. As Martha Ward remarks, the critics believed that the voyeuristic perspective revealed woman as instinctual animal. Only one critic, Octave Maus (in the periodical *L'art moderne*, Brussels, 27 June 1886) was able to see anything positive about the exposure of woman's unselfconscious physicality. He imagined the bathers as domestic cats cleaning themselves, whereas the majority of the critics chose to compare their gestures to the wild movements of monkeys or frogs (see Ward, "The Rhetoric of Independence," pp. 432–433).

30. Snow, *A Study of Vermeer*, p. 30. In a letter of 1884, Degas describes what seems to be precisely such an ontologically negative self-assessment: "If you were a bachelor and fifty years old (which I became a month ago), you would have moments such as I have when you would close yourself up like a door, and not only to friends. You suppress everything around you, and, once

alone, you annihilate yourself, you kill yourself finally, out of disgust." See *Lettres de Degas*, ed. Marcel Guérin (Paris: Grasset, 1931), pp. 64–65.

31. Henri Fèvre, in *La revue de demain* (May–June 1886), quoted in *The New Painting*, p. 453.

32. J. M. Michel, in *La petite gazette* (18 May 1886), quoted in *The New Painting*, p. 453.

33. Félix Fénéon, *Les Impressionistes en 1886* (Paris: Publications de la Vogue, 1886), p. 10; quoted in Lipton, *Looking into Degas*, p. 179.

34. Huysmans wrote of this painting in his review of the 1880 *Exposition des indépendants:* "What is marvelous about this work is the power of reality it conveys; these whores are brothel whores and no other kind. Their poses, their irritating odor, their unhealthy skin, lighted by gaslight in this watercolor covered by gouache, have a really strange, truthful precision. This is no doubt the first time such women are portrayed so firmly, so directly. Their character, their bestial or puerile humanity, is also represented. The entire philosophy of love for money is shown in this scene, where, after having entered voluntarily, driven by a stupid desire, the client reflects and, having cooled off a bit, ends by remaining unresponsive to the offers he is made." In Huysmans, *L'art moderne / Certains*, pp. 120–121.

35. Hollis Clayson, "Avant-garde and Pompier Images of Nineteenth-Century Prostitution: The Matter of Modernism, Modernity and Social Ideology," in Benjamin Buchloh, ed., *Modernism and Modernity: The Vancouver Conference Papers* (Halifax: Press of Nova Scotia College of Art and Design, 1983), pp. 56–58.

36. Charles Baudelaire, *Oeuvres complètes* (Paris: Pléiade, 1961), p. 1189.

37. All of these etchings are included in Georges Bloch, *Pablo Picasso, Volume IV: Catalogue of the Printed Graphic Work, 1970–1972* (Berne: Kornfeld and Klipstein, 1979).

38. The degree to which this project is free to treat the real as material for private fantasy is strikingly illustrated by two etchings in the Degas series (Bloch, *Pablo Picasso,* nos. 1968 and 1969), where suddenly the whorehouse appears as an ideal Hellas and a prostitute becomes an Arcadian deity dallying with a faun.

39. "So the ballerina *is not a woman who dances,* for the juxtaposed reasons that *she is not a woman,* but a metaphor summing up one of the elementary aspects of our form, sword, cup, flower, etc., and that *she does not dance.*" Mallarmé, *Oeuvres complètes,* p. 304.

40. Sigmund Freud, "Fetishism," in Freud, *Sexuality and the Psychology of Love,* ed. Philip Rieff (New York: Collier, 1963), p. 216.

41. Here my argument joins up with that developed by Howard Bloch in regard to medieval French literature. Bloch shows that the early misogynistic tradition of Biblical exegesis interpreted woman as "a tropological turning away" from the proper and literal, which is synonymous with male being. See Bloch, "Medieval Misogyny," *Representations* 20 (Fall 1987).

42. For an excellent discussion of the relation of Degas's imagery to the graphic language of caricature, see Carol Armstrong, "Reading the Oeuvre of

Degas," in Armstrong, "Odd Man Out: Readings of the Work and Reputation of Edgar Degas" (Diss., Princeton, 1986).

43. Beatrice Farwell has written an interesting essay about the relation of "realist" treatments of the nude to the popular tradition of erotic imagery. See Farwell, "Courbet's 'Baigneuses' and the Rhetorical Feminine Image," in Thomas Hart and Linda Nochlin, eds., *Woman as Sex Object: Studies in Erotic Art, 1730–1970* (New York: Newsweek, 1972), pp. 65–79.

44. Luce Irigaray, *This Sex Which Is Not One* (Ithaca: Cornell University Press, 1985), p. 177.

45. Many of the monotype images, especially those done in the dark-field manner, convey an almost tactile sense of this marking, insofar as Degas often modeled the women's bodies by pressing on the ink with his fingers, leaving visible imprints.

46. I first encountered this interpretation of the monotypes in Susan Hollis Clayson's stimulating work "Representations of Prostitution in Early Third Republic France" (Diss., University of California, Los Angeles, 1984), to which I am greatly indebted. Although Clayson remarks that "it is a hopeless task to gauge the misogynistic content of an image" (p. 105), her illuminating analysis of the monotypes constitutes an implicit defense of Degas's representational practice. "The point of [the prostitutes'] particular, tenacious physicality," she writes, "seems to embed them in a world of the sheerly material, where the subjective 'self' has been suspended, cancelled, or long since overridden. Degas' prostitutes lead an existence in which the 'self' and the body have become the same, and the women's sexuality has been lost entirely to the world of exchange" (p. 115).

47. My thinking about pornography is indebted to two articles: John Ellis, "Photography/Pornography/Art/Pornography," *Screen* 21 (Spring 1980); and Graham Knight and Berkeley Kaite, "Fetishism and Pornography: Some Thoughts on the Pornographic Eye/I," *Canadian Journal of Political and Social Theory* 9 (Fall 1985). I would like to thank Constance Penley for recommending these articles.

48. Walter Benjamin, *Charles Baudelaire: A Lyric Poet in the Era of High Capitalism* (London: New Left Books, 1973), p. 59. In *Das Passagen-Werk* (Frankfurt: Suhrkamp, 1982), I, 637, Benjamin declares, "Love of prostitutes is the apotheosis of intuitive feeling for the commodity [Einfühlung in die Ware]."

49. *Correspondance de Berthe Morisot,* ed. Denis Rouart (Paris: Quatre Chemins–Editart, 1950), p. 23.

50. Ibid., p. 31.

51. Quoted in Adhémar and Cachin, *Degas,* p. 86.

52. Norma Broude, "Degas' 'Misogyny,'" *Art Bulletin* 59 (March 1977). Broude combines a biographical approach with thematic and visual analysis to conclude that Degas valued intellectual independence, creative accomplishments, and individual character in women. Broude's argument, based on her readings of Degas's portraits of women of his own social class, has trouble accounting for his pictures of lower-class women, whom she finds "reduced to types" (p. 101).

53. See Carol Armstrong, "Odd Man Out," ch. 5: "The Myth of Degas," esp. pp. 352–358. The components of the myth that I enumerate below are those identified by Armstrong.

54. At the outset of a monumental four-volume monograph on Degas, P. A. Lemoisne suggests that the peculiarity of his subject makes the endeavor he is undertaking almost impossible. Since Degas's works are "so full of reticences, so willfully effaced," in order to understand the artist's evolution one should get to know the man. "But if there was ever a man difficult to know, walled up as he was in an impregnable discretion, a kind of timidity that made him caustic and often severe when he felt menaced, that man was Degas . . . When you try to get closer to the man, you soon find yourself turning in a vicious circle, Degas having been truly himself, audacious despite an insurmountable modesty, ardent despite a fierce reserve, decisive despite eternal scruples, brilliant despite an innate sobriety of expression, only in his works" (*Degas et son oeuvre*, 2 vols. [Paris: P. Brame & C. M. de Hauke, 1946–48], I, 1–2). One aspect of the Degas myth that biographers have built up from the most meager evidence into an indisputable cause of the artist's misogyny is his impotence. For example, Roy McMullen declares that "there can be little doubt that [the] reason for [Degas's] celibacy . . . was impotence—either psychic or physical impotence, and perhaps, as is often the case, a combination of the two" (*Degas: His Life, Times, and Work* [London: Secker and Warburg, 1985], p. 268). In an article entitled "Degas as a Human Being," whose thesis is that the artist barely qualified, Benedict Nicholson speculates that "there may be something in the theory that he was a repressed homosexual" (*Burlington Magazine* 105 [June 1963]: 239).

55. See McMullen, *Degas*, pp. 7–8. In the 1830s the family paid to have a bogus genealogy drawn up to confirm their noble heritage and their claim to the aristocratic name "de Gas." According to his niece's report, Degas said that he changed the spelling of the family name because "the nobility is not in the habit of working. Since I want to work, I will assume the name of a commoner." See Jeanne Fevre, *Mon Oncle Degas* (Geneva: Cailler, 1949), p. 23.

56. Paul Gauguin, *Paul Gauguin's Intimate Journals* (Bloomington: Indiana University Press, 1958), p. 131; cited in Lipton, *Looking into Degas*, p. 191.

57. Noting this and other conflicts in Degas's class position, Eunice Lipton concludes that it was because "he had little at stake in the prejudices of a particular social group" and was located "outside conventional social and emotional structures" that he was able to develop his richly ambiguous artistic vision (*Looking into Degas*, p. 195).

58. In the brilliant conclusion to her thesis, Carol Armstrong discusses Degas's photographic self-portraits as exercises in viewing a self that cannot be represented as a subject seeing, and examines in particular the portrait of Mallarmé and Renoir, in which Degas is an effaced presence reflected and negated in a play of mirror images. She reads these photographs as emblematic of Degas's lifelong preoccupation with "the act of vision as a fact of self-negation" ("Odd Man Out," p. 411). Some of Armstrong's thoughts on Degas's photographs can be found in her recent article "Reflections on the Mirror:

Painting, Photography, and the Self-Portraits of Edgar Degas," *Representations* 22 (Spring 1988).

59. The possibility of such a reading was suggested in Susan Suleiman's discussion of an earlier version of this chapter, presented at the third annual Conference on Twentieth-Century Literature in French at Baton Rouge (1986). I am grateful to Professor Suleiman for her perceptive and stimulating critique, to which I hope the present version of my study is at least a partially adequate response.

60. Lemoisne, *Degas et son oeuvre*, I, 119.

61. Henri Perruchot reports this comment in his *La vie de Toulouse-Lautrec* (Paris: Hachette, 1958), p. 199.

62. Emile Bernard (1868–1941), the precocious artist of whom Lautrec painted a wonderful portrait in the winter of 1885–86 (Tate Gallery, London), and a fellow student in the mid-1880s with Lautrec and van Gogh in the Atelier Cormon, is an interesting transitional figure between Degas and Lautrec in the treatment of the prostitution motif. Sometime between 1885 and 1887, he produced an impressive large pastel drawing, *The Hour of Flesh* (private collection, Paris), in which men are dimly perceived outside a café accosting prostitutes under lamplight. In 1888 he put together an album of a dozen watercolors, done in a flat, schematic manner, which he entitled *In the Brothel* and sent to his friend van Gogh in Arles, inspiring the latter to undertake two paintings with a similar theme (*The Brothel* and *The Dance Hall*). On the relation of Lautrec to Degas and other artists of his time, see Matthias Arnold, "Toulouse-Lautrec and the Art of His Century," in Riva Castleman and Wolfgang Wittrock, eds., *Henri de Toulouse-Lautrec's Images of the 1890's* (New York: Museum of Modern Art, 1985).

63. Reported in Jean Bouret, *Toulouse-Lautrec* (Paris: Aimery Somogy, 1963).

64. Lautrec's studies for the synthetic *Au salon* tend to show more individual contact between inmates. Thus, in *The Two Friends* (Musée d'Albi), an early version of the two central figures, Mireille is shown snuggling responsively close to her companion, whose arm reaches over tenderly to caress her, suggesting a lesbian relationship. For a good commentary on this and other images by Lautrec, see Charles Stuckey, *Toulouse-Lautrec: Paintings* (Chicago: Art Institute of Chicago, 1979).

Seven. Decomposing Venus

1. Emile Zola, *Nana*, ed. Henri Mitterand, in *Les Rougon-Macquart*, vol. II (Paris: Pléiade, 1961), pp. 1468. Hereafter abbreviated *N.*.

2. Quoted from the manuscript in the Bibliothèque Nationale. Mitterand reproduces a part of this description on p. 1677 of the Pléiade edition. The word *cul* here seems most appropriately translated as "cunt," although elsewhere in Zola the same word has connotations that make "ass" a more accurate translation.

3. Did Zola actually believe the popular fable that a menstruating woman could cause milk to curdle? Probably not. Authoritative works on female physiology—for example, Raciborski, *Du rôle de la menstruation* (Paris: Baillière, 1840), and Brierre de Boismont, *De la menstruation* (Paris: Baillière, 1842)—make a point of disproving this folk prejudice. Zola may well have known that the idea was discredited but may have wanted to appropriate its continuing power to reinforce the mythic dimension of Nana's persona.

4. I will quote from the following editions of these books: *L'Amour* (Paris: Calmann Lévy, 1899), abbreviated *A*; and *La Femme* (Paris: Flammarion, 1981), abbreviated *FE*.

5. See F. A. Pouchet, *Théorie positive de l'ovulation spontanée* (Paris: Baillière, 1847). In 1859 Pouchet published *Hétérogénie, ou traité de la génération spontanée* (Paris: Baillière), in which he traces the genesis of life from decomposing vegetable and animal matter that makes up the earth's crust. This theory of life, which Pouchet saw as originally female, originating from death, put him in conflict with the so-called *panspermistes,* led by Pasteur, for whom life came into being through the contact of germ and eggs held in suspension in the air. For a discussion of the controversy, see Jean Rostand, *La genèse de la vie* (Paris: Hachette, 1943); and Jean Borie, *Mythologies de l'hérédité au XIXe siècle* (Paris: Galilée, 1981). For an illuminating overview of the fantasy-ridden history of reproductive biology, see Thomas Laqueur, "Orgasm, Generation, and the Politics of Reproductive Biology," *Representations* 14 (Spring 1986).

6. Jules Michelet, *Journal,* 4 vols. (Paris: Gaillimard, 1962, 1976), II, 328. Hereinafter abbreviated *JO*.

7. Jules Michelet, *La Mer,* ed. Jean Borie (Paris: Gallimard, 1983), pp. 151, 152. The citations immediately following are from pp. 151 and 153.

8. In Gerbe's anatomical atlas, Michelet found equally striking visual evidence of the terrible beauty of a fertile womb in certain vividly colored plates that show the state of the womb immediately after a baby's birth. He recommends that every husband steel his senses by viewing these pictures of "the womb crying blood, . . . the prodigious irritation of the organ, the murky torrent that exudes so cruelly from the devastated ravine" (*A,* 226). As Jean Borie points out, Michelet's attitude in looking both at female cadavers and at the representations of post-partem wombs is that of a colonialist explorer on a dark continent, pushing back the frontiers of European knowledge about origins. See Borie, *Mythologies de l'hérédité,* esp. pp. 48–49.

9. Prosper Lucas, *Traité philosophique et physiologique de l'hérédité naturelle,* 2 vols. (Paris: Baillière, 1847, 1850), II, 719. The notion of the wandering womb was replaced in nineteenth-century medical treatises with that of a *boule* which was supposed to originate in the uterus and mount slowly through the abdomen and lungs to the neck, where it produced a painful feeling of strangulation and ultimately caused convulsions. Prosper Lucas (*Traité,* II, 270) refers with approval to this theory as it was put forward by E. Esquirol, also a friend of Michelet's, in his authoritative three-volume work *Des maladies mentales* (Paris: Baillière, 1836).

10. Pierre Briquet, *Traité clinique et thérapeutique de l'hystérie* (Paris: Baillière,

1859), pp. 90, 125. Jules Déjerine, *L'hérédité dans les maladies du système nerveux* (Paris: Asselin et Houszeau, 1886), p. 225.

11. The best discussion of Michelet's views on female nature is Thérèse Moreau, *Le sang de l'histoire: Michelet, l'histoire et l'idée de la femme au XIXe siècle* (Paris: Flammarion, 1982), a brilliant book to which I owe much. Also wonderful on Michelet and women are Roland Barthes, *Michelet* (Paris: Seuil, 1954); and Jeanne Calo, *La création de la femme chez Michelet* (Paris: Nizet, 1975). For an excellent comprehensive overview of Michelet's work, see Lionel Gossman, "The Go-Between: Jules Michelet, 1798–1874," *MLN* 89 (May 1974); and idem, "Jules Michelet and Romantic Historiography," in *Scribners' European Writers,* ed. Jacques Barzun and George Stade (New York: Scribners, 1985), V, 571–606. Especially good on Michelet's work in natural history and his relation to language is Linda Orr, *Jules Michelet: Nature, History, and Language* (Ithaca: Cornell University Press, 1976).

12. Pierre-Joseph Proudhon, *La pornocratie, ou les femmes dans les temps modernes* (Paris: Marpon et Flammarion, n.d. [1875]), p. 28. Subsequent citations in this paragraph are on pp. 260, 247, 76.

13. The 1864 English translation of d'Héricourt, *A Woman's Philosophy of Woman, or Woman Affranchised,* has recently been reprinted by Hyperion Press (1981). D'Héricourt confronts Michelet on his own ground, arguing that "it is a principle in biology that no physiological condition is a morbid condition; consequently, the monthly crisis peculiar to women is not a disease, but a normal phenomenon" (*A Woman's Philosophy,* p. 21). Passages from the works of d'Héricourt, Lamber, and other anti-Proudhonian women (Julie Daubié, Olympe Audouard, André Léo) can be found in Maïté Albistur and Daniel Armogathe's anthology *Le grief des femmes* (Paris: Hier et Demain, 1978), which documents their not always trustworthy *Histoire du féminisme français* (Paris: Editions des femmes, 1977).

14. In the first issues of this journal, Maria Deraismes, who was to become the leading moderate feminist of the 1870s, made a point of attacking the debasement of woman that accompanies the typical male fantasmatic construction of her image. In an article entitled "Ce que veulent les femmes," she wrote: "What women want is for men to stop basing their greatness on the systematic debasement of women. What women want is not to be brought up, educated, molded, according to some conventional image, an image conceived in the brain of poets, novelists, or artists and therefore unreal" (quoted, in translation, from *Le droit des femmes* [10 April 1869]: 1, by Claire Goldberg Moses, *French Feminism in the Nineteenth Century* [Albany: State University of New York Press, 1984], p. 185). Moses gives a useful analysis of the reemergence of feminist activism in the 1870s and of the work of Maria Deraismes and Léon Richer.

15. This report is cited by Edith Thomas in the best account to date of women's activities during the Commune, *Les Pétroleuses* (Paris: Gallimard, 1963), p. 263.

16. Both these events are referred to as facts by the police prefect C. J. Lecour; see Lecour, *La prostitution à Paris et à Londres, 1789–1877,* 3rd ed. (Paris: Asselin, 1882), p. 337.

17. Arsène Houssaye, an enemy of the Commune, tells in his book *Les comédiens sans le savoir* of the arrest of a prostitute, gun in hand, who regrets only that she has not managed to kill more than one of the enemy soldiers whom she holds responsible for the death of her lover. She is summarily executed (see Thomas, *Les Pétroleuses,* p. 182).

18. Lecour notes with satisfaction that in the six months after the Commune the police registered twice as many prostitutes as during the same period in previous years and arrested 3,702 *filles publiques* and 2,935 *insoumises* (*La prostitution,* p. 339).

19. I do not mean to associate Zola with the most reactionary anti-Communard discourse. As Roger Ripoll has shown, Zola was capable of a certain sympathy for individual Communards (among them, the painter Courbet), while he saw the movement as a whole in extremely negative terms, terms familiar to us from his novels: the brutality of the "bête humaine," the madness of "esprits détraqués," the drunkenness of pleasure-seeking crowds. See Ripoll, "Zola et les Communards," *Europe* 468–469 (April–May 1968), where these phrases are quoted from letters Zola wrote to the journal *Sémaphore de Marseille* in May 1871.

20. Hippolyte Taine, *Les origines de la France contemporaine,* 6 vols. (Paris: Hachette, 1876–1894), vol. I: *La Révolution,* p. 70. Quoted by Susanna Barrows, *Distorting Mirrors: Visions of the Crowd in Late Nineteenth-Century France* (New Haven: Yale University Press, 1981), p. 77.

21. See Alain Corbin, *Les filles de noces: Misère sexuelle et prostitution* (Paris: Aubier Montaigne, 1978), pp. 36–53.

22. See Corbin's discussion of abolitionism, ibid., pp. 315–344. Corbin notes rightly that there is not one but a plurality of abolitionist discourses. My focus on Louis Fiaux narrows and simplifies a complex debate that also involved socialist thinkers, workers' congresses, and other groups. The misogynist tenor of Fiaux's work was drawn to my attention by Jill Harsin's analysis, *Policing Prostitution in Nineteenth-Century Paris* (Princeton: Princeton University Press, 1985), pp. 303–307. For a detailed discussion of the politics of the abolitionist debate, see Elisabeth Anne Weston, "Prostitution in Paris in the Later Nineteenth Century: A Study of Political and Social Ideology" (Diss., State University of New York, Buffalo, 1979).

23. Louis Fiaux, *Les maisons de tolérance: Leur fermeture* (Paris: Carré, 1892), p. 21. Subsequent citations in this paragraph are on pp. 280, 267, 287.

24. Harsin, *Policing Prostitution,* p. 304, quoting from Fiaux, *Les maisons,* 135, 281.

25. Letter to Zola, 15 February 1880.

26. Emile Zola, in *Le Figaro,* 18 December 1866; quoted by Aimé Guedj in his introduction to Zola's *Le roman expérimental* (Paris: Garnier-Flammarion, 1971), p. 31, hereafter abbreviated *RE.* Guedj also cites another typical passage from a laudatory review of 15 April 1873 in *L'avenir national:* "*Jane* [a play] is in my opinion a veritable dissection . . . It has the nakedness of a lesson in anatomy. The human cadaver, the human beast, is laid out on the table of the

amphitheater. In three cuts of the scalpel, the flesh is exposed, and the demonstration is done" (*Le roman experimental*, p. 41).

27. Letter to Céard of 13 December 1879; quoted by Henri Mitterand in his useful and informative notes to *Nana* (Pléiade edition), p. 1692.

28. Letter to Céard of 18 December 1879; quoted ibid., p. 1737.

29. Quoted from the manuscript of the preparatory dossier. Zola noted elsewhere in this dossier that Nana is "rot from below, *L'Assommoir* drawing itself up and rotting the upper classes" (cited by Mitterand, notes to *Nana*, p. 1666).

30. The reading of Nana as scapegoat is forcefully argued by Chantal Bertrand Jennings, "Lecture idéologique de *Nana*," *Mosaic* 10, no. 4 (1977). See also idem, *L'éros et la femme chez Zola* (Paris: Klincksieck, 1977).

31. See Michel Serres, *Feux et signaux de brume: Zola* (Paris: Grasset, 1975), pp. 237–244.

32. Cesare Lombroso and Guglielmo Ferrero, *La femme criminelle et la prostituée* (Paris: Félix Alcan, 1896), p. 319. An English version of this book, which was originally published in Italian, leaves out most of the material on prostitution: *The Female Offender* (New York: Appleton, 1915).

33. This sacrificial reading of Nana's role links her in an unexpected way to the prostitutional heroines of a number of Maupassant's stories. La belle Irma of "Le lit 29" (1884) deliberately contracts syphilis so as to use her body as an offensive weapon, infecting as many Prussian officers as possible before her death. In "Boule de suif" (1880), which takes place at the time of the German occupation of Rouen, the prostitute heroine is persuaded by her hypocritical fellow voyagers, whose coach has been held up by an enemy officer demanding her sexual favors, to abandon her patriotic principles, which she does for the good of the unworthy group. Maupassant generally paints a picture of the prostitute as "bonne fille," "La maison Tellier" (1881) being the best-known illustration. Here the madam closes up her *maison* to take the inmates to her niece's first communion in the country. The whores are portrayed as full of good will, naturally religious, and sentimental. Maupassant stresses their beneficial function in preserving the bourgeois social order: violence almost breaks out when the brothel is found closed, and its reopening is cause for rejoicing and reconciliation among patrons of different social classes. Although these three stories are laden with irony directed against the hypocritical duplicities of bourgeois morality, they do not dramatize powerful fantasmatic conflicts and show little innovation in literary form. This is why I have chosen not to discuss them in detail in the context of my study.

It may be partly because Maupassant's obsessive imagination so readily saw *all* women as whores that his portraits of actual prostitutes are relatively banal. His is a classic oedipal scenario: when the desired good mother is revealed to be sexually active in her own right, her fantasized promiscuous sexuality becomes the sign of the degradation of all women. The most powerful illustration of this fantasy is Pierre's vision, after he has convinced himself of his mother's adultery, of women on the beach at Trouville "as an immense flow-

ering of feminine perversity . . . The vast beach was no more than a love market where some sold themselves, others gave themselves, some put a price on their caresses, others only promised themselves. All these women were thinking of the same thing: to offer and make desirable their flesh already offered, already sold, already promised to other men . . . His mother had done like the others, that's all!" (*Pierre et Jean* [Paris: Gallimard, 1982], pp. 140–141.) In *Bel-Ami*, when Du Roy suspects his wife of having cuckolded her first husband, his immediate reflection is, "All women are whores; one's just got to use them and give nothing of oneself in return" (*Bel-Ami* [Paris: Gallimard, 1973], p. 267).

34. This is Zola's argument in an article he published, before the last chapters of *Nana* were even written, to counter the accusations of obscenity that the first installments of the novel were already attracting. See Mitterand's extracts from the article in *Nana*, pp. 1689–90.

35. Little is known about Zola's relationship with Berthe. The only evidence comes from two letters, one from Zola to a friend in early 1861, the other from another friend who had just read the novel in November 1865. Both are cited in the "Notice" to *La confession de Claude*, in *Oeuvres complètes*, vol. I (Paris: Cercle du Livre Précieux, 1966), pp. 113–115; hereafter abbreviated *CDC*. The most extensive discussion of this novel that I know of is by John Lapp, *Zola before the Rougon-Macquart* (Toronto: University of Toronto Press, 1964), pp. 48–66.

36. The five sketches of prostitutional life that Céard, an expert, produced for Zola's pleasure are printed in *Nana*, pp. 1678–82.

37. This reading has been suggested in Naomi Schor, *Zola's Crowds* (Baltimore: Johns Hopkins University Press, 1978), pp. 101–102. It has been refined and elaborated by Janet Beizer in two excellent articles, "Uncovering *Nana*: The Courtesan's New Clothes," *L'esprit créateur* 25 (Summer 1985); and idem, "The Body in Question: Anatomy, Textuality, and Fetishism in Zola," *L'esprit créateur* (Spring 1989).

38. No one has explored Zola's fantasmatic geography with greater insight than Jean Borie, *Zola et les mythes* (Paris: Seuil, 1971). Borie explores in detail the connection between excrement, sexuality, and the death instinct in Zola's creative imagination. See also Borie, *Le tyran timide: Le naturalisme de la femme au XIXe siècle* (Paris: Klincksieck, 1973), which is primarily a reading of Zola's *La joie de vivre*.

39. Sander Gilman, who reads Nana's "decaying visage [as] the visible sign of [her] diseased genitalia," links this image suggestively to the allegorical figure of *Frau Welt*, who hides her deadly female disease with a mask of beauty, and to the prevalent late-nineteenth-century fantasy linking destructive female sexuality to the primitive, diseased world of the black. See Gilman, *Difference and Pathology: Stereotypes of Sexuality, Race, and Madness* (Ithaca: Cornell University Press, 1985), p. 105.

40. These notes have been edited and published by Henri Mitterand; see Zola, *Carnets d'enquêtes* (Paris: Plon, 1986), pp. 323–333.

41. See the "Arbres généalogiques des Rougon-Macquart," in *Les Rougon Macquart,* vol. V (Paris: Pléiade, 1967).

42. Charles Richet, "Les démoniaques d'aujourd'hui," *Revue des deux mondes* 37 (1880): 345. Subsequent citations in this paragraph are on p. 343.

43. Emile Zola, *Les romanciers naturalistes,* in *Oeuvres complètes,* vol. XI (Paris: Cercle du Livre Précieux, 1983), p. 146.

44. Letter to Madame Roger des Genettes, 18 April 1880.

45. Gustave Flaubert, *Carnets de travail,* ed. Pierre-Marc de Biasi (Paris: Balland, 1988), p. 549. Hereafter abbreviated *CT.* The angular brackets in the following citation represent words Flaubert added; regular brackets signify words barred in the manuscript. De Biasi's monumental edition of Flaubert's working notes is an invaluable source of information, scrupulously edited and presented.

46. Cited by Mitterand in the Pléiade edition of *Nana,* p. 1674.

47. Flaubert's great admiration for the "epic" ending of Zola's novel is all the more understandable when we know that he had imagined a similar closing scene of degradation for his book. According to Maxime Du Camp, Flaubert regretted that he had finished *L'éducation sentimentale* before the capitulation at Sedan, since the perfect ending for it would have shown the emperor being insulted and spat upon by captured French soldiers whose column had crossed the path of the retreating emperor's carriage. He told Du Camp that he hoped to use this *rude tableau final* in his projected novel about Compiègne and the Second Empire (see Marie-Jeanne Durry, *Flaubert et ses projets inédits* [Paris: Nizet, 1950], pp. 254–255).

48. The brothers found the description of this unusual pathology in Jean-Louis Brachet, *Traité de l'hystérie* (Paris: Baillière, 1847). For an extensive analysis of the role of Brachet's work in the genesis of *La fille Elisa,* see Robert Ricatte, *La genèse de "La fille Elisa"* (Paris: Presses Universitaires de France, 1960), pp. 60–65; and idem, *La création romanesque chez les Goncourt, 1851–1870* (Paris: Armand Colin, 1953), pp. 296–298. On Brachet's authority, the Goncourts show hysteria to be caused by prostitution. The entire second half of the novel constitutes an attack on the Auburn system of prison regulation, which required silence on the part of all inmates and, according to Edmond de Goncourt, drove them crazy. Thus, the novel breaks into two parts, with little continuity between them. So external is Goncourt's viewpoint, that Elisa is no more talkative when she is a free woman than when she is compelled to silence. Ricatte has published the Goncourts' notes on their reading of Parent-Duchâtelet (*Genèse,* pp. 205–207), on Lecour (*Genèse,* pp. 207–209), and on various studies of penitentiary systems. Edmond's perspective on the whore as a subject for art, Ricatte demonstrates in an interesting analysis, was greatly influenced by the pictures of Constantin Guys (*Genèse,* pp. 146–153).

49. Edmond and Jules de Goncourt, *Journal,* 4 vols. (Paris: Fasquelle-Flammarion, 1956), I, 1239. Subsequent citations in this paragraph are from I, 1239, 1042, 1043.

50. On another occasion, the Goncourts record a conversation that pro-

duced "a great dissertation on the smells of the theater" (*Journal,* I, 895), which suggests that this was a common subject of observation well before Zola produced his extraordinary evocation of behind-the-scenes odors in *Nana.* Flaubert himself tells of a visit to the *coulisses* of the Cirque theater, which he found *"énorme! énorme!* . . . I breathed in all kinds of smells of women and scenery, which were mixed up with the belches of the hairdresser." Gustave Flaubert, *Correspondance,* ed. Jean Bruneau, 2 vols. (Paris: Pléiade, 1973, 1980), II, 621, letter of 28 July 1856.

51. Quoted by Mitterand with no source indicated, *Nana,* p. 1693.

52. Ibid. The author is a certain Georges Ohnet.

53. See *Carnets d'enquêtes,* p. 311. Zola's notes on his conversations with Laporte and Halévy are on pp. 307–315.

54. Here I am in disagreement with Sander Gilman, who claims that Nana's protuberant buttocks are a sign of an atavistic physiology linking her, in contemporary male fantasy, to primitive African origins and that her ear can be identified as the so-called "Darwin's ear," lacking convolutions and lobe, another sign of atavistic degeneration (*Difference and Pathology,* p. 102). Surely to paint a woman with ample embonpoint is not necessarily to elicit fears of pathological corruption, and the representation of Nana's ear is no doubt a function of painterly technique rather than a pseudo-clinical identification.

55. *Carnets d'enquêtes,* p. 313.

Eight. Huysmans

1. Joris-Karl Huysmans, *A Rebours* (Paris: Gallimard, 1977), p. 197. All future references to this Folio edition, edited with an excellent introduction and informative notes by Marc Fumaroli, will be abbreviated *AR.*

2. See Alain Corbin, *Les filles de noce: Misère sexuelle et prostitution* (Paris: Aubier Montaigne, 1978), p. 364. My discussion throughout this paragraph and the next is directly inspired by Corbin's analysis on pp. 362–370 of his invaluable study. On neoregulation, see also the last chapter of Jill Harsin, *Policing Prostitution in Nineteenth-Century France* (Princeton: Princeton University Press, 1985).

3. Charles Mauriac, *Leçons sur les maladies vénériennes professées à l'Hôpital du Midi* (Paris: Baillière, 1883), pp. 186–187; Emile Richard, *La prostitution à Paris* (Paris: Baillière, 1890), p. 23. Both are quoted in Corbin, *Les filles de noce,* p. 364. Near the turn of the century, estimates of infection skyrocketed: by one estimate 13 to 15 percent of the male population was diseased; another expert thought 20 percent would be more accurate. In 1902 the director of the Institut Pasteur considered that there were a million contagious syphilitics in French society.

4. From a lecture by Professor Barthélemy at a dermatology and syphilography conference held in Paris in 1889. Quoted in Corbin, *Les filles de noce,* p. 364.

5. Corbin lists these and many other supposed causes of contamination in

his article "Le péril vénérien au début du siècle: Prophylaxie sanitaire et pro-phylaxie morale," *Recherches* 29 (1977): 250. It is interesting to note that Louis Fiaux, the medical authority we encountered in the previous chapter, lists an equally horrific series of contagious infections, mostly derived from Fournier, as evidence that the system of regulation is unworkable and should be abolished. Fiaux tries to be ecumenical in his cautionary anecdotes. He tells of Catholics spreading syphilis by kissing the crucifix, Protestants contaminating one another by drinking from the Communion cup, and Jewish rabbis infecting babies by sucking the blood from the penis after circumcision (*La police des moeurs en France et dans les principaux pays de l'Europe* [Paris: Dentu, 1888], p. 340). Fiaux is admirable for his insistence on the role of men in spreading syphilis: "L'homme," he writes, "est donc par excellence le *syphilisateur* des filles plus ou moins publiques—qui, elles, sont les *syphilisées*" (p. 349). The clients of prostitutes, Fiaux argues logically, should be subject to the same medical inspections as the women they may possibly infect. Needless to say, Fiaux's proposal, already considered utopian when it was put forward a century earlier by Restif de la Bretonne, fell on deaf ears.

6. For more on this subject, see Alain Corbin, "L'hérédosyphilis, ou l'impossible rédemption: Contribution à l'histoire de l'hérédité morbide," *Romantisme* 31 (1981): 131–149.

7. For an excellent discussion of this phenomenon, which foregrounds its representation in the visual arts, see Theresa Ann Gronberg, "Femmes de Brasserie," *Art History* 7 (September 1984): 329–344.

8. See the passages from *Les Déracinés* quoted in Corbin, *Les filles de noces,* p. 253. Corbin studies the phenomenon of the *brasseries à femmes* on pp. 250–254.

9. In 1876 Edmond de Goncourt tells an anecdote which confirms Huysmans's judgment that virile sexual energy is lacking in this degenerate age: "Lachaud, the lawyer, presented a *topical* detail tonight on the degeneration of the man of the people and of the worker, a detail he got from the madam of a brothel on the outer boulevards. She told him that there was nothing more to do in her profession, coitus having lost much of its fury. She added that, in the old days, one had to supervise any man who took a girl to bed, to make sure that he didn't pull off two shots right away. Now such supervision was no longer necessary: the man of 1876 does not double up." Edmond and Jules de Goncourt, *Journal,* 2 vols. (Paris: Fasquelle and Flammarion, 1956), II, 1132.

10. Joris-Karl Huysmans, *Marthe: Histoire d'une fille,* in Huysmans, *Oeuvres complètes,* vol. II (Paris: Crès, 1928), p. 11.

11. Huysmans himself saw the book in these terms. In a pseudonymous autobiographical text, he wrote: "Here and there [*Marthe*] includes some accurate observations and it already reveals some morbid qualities of style, but the language, in my opinion, is too reminiscent of Goncourt's. It's a beginner's book, curious and vibrant, but clipped short, insufficiently personal." Quoted ibid., pp. 146–147.

12. For an intelligent reading of the narrator's position and of the impor-

tant role of Ginginet as a subversive presence, see Hilde Olrik, *"Marthe:* Une prostituée du XIXe siècle," *Revue des sciences humaines* 43 (April–September 1978).

13. "Emile Zola et *L'Assommoir,"* in Huysmans, *Oeuvres complètes,* II, 190.

14. Joris-Karl Huysmans, *Là-Bas* (Paris: Garnier-Flammarion, 1978), p. 33. Hereafter abbreviated *LB.*

15. This resemblance is noted in a suggestive, almost lyrical book by Patrick Wald Lasowski, *Syphilis: Essai sur la littérature française du XIXe siècle* (Paris: Gallimard, 1982).

16. For an astute analysis of the function and structure of dream narratives in Huysmans, see Françoise Carmignani-Dupont, "Fonction romanesque du récit de rêve: L'exemple d'*A Rebours,"* *Littérature* 43 (October 1981): 57–74.

17. Joris-Karl Huysmans, *En Rade* (Paris: 10/18, 1976), p. 210. Hereafter abbreviated *ER.*

18. This dental imagery recalls the memory Des Esseintes evoked earlier of his own mutilation by a brutal doctor who, while pulling out a tooth, seems, on the level of unconscious association, to be simultaneously castrating and raping him. See Carmignani-Dupont, "Fonction romanesque du récit de rêve," pp. 60–61; and Michel Collomb, "Le cauchemar de Des Esseintes," *Romantisme* 19 (1978): 79–89.

19. Sigmund Freud, "Medusa's Head," in Freud, *Sexuality and the Psychology of Love* (New York: Collier, 1963), p. 212.

20. My attention was drawn to this passage by Jean Decottignies's illuminating discussion of it in his fine article, *"Là-Bas,* ou la phase démoniaque de l'écriture," *Revue des sciences humaines* 43 (April–September 1978): 69–79.

21. Emile Zola, *La faute de l'abbé Mouret,* in *Les Rougon-Macquart,* vol. I (Paris: Pléiade, 1960), p. 1489.

22. Ibid., p. 1490.

23. Discussing the abbé Mouret's organic nightmare, Jean Borie asks rhetorically: "In the supreme nausea represented for him by nature assaulting *his* church, . . . is it not once and for all the horror of castration that is revealed?" (*Zola et les mythes* [Paris: Seuil, 1971], p. 67). A striking passage in *La joie de vivre* brings together once again imagery of female mutilation and the figure of a tree. It is the description of Louise's genitals after she has given birth: "Nothing remained but suffering humanity, childbirth amidst blood and filth, bursting open the mother's womb, stretching to the point of horror the red slit, like the slash of an axe that opens the trunk of some great tree, spilling its lifeblood" (*Les Rougon-Macquart,* II, 1096). This fantasmatically charged passage links castration, anality, female fertility, and phallic virility.

24. Emile Zola, *La Curée,* in *Les Rougon-Macquart,* I, 357. Hereafter abbreviated *C.*

25. Naomi Schor, *Breaking the Chain: Women, Theory, and French Realist Fiction* (New York: Columbia University Press, 1985), p. 45.

26. This passage is perceptively analyzed by Jean de Palacio in a fascinating article, "La féminité dévorante: Sur quelques images de la manducation dans la littérature décadente," *Revue des sciences humaines* 42 (October–December

1977): 601–618. See also his complementary discussion, "Messaline décadente, ou la figure du sang," *Romantisme* 31 (1981): 209–228.

27. Alain Buisine, "Le Taxidermiste," *Revue des sciences humaines* 43 (April–September 1978): 59–68.

28. Joris-Karl Huysmans, *Sainte Lydwine de Schiedam,* 2 vols. (Paris: Crès, 1932), I, 80. Hereafter abbreviated *SL.*

29. Jean-Luc Steinmetz has made this point before me in his stimulating article "Sang sens," *Revue des sciences humaines* 43 (April–September 1978). "The sheer number of ailments that assail Lydwine," writes Steinmetz, "finally indicates clearly to her that a frighteningly incarnated language binds her to unity. And this language is in fact a writing applied onto living flesh" (p. 86).

30. In *Les foules de Lourdes,* published in 1906, two years before his death, Huysmans declares himself so blasé about ordinary cases of mutilated, putrefying human bodies "sans luxe d'horreur particulière" ("without the special attraction of any particular horror"), that only the most "exorbitant cases" can still give him "the giddiness of excess." Such satisfying horror, literally disorbited, is provided by "larval heads like that of this woman whose eye was brandished, resembling that of a slug, at the end of a tentacle." *Les foules de Lourdes* (Paris: Crès, 1934), pp. 291–292.

31. In *En Rade* Jacques Marles reads an article that offers a scientific version of Lydwine's miraculous sublimation: a certain Professor Selmi has discovered in the putrefaction of cadavers a substance called ptomain, which is wonderfully perfumed. Jacques then indulges in a long, very funny meditation on the various ways this discovery could be exploited commercially: extracts of their ancestors, of long-dead fathers and mothers, for instance, could be prepared for the use of rich families (the poor could be sold perfumes made from corpses disintegrating in the *fosse commune*); these "sublimated emanations of the dead" (*ER,* 196) could then be kept close to one, on one's handkerchief, for example, for easy spiritual access in case of distress; should scientific advances overcome the toxicity of ptomains, families would be able to sit down to meals flavored with a little of the corporeal essence of a departed relative, furthering through gustatory delectation the spirit of family unity.

32. In his heavy-handed satirical novel of 1894, *Les Morticoles,* Léon Daudet, son of Alphonse, imagines a country of maniacs ruled by quack doctors. The description of the women's hospital ward serviced by Dr. Foutange, in whom one easily recognizes Charcot, a figure that haunted Daudet throughout his career, is intended to bring out the analogy to a brothel. I abbreviate the lengthy passage: "In the middle of this masquerade, about thirty women fidgeted and stretched themselves, some young and pretty, others old, but all made-up, their wrinkles chalk-white and red . . . Dressing gowns, open on the side, revealed flanks and thighs . . . Some *filles* adopted nonchalant poses, lying all dressed on their beds, making their hips stand out . . . Our entry into this harem attracted lively attention. We felt all those feverish looks, accented by mascara and rouge, concentrated on us . . . I saw two in a tight embrace [the characteristic linkage of lesbianism and prostitution]" (*Les Morticules* [Paris: Fasquelle, 1956], p. 163). For a discussion of Daudet's strangely conflicted relation to

Charcot, see Elisabeth Roudinescu, *Histoire de la psychanlyse en France: I (1885–1939)* (Paris: Seuil, 1986), pp. 60–68.

33. It is interesting to note in this regard that society women, who were commonly compared to courtesans in the late 1860s to early 1880s, are felt to resemble hysterics by the late 1880s. Edmond de Goncourt notes in his *Journal* on 17 April 1889: "They [women of society at this moment] look just like hysterics from the Salpêtrière, let loose by Charcot into the world" (IV, 961). Goncourt detested Charcot, whom he considered a powermonger and whose "tyrannical sovereignty" and "corrupting maneuvers" (*Journal,* IV, 17) he wanted to see unmasked.

34. See Jan Goldstein, "The Hysteria Diagnosis and the Politics of Anti-clericalism in Late Nineteenth-Century France," *Journal of Modern History* 54 (June 1982): 213. This article has now largely been integrated into the last chapter of Goldstein's important book, *Console and Classify: The French Psychiatric Profession in the Nineteenth Century* (Cambridge: Cambridge University Press, 1987).

35. Jean-Martin Charcot, *Leçons du mardi à la Salpêtrière. Policlinique, 1887–1888* (Paris: Progrès Médical/Delahaye & Lecrosnier, 1888), p. 115. Cited in Georges Didi-Huberman, *Invention de l'hystérie: Charcot et l'iconographie photographique de la Salpêtrière* (Paris: Macula, 1982), p. 25. My discussion of Charcot is indebted to Didi-Huberman's forceful interpretation of what went on at the Salpêtrière; to Gérard Wajeman's book *Le maître et l'hystérique* (Paris: Navarin, 1982), which provides a broader historical and theoretical context for the phenomenon of fin-de-siècle hysteria; and to Elisabeth Roudinesco's excellent overview in the early pages of her *Histoire de la psychanalyse,* I.

36. Pierre Briquet, *Traité clinique et thérapeutique de l'hystérie* (Paris: Baillière, 1859), p. 3. The subsequent citation is on p. 102.

37. *Histoire de la psychanalyse,* I, 209–210. Roudinesco goes on to suggest that a major reason for the French medical establishment's resistance to Freud's concept of the libido was its commitment to thinking about sexuality "under the sign of syphilitic exuberance" (p. 210). Whereas Freud separated himself progressively from the doctrines of heredity and organic degeneration, the French continued to stress the biological connection between human and animal sexuality. In a particularly brilliant section of her book (pp. 87–100), Roudinesco shows that one of Freud's motives for abandoning the theories deriving from Darwinian biologism was their susceptibility to being used for racist, in particular anti-Semitic, ends. It is, indeed, clear that an ideology that stigmatizes woman in the ways I have traced throughout this book easily transfers similar stigma onto the Jew (and the homosexual, and the black). Charcot, for instance, spoke of the "especially marked predisposition of the Jewish race for hysteria" (cited by Alexander Pilez, *Beitrag zur vergleichenden Rassen-Psychiatrie* [Leipzig: Denticke, 1906]; quoted in turn by Sander Gilman, *Disease and Representation: Images of Illness from Madness to AIDS* [Ithaca: Cornell University Press], p. 169).

For analyses of the ideological and historical relations between stereotypes of women, blacks, Jews, and similar images of the "Other," see the recent books

by Sander Gilman, especially *Difference and Pathology: Stereotypes of Sexuality, Race, and Madness* (Ithaca: Cornell University Press, 1985). On issues of heredity and degeneration, see Jean Borie, *Mythologies de l'hérédité au 19e siècle* (Paris: Galilée, 1981); Robert Nye, *Crime, Madness, and Politics in Modern France: The Medical Concept of National Decline* (Princeton: Princeton University Press, 1984); and J. Edward Chamberlain and Sander Gilman, eds., *Degeneration: The Dark Side of Progress* (New York: Columbia University Press, 1985).

38. Jean-Martin Charcot, *Oeuvres complètes*, 9 vols. (Paris: Progrès Médical / Lecrosnier & Babé, 1886–1893), III, 15. This admission is analogous to the more famous one Freud recounts of Charcot's declaring gleefully at an evening reception that in the case of a hysterical woman with an impotent or very awkward husband, the cause was quite simply "la chose génitale, toujours, ... toujours, ... toujours" ("On the History of the Psycho-Analytic Movement," *The Standard Edition of the Complete Psychological Works of Sigmund Freud* [London: Hogarth, 1957], XIV, 14). Freud says he was "almost paralyzed in amazement" by this statement and wondered why Charcot never mentioned this etiology in his clinical lessons. On another occasion, Freud speaks of Charcot's "personal disinclination to . . . single out the sexual factor in the aetiology of hysteria" ("The Aetiology of Hysteria," *Standard Edition*, III, 199).

39. See Jean-Martin Charcot and P. Richer, *Les démoniaques dans l'art* (Paris: Delahaye & Lecrosnier, 1887). Freud, of course, was also fascinated by the parallels between hysteria, witchcraft, and demonology. Indeed it seems likely that, in the late 1880s and early 1890s, both Huysmans and Freud were coming to terms with Charcot's teaching, asking themselves similar questions about how to get beyond its positivistic organicism. It was precisely in relation to the problem of witchcraft and possession that Freud began to focus on the role of sexuality in the genesis of hysteria. "Do you remember," Freud writes Fliess on 17 January 1897, "that I always said that the medieval theory of possession held by the ecclesiastical courts was identical with our theory of a foreign body and the splitting of consciousness? But why did the devil who took possession of the poor things invariably abuse them sexually and in a loathsome manner?" (*The Complete Letters of Sigmund Freud to Wilhelm Fliess, 1887–1904* [Cambridge, Mass.: Harvard University Press, 1985], p. 224).

40. Jules Claretie, "Charcot, le consolateur," *Les annales politiques et littéraires* 21, no. 1056 (1903): 180. Quoted in Didi-Huberman, *Invention de l'hystérie*, p. 261.

41. D.-M. Bourneville and P. Régnard, *Iconographie photographique de la Salpêtrière* (Paris: Progrès Médical / Delahaye & Lecrosnier, 1878), II, 140.

42. One of the more bizarre moments at the Salpêtrière must have been the time Augustine claimed to recognize her rapist among the spectators at a clinical lesson. As Didi-Huberman observes (*Invention de l'hystérie*, p. 251), it was as if the rapist, if indeed it was he, had come to admire the dramatic spectacle of his handiwork. Augustine, we are told, suffered 154 attacks in that day alone.

43. See Bram Dijkstra, *Idols of Perversity: Fantasies of Feminine Evil in Fin-de-Siècle France* (New York: Oxford University Press, 1986); Annelise Maugue,

L'identité masculine en crise au tournant du siècle (Paris: Rivages, 1987); and Alain Corbin, "Cris et chuchotements," in *Histoire de la vie privée* (Paris: Seuil, 1987), IV, 563–610.

44. Cesare Lombroso and Guglielmo Ferrero, *La femme criminelle et la prostituée* (Paris: Félix Alcan, 1896), p. 578. Subsequent citations in this paragraph are on pp. 53, 603. For an excellent discussion of Lombroso's terrified vision of female sexuality, see Hilde Olrik, "Le sang impur: Notes sur le concept de prostituée-née chez Lombroso," *Romantisme* 31 (1981): 167–178.

45. Séverin Icard, *L'état psychique de la femme pendant la période menstruelle considéré spécialement dans ses rapports avec la morale et la médecine légale* (Paris: Félix Alcan, 1889), p. ix.

46. Max Nordau, *Degeneration* (New York: Howard Fertig, 1968), p. 302.

47. Ibid., p. 309. While castigating the fin de siècle for its degeneracy, Nordau often demonstrates a typically decadent, post-Darwinian delight in the rhetoric of organic reversion. Here, for example, is a passage from his conclusion: "The relapse of the degenerate may reach to the most stupendous depth. As, in reverting to the cleavage of the superior maxillary peculiar to insects with sextuple lips, he sinks somatically to the level of fishes, nay to that of the anthropoda, or, even further, to that of rhizopods not yet sexually differentiated; as by fistulae of the neck he reverts to the branchiae of the lowest fishes, the selacious; or by excess in the number of fingers (polydactylia) to the multiple-rayed fins of fishes, perhaps even to the bristles of worms; or, by hermaphrodism, to the asexualily of rhizopods—so in the most favorable case, as a higher degenerate, he renews intellectually the type of the primitive man of the most remote Stone Age; or, in the worst case, as an idiot, that of an animal far anterior to man" (ibid., p. 556).

48. See Jean Laplanche, *Problématiques III: La Sublimation* (Paris: Presses Universitaires de France, 1980); Leo Bersani, *The Freudian Body: Psychoanalysis and Art* (New York: Columbia University Press, 1986); and idem, "'The Culture of Redemption': Marcel Proust and Melanie Klein," *Critical Inquiry* 12 (Winter 1986): esp. 407–414.

49. This emphasis on representation is suggestively similar to Freud's point in an article of 1888–1893, in which he expresses a fundamental disagreement with Charcot's neurological goal of localizing hysterical lesions. "I, on the contrary," writes Freud, "assert that the lesion in hysterical paralyses must be completely independent of the anatomy of the nervous system, since in its paralyses and other manifestations hysteria behaves as though anatomy did not exist or as though it had no knowledge of it" ("Some Points for a Comparative Study of Organic and Hysterical Motor Paralyses," *Standard Edition*, I, 169). Hysteria ignorant of anatomy: this is precisely the negation of the (female) organic ground so ardently desired by the writers and artists of the decadence and fin de siècle. Hysteria, Freud argues, operates in terms of a representation of the body. The form of this representation is determined in function of received verbal signs: "It [hysteria] takes the organs in the ordinary, popular sense of the names they bear" (ibid.). This move from anatomical organs to language initiates Freud's passage from neurology to psychology and leads eventually to

his invention of psychoanalysis. It foreshadows, moreover, his abandonment of the seduction theory in favor of the Oedipus complex. In the present context, I can do no more than suggest the interest of examining the function of sublimation in Freud's ongoing theoretizations to determine to what extent they may have been driven by the kind of traumatized relation to the "natural" female body I have ascribed to fin-de-siècle artists and writers. (Such an analysis would have to examine, for instance, what Freud's essentialism has in common with that of Briquet and Charcot. Consider a passage such as this from a text Freud sent to Fliess on 1 January 1896: "The natural sexual passivity of women explains their being more inclined to hysteria"—*The Complete Letters of Sigmund Freud to Wilhelm Fliess*, p. 169).

50. Edward Said, *Beginnings: Intention and Method* (New York: Basic Books, 1975).

51. Buisine, "Le Taxidermiste," pp. 67–68. On the simulacrum, the entropic pathology of organic life, and the crisis of representation in Huysmans, see the excellent articles by Françoise Gaillard, *"En rade,* ou le roman des énergies bloquées," in *Le Naturalisme: Colloque de Cérisy* (Paris: 10/18, 1978); and *"A Rebours:* Une écriture de la crise," *Revue des sciences humaines* 43 (April–September 1978): 111–122.

52. Octave Mannoni, "Je sais bien, mais quand même," in *Clefs pour l'imaginaire, ou l'autre scène* (Paris: Seuil, 1969), pp. 9–33.

53. This connection is brought out in detail by Jean-Luc Steinmetz, "Des Esseintes en procès," in *Mélanges Pierre Lambert consacrés à Huysmans* (Paris: Nizet, 1975), pp. 77–98.

54. Jean Laplanche argues persuasively that sublimation "involves the idea of a sort of repeated, continual neocreation of sexual energy, hence the continual reopening of an excitation . . . This extemporaneous sexuality, woven into the creation of a work is . . . ultimately linked to the question of traumatism" (*Problématiques III: La Sublimation,* pp. 249–250).

55. See Schor, *Breaking the Chain,* pp. 111–126.

Conclusion.

1. I find my thesis corroborated in a recently published book by Griselda Pollock, *Vision and Difference: Femininity, Feminism and Histories of Art* (London: Routledge, 1988). Pollock notes that "it is a striking fact that many of the canonical works held up as the founding monuments of modern art treat precisely with this area, sexuality, and this form of it, commercial exchange" (p. 54). Evoking both *Olympia* and the *Demoiselles d'Avignon,* Pollock calls on art critics "to recognize modernist painting not exclusively as the heroic struggle for individual expression or the equally painful discipline of purification and stylistic innovation but as a more fundamental discourse around the paradoxes and anxieties of masculinity which hysterically and obsessionally figures, debases and dismembers the body of woman" (p. 159).

2. Leo Steinberg, "The Philosophical Brothel," *October* 44 (Spring 1988):

64. Subsequent citations in this paragraph are on pp. 63, 46, 71. This essay was first published in *Art News* 71 (September–October 1972).

3. See Mary Mathews Gedo, *Picasso: Art as Autobiography* (Chicago: University of Chicago Press, 1980), p. 79.

4. See Michael Leja, "'Le vieux marcheur' and 'Les deux risques': Picasso, Prostitution, Venereal Disease, and Maternity, 1899–1907," *Art History* 8 (March 1985): 68.

Credits

Parts of certain chapters in this book have appeared earlier in different form: "Of Whores and Sewers: Parent-Duchâtelet, Engineer of Abjection," *Raritan* 6 (Winter 1987); "Prostitution and Narrative: Balzac's *Splendeurs et misères des courtisanes*," *L'esprit créateur* 25 (Summer 1985); "Female Sexuality and Narrative Closure: Barbey's 'La vengeance d'une femme' and 'A un dîner d'athées,'" *Romanic Review* 74 (May 1983); "Manet's *Olympia:* The Figuration of Scandal," *Poetics Today* 10 (Summer 1989); "Degas's Brothels: Voyeurism and Ideology," *Representations* 20 (Fall 1987); "Huysmans: Writing against (Female) Nature," in *The Female Body in Western Culture: Contemporary Perspectives*, ed. Susan Suleiman (Cambridge, Mass.: Harvard University Press, 1986). For permission to reuse this material, I wish to thank the respective editors.

Index

Abolitionism, 163, 308n22; and the Commune, 209; and feminism, 211; in (1878), 234. *See also* Misogyny

Adam, Antoine, 36

Antigny, Blanche d', 230, 233

Armstrong, Carol, 170, 171, 186, 191, 304n58

Augier, Emile, 95, 115

Balzac, Honoré de, 34–42, 53–68; and Parent, 34, 35–36, 38, 39, 53, 69–70; *Splendeurs et misères des courtisanes,* 35–36, 37–42, 46, 53–68, 70, 98; *La fille aux yeux d'or,* 38; and Esquiros, 45; compared to Sue, 46, 53, 54–55, 64, 66; and Baudelaire, 72; and Flaubert, 135, 141, 150, 154–155; cited by Zola, 216; analogous to Charcot, 252; *Ferragus,* 279n12; *Les Marana,* 281n22; and Vidocq, 281n35; *Illusions perdues,* 282n42; *La peau de chagrin,* 284n3. *See also* Genderification, creative; Reformed prostitute, archetype of the

Barbéris, Pierre, 61

Barbey d'Aurevilly, Jules: on dandyism, 74–76, 87, 88, 184; "La vengeance d'une femme," 75–81; and Sue, 76; "A un dîner d'athées," 81–88; and Parent, 83; and Baudelaire, 87, 88; and Flaubert, 140; and Zola, 221; *Les Bas-bleus,* 286n19. *See also* Genderification, creative; Sublimation

Barrès, Maurice, 236

Barthes, Roland, 75

Bataille, Georges: on *Olympia,* 113–114, 118, 126, 266; and Baudelaire, 114; *L'Erotisme,* 114, 115; and Flaubert, 151. *See also* Misogyny

Baudelaire, Charles: art as prostitution, 1, 71–74; "La Fanfarlo," 71, 158; on dance, 71; on Guys, 71, 73–74, 175; idea of female beauty, 71, 74, 97, 290n39; on Balzac, 72; on the *flâneur,* 73–74, 98; and Barbey, 87, 88; and Bataille, 114; and Manet, 125, 292n51; and Flaubert, 132, 133, 141; and Huysmans, 261; Sartre on, 284nn5,6, 287n17; his brothel dream, 292n5. *See also* Genderification, creative; Misogyny

Baudrillard, Jean, 97, 101, 147

Baudry, Paul, 105, 107, 233

Beauvoir, Simone de, 280n18

Béguin, Albert, 39, 40

Beizer, Janet, 282nn38,40, 283n47

Benjamin, Walter: on the *flâneur,* 98–99, 104, 125, 155, 189; on the prostitute's stare, 107

Béraud, F.-F.-A., 22–23, 25, 26, 279n13, 280n17

Berger, John, 105

Bernard, Claude: and Zola, 214; and Charcot, 252

Index

99; in Bataille, 113–115, 126; in
Flaubert's circle, 129–132; in
Flaubert, 129–134; in Huysmans's
view of Degas, 168–170; in
Picasso, 181, 270; exposed by
Degas, 190, 194; in criticism of
Degas, 190–191; in Degas, 191–
192; in Michelet, 206–207; in
Proudhon, 208; in abolitionist dis-
course, 211–212; in Zola, 216,
227; in Huysmans, 244–247; in
Charcot, 252–253; in Mirbeau,
300–301n24

Modernism, 2, 88; and male prosti-
tution, 70; in painting, 114, 266;
and prostitution, 163, 268; in
Degas, 194; in Huysmans, 263–
265; in Picasso, 270; and gender,
273–274

Morisot, Berthe, 190

Mulvey, Laura, 118

Nordau, Max, 260, 318n47

Olympia (Manet): response to, 102–
104; and the nude, 105; her gaze,
107–109; her class, 110–111;
defended by Zola, 112–113, 126,
266, 290n32; Bataille's analysis,
113–115; her name, 115–116; her
hand, 117–119; her servant, 120–
124

Opera: ball, 36, 40, 280n17; dance
foyer, 159; *coulisses*, 160

Païva, La: 100–102, 104; her bed,
100, 196, 233, 288n22; painted by
Baudry, 105

Parent-Duchâtelet, Alexandre, 2, 3,
6, 8–33, 83, 99, 159, 163, 270–
271; on *poudrette*, 8–10, 13; on
sewers, 10–11; on causes of pros-
titution, 17–18, 210; and clandes-
tinity, 26–28; and the law, 28–33;
and Balzac, 34, 35–36, 38, 39, 53,
69–70; and Sue, 46, 50; and

Barbey, 83; and Manet, 112, 115;
and Flaubert, 150; and Zola, 202,
218; and hysteria, 206; and
Proudhon, 208; and Charcot, 252.
See also Regulation

Paris: its pathology, 36–37, 76; as
prostitute, 38; Cité district, 46–47,
48, 50, 89

Pearl, Cora, 93, 230

Petit, Jacques, 85

Photography: pornographic, 111,
125, 184; use by Degas, 191

Picasso, Pablo: *Parody of "Olympia,"*
123; late etchings, 177–181, 185;
Demoiselles d'Avignon, 266–270;
and syphilis, 268–269. *See also*
Misogyny

Poittevin, Alfred Le, 129, 130,
295n19

Police: registers, 16, 35; dispensary,
16, 24; and the law, 28, 33, 62–
64; and *l'arbitraire*, 29. *See also*
Regulation

Pornography, 186–189. *See also* Pho-
tography

Pouchet, Félix Archimède, 203, 218

Prendergast, Christopher, 59, 66, 67,
282nn38,39, 283n45

Proudhon, Pierre-Joseph, 208, 209

Reff, Theodore: on *Olympia*, 117,
119, 122; on Degas, 298n5

Reformed prostitute, archetype of
the: in Rousseau (Lauretta Pisana),
42; in Hugo (Marion de Lorme),
43–44; in Esquiros, 44–45; in Sue
(Fleur-de-Marie), 45–52; as
revised by Balzac (Esther Gob-
seck), 51–56, 65–66; in Dumas,
fils, 94; satirized by Villiers de
l'Isle-Adam, 95–96; influence on
Zola, 219–220

Regulation (of prostitution): system
of, 2; compared to artistic strate-
gies, 2; Parent's advocacy of, 16–
17, 20, 31; Restif's plan for, 19–